DEATHWATCH

D1465323

FILM AND CULTURE

JOHN BELTON, EDITOR

B.S.U.C. - LIBRARY

00276553

FILM AND CULTURE

A series of Columbia University Press

EDITED BY JOHN BELTON

For the list of titles in this series see page 277

AMERICAN FILM,
TECHNOLOGY, AND
THE END OF LIFE

DEATHWATCH

C. SCOTT COMBS

COLUMBIA UNIVERSITY PRESS NEW YORK

BATH SPA UNIVERSITY
NEWTON PARK LIBRARY
Class No.
791·436548 COM
30/06/15

Columbia University Press
Publishers Since 1893
New York Chichester, West Sussex
cup.columbia.edu
Copyright © 2014 Columbia University Press

All rights reserved

Library of Congress Cataloging-in-Publication Data
Combs, C. Scott.
 Deathwatch : American film, technology, and the end of life /
C. Scott Combs.
 pages cm. — (Film and culture)
 Includes bibliographical references and index.
 ISBN 978-0-231-16346-0 (cloth : alk. paper) — ISBN 978-0-231-16347-7
(pbk. : alk. paper) — ISBN 978-0-231-53803-9 (ebook)
 1. Death in motion pictures. 2. Mortality in motion pictures.
3. Motion pictures—United States—History and criticism. I. Title.

PN1995.9.D37C66 2014
791.43'6548—dc23
 2014001350

Columbia University Press books are printed on permanent and
durable acid-free paper.
This book is printed on paper with recycled content.

Printed in the United States of America
c 10 9 8 7 6 5 4 3 2 1
p 10 9 8 7 6 5 4 3 2 1

Cover photograph provided by Photofest
Cover design by Lisa Hamm

References to websites (URLs) were accurate at the time of writing. Neither
the author nor Columbia University Press is responsible for URLs that may
have expired or changed since the manuscript was prepared.

Portions of chapter 2, "Posthumous Motion: The Deathwork of Narrative
Editing," was first published in *Cinema Journal* 52.1 as the article "Mobile Endings:
Screen Death, Early Narrative, and the Films of D. W. Griffith," by Scott Combs,
pp. 90–106. Copyright (c) 2012 by the University of Texas Press. All rights reserved.

CONTENTS

Acknowledgments vii

INTRODUCTION: AN ELUSIVE PASSAGE | 1

1 MORTAL RECOIL: EARLY AMERICAN EXECUTION SCENES
AND THE ELECTRIC CHAIR | 27

2 POSTHUMOUS MOTION: THE DEATHWORK
OF NARRATIVE EDITING | 65

3 ECHO AND HUM: DEATH'S ACOUSTIC SPACE
IN THE EARLY SOUND FILM | 103

4 SECONDS: THE FLASHBACK LOOP AND
THE POSTHUMOUS VOICE | 143

5 TERMINAL SCREENS: CINEMATOGRAPHY AND
ELECTRIC DEATH | 179

CODA: END(INGS) | 215

Notes 221

Bibliography 259

Index 269

ACKNOWLEDGMENTS

MANY OF my teachers leave their marks on this book. I was transformed at the University of Chicago, where I sat as an undergraduate in Tom Gunning's classes on early cinema. Our conversations over the past decade have helped to shape many of the arguments that follow. Also at Chicago, James Lastra endured long office hours with me; many years later, he inspired my writing. The early stages of this book were researched and written at the University of California, Berkeley, where I was a graduate student. I am indebted to a number of professors and colleagues there, especially Carol Clover, without whom this book would not exist. Our conversations oriented me in the material and continue to inform my thinking and writing. Linda Williams offered tough and indispensable criticism at every step. Guy Micco generously donated his medical films, expertise, and friendship. Anne Nesbet provided insightful feedback on early drafts; Marilyn Fabe invited me to lecture on early cinema at a pivotal moment and always offered support. Several interlocutors in the Berkeley community influenced this book: Sylvia Chong, Amy Corbin, Guo-Juin Hong, Russell Merritt, Mark Sandberg, Gordy Steil, Andrée Toussaint, and Kristen Whissel.

A number of colleagues at St. John's University have read this book in its late stages, either in part or in whole: thanks to Amy King (for her inexhaustible support, acuity, and rigor), Dohra Ahmad (for her

feedback on early sections), Kathleen Lubey (for her candor about ducks and pinchers), John Lowney (for the Americanist queries). Stephen Sicari managed my anxiety with admirable grace. I am also grateful to Adam Lowenstein for helpful commentary on a late draft.

Special thanks to Domietta Torlasco for her sensitivity to images and her intuitive grasp of the personal stakes of this project. My friend Douglas Lindeman did not live to see the completion of the book, but his words of confidence helped create it. So many students at St. John's have kept me going—especially John Nance, Jeffrey Maiorino, and Stephen Pasqualina. Thanks to Phillip Grayson for his diligence. A large portion of this was written at Igloo Café in Astoria, New York; I thank the establishment and everyone working there. Thanks to my circus friends for the artistic and athletic outlet. I want to thank my parents, Charlie and Lorraine, and my sister, Cindy, who supported my decision to think and write.

My life has been defined by my experiences as a student, and it is for all of my teachers that I have the biggest sense of gratitude. I would especially like to thank Virginia Marcus, my eleventh grade English and Humanities teacher, who came into my life and redefined its possibilities. It is to her that I dedicate this book.

DEATHWATCH

INTRODUCTION

AN ELUSIVE PASSAGE

The train comes to a stop, and grey figures silently emerge from
the cars, soundlessly greet their friends, laugh, walk, run, bustle,
and . . . are gone.

—MAXIM GORKY

JUST A few years after Oscar Wilde observed that "life imitates art
far more than art imitates life," the cinema was born, promising an
unprecedented mimetic accuracy. The names of the early cameras—
cinematograph, kinetoscope, bioscope—hailed the instrument's cre-
ation of life through believable vital images. Cinema was "watching
life" and "writing movement." But not all early spectators felt so con-
fident about the realism of the moving image. In a now well-known
response, Russian literary figure Maxim Gorky bemoaned the cin-
ematic image as a sad modicum of the world he inhabited. Viewing
moving images projected by the Lumières' cinematograph, Gorky
described these images as reflecting something less than the reality of
flesh and bone. The screen offered merely life's "shadow," motion's
"soundless spectre." He watched as the figures that were mobilized
before him passed by and out of sight: the moving scene "teams with
life and, upon approaching the edge of the screen, vanishes somewhere
beyond it."[1] The marvelous new medium struck him as evanescent

and unstable, prone to passing into darkness and absence. Cinema, it seemed, could hardly sustain the life it promised.

We could take this opportunity to define the deathly nature of the cinematic image as the offscreen space to Gorky's frame, the place "beyond" the border where life flows. What can be seen can be unseen. But there is more to consider in this anecdote. In Gorky's eyes cinema produces not only life's phantom trace but also the *potential* for death. The fact is that cinema has been "dying" ever since Gorky's encounter in at least three obvious ways: by representing evanescence in much the way Gorky describes; by subtending itself to the next new screen technology and thereby dating itself; and by staging scenes in which living figures (humans, animals, aliens) and even "living" ones (robots and computers) can be seen in the act of dying. In some specific cases dying has packed in the crowds at movie theaters. (It is ironic that the second form of passing away has bolstered the medium from possible extinction.) What moves and entertains audiences in these spectacular instances—say, *Psycho*'s protagonist's being slain midway through the film, *Saving Private Ryan*'s smorgasbord of combat horrors, *Kill Bill 2*'s joyful staging of the Bride's execution of the Crazy 88 members, for example—seizes on the cinema as an apparatus uniquely capable of unfolding the process of dying before our eyes.

Movie technology has remained linked to dying since at least the 1895 Edison Company reenactment of a death by beheading (*The Execution of Mary, Queen of Scots*). We watch protagonists, secondary characters, unnamed groups, and digitized hordes perish in movies and on television. David Thomson muses that "the American 18-year-old has seen 20,000 acts of killing in movies and on tv." According to Thomson, actors achieve legendary status for the way they wilt—James Cagney's footwork, Edward G. Robinson's "cadenzas" and "whirling expirations," and Lillian Gish's self-induced sicknesses.[2] Some genres, we know, are especially concerned with death, so we pick them when we are looking for it: slow and pathetically attended in the weepie, sudden and with painful explicitness in horror. We find websites devoted to amassing "greatest" movie death scenes, such as Tim Dirks's Filmsite, where a skull and crossbones icon references a scene's ranking on other lists (*Total Film Magazine*'s "50 greatest") and files

it into generic categories (i.e., "melodramatic," "horror," etc.).[3] Not every filmed death is so frivolous. Other websites specialize in the "caught on camera" and "faces of death" variety, storing and selling actual footage, recorded, in most cases, by film and video cameras, not to mention the countless "snuff" or "mondo" films and videos still available for purchase and rental.[4] The archival potential of the web to categorize fatal footage is nowhere clearer than on YouTube, where one can play and replay a variety of human and animal clips, featuring accidents and executions by chair, rope, and gun. And what the camera captures is not always a rote shorthand: despite the tendency to think of special-effects violence as the norm, the dying we see on film is often not over in the blink of an eye but enjoys an endurable tenure. It is quite often nonviolent in nature. Slow or static "dyings" indicate a more watchful capability of the camera than do spectacular killings that show spilled blood and lost limbs. Cinema's ability to stage, time, and dilate the process of dying underwrites more generally its propensity to do so suddenly and violently.

Films routinely visualize the transformation of human bodies from "alive" to "dead" in both fictional and real sequences. Not much competes regarding our access to mortality; movies have all but replaced actual experience. Thomson guesses "we have witnessed a lot of killings . . . I wouldn't doubt 100,000" to conclude "I have seen just two dead bodies. From what I can gather, asking around, two is on the high side—enough to be thought a little morbid."[5] We know, for instance, that the percentage of Americans who die in hospitals or nursing homes steadily increased last century, from 20 percent in 1900 to 50 percent in 1949, 75 percent in 1980, to about 80 percent in 1997 (about a quarter of these inside nursing homes).[6] If it is placed outside the home, Philippe Ariès suggests, death becomes "forbidden"; it is "effaced," made "shameful" as an interruption of social life.[7] The trend to move it out of sight coincides with efforts to render and monitor death with machines that promise to indicate precisely when it occurs, like the EKG and EEG monitor, or devices that promise to inflict it tractably and instantaneously, as in electrical forms of capital punishment. The cinema camera has played an influential but unacknowledged role in this history. The same technology that has been used for entertainment

has also been used in medical practice. From biopsies and body imaging tests to posthumous autopsies, both analog and digital imagery have gained evidentiary and indexical status, ushering the analytical gaze back into the past or deeper beyond the barrier of skin. Medical doctor Robert Artwohl revisited the footage taken by Abraham Zapruder of President John F. Kennedy's assassination, wanting to disprove Oliver Stone's use of that footage in his 1991 film *JFK* as evidence for a multiple gunmen theory. Artwohl published in the *Journal of the American Medical Association* a kind of "autopsy" performed on the Zapruder movie, arguing through frame-by-frame analysis that Kennedy's reaction to the bullets evinces continuity.[8]

Perhaps most instructively, the use of video and digital screens to monitor critical condition is customary in the hospital room, pointing to an interdigitation between "screen" and "real" death. The moving image, understood in an expanded sense (analog, video, digital), has supplied both amateurs and professionals with a reference point. Mr. Wilde may well have appreciated the fact that death has become imitative of art as well. It is difficult to tell where "real" ends and "movie" begins.[9] The very fact of the "snuff" film—a genre of enacted deaths purported to be real—indicates that a perceptual ambiguity between the real and the staged thrives in screen culture.

The overlap between dying and moving images knows a formal dimension. Still image traditions of painting and photography can intimate moments before or just after, leaving something quite fundamental to the imagination. But with cinema comes the lure of capturing a fuller transformation. Indeed, the moving image itself *transforms*. Like the body, it moves.[10] Even so, this elongated visual form does not illuminate the secrets of the death moment. The excess of motion makes difficult any attempt to ascertain such a moment. As Vivian Sobchack writes of the Zapruder film: "Played again and again, slowed down, stopped frame by frame, the momentum of death escapes each static moment of its representation and frustrates our vision and thus our insight."[11] Looking for a "moment" belongs to an earlier conception of death as a single commutative interruption of life, a notion that still persists though it has been updated by science. It is also a notion that has found its visual illustration in

the photograph. Writing of photography's essential temporal quali-
ties, Roland Barthes suggests that the materiality and stillness of the
image reinforces its marking of the past as present in the form of
a visible instant. This instant is mirrored by the click of the cam-
era's button: "Death, outside of religion, outside of ritual, a kind
of abrupt dive into the literal Death. *Life/Death*: the paradigm is
reduced to a simple click, the one separating the initial pose from
the final print."[12] Though motion pictures produce instantaneous
effects, they do not produce instant death, undoing the switch-like
break between two states of being, or what Barthes, invoking the
click of the photographic camera's button, writes as "Life/Death."
Film strives to maintain that slash but blends two separate states.
The slash blurs out of focus. If we assess film's ontological con-
nection to death by way of photography, we realize a very different
quality confronts us in the moving photograph. For Barthes, pho-
tography's stillness, its rigidity as an object and temporal document,
denotes the exsanguination of the corpse itself. Cinema, however,
cannot achieve such a suspension of time (or, for that matter, a pure
arrest of motion) even in its approximation of photographic stillness
we call the "freeze-frame." Cinematic death-as-stillness cannot be
thought, or at least, it cannot be thought photographically. So where
does death belong in the moving image if not in visible corpselike
stasis or time's frozen halt?

Cinema death takes place somewhere between a precise moment
and a complex progression in time. The camera is connected to other
machines—gadgets ranging from toys to medical instruments—that
have been thought to bring death closer to the doctor, the scientist, or
the viewer but that raise new concerns or cast new doubts. "Our tech-
nology has not illuminated death; it has only expanded the breadth of
our ignorance," writes Dick Teresi in his study of brain death.[13] For
centuries machines have been used to supplement touch and sight in
various ways: to determine a person dead, to specify the death moment,
or to give the beholder a sense of temporal mastery. A full history is
not tenable here, but a sampling of some of the earlier moments in
medical history and popular culture when experimentation and doubt
converged around machines will help place cinema along a specific

technological trajectory, one that allows us to understand its death sign as both precise and fluctuating.

Two different but related ambiguities stand out in this history: one, the overlap and confusion between machine and human mobility (and vitality); two, the understanding of electricity as both a vital and lethal force. Distinguishing between animate (or "living") and inanimate (or "dead") objects, as we will see, becomes part of the question of determining when living bodies transition from one state to another. An important place to begin is the seemingly self-moving automata of the eighteenth century, those human- or animal-like clockworks that imitated gestures ranging from writing to defecating, playfully complicating the line between human and machine. In 1737 French inventor Jacques de Vaucanson created a doll that played the flute more quickly than any human could, performing not lack but superiority. The public display of these toys was often accompanied by an opening of the cabinet or doll to reveal the machinery inside, proving that the machines were not running on souls and that movement could be understood mechanistically.[14] There were other jovial dolls, including a tambourine player, a poem writer, and a chess enthusiast, but as Gaby Wood argues, these androids also questioned what makes a human body a *human* body. In a (possibly fictional) story told about Descartes, the philosopher carried with him on a sea trip to Sweden an animate doll named after his daughter Francine, who had died seven years earlier. The story—whether or not true—clinches the point that machines were perceived to imitate and outlive us. Wood argues that the automaton induces the uncanny because it mimics human movement but lacks an understanding or experience of time: "Men are mortals, clocks are not."[15] In this line of thinking it is the beholder that links machines to mortality: androids embody death because they present movement that seems everlasting, a privilege the viewer cannot enjoy. As Wood points out, the word *replicant*—the modern android found in Ridley Scott's *Blade Runner* (1982)—combines into an uncanny mixture both the terms *replica* and *revenant*.[16]

Anxiety about mechanical embodiment—the revenant side of the equation—can be found harboring cinema's invention, in both fact and fiction. Auguste Villiers de l'Isle-Adam's fantastical account of

Thomas Edison in *L'Ève future* (1886) expresses both a desire for and fear of artificial life. In this science fiction tale, the scientist invents for his friend Lord Ewald an android with the faculty of speech to replace Ewald's attractive but docile and intellectually vapid fiancée. In E.T.A. Hoffmann's earlier story "The Sandman" (1816) a young student, Nathanael, falls for a girl he sees in a window, only to find later that she is a doll cocreated by older men. In such stories males fall in love with female dolls and die before consummating the relationship. If, following Annette Michelson, we look to the android in *L'Ève future* as a proleptic glimpse at the representational structure of the cinema, we must acknowledge that it is an incomplete, even optimistic, one.[17] Those who think about films *as films*, as material objects, are accustomed to regarding them as fragile and impermanent. Reels deteriorate and fade; they can be destroyed. Machines do die, even mechanical dolls. (In fact, they often "die" more than once, a point to which I will return.) The viewer can also be reminded of death by the machine's breakdown, by a dying that it projects. Eighteenth-century mechanists such as John Fothergill believed that suspended animation was a death that might be cured by restarting—that is, resuscitating—the body, like rewinding a stopped clock.[18] Scientists in the competing vitalist camp argued that death had not really occurred in suspended animation, that the vital principle was still present as a potential for life.

Eighteenth-century gadgets (human dolls, birds, and shitting ducks) blurred the line between the mobile body and machines, but the line was further eroded in the nineteenth century with electricity, a technology that would be used both to resuscitate and to kill. Along with mechanistic conceptions of life and death, new thoughts circulated about what vital forces animate us. Mary Shelley's father, William Godwin, chronicled doll makers in *Lives of the Necromancers*, but Shelley's 1818 horror story *Frankenstein* was equally inspired by the use of electricity to animate apparently lifeless bodies. Some uncertainty about determining death has always existed, warded off by an enduring belief that breath and pulse were surefire indicators of life.[19] But for physiologists and physicians in the eighteenth century, these old criteria were suspect. In 1740, Danish anatomist Jacques Bénigne

Winslow warned about the dangers of premature determination of death, insisting that putrefaction, not even rigor mortis, was the only reliable indicator. Such a claim was echoed throughout the following century by the likes of Bruhier (himself obsessed with verifying death) and Diderot.[20]

A number of medical discoveries yielded this suspicion. William Harvey's description in 1728 of the heart's pumping and circulation of blood led some to question the absent pulse as a death sign. According to medical historian Martin Pernick, eighteenth-century medicine experimented with mechanical and technical discoveries on the apparently lifeless body to regain certainty in the face of resuscitation methods.[21] Victims of drowning were successfully resuscitated; the first treatise for artificial respiration appeared in 1740. But electric shock (a technique more directly related to this study) soon dominated research on restoring heart and nerve functions. The first human case of resuscitation came in 1755. Giovanni Aldini—nephew of Luigi Galvani and one inspiration for Mary Shelley's Doctor Frankenstein—publicly displayed electricity's powers to cause twitching and apparent movement on an executed corpse in 1803.

Deathlike states were suspicious because of electricity's demonstrated power of animating the inanimate and resuscitation's efforts in restoring life when it looked like it had been lost. Physicians studied and speculated on suspended animation, catalepsy, and coma in order to detect vitality's lack. Both technical and invasive, nineteenth-century death tests introduced such distressing items as a steel needle stuck deep into muscle tissue, a heated cautery deeply inserted into the throat, and a nipple pincher.[22] The nineteenth-century fear of premature burial helped legitimize the medical profession in the public imagination. As Pernick argues, new and milder instruments of detection (the stethoscope was introduced in 1819 by René Laennec), as well as new methods of resuscitation (not just electroresuscitation but also open-chest massage), helped allay premature burial panic. This is not a story of Foucauldian shift, of one paradigm's replacing entirely an older one. Previously favored methods were, and are, still valued—discoloration, rigor mortis, breathlessness. But technical expertise bolstered the profession when dealing with intangible and

invisible signs. The medical gaze turned inward, too, with the later inventions of the electrocardiograph (1903) and the electroencephalograph (1924), both of which pictured external information about the body's hidden vital activity. By the time the EEG was introduced, failure to respond to electrical stimulation was considered an infallible indicator, and by 1930 one physician defined life as the ability to generate electrical current.[23]

There is, of course, a flip side to the use of electrical machines to supplement old methods of determination. In the 1880s electricity was also used to induce death, first experimentally by amateurs and scientists, later by American law as an accepted means of capital punishment. Whereas Aldini electrified corpses to promote his uncle's galvanic fluid, Harold Brown electrocuted animals in Edison's lab to promote the lethal effects of George Westinghouse's alternating current. (We will meet Mr. Brown later.) This current was later used to execute William Kemmler on August 6, 1890, and despite eyewitness reports alleging a terribly bungled incident, electrocution quickly became the law of the land. Six states still have recourse to the electric chair. With the chair, a machine thought to deliver a spectacle of instantaneous vital cessation produced a horrifically imprecise and gradual process.

Cinema—born of electricity—comes to play in this medical history of staging animation, studying vitality, and watching it end with the aid of technical instruments. What distinguishes cinema from these earlier devices is visual and temporal—it projects an image removed from the spectator by the screen, and it produces a more sustained temporality. We should not look to movies, however, to fix by magic the problems of modern medicine, to do it "better." Despite new technologies, public confidence in the medical institution has waned since the rise in the 1960s of brain death as a criterion for removing patients from life support and the concomitant increase in organ transplantation. Debates over whole-brain vs. higher-brain criteria continue, and, given the 2008 white paper report of the President's Bioethics Committee arguing in effect that higher-brain death need not be established in order to meet the criteria for whole-brain death, the debates seem likely to continue.[24] Though technology has been used to measure

vitality and monitor its absence, it has also contributed to an understanding of death as a process of multiple deaths, a staggered trajectory. To quote the narrator of Science Channel's *Back from the Dead*, who describes a flatline—that most common moving medical image in the popular imagination—on a hospital monitor: "This is not the time of death, but it is the time of dying."

Let us return, then, to cinema, where we watch the transformation from alive to dead unfold, or the "time of dying." Looking closely, we see death happen here both cleanly and turbulently, precisely and momentously. A combination of instantaneity and flux situates film within this modern trajectory of monitoring and visualizing cessation more precisely with supplemental devices. The first and last chapters of this book bring to bear on film two such devices—the electric chair and the heart monitor. These two devices have their differences, clearly (the chair is lethal and inflicts its vital cessation), but both are thought to be capable of immediately visualizing death as occurring in time. The other chapters take up film-specific technologies—narrative editing, synchronized sound, postsynchronization—as related instances of a machinelike precision. The link between the movie and the medical screens is particularly enlightening because of their mutual projection of *moving* images. Just as films visualize a mobile death sign for spectators, so, too, the monitors in intensive-care units register the flowing waves of the heart's vitality and their gradual weakening and slide to "flatline." Both these moving images "confirm." The EKG has become so user-friendly, so self-evident, that it competes with the dying body for our attention during a deathwatch. The screen has become an uninvited guest within the final tableau. At an interdisciplinary conference on death and dying at the University of California at Berkeley, Dr. Guy Micco described his need to turn off the still-bleeping machine after declaring dead his patient "Mr. Reggie":

> . . . something unusual then happened at his bedside. Mr. Reggie's heart's EKG, electrocardiogram monitor . . . was on, just above and to the left of his head. And we all stood there transfixed by this electronic representation of his life, watching the ever-slowing tracing of the electrical activity of this man's dying, or what we thought was this man's

dying, but not dead yet heart, and listening to its soft beeping accompaniment. Mr. Reggie was in some strange liminal state, as were we, for what felt like a very long time. Then somehow . . . something broke the spell, and I turned off the monitor, announcing at that time, as doctors are want [*sic*] to do, that the patient had died. The family then turned their gaze and attention to their beloved . . . [25]

Micco's anecdote is corroborated by another story from Dr. John Murray, a medical doctor in San Francisco, who recounts monitoring vitals in the final hours of his patient "Mr. Guzman." Here we can see the difference between a lay and a professional encounter with the monitor screen. Though the head nurse turns off the "television screen" beside Mr. Guzman's bed, she keeps it on in the nurse's station because, as Murray explains, "We must know what is going on at all times." He offers an explanation of this difference: "She turns the bedside monitor off because we have learned that relatives and friends tend to pay more attention to it than to their loved one. People become obsessed watching the electrocardiographic squiggles that announce each heartbeat marching across the screen. Although the physiological nuances are undoubtedly overlooked, the deeper meaning of the electrical signals of life is hard to miss when they slow in frequency, gradually widen in appearance, and then finally stop altogether." [26]

We will return to this narrative of slow, widen, and stop. Suffice it to say that the "deeper meaning" is indeed difficult to miss, for though dying is gradual rather than instantaneous, the monitor tracks its narrative with marked changes—from wavy to linear. That is, it translates, or rather reduces, a gradual and uneven unfolding into a sequence of clearly marked stages, like points on a line. But in both anecdotes the monitor must be turned off because it replaces the body and the drama that customarily surrounds it. Though it is delivered on a "television," the electrical output of the heart is tracked cinematically, that is, as an indexical sign that moves over time, one that is connected to its referent through physical contiguity. These anecdotes complicate our faith in the monitor by reminding us that it can give mixed messages—an image of fatality that does not match the present knowledge of the body, or the familiar bleeping of vitality set against the visible inactivity of the

deceased. Both hospital monitor and movie screen are thought to be able to visualize death precisely, and both come up short.

The uncanny occurrence of life's end amid ongoing bleeps and visible waves ("squiggles") has a rich prehistory in the cinema. Decades before the hospital monitor, films approached the flatline's out-of-body precision, and they were often confounding rather than clarifying. The conflict between precision and flux, between finality and flow, characterizes electrical productions of the death moment—electrocution, electrocardiography, and cinematography. Again, I list these technologies together because they are understood to produce a visible instant. In movies much occurs after apparent death that extends the focus of the camera's and the spectator's visual attention; some vital stirrings on the screen, such as a still-moving body or a pan shot, seem to upend the primacy of the corpse. *When has death really happened?* Like the executioner and like the EKG monitor, the camera compensates for an alleged moment of internal precision by looking outside the body—to another figure's gesture, to a face, a landscape, out the window, up to the sky, at earlier images. (Presumably these are some of the places we are meant to look when the monitor is unplugged bedside, as in Dr. Murray's account. Perhaps they are where it is thought we used to look.) These compensatory movements trace a search for finality's sign beyond the body in question. As I look for death in the moving photograph, I cannot find it in either the body onscreen or the fixity of the image. Instead, I can trace its reverberations outside the body, in external space, related faces, in other figures, and in the spectator's own body. Projected against film's momentous flux, death becomes an instance of temporal unfixity by inviting repetition, acceleration and deceleration, and reversal. What emerges in my analysis is a certain persistent tendency in the cinema to represent death as always occurring more than once and in more than one place.

THE AGE OF MECHANICAL REDYING

Those who have tried to locate an essential connection between cinema and death divide into two camps—one searching for a visible quality

within the filmic image, the other questioning what death might "be" before assuming what it might look like. In the first group we find important works by Garrett Stewart and, more recently, Laura Mulvey, who read cinema death in relation to photography. For both scholars static images in film, like the irruptions of the freeze-frame, conjure up an immobility that is always deferred by the medium in its essential flow forward; if the movie "pauses," it will unpause.[27] Though he sustains an interest in medium specificity, studying "the visual phenomenon of death as only cinema, never photography, can capture it," Stewart does proceed with confidence about when death occurs, or rather, that it occurs *as an event*. He conceptualizes death *photographically*. It is "the *moment* of the character's conversion from subject to object" (154), for instance. Whether or not it occurs as a moment is not a question he seriously probes because film is not expected to reflect somatic death, much less teach us how to think about it. When there are corpses onscreen, death is abundantly evident, like a concept depicted (i.e., written, painted). The visible corpse inserts into narrative cinema a before-and-after; this insertion naturally requires the corpse be immediately apprehended.

Mulvey, too, reads cinema death as narrative stillness: "Of all the means of achieving narrative stasis, death has a particular tautological appeal, a doubling of structure and content."[28] Thus her reading of Marion Crane's death in *Psycho* privileges the stillness of the corpse—simulated by a close-up of her still-open eye—as a marker of narrative paralysis. Mulvey's language imparts to the camera an act of objective reportage: she writes of the "momentary pause to register [Marion's] transition from living human being, in whose story the audience has been deeply involved, to corpse."[29] For Kaja Silverman this shot marks a pivot away from our identification with the victim Marion Crane, which is "sustained up until the moment when Marion is definitively dead, an inanimate eye now closed to all visual exchanges." At this point "we find ourselves in the equally appalling position of the gaze which has negotiated Marion's murder."[30] Begun in photography, the search for nonbeing ends in the symbolic confirmation of corpses. But looking at film's ability to "depict" death as an object misses the extent to which those in front of and behind the camera have tried to

figure out whether it has a moment, if there is a way to visualize it as one instant or many, and, if many, how to prioritize one over others, and if so, which one to privilege—in short, it misses the point that the act of dying is an object, too, with no certain culmination or boundary. Nor is there much room left to wonder if the onscreen corpse is "definitively dead," an anxiety that movies tirelessly exploit.

In the other camp we find a diverse variety of commentators who share a mutual interest in dying as a unit, or expression, of time. Film commits images to a time-based form, making repetition possible. The act of replay would seem to thwart an analysis of death as a temporal event, indicating more deferral. (If death can be repeated, it is not death; it is something else.) But two essays that have recently inspired critical work on screen violence show us that death's temporal relationship to film yields significant insights into the medium. Though not written at the same time, André Bazin's "Death Every Afternoon" (1949) and Pier Paolo Pasolini's "Observations on the Sequence Shot" (1967) were each inspired by the act of watching a recording of an actual death.[31] Other scholars have discussed these essays but have not emphasized their working through film form to understand a transformative process we might call dying. For Bazin, watching the footage of a bull's gorging in Pierre Braunberger's *The Bullfight* (1951) brings photography to mind, but as a contrast rather than a correlate. Working from the idea that we experience our deaths as unrepeatable, Bazin remarks: "We do not die twice. In this respect, a photograph does not have the power of a film; it can only represent someone dying or a corpse, not the elusive passage from one state to another" (30). Film's capacity to make a repeatable viewing experience out of that "elusive passage" amounts to an "obscenity" on par with the depiction of a sexual act. Like sex, death brings forth a subjective time, "the absolute negation of objective time" (30). It cannot be experienced publicly. Influenced by Henri Bergson's notion of *durée*, Bazin sees objective time as unfolding irreversibly. Activity can be reversed and repeated in cinema; however, death is the ultimate irreversible experience, so it is understood as a supreme occasion for film to demonstrate its ability to reverse time. Death marks cinematic temporality.

Pasolini's film inspiration is the Zapruder footage I mentioned earlier. Repetition is not the crux of his argument.[32] But looking closely,

we find correspondences between Bazin's essay and Pasolini's. What concerns Pasolini is editing—specifically, the ability to arrange different views of an unfolding event from individual shots after they are taken.[33] Edited sequences might give us a privileged glimpse of death because they are constructed in postproduction. Unmitigated real footage, like that of Kennedy's death, affords the recorder a chance to make legible the actions that constituted the event. It all *happens* too fast to compute exactly what *happened*. Pasolini envisions multiple cameras at different angles recording the assassination, all the "other visual angles" that could capture unique slices of the event. These angles are understood as the embodied perspectives of other witnesses, so the subjective shot is personified as a partial gaze. In this hypothetical scenario "subjective sequence shots" could be assembled by a "clever analytical mind" into one final, newly edited, sequence (234, 235). By "choosing the truly meaningful moments of the various subjective sequence shots and consequently finding their real ordering," the editor would create "objectivity" through the partial views, a "montage" (235). Life's final gesture does not bequeath meaning—it is not completed—until the isolated perspective is joined with multiple others. The editor becomes a "narrator," a storyteller that confers past tense to real actions otherwise stuck in the present. With help Zapruder could turn the film of Kennedy's dying into a montage of Kennedy's having died. If all human gestures are understood ultimately after the end of lived experience, it follows that editing performs a unique deathwork on uninterrupted footage. Kennedy's final gesture—the act of dying—poses a metonymic problem that editing solves.

Though Pasolini discusses here an actual death recorded on film, his montage of reality remains hypothetical. It does not pertain to unedited footage that precludes hindsight or rearrangement; in fact, it seems to favor the fiction film, that hypostatic collection of present pieces assembled into a newly configured past. This is miles from Bazin's recoil at repeated viewings of actual executions. Replay becomes obscene when it induces repeated fatal incidents, like the shooting of a gun: "In the spring of 1949, you may have seen a haunting documentary about the anti-Communist crackdown in Shanghai in which Red 'spies' were executed with a revolver on the public square. At each screening, at the flick of a switch, these men came to

life again and then the jerk of the same bullet jolted their necks. The film did not even leave out the gesture of the policeman who had to make two attempts with his jammed revolver, an intolerable sight not so much for its objective horror as for its ontological obscenity" (30). The filmmaker's missing intervention into the murder is thematized by the onscreen jamming of the revolver. The delay becomes a sadistic indication of deferral's failure. This brings Stewart's aphorisms to mind: cinema is "death in serial abeyance," and elsewhere, "photography is death in replica, cinema is dying away in progress."[34] But cinema in Bazin's anecdote demonstrates there is really no such thing as an abeyant death. Reading Bazin and Pasolini together, we learn something else about both edited and unedited footage: the former can control the unassailable disorganized present tense in which we live, whereas the latter can change forever the present's status as unrepeatable. (One might also assume that it can slow it down and speed it up, and that slow motion and fast motion would similarly challenge the inalienable temporal flux upon which *durée* rests.)

The larger point is that these two theorists who look at death to understand film's temporal logic move quickly to replay. For Pasolini film can make the present past, not by whimsically blending subjective shots into one another so that they melt into *durée* but by breaking them up and putting them back together. The goal of the sequence shot is not to destroy the present but "to render the present past." For Bazin it is a cinematic specialty to repeat *durée*. His essays make clear elsewhere the asymptotic relation of unedited long takes to lived time, but he takes a strange turn with the bull's fall.[35] At essay's end he suggests that screen death does not replace the real event offscreen. Both gain powerful significance exactly because the cinematic does *not* replace the real: "This is why the representation on screen of a bull being put to death (which presupposed that the man has risked death) is in principle as moving as the spectacle of the real instant that it reproduces. In a certain sense, it is even more moving because it magnifies the quality of the original moment through the contrast of its repetition. It confers on it an additional solemnity" (31). Film moves the spectator closer to death: it is *more* moving because it cannot actually touch lived time's privileged interruption despite its unique ability

to harness death's temporal process. This is not death in perpetual abeyance but in gradual approach. In fact, Bazin speculates cinematic representation elegizes its failure to bring death to the viewer. Punning off the French word for remorse (*remords*) with his term *re-morts*, he hails the "eternal dead-again" of the cinema, reminding us that lived time, as opposed to cinematic time, ends. The essay's title phrase plays on this difference as well. Cinema can never arrive at death just once (which is to say it can never arrive). This is the reason cinema becomes "death every afternoon"—it moves us toward, but does not reach, its goal. In the place of direct experience, it magnifies, retimes, and repeats the spectacle object. In a move that reinforces Dziga Vertov's kino-eye, we might say simply that the movie camera "sees" death differently than we can unassisted. Behind his language of resurrection, Bazin suggests that film cannot capture death—not because it cannot show the loss of life but because it cannot do so only once.

Frequently in such discussions, and in my own close readings that follow in this book, there appears a friction between human experience and a technology-assisted perception that runs, very often, on electricity. That contrast is obvious in electrocution and hospital accounts, but it is equally common in movies. Death's evasion of the unassisted gaze compels that gaze to look toward machines for precision and authority. Pasolini points out one mechanical surplus of the camera when he mentions hindsight. The process of single-take dying can only be finalized by editing—the editor/narrator finishes the process by looking back from beyond the position of any one embodied spectator. Only the camera can provide the illusion of being in two places at once. Replaying death for Bazin is likewise beyond embodied human perception: the result is an eternal dying (*remorts*, or we might say as *remoriens*), not resistance to fatality. Simply put, the spectator cannot do anything eternally; thus film creates a time beyond human occupancy. The technique of the photographic camera earlier accompanied Barthes's impression of the image's fatality, as if the shudder occurring in the spectator were triggered by the revelation of a mechanical nature beneath the human.[36] But the moving image invokes the mechanical differently, committing an unwieldy process to a separately observable strip that sets up the spectator to search for a real occurrence that may not have existed before.

While Pasolini and Bazin both refer to actual footage, we can discover the deathwork of editing and what I will call "posthumous motion" (replay, repetition) in fiction films as well. If the single shot is linked to dying, it wants to terminate, to come to a close and empty out the signifiers of life. Editing is Pasolini's solution; repetition is Bazin's. But we might also see life's absence in other figures and images. What I see in movie death scenes—from the goriest to the weepiest—is a mixture of the techniques of repetition and retrospective arrangement. Sobchack claims the fiction film tames the perceptual excess of death by clarifying the moment through careful staging or special effects prepared for the camera. Made up of iconic and symbolic signs, "representations of death in fiction film tend to satisfy us—indeed, in some instances, to sate us or overwhelm us so that we cover our eyes rather than, as with the Zapruder film, strain to see."[37] This seems true. But just because fictive death "is experienced as visible within representation" does not mean that it *is* anymore visible. (It is often experienced as visible only by other observers in the scene, in fact, who screen the body for us.) One needs others to die, at least cinematically. The final moment is not clearer in the fiction film. There, too, death occurs but stays hidden by the body. No external fold can show the inner lining. In those cases in which movies stage the end from "inside" the consciousness of a dying person, we often get an externalized object or image—a reverse shot, a fade-to-black—that indicates a something or somewhere "else." The fiction film pressures the image to harness the death moment because such a moment is visibly present while not directly visible—it can be seen on other surfaces, and as a consequence of its projection there, it is repeated to compensate for a lagging precision. These new moments must inculcate the impression of an actual occurrence, though that occasion is spurious. The screen body dies several times and in several places.

To take an apotheosized example of a violent death by way of contrast, consider the various images of finality that conclude *Bonnie and Clyde*. Here the camera pauses to show Bonnie's slow-motion hand buoyantly resisting stillness, juxtaposed to the car. Now the camera reiterates the ricocheted bodies by shooting them through a cracked windshield. A long shot takes us out of the compressed scene of

violence to bystanders who slowly approach the bodies for a closer look. Now the camera focuses on the face of a single beholder—Ivan Moss, the man responsible for arranging the gangsters' ambush. The camera shows little interest in confirming the fact that either Bonnie or Clyde is dead by privileging a moment or examining their bodies. Rather, the variegated process under way is one in which the camera searches for multiple and powerful ways to embed their deaths in the world, to produce meaningful recognitions, to follow the reverberations of the aftermath. The film slows down, speeds back up, magnifies, cuts up, rearranges, repeats, and moves away—all of the techniques flagged as cinematic specialties by our two earlier theorists. Whether real, fictional, or somewhere ambiguously in between, death in film is not conclusively over without further supplemental gestures performed on the outside of the human body.

This book is an examination of these supplemental but requisite gestures, the force and form they have, and the reasons for their effect. Without these we would not have death on the screen. They are only officially external, or supplemental, to the scene, and the scene comes to include them. I refer to the process of confirmation performed outside the body—by, say, a pan away, or a cut to a medium close-up of a witness—as "registration." And when that acknowledgment is embodied (gestured, vocalized) by another screen figure, I call that figure a "registrant." This figure need not always be a human being; it is sometimes an object, or part-object, or animal, or plant. Registration concludes dying in order to commit it to a time and place. Pasolini forgets, perhaps on purpose, that there is no version of the Kennedy assassination against which the Zapruder footage can be judged: we think of his death as incomplete because it is filmed; in clear view it tantalizes us to look again, to look for more. One of its most disturbing traits is its lack of identifiable registration—no witnesses to acknowledge that the president has died (indeed, he is pronounced dead later), no final contact with his body, no hesitation in the motorcade's course. Kennedy's dying concludes offscreen. Instantaneous clarity is lacking in film, especially since the moving image insists such a moment can be found *within time*.

When state prisoners were electrocuted in the late nineteenth century, their still-moving bodies exceeded the instantaneity on which

electrocution was founded in the first place. Capturing the absolute moment on the hospital monitor does not equate magically to its occurrence. Death must still be pronounced by the doctor, sometimes in vain. It must be registered. The camera shares much with these other technological gadgets. Although premised on accuracy, it resorts to other symbolic forces (doctors, lawyers, witnesses) to confirm death's having happened. Much like in the legal and medical contexts, death in film is posthumous, its resolution after the fact, its prioritized moment obscured. Philippe Ariès writes of the mechanical cessation of care in the modern hospital: "Death has been dissected, cut to bits by a series of little steps, which finally makes it impossible to know which step was the real death, the one in which consciousness was lost, or the one in which breathing stopped."[38] Vivian Sobchack connected the "little steps" of technical support to those of filmic montage when she first wrote of documentary death in 1984: "the contemporary dissection of death into a series of 'little steps' . . . is paralleled by the initial recording of death by film moving through camera and projector in twenty-four 'little steps' per second and, finally, in always disappointing post hoc attempts to 'find' and 'see' the *exact* moment of death in nonfiction films through a close inspection of every frame recording the event."[39]

The registrants that step in to apprehend a dying has concluded offer the symbolic function of medical and legal witnesses that work for the state. Given the modernity of its context, it is important to note that the registrant functions as a witness whose power exceeds—sometimes defiantly—the boundaries of the state. Registration is embodied but dispersed, in excess of any one body, including the human body. And insofar as the spectator behaves as a registrant, the moment of apprehension is not isolated but recurs through multiple viewings, a repetition not unlike Adam Lowenstein's model of horror spectatorship as dynamic in affect because multilayered in time.[40]

Death confounds representation, or as Elisabeth Bronfen and Sarah Webster Goodwin tell us in their introduction to an anthology on the topic, "Every representation of death is a misrepresentation."[41] But film's lack persists as a technical scourge. Pasolini implies the Zapruder footage unfolds too fast; Sobchack muses that recorded

hospital deaths unfold too slowly.[42] How does cinema get dying "right"? Even when the footage is clocked at real time and unedited, the ability to replay the footage changes the temporal frame of the original occurrence in the way it allows access. We look to fictional scenarios to organize and clarify the end of life, for they certainly have greater recourse to the profilmic (again, Sobchack claims the fictive "satiates" whereas the real "evades"). It is true the fiction film can draw out or eclipse the death moment, combine various views, and stage registration multiple times, and that is why I take up a serious study of entertainment films in this book. But the distinction between fictional (diegetic) and nonfictional (indexical) film is itself, of course, problematic. It is often difficult to tell that difference. With death footage, that ambiguity is often the point of making the film. What is thought to be documentary often turns out to be fictive, as with the "snuff" film, and there are instances when actual footage is shot and edited according to narrative codes previously established, such as Jan Oxenberg's documentary of her grandmother's death, *Thank You and Goodnight*.[43] Both fictional and actual footage "produce" rather than "represent" death as an object extrinsic to the beholder, and in this process the spectator becomes internal to the object through identification with the registrant. The multiple posthumous markings we find there, the compensations for photographic lack, are not simply representational crises but encounters between human comprehension and machine-based accuracy. Without these markings onscreen, we could not have death as we know it.

A HISTORY OF MEDIAL INNOVATION

But we've got to verify it legally
to see, to see,
if she, if she,
is morally, ethically, spiritually, physically,
positively, absolutely
undeniably and reliably dead!
—*THE WIZARD OF OZ* (1939)

This book departs from the tradition of writing about film violence.[44] Of course, ubiquity is a good reason to focus on spectacular death.[45] Perhaps intimate watching lacks entertainment value, as bell hooks suggests: "Dying that makes audiences contemplative, sad, mindful of the transitory nature of human life has little appeal."[46] In any event I need to move away from violence (that is, the infliction of mortal wounds in a causal chain of bodies) because I am in search of an intimate relation between the dying person and the registrant, and between both parties and the camera. This is not to say that registration does not attend murder, only that its appearance in slow or static "dying" dilates—allowing us time to see clearly—the posthumous and disembodied effect of screen death more generally. This is also not to say that the difference between a violent and nonviolent death is absolute. Simone de Beauvoir, for one, refuses to acknowledge such a thing as "natural death" in her account of the final stages of her mother's fight with cancer.[47] But seeing dying provides an analytical suspension that captures the film medium's grappling with time, terminal stages, and the moving body. Films that do sustain an engagement with the final few moments of life often resort to supplemental features of editing and mise-en-scène to seal the deal; these features, in turn, visualize change in the world *outside* the body, not *on* it or *in* it.

To emphasize the technological nature of the camera's search, I move through a reading of films from historical periods when technical innovation is evident—the turn to narrative, for instance, or the transition to sound. This history reveals that technical developments, as much as actor talent or period style, contribute to the impression of when, where, and how life ends. Screen death, in other words, has a formal history. Formal possibilities emerge at each stage of innovation before settling into standardized technique. Lists such as Tim Dirks's "greatest death scenes"—and static claims like Sobchack's distinction between "indexical" and "fictive" or Stewart's and Mulvey's on medium ontology—show little regard to technical developments in the cinema. A full history is not possible here. But there is more than one "death," and thinking of its "madeness" reorients the way we think about cinema and the dying body.

To think about that relationship, I have set up my own deathwatch—a sustained look at movie scenes in which the image seems to foreground the anticipation for death and the search for a perceptible break in vitality.[48] To answer the question of when death has really happened, it is imperative to look at scenes that seem to be invested in answering that question, whether this interest is attributed to the camera, to the embodied gaze of onscreen or offscreen beholders, or to narrative form more generally. American film structures the death moment around switches, instantaneous effects, or formal cutoffs—different barriers, or partitions, to divine *Life/Death* that, in turn, express a quality set against *one* privileged moment. This book is organized around medial shifts in that architecture. Starting with the earliest motion pictures, chapter 1 connects the electrocuted body to cinema's first attempts to visualize death. Early films often wanted the moment the body stops moving. Trick reenactments of beheadings, hangings, and lynchings were common early on, such as Edison's *Execution of Mary, Queen of Scots* (1895) and American Mutoscope's *An Execution by Hanging* (1901). Clearly salacious, execution films staged the substitution of human with dummy body to inculcate the impression of an instant cleanly marked. When the Edison Company turned to electrocution as a film subject (*Execution of Czolgosz*, 1901; *Electrocuting an Elephant*, 1903), a new image emerged that expressed the duration of dying without substitution. Both types of execution films employed registrants in the frame to conclude the scene. The on/off electrical switch organized perception around a clean break, but in both real application and its translation to the screen, this switch produced an untenable process that had to be verified after and elsewhere.

The middle chapters take up still "dyings" vis-à-vis technical possibilities specific to the medium—narrative editing, synchronized sound, voice-over, and noniconic screens. Each of these technical accoutrements affords filmmakers a new "switch" to pull. Chapter 2 looks at early story films of D. W. Griffith (1908–13) to consider the changes that occur within the scene of registration once movies bridge together several shots to unfold a story in a fictional world, or "diegesis." Narrative editing harnesses dying as a temporal process, but there is always the threat of incompletion. In Griffith's films at Biograph Studios, the

dying moment is structured around its onscreen perception, affording the registrant, and us, additional moments to gather around the body, or the space where the body was last seen. The techniques of repetition and disembodiment in the earlier moving images are still at work in the narrative features. But there is more. In films such as *The Country Doctor* (1909), *The House with Closed Shutters* (1910), and others, we see the first signs of a response to death emerge within the filmic image, something in the scene after registration. A number of nonhuman or nonfigural registrants appear as well, marking what I call "posthumous motion" as a transitional or repetitive trope.

With registration and posthumous motion in mind, chapter 3 moves to some important films from American cinema's transitional period to sound. The soundtrack offers filmmakers another on/off device that sets up potential precision (the last word or audible breath, for instance). What develops is a strategy to use offscreen sound as a registrant. The early period is an experimental moment—one loaded with movies that make thematic connections between the soundtrack and the dying body or between the soundtrack and the registrant. These early films clinch the importance of recorded sound as an accoutrement, years before the nondiegetic musical score would become the norm. No longer merely seeing dying, in these films we are hearing dying. And what we hear does not emerge from the dying body but rather from the acoustic space surrounding the body, contrasting sound with image in various ways. *The Jazz Singer* (1927), for instance, covers the Cantor's final gesture with his son's offscreen singing. In *Applause* (1929) Kitty Darling dies while voices chatter and quibble offscreen, unknowingly. Sound envelops the dying body in an acoustic fold and employs the voice's posthumous dimension to extend screen focus outside the body. Chapter 4 continues this thread by looking at voice-over narration, another manipulation of synchronized sound but one that poses a variation on earlier films. From John Ford's *How Green Was My Valley* (1941) to film noir to more recent noir descendants (*The Sixth Sense*, 1999; *Donnie Darko*, 2001), American cinema shows a perdurable interest in the disembodied voice to "open" the experience of dying from the inside. Often the disembodied voice triggers a doubling of the death moment, a second chance to approach an

ending that could not be anticipated the first time around. As a consequence of filmic repetition, the voice-over keeps the process of dying in permanent suspension, though it seeks exactly to provide closure.

I bracket this study with offscreen death technologies, returning to another electrical machine in chapter 5—the EKG or EEG monitor. Films that feature flatlining characters, from *2001* (1968) to *Steel Magnolias* (1989) to *The Matrix* (1999), stage the interface between a younger screen technology and its parent source. What the cinema screen offers that the hospital screen cannot is a representational form that exceeds indexicality. Movies do not need to read the lived body truthfully as do hospital machines, yet they place the flatline within visual and narrative sequences that stage in effect the verification of death via screen technology. The movie camera reads the monitor screen—positioned outside the body—to grasp an exact instant it has long sought. But, time and again, the lineated waves and steadied bleeping do not announce the terminal moment with certainty, no more on film or television than in reality. Passing as a faithful indicator, the flatline allows the camera to resume its play with figural forms, but these forms reveal anxieties about the attendance of machines at our deaths.

This cinema history of death and dying is based on close readings of American films and moments of cultural significance. However, it is not my claim that the history of formal innovation is unique to this cinema; it is only here that I draw the line. Nor am I searching for a uniquely "thematic" occupation with death in these films. If, like Leslie Fiedler in his canonical work on the American novel, we look for a characteristic national sensibility, I'm not certain we would find it by looking at causes of death or by recapping plots.[49] We would do better, it seems to me, to look at the connections between plot and form, between theme and the technical possibilities of the medium. In doing just this, I do hope to question the usual characterization of American cinema's representation of death as violent and sensational. This description—often intended as a critique of Hollywood's deflection of our attention away from mortality—does not hold up when we look at the historical record. Slow or static "dyings" appear at key transitional moments in American film history, and it is to them that I would

like to draw my reader's attention. Dying in my examples is less spasmodic and spectacular than one might expect. For example, it is true that chapters on execution, on film noir, and a section on the gangster film would seem to belie the rubric of sustained dying. However, though criminals and antiheroes might suffer rather violent gunshot wounds, they are seen dying for a protracted moment in time. Theirs is a violent death, to be sure, but it is also often a stoic and talkative dying. Again, I am watching scenes in which the camera—under someone's operation—also seems interested in the final moments, even if the blow to the body would seem fatal and death foregone. It is therefore sometimes necessary to cross generic dividing lines, not to suggest genre is irrelevant but to underline an enduring interest throughout American film history in human and visual/spatial responses.

Throughout these readings I look at the relationship between embodied human perception and mechanical surplus. In the context of increasing technology, the registrant figure in American cinema has something to tell us about the need to perceive death as a human, even communal, event rather than as an integer or commutative announcement. To conclude this study of the technical conditions for the aesthetics of a mobile death, an epilogue considers recent recordings (film and video) made in hospital or at home that structure real death "cinematically." These moving images appear as a kind of afterthought or redress to Hollywood. It seems that the screen body might replace the mortal body as locus for registration, with the camera as registrant. Acts of replay and disembodiment in real recordings would seem to suggest an end point for cinema's excursion into dying as an experiment in form. Death has not only lost its bite; it has lost its fundamental terminality. Movies have played a part in the erosion of that slash—real or perceived—that we imagine separates death from life.

1

MORTAL RECOIL

EARLY AMERICAN EXECUTION SCENES AND THE ELECTRIC CHAIR

I also could suggest a few themes for development by means
of a cinematograph and for the amusement of the market place.
For instance: to impale a fashionable parasite upon a picket fence,
as is the way of the Turks, photograph him, then show it. It is not
exactly piquant but quite edifying.

—MAXIM GORKY

IN THE FIRST DECADE of their production movies took a formal interest in strategies for screening dying. Gorky's feelings about the moving photograph's frail vitality, his impression that screen figures seemed to inhabit a world of dead eternity, may not have missed the mark by far. From 1895 to 1905 American and European producers made good on Gorky's suggestion that violent death would prove endemic to the medium. Showing the transformation of bodies from "alive" to "dead" provided one of cinema's earliest and most unique "attractions."[1] Where Gorky chastised readers with the specter of a Turkish impaling, American films delivered a bevy of execution scenes, imitating the techniques of the blade, the noose, the rifle, and the electric chair.

Cinema's wrangling with the death moment begins, then, when cinema begins, involving particular technologies and a series of

technical questions about the body. In an attempt to divine the medium's alacrity, its punctual possibilities, and its mobile excess, early filmmakers pictured, or tried to picture, the moment a moving body stopped moving. Meanwhile, execution procedure was being modernized offscreen through techniques of disembodiment and repetition—the electric chair ensured that the act of dying remained spatially constrained, and the electrical switch afforded the executioner more hands-off distance from the body. Technicians and lawmakers alike championed the modernity of electrocution. In Thomas Edison's base state of New York, electricity became the new method of state-sponsored murder. The commission given the dubious honor of advocating for the chair praised the speed of electrical death as "instantaneous," that is, faster and cleaner than any previous means. This legal decision was shackled to a series of public displays Edison himself promoted years before introducing the cinematograph. The spectacle of the electrocuted body—first animal, then human— preceded and anticipated the body spectacles made ten years later by the Edison Company. And this body was, as we will see, a *dying* body, one that sustained the process of transformation, structuring the search for a stop in vitality.

More than just picturing execution, however, early films emulated the structure and logic of lethal devices. Edison's films, more than those of his competitors, showcased the modernized speed of visible death, as if grappling with its filmic equivalent. There is a rough evolution in these early films, too, starting with guillotine or scaffold scenes before culminating with electrocution. In each encounter with a lethal machine, filmmakers invariably transposed the mechanics for the screen. The instantaneous break between alive and dead becomes increasingly erosive as we look through early cinema, culminating in films that are not conclusive on whether, much less when, death occurs. Edison's execution scenes—both evidentiary and reenacted— clinch the possibilities and limitations of the camera as its own death technology by discovering formal qualities that would prove perdurable to moving images. Principal among these discoveries is the perceived want, or need, for human recognition that screen dying has terminated.

EDIT, EXECUTE

> I wanted so much to be a part of history, but what sort of a history
> was it, if there was no guillotine?
> —SERGEI EISENSTEIN

Aspiring to shock and titillate with moving images, filmmakers resourced executions for a quick fix. Planned killing appealed as a chance to control time and inspired tricks of the cinematic frame. In other words execution influenced editing, down to the level of the shot and its internal relations. Just a cursory look through early catalogs reveals the influence of execution on content; less obvious, perhaps, is the influence on form. The ability to produce sudden violent effects by cutting between shots was hailed by early commentators, notably Sergei Eisenstein, who linked montage to the slash of the guillotine. Anne Nesbet comments: "[Eisenstein] longs for a history that can cut, that one can really feel (history and film both being fundamentally indebted to relentless editorial blades: guillotine; scissors)."[2] Cutting the filmstrip to produce jarring juxtapositions—including beheading—echoes the swish of the guillotine's triangular blade.

So, too, does the electric chair hover over the cinema of attractions. The chair affords another metonymic object for early cinema's mode of display—it directly addresses a theatrically arranged audience awaiting a timed spectacle. Electrocution's various gadgets, and their bureaucratized operation, withhold any one responsible figure. Translated to the screen, this disembodiment allows an image of dying to unfold without attributing clear cause and effect to the dyad of assailant and victim. What we see is a "hands-off," still dying. Staging the process whereby a moving body was suddenly stilled offered filmmakers an opportunity to define movement through its lack. Jonathan Auerbach has recently suggested that early filmmakers and spectators worked out their anxiety about the new medium's creation of lifelike movement by "suspending the animating magic . . . in order to dwell on the body immobilized."[3] Whatever the ascribed motive, it is clear that early films were more than passively interested in the dying body, and filmmakers and theorists have often made the connection. Film students snicker when they first hear

of Jules-Etienne Marey's chronophotographic "gun"—an early movie camera that took a series of still images of moving bodies, such as a bird in flight. The hunting analogy indicates a more persistent connection than the one proposed by Eisenstein between (film) cutting and (head) slicing. Nonetheless, it spells murder. Seizing objects that will live no longer in their newly projected forms, the camera brings with it a material finality unlike the artist's brush or the writer's pen. Famously, André Bazin's notion of the photograph's power to embalm as in amber speaks to the lethal effects of the camera. Marey's killing the object under view in order to render it in a new form returns in Vsevolod Pudovkin's point that "every object, taken from a given viewpoint and shown on the screen to spectators, is a dead object, even though it has moved before the camera."[4] The examples go on. Filmmakers and technicians alike have understood for more than a century that the camera in various ways brings about death.

Eisenstein may well have been aware of the Edison Company's 1895 filmed beheading titled *The Execution of Mary, Queen of Scots*. This short kinetoscopic sequence was the first in a series of early execution films. It lasts about seventeen seconds, delivering a quick fix indeed—blink and you might miss Mary's decapitation. The executioner, framed centrally in an outdoor long shot (his height roughly matches the frame's vertical limits), touches the chopping block with the sharp end of his axe: to his right, Mary is blindfolded by one of two other women in the frame. Eyes covered, she kneels down by the block and bows her head over clasped hands. The blade is raised. Behind the executioner and his kneeling target, male onlookers cloaked in period garb are gathered in a background line (fig. 1.1). When the axe falls the crowd separates in its reaction: the two women framing screen left and right cover their eyes and brace themselves, while the men behind encourage the cutting by first raising their scepters and then physically leaning into the axe's fall, mimicking the executioner's swing. As the head rolls away from the stump of violence, the onlookers jump a bit and move in closer to examine the headless body, then the removed head, then finally both, back and forth. The executioner picks up the head off the ground and then raises it over his own, to the noticeable approval of his male witnesses, in an image of conquest (fig. 1.2).

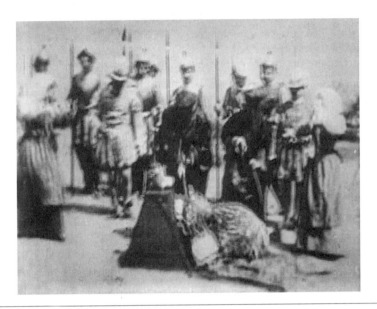

FIG 1.1 The prosthetic head is chopped off in *The Execution of Mary, Queen of Scots* (Edison, 1895).

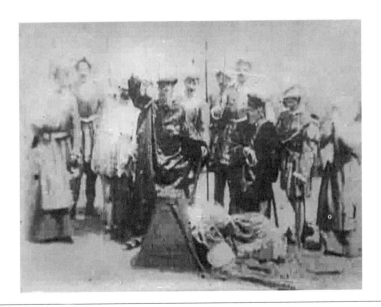

FIG 1.2 The executioner raises the removed head in an image of conquest in *The Execution of Mary, Queen of Scots* (Edison, 1895).

Even in this most rudimentary of movie deaths, even in a scenario in which the death moment could not be more clearly marked, there is a sense that the action itself is not enough to generate an ending. The image of beheading is unfinished. Someone inside the scene must confirm that dying is complete.[5]

Of course, no one lost a head—the film employs a trick device to switch out a living body for a dummy. The result, when played back, is the impression of a neck suddenly sliced and a head clearly removed. Some confusion accompanies this movie's classification, and for good reason, for although we can quickly see the cantankerous trick, it is not clear if 1895 spectators could do the same. Charles Musser, for one, suggests not: "When the two takes were spliced together, the interruption was not evident to the spectator and appeared as one continuous shot."[6] Musser nuances his claim about the novelty of the substitution splice with a note on its historical limits. Though stop-motion and the scene of beheading were both innovations, "[Alfred] Clark's film subjects commanded only modest sales, and very few additional pictures were made in the following months."[7] For a short time, then, spectators may have believed that film decapitation looked as real as any other subject, so the notion of a visual hoax may not have smacked of fraudulence. Furthermore, because the viewer could not control the image seen through the kinetoscope peephole, he or she could not easily look "closer."

Modern spectators detect fakery but are often less than astute when explaining the procedure responsible.[8] At some point after the actor playing Mary (Robert Thomae) is escorted to the chopping block, the camera is turned off. Out goes actor, in comes dummy. With bodies in place, the camera starts again. The profilmic substitution of bodies creates two separate strands of recorded film that are then taped together, or spliced, within an individual frame (those "editorial blades" at work). What we see is the executioner neatly remove head from shoulders—not a hard task if the dummy's head is loosely affixed. The instant of the axe's "swish" depends for its effect on another instant of bodily substitution.

Besides the dummy, there is another way the film makes decapitation legible. The executioner himself lifts up the head at the end, drawing

attention to the manual effort of its removal. Though the head chop seems instantaneous, the death moment it produces is something else. For one thing, *no one dies*, so the appearance of sudden cutting is partly undermined by the knowledge that this is not happening in the spectator's presence. For another, the movie resumes past the chop—the executioner's final gesture stamps the film with a different ending than would have the queen's besieged body. Though the camera demonstrates its efficiency in removing heads, the royal executioner signals the end of the film's spectacle.

This executioner registers what he has "done" to the body as a way to mark two things simultaneously—one, that he (or we could say the film, or filmmaker) has murdered the queen; and two, that the main event on display has expired. This first film executioner is an example of what I call the "registrant." Most often, the registrant is a human figure that steps in to make clear to the camera/spectator that death has occurred, in a visible (or, later, audible) pronouncement. Historic eyewitness accounts of Mary Tudor's beheading differ on whether or not her head was lifted. Writing about the role of demonstrated heads during the French Revolution, Regina Janes describes the ideological force of sovereign as showman: "When the sovereign displays a head, he shows it not to his equals but to his people. They are the objects of that display, both as raw material [the executed victim] and as audience. Their heads are the heads that are elevated, and it is they who must learn the lesson taught by them."[9]

Here, the actor is not only signaling the power of the state or of the people enacted by the state—he is doing something much more practical. He corroborates with the power of the image to conjure the spectacle in the first place. Unlike the queen's, *his* body remains continuously intact and mobile. It would make sense to think of registration as having a temporal relation to the death moment—in other words, death first, visible registration second. The moving image's persistent motion creates one effect, and the camera provides embodied recognition of that effect. The registrant "sees" and "feels" for the camera. This second figure becomes the beholder whose actions disseminate death throughout the picture. The registrant figure functions similarly to a coroner who works in an official capacity to read (i.e., record, log)

the body. The term *coroner* comes from *crowner*, one who works for the head of the king, or one who counts heads for the crown. Edison's movie lacks a king-sponsored crowner, but all registrants in the fiction film work to mark the time and place of death *for the image*, and, as such, their work is dispersed—bureaucratic rather than monarchical.

The French Revolution proves relevant here not just because of its legendary object—the guillotine—but also because it broadened the popularity of magic theater. Mary's film decapitation belongs to a nineteenth-century tradition of staged beheadings in magic shows and later in the penny arcades, a tradition 1895 spectators would have known. Flip through Erik Barnouw's *The Magician and the Cinema*, and you will find an advertisement (ca. 1890) for Carl Hertz's grand finale, in which he holds his own head in his right hand and his wife's head in his left. Civil engineer Henry Dircks published *The Ghost!* detailing the mechanics for, among other macabre effects, pulling off your head onstage.[10] It is best not to underestimate the complex workings of the phantasmagoria and other magic lantern shows.[11]

The Execution of Mary, Queen of Scots certainly recalls these previous hallmarks of visual culture—crowners, guillotine, and magic. But focusing on the substitution splice, we already see that the cinema could kill by intervening in its own unique way. Unlike magic shows and earlier beheadings, Mary's death was not produced within the presence of the spectator, nor did it result from a known act of demonstration. For that matter the theatrical renditions of Mary's life (and there are many from this period) could choose to omit her onstage beheading. Robert Blake's three-act theater drama of Mary's trial and execution, written and staged one year before Edison's kinetoscopic sequence, counts for one instance of stage death, reminding us of the difference.[12] Act 3, scene 2 takes place in the Hall of Execution. The executioners ask Mary to pardon them; her last words are a prayer to deliver her empire from unquiet times. And then, Blake's stage notes read: "The Queen lays her head on the block, supporting herself with her hands. The Executioners on each side bend down and remove the hands. Then the axe is raised amid general weeping, and the curtain falls. THE END."[13] Where the play ends with a curtain fall, the movie persists with a head chop. The Edison Company ignored the drama of

events leading up to the play's end point; Edison's little movie settles in where the play did not go. Certainly Mary's beheading scene was taken up elsewhere in nineteenth-century visual entertainment, and a precedent for the substitution splice may well have been slip slides for the magic lantern, which involved two glass plates on top of one another with a thumb-and-finger notch to move one plate and produce surprising transformations in the projected image.[14] But more like a penny arcade designer, William Heise and company extracted execution from any unnecessary context. As is clear with Edison's *The Kiss* (1896), a quick record of Mae Irwin and John Rice's smooch reprised from the stage play *The Widow Jones*, peephole moving pictures often focused solely on the most salacious moments in plays.

Until 1905, execution films thrived as a particularly popular sub-genre, offering spectators a mixture of what Miriam Hansen calls "partial pleasures."[15] And these pleasures sufficed more than the labels of documentary and fiction we are accustomed to using. But the stop-motion technique waned in credibility, giving way to the impressions of décor and space. The Edison Company reenacted Joan of Arc's burning at the stake (1895) with the same splice device before moving on to hangings. I have found catalog entries for hangings, gunfire executions, and a series devoted to the hanging of a female criminal. And other heads were paraded, as in the end of Sigmund Lubin's *Beheading the Chinese Prisoner* (1900), when "the executioner displays the head to the spectator to serve as a warning for evil doers."[16] Reflecting at times a confused mixture of belief and disavowal, catalog classification of such films blurs the line between actuality footage and reenactment. For example, American Mutoscope's *An Execution by Hanging* (1898) looks by all accounts to feature the actual hanging of an African American male. Describing the film as "a very ghastly, but interesting subject," the catalog reads: "This is probably the only moving picture that was ever made of a genuine hanging scene. It was taken in the court yard of the Jacksonville jail, and shows the execution of a negro." This executed male was replaced by a woman in American Mutoscope and Biograph's later identically titled—and clearly faked—remake of the film.[17] Available separately or as the third installment of a trilogy (preceded by *Reprieve from the Scaffold* and *Reading the Death Sentence*),

this film purports to show "what appears to be a public execution of a woman." After Mary Tudor, execution subjects were anonymous. *An Execution by Hanging*'s Paper Print Collection entry suggests the novelty of undetected substitutions had worn off by 1905, while having become an important disclaimer to be made about the films: "The set looks legitimate and so does the execution. However, there seems to be some stop action photography before the actual springing of the trap."[18] Now noticeable, the trick nonetheless did not interfere with the mise-en-scène's stamp of authenticity.

As I have suggested, splice films involved at least two kinds of doubling—the trick itself, and the registrant's gestured display of the trick's success. The substitution of living body for dummy did not occur at the death moment, of course, but rather at the beginning of the axe's fatal arc (*Mary*) or the moment before the gallows floor drops away (*Execution by Hanging*)—that is, just where it could let unfold an image of the fullest process. The splice combined holistic with split/asphyxiated body. In another instance, *Execution by Hanging*'s hooded woman is replaced with a dummy before dropping. Mary Ann Doane writes of the break in the footage: "When the film is screened, the break is all but invisible. Such a strategy is a denial of process and ensures the spectator's experience of continuous time."[19] Doane's "all but invisible" leaves more room for early spectator disavowal than Musser's previous comment on *Mary*. But her remark on the "process" of the substitution misses the extent to which perceptible bodily reaction to the fatal moment also ensures continuous time.

Execution reenactments illustrate the importance of timing in editing screen events. Poised to induce instant death, to get the right timing of a head chop or a neck break, these moving pictures also exceeded any violent instantaneity, doubling the procedure. For one head chop or suddenly broken neck there was another "chop" on the level of the strip. Timing was likewise essential for a magician's physical tricks. Metamorphic acts common to the stage often involved the transformation from "alive" to "dead," as for example the sideshow transformation into a skeleton of a volunteer from the crowd. This effect is created by placing on a diagonal axis a glass wall, onto which is projected the image of an actual skeleton hidden on the side both

from the volunteer and from the astonished spectators. The two figures spatially coincide. Transformation often involved the split-timing synchronization of lights—turning off the lights on the volunteer to be rendered skeletal, and turning on the lights for the skeleton's full projection.[20] That said, the timing of film effects departed from the stage in two significant ways.

First, the moving image retained environmental traces of the scene where death seemed to occur. The outdoor locations, notable in a film like *Mary*, contributed to the impression that the camera was in fact *there*, where spectators were not.[21] The image was bounded less by the proscenium's three walls and more by the screen's two-dimensional frame. That frame—an intermittently changing window onto the world—filtered an event from an elsewhere and an else*when*. Anne Friedberg has argued that the gaze constructed by the cinematic experience continued virtual and mobile perceptions of space and time earlier introduced by the panorama and diorama. These venues provided virtual spatial mobility by "bringing the country to the town dweller" and virtual temporal mobility by "transporting the past to the present."[22] The fact that film's special effects were not produced within the actual space and time of the audience (that they were prerecorded) favored cinema's further removal from the theatrical idiom of magic. With the advent of the screen-side lecturer during exhibition who would introduce and present the image to a live audience, magic's address of the spectator regained some footing. But despite what the lecturer said, the trick was still performed by the apparatus and not the *monstrator*.

Second, filmmakers worked with a unit of time that was unavailable to stage performers or technicians. Reclaiming the work of Méliès's magic films for their use of cutting, André Gaudreault finds that the transposition of stage effects to the screen required Méliès to further intervene as editor to employ stop-motion substitution. Méliès himself explained: "Every appearance, disappearance or substitution was of course done in the camera but was always re-cut in the laboratory on the negative, and for a very simple reason: this trick effect . . . will not work if the rhythm is broken. But the inertia of the camera was such that it was impossible to stop on the last frame of the 'shot' before the 'trick,' change the background or the characters, and start up again on

the first frame of the 'shot' after the 'trick' without having a noticeable variation in speed."[23]

Méliès suggests that cinematic spectacle was dictated by the speed or "rhythm" of the moving image; this surplus dimension of time required the role of the editor to further splice the two separately recorded strands of live action. Gaudreault contends, "Fundamentally, Méliès' films are montage films except that . . . before and after a stop-motion substitution, the framing remains the same."[24] Tom Gunning extends this line of analysis by suggesting that much of early cinema was interested in continuity of viewpoint over shots and thus did involve editing. Continuity achieved through duplicated framing is quite distinct from the continuity system of later narrative cinema, yet it confirms that substitution acts did not passively replicate the theatrical proscenium for magical effects. "Early films are enframed rather than emplotted," Gunning explains, "and what is contained by their framing is often a result of a detailed and complex labor [that] labors to efface its traces just as surely as did the later classical style."[25] Edison's film, like many by Méliès, worked with a cinema, not a theater, of illusion. Cinema was playing with the pieces, giving those inanimate pieces a temporal relation that produced not a theatrical unity, but rather a "cinematic synthesis of time."[26]

The synthetic death event obscured cinema's potential to allow the transformation to unfold over time. Not that still images before cinema fared any better: the axe's descent evaded painting's depiction of a static scene. Film makes good on the still image's lack by withholding, by duplicating (and duping), rather than by capturing. *Mary*, then, is a metaimage for all images of death; it covers and conceals in order to make transparent the opacity of its sign. Curiously, what is concealed is not the body's secret moment but the substitution of bodies. Death came to the cinema as prosthetic: one lack (the instant in time) is replaced by another lack (the perceived manifestation of that instant on one body). The beheading footage brings to mind Louis Marin's discussion in "The Tomb of the Subject in Painting" of the depiction of St. Blaise's martyrdom in the church of Berzé-la-Ville, in which the removed head and the raised axe are presented adjacently. In cinema there is not as clear a beginning and end point—an "inchoative" and

"terminative" aspect, as Marin writes—for the execution event.[27] The earliest scenes wanted to dilate the successive stages of the body's destruction, to posit more than two isolated instants, but they also worked to create the impression of death as happening instantaneously, visualizing the relation between "before" and "after."

What emerges is an interest in the process of dying, a visible trajectory that elaborates on the quick fix. Screen dying accommodates changing articulations of screen time. Execution reenactments would soon come in the context of longer films, multishot reels that showcased key moments of the procedure leading up to a killing. There is room to speculate that the approach to an execution edged out the spectacle itself because it supplied spectators with greater psychological investment. Perhaps spectators' interest in timed executions lay more in the experience of suspense (i.e., enjoying the pace of the film in arriving at the moment of killing) than in the synthetic body effect. But, it must be said, these longer films certainly did not provide narratives in the usual sense. Pathé's *Histoire du crime* (1901), for example, came as a set of autonomous shots rather than as a single continuous action: in the first shot the burglary and murder; in the second the criminal's capture; and so on, until the final two shots introduce us to the painted backdrop image of a guillotine and a dissolve to the device where we watch the condemned's beheading. Though the shift to a protonarrative format of multiple shots added a diachronic dimension to films, the death shot remained untouched. For the Pathé film Ferdinand Zecca relies on the stop-motion substitution of body for dummy. Such persistent formalism reiterates Noël Burch's conclusion that early cinema's mode of address was defined by an "autarky" of the shot, a central facet of cinema's "primitive mode of representation."[28]

Pathé's *Histoire du crime* was based on a then-current exhibit at the popular Parisian wax museum, the Musée Grévin. In the museum context a walking spectator could follow the course of events leading up to a convict's execution, reported as *faits divers* in newspapers.[29] Sequences of static scenes, the early film and the wax museum resemble one another: both narrate the proceedings surrounding the criminal through autonomous vignettes pieced together. The wax museum requires the mobility of walking spectators, but the Pathé film can add

time and motion to each vignette. The addition of time and motion means neither actual duration nor narrative flow, however, for each shot of the film (including the final one in which we see the guillotine substitution splice à la Edison) vibrates merely with the potential for independent temporal verisimilitude.

It seems the walk toward and away from the spot of execution proved more cinematic than the body event itself. By 1903, execution films were structured around the position of onlookers at least as much as, if not more than, the unnamed outsider's desire for the quick fix. *Histoire du crime* features an elaborate dream sequence from the waiting cell. And consider Peter Elfelt's 1903 Danish film *Henrettelsen* (Capital execution), based on a real mother's execution at the guillotine for killing her children. The film is thought to have concluded with the condemned's head being placed on the chopping block, though it is not clear if the death was filmed. For that matter the director later admitted he was not interested in filming the crime she committed: "A man got the idea of recreating it [the murder] in moving images. A horrifying idea. It didn't appeal to me at all."[30] Elfelt's ambivalence about shooting the murders for public consumption—magnified perhaps by the extraordinary fact of a female culprit—may have led him to locate the emotional center of the film outside the chamber. (Doing so certainly made the film that much more of a dramatic story than a document or reenactment; Elfelt himself was a documentary filmmaker, this his first and last "fiction" film.) A priest and the guard escort the female convict to the center of a long shot of a hallway with arched suggestions of perspectival depth on the flat backdrop (a common early staging). In the center a man stands looking on, taking off his hat as they come nearer. The escorts continue past as a priest wipes away a tear from his eye. Other bodies trace a trajectory through the final hallway. *Henrettelsen* focuses on the approach to execution rather than the body event, perhaps because the communicative bodily change was not her dying but rather the priest's pathos-filled reaction.

An American example of the drift toward process—this time of death's aftermath, not approach—can be found in the series of films of William McKinley's funeral cortege distributed just days after the service. McKinley was assassinated on September 6, 1901, by Leon

Czolgosz, an anarchist born of Polish immigrants. The assassination was not filmed, despite the presence of Edison cameras at the Pan-American Exposition in Buffalo, where the crime took place. (There is, however, a minute-long pan shot of the sandwiched crowd outside the Temple of Music that may indicate awareness of the event offscreen.)[31] Several films of the funeral procession were distributed to audiences, however, making use of cinema as a "visual newspaper." One in particular, *McKinley's Funeral Cortege at Washington, DC*, begins with establishing pans of the crowd before focusing on the military and civilian suites (fig. 1.3). Auerbach points out the presence of African American children looking into the camera close up: it is a particularly effective moment, as the camera is slowly pivoting in a circle and children, both white and African American, come in close and stare, one furrowing his brow.[32] The footage documents in various iterations of movement the witnesses, or registrants, of the president as they pass by or are themselves passed by the moving (panning, pivoting) camera. What we see is a kind of late registration, but there is no visible corpse;

FIG 1.3 Disseminating the president's death in *McKinley's Funeral Cortege at Washington, DC* (Edison, 1901).

rather, the film disperses the missing body throughout a space mobilized by witnesses. McKinley's assassination seems nearly overloaded with potential for expression, though the object itself was missed.[33]

The point is that around 1901 the thrill of a stand-alone trick effect seemed to wane, replaced by images of duration. Electrocution, the new killing technique, involved more time, literally, in the act of execution. Form followed content: as the pictured execution technique was modernized, the picture itself became less edited, that is, less fishy as actual footage. There is a simple explanation for this. Gunfire and electricity were exploited as spectacular lethal agents for the screen. Because they themselves move imperceptibly fast, they are best apprehended in their results. As the pictured execution method changed the ways the camera could enframe the act of dying, it also altered the behavior of the registrant. The beholder more clearly occupied the deathwatch that the camera had set up, and the registrant more completely marked the spectator's own relation to the dying body onscreen.

PROJECTING THE CHAIR

Even without elaborate narration, early films were concerned with signaling the end of a completed action—in our case, the change from "dying" to "dead," or what Kaja Silverman, writing of Norman Bates's shower victim in *Psycho*, labels "definitively dead."[34] Early on, methods of screen murder bore more than just a resemblance to execution; staging death afforded camera operators a plentiful resource for exploring mise-en-scène, framing, and registration. But before cinema the modernization of execution technique involved both increased precision and a new excess of sustained bodily motion. By no means do I claim to offer the first narrative of that history. But it is crucial to understand Edison's role in electrocution so that we can see the direct link between onscreen and offscreen technique. The "on/off" switch of electrical current replaces the cut in earlier splice films as the device that produces a mobile death. The cut is now placed at the end of the dying spectacle and functions as a limit to visibility.

During the 1880s, animal experiments in the United States employed an invisible agent—electricity—to induce a theoretically instantaneous

death on living subjects. Electricity's engineered threshold of death was more precisely a new voltage. Investigators played with increasingly high levels to close the gap between dying and "definitively dead." By this time, electrifying animals had become a public attraction. Animals of varying sizes were shocked at the Barnum and Bailey circus in Bridgeport, Connecticut, to show off (and to see) members of different species respond to electrical force. From baboons to seals to small monkeys, large dogs, and finally elephants, electricity unleashed a spectrum of animated reactions. The use of electricity to execute humans was first officially introduced in 1886, when New York governor David Bennett Hill commissioned a group composed of Alfred Southwick, Matthew Hale, and Elbridge Gerry to examine the most humane means to end life.[35] After two years of research, which included writing to Thomas Edison to request his opinion, their published report to the New York legislature argued in favor of electrocution on account that its death would be "instantaneous and painless" and "devoid of all barbarism."[36] Eliding prolonged technique with torture, the commission alphabetically cataloged previous means to terminate life, from beheading to suffocation. (Note early cinema's weird recapitulation of this cataloging impulse in its modernization of the execution scene.) This newest "instantaneous" death would get rid of the horror of botched hangings. A switch would now clean up, as it were, visible death, by taking dying out of the spectacle, by omitting the live writhing of a body still in pain. Electrocution proponents, like filmmakers later on, attempted to situate the death moment within a newly induced movement and temporal flow, to hide it from lay spectators. The commission was also interested in curbing the spectacle of those "scaffold dances" at which unruly crowds tended to gather. Included in their report was a press gag clause that advised fewer than twenty attendees be permitted entrance to the executions, which should only take place in one of the three state prisons. That audience would include a state Supreme Court judge, two physicians, and "twelve reputable citizens," a nod toward democracy in an otherwise hierarchical arrangement.[37]

To confirm success, the Death Commission relied on a series of its own animal tests conducted by Alfred Southwick for the Society for the Prevention of Cruelty to Animals. A steamboat engineer and dentist, Southwick corroborated with Buffalo physician George Fell

to electrocute stray dogs, standing them in cages filled inch-deep with water and placing an electrical cord inside. The SPCA commended their electrical method for inducing death "instantaneously and seemingly without pain."[38] Scientists had first played with lethal electricity in the early 1880s to euthanize animals, providing old or abandoned strays with a "good" death. However, the exact voltage and amperage needed "to produce death with certainty in all cases," notably human cases, remained unknown. At first Edison refused to comment on the electrocution commission, writing Fell that he was opposed to capital punishment in general, but after subsequent nudging that electrocution would at least sanitize the process, Edison offered his opinion that "the most suitable apparatus for the purpose is that class of dynamo-electric machine which employs intermittent currents." He went on to name names: "The most effective of these are known as 'alternating machines,' manufactured principally in this country by Mr. Geo. Westinghouse, Pittsburgh."[39] But on June 5, 1888, the day after the *New York Times* reported the new (slightly modified) electrical law set to pass, a little-known entrepreneur named Harold Brown published a letter in the *New York Evening Post* titled "Death in the Wires," in which he warned that high voltage of alternating current would be dangerous if put to residential or commercial use. Brown commissioned Edison's lab at Menlo Park to perform tests to demonstrate his claim, and Edison was eager to oblige, for he was about to engage in a battle to save his own direct current from the Westinghouse-Tesla monopoly of alternating current, a two-way stream that could be carried at higher voltages and at greater distances.[40] Both Brown and Edison meant to exhibit the peculiar devastation only AC could commit to a living body, a faster death from farther away.

Edison filmmakers did not move straight to electrocution. In 1898 the company tried and failed to record violent wartime action in the Spanish-American War.[41] A particularly disturbing result is *Shooting Captured Insurgents*, filmed once again by William Heise (August 5, 1898). In it a static camera displays an armed battalion of Spanish soldiers that march a line of Cuban prisoners to stand alongside a wall (Auerbach calls it a "jungle hut"), with backs to their rifles. The realistic effect of their ballistic deaths emerges from the vulnerability

of the prisoners' backs; we see a line of gunpowder coincide with a row of falling bodies.[42] Staging obvious traces of war with rifles and uniforms, the film appropriates mise-en-scène as a narrative extension of the besieged body.[43] *Shooting Captured Insurgents* makes more use of the frame's spatial depth than previous examples, setting up the men in a diagonal line along the wall that ends with the figure of a soldier who waves his sword to start the shooting. The immediately perceptible cause-and-effect between gunpowder and fallen bodies, and, more important, the absence of any effort to attend to the bodies after the flash of smoke, may have further indicated to an audience these were not American bodies. Unlike other reenactments from the war that stressed American military power and progress, this short film demonstrated a violent act performed by and on "foreign" bodies.

The film documents the lengths to which the Edison Company would go to create a certifiable impression that the camera was present. Kristen Whissel has argued that early reenactments were modeled on precinematic live historical reenactments such as Buffalo Bill's Wild West show. Familiar with the live show as commercialized leisure, spectators were likely sensitive to the impossible positioning of the camera within the war films and appreciated the resulting images as offering a place on the "scene of history" otherwise denied. Whissel describes the reenactment as a "limit case" between early cinema's panoramic potential and the blinding, destabilizing limitations of modern imperial warfare. Given the war film's "illusory presence-on-the-scene," the genre created anticipations for the ideal war actuality as a film that would contain the reality effects established by reenactments: "Rather than the battle re-enactment film 'faking' or simulating the actuality, the actuality film aspires to achieve that which the re-enactment had already accomplished: the illusory placement of the camera-spectator as a participant-observer on the scene of a historical spectacle it records/perceives."[44] This is a crucial point: by the time the Edison Company filmed a real death, the format of fake death was structured for imitation. Synchronizing gun smoke with suddenly besieged bodies could satisfy the viewer's curiosity, as well as whet the appetite for actualities that made good use of such reality effects. The frame's margins blocked out any effort (such as a cameraman's

shouted command) to maintain that illusion of synchronization. Once again, death is enframed rather than emplotted, but the difference here is that there is no sign of an edit or break in the footage. Indeed, Auerbach notes the acting style as the sole giveaway.[45]

Perhaps the best-known example of a single-take reenactment of dying is Edison/Porter's *Execution of Czolgosz with Panorama of Auburn Prison*. McKinley's assassin was executed with three jolts of seventeen hundred volts of alternating current on October 29, 1901. Released in December, the film begins with two rightward pans, the first of a train in front of the prison walls, the second from higher up revealing a piece of the yard. These pans were taken outside the prison on the day of execution. Missing out on the chance for actual footage leads again to embellishment.[46] A dissolve takes us to a static long shot of an interior corridor where guards arrive to escort Czolgosz from his cell. Note the similarity between Elfelt's *Henrettelsen*: here, the dissolve links reenacted scenes to an actual location. A second dissolve takes us to the empty chair: operators place a bank of lightbulbs (Edison's own incandescents) on the chair and thrice illuminate them with electric force. Ostensibly, this demonstration tests the current within the execution room, but, in service to the reenactment, it also legitimates the frame's ability to manifest electricity. The film also echoes details reported in newspapers. When the actor playing Czolgosz is led into the room, he stumbles on his way to the chair, matching the *New York Times* report.[47] Strapped in, he undergoes electrification in three apparent upward jolts, returning to seated inertia each time.[48] Two medical witnesses come in close to examine him with stethoscopes and, along with the warden, mutely pronounce him dead (fig. 1.4). As with *Mary*, dying is not complete without a figure (or multiple figures) gesturing vitality's lack.

The film's structuring of events, beginning with the pans and unfolding in one locale at a time, departs from newspaper accounts that would typically start in the chamber, move to Czolgosz's cell, and return to the chamber. According to the logic of the film the Czolgosz figure is executed at roughly the same time established by the opening shots. Porter's clear chronological order suggests he wanted to structure the film as a procession of events beyond the perspective of any

FIG 1.4 Registering the body in *Execution of Czolgosz* (Edison/Porter, 1901).

one witness, creating a transcendent observer out of the spectator. With the pans attached, *Execution of Czolgosz* intermingles actuality and reenactment footage. Of this pair, the reenactment carries the burden of the desire to see. Auerbach notes that the film "in its curious hybrid form seems to oscillate between historical fact and grim, obscene amusement, akin to a snuff film."[49] The term *snuff* generally describes a desire to authenticate by emulating reality effects. We can see how the uninterrupted footage in *Shooting Captured Insurgents* and *Execution of Czolgosz* delivered a different reality effect, one that begets a desire for actual footage. The content of so-called snuff films is also hybrid, combining human with animal footage. Such films from the 1970s, like *Faces of Death* and *Mondo Cane*, mixed the two: animals get dismembered for food or sacrifice while humans get destroyed in unusual ways—eaten by alligators, executed publicly, electrocuted. Single-shot slices into furry bodies seem to speak for themselves, while the spastically marked handheld quality of the people footage bespeaks fakery. Such films intermingle animal and human for purposes of authentication: the realness of the human is on loan from the animal. Such a binary can be traced back to the cinema of attractions

and the reenactment's earliest codes for imitation. Edison's later film of an actual animal execution, *Electrocuting an Elephant* (1903), has also been casually referred to as a snuff film, with the consequence of confusing the term. "Snuff" was indeed presaged somewhere between these two films, in the relationship between trick human (*Execution of Czolgosz, Shooting Captured Insurgents*) and authentic animal (*Electrocuting an Elephant*) death.

Like other filmed electrocution reenactments before it (e.g., *A Career of Crime, No. 5: The Death Chair*), Porter used the frame to manifest the difference between the "on" and "off" of the current—when Czolgosz is jolting, the current is "on"; when he is not moving, it is "off." The actor's throes instantiate the switch-like effect of electricity, of the incandescent bulbs previously switched on and off, and, due to the frame's covert visibility, of the screen itself. Just as electricity creates moving images by projecting a filmstrip, it also creates visible dying. Again, death technology overlaps with cinema technology. Both the film and its featured spectacle are the indirect results of electricity's presence, an entity not otherwise detected. Certainly this is not the only early film that explored the effects of electricity on the body. Vitagraph's 1907 *Liquid Electricity; or, the Inventor's Fun with Galvanic Fluid* features a scientist who shoots a syringe of "galvanic fluid" into fatigued bodies, causing them to leap into hyperkinetic motion.[50] Such a film represents the other side of electrical movement, presenting "galvanic fluid" as a rejuvenating solution to the weariness of modern life. But electrical dying is also spasmodic, staging the return to stillness as a sign of death, but one that has to be confirmed beyond its visible evidence. *Czolgosz* cannot go past its own motive force to signify electricity's absence, not in this case. ("Lights out" might do it but only symbolically. Before lights go out, the body must be signified as dead.) It is impossible to really know what Czolgosz's bodily return to inertia means. That is why our act of looking is completed—or indefinitely deferred—by the gestures of registration outside the body.

Just as with the splice films, registration serves to terminate the time of dying, to bring the film to rest. Staged in a long shot against a flat backdrop collapsing all depth, Czolgosz's execution leaves no traces behind on the actor's body. Consistent with the Death Commission's

goal, no death signs emanate from this spectacle object. To confirm finality, the picture scene itself is left with the task of signifying that death has just happened. Thus, one of the operators listens through a stethoscope to confirm breathing and pulse have indeed stopped and passes the tool to another technician on Czolgosz's other side. Facing the warden, the first doctor nods. Closer still to the edge of the frame, the warden (James White) takes his cue, turns, and looks at the camera. (He is in fact signaling to cameraman Porter the need to cut.)[51] Across the flow of light this last living gaze provides the ultimate contrast to the gaze that sees no longer (Czolgosz's), in a relay of confirmations addressed to the camera. The hands and ears of the technicians touch and listen for us; these hands and ears give evidence to the change the camera alone cannot supply. Remembering Michael Fried's distinction, we might say that electrocution becomes the turning point between experimental onscreen "absorption" (the figures addressing the body in question) and narrative "theatricality" (the pivot of interest away from that body in the form of direct address).[52] The unconcealed gaze of the warden turns outward, faces the camera, and produces its own finale; it must do this because there is (supposedly) no more motion to attribute to the corpse. Czolgosz's motionlessness in fact gets externalized and incorporated elsewhere, turned into the technician's final gesture. Dying cannot autonomously address a spectator as having concluded. The end must be accounted for by someone else.

As with the earlier film executioners, here the medical and legal registrants perform a service that was not explicit in the actual unfilmed electrocution: they confirm that the film's action has come to an end, the gap between "dying" and "dead" closed for the sake of an image. That is, the nineteenth-century means of listening for breath with the stethoscope is corroborated, and supplanted, by the exchange and delivery of gazes in relation to the shot. The camera, like the electrical current, creates the paradox of an instantaneous death that unfolds over time. Gesticulating someone else's absent vital signs turns the action of dying into a narrative of death seen, passed over, and concluded. The registrant's movements conclude the tenured process of dying. I have in mind Mary Ann Doane's reading of the film and

her larger project on the contingent and ephemeral qualities of time mediated by photographic technologies. In her analysis contingency relates to the unexpected and unpredictable, to events that resist being charged with meaning and that pose both a lure and a threat to modernity's abstract organization of time. It follows that the execution reenactment of early cinema offers Doane a privileged object because it tries to bequeath meaning to what may be the most contingent event in human life: "Death would seem to mark the insistence and intractability of the real in representation."[53] By taming dying, cinema structures the most temporally evasive of actions. Indeed, the electrical killing is nothing if not tame—Czolgosz is extremely well behaved in his dying. Doane argues that *Execution of Czolgosz*'s compression of events conforms to the popular conception of electricity as an instantaneous force, associated with, as Mark Seltzer puts it, "a sense of immediacy and the pure present."[54] The "on" of the electrical current—the dying—provides something of a "pure present" that must be made to pass, or, recalling Pasolini's discussion of editing, we might say it is a present that must be made "past," through hindsight.

Several problems attend Doane's analysis, not least of which is her notion of death as the ultimate intractability of the real in representation. We might ask: *which* death? It is difficult to imagine a less unpredictable event than an execution foreseen, planned, and scheduled for midnight. There is, however, something quite uncertain in electrocution procedure that Doane does not discuss. The voltage needed to secure instantaneity was (and is) largely theoretical and subject to horrific miscalculation. In this regard we need to disambiguate real executions from filmic ones (Doane's syncope between the two becomes more problematic in her reading of Edison's elephant footage, which I will discuss next), for cinema can "clean up"—that is, time and structure—what in actual practice is an unwieldy process. Certainly, electrical dying was far from instantaneous, but *Execution of Czolgosz* strives for a legible image. The lack of cuts in the chair scene enhances the film's power to visualize the electric force stiffening the body. If the switch remains offscreen, it cannot intrude on or disrupt the primacy of the actor's unassisted thrust forward, signifying the "on" of AC flow.[55] Since the actor's shaking can be neither matched

nor mismatched to an onscreen device, his recoils seem to take their cues directly from offscreen space. This is all the more important considering the film's efforts to mandate the very threshold between life and death. Despina Kakoudaki has observed that the electrical body may connote death as a sudden event (like the turning on and off of a switch), but it also creates an excessive bodily movement.[56] Electric bodies visualize dying, not death. The offscreen switch controls the barrier between dying and inertia, but merely by crossing that threshold repeatedly.

The electric chair's switch and the cinema camera thus share a certain historical emergence. Auerbach posits the two in a lethal analogy: "Facing one another, movie camera and electric chair become mirror images, so that a new technology proclaimed to reproduce life uncannily serves to register the process of dying."[57] Doane draws on Walter Benjamin to designate any filmic sign as one that repeats a missed encounter, and Benjamin locates novelty in the transformation of longer processes into sudden singular hand movements made possible by mechanical gadgets. Benjamin's important formulation reads: "Of the countless movements of switching, inserting, pressing and the like, the 'snapping' of the photographer has had the greatest consequences. A touch of the finger now sufficed to fix an event for an unlimited period of time. The camera gave the moment a posthumous shock, as it were."[58] The photograph's "posthumous shock" captures a precise moment that is already dead once captured. While we might quarrel with Benjamin's idea that a photograph is more important than, say, a gun, his point does conjoin the modernity of electrocution and cinema. Doane suggests that the "contingent" receives a posthumous shock through cinematic recording and replay.[59]

But there are other posthumous shocks, ones particular to death as a missing moment. Functioning in fact posthumously, the cinematic registrant finalizes dying with gestures outside the body in question. In fact, the actor playing the warden, not Czolgosz, enacts the most startling posthumous shock. The convict's *dying* occurs in multiple jolts, but his *death* is not nearly as evident in his body. Visually, it happens in its having happened. Given the concluding power of the registrant's gesture, one could say that Czolgosz's death occurs posthumously,

that is, in the confirmation afterward. With the screen figure of the registrant, cinema gave death a posthumous shock. The registrant is a proxy for the spectator, staging future posthumous shocks in repeated viewings. Such a deferral of death through registration triggers a *nachträglichkeit* in its very effort to terminate it clearly.

Execution of Czolgosz tidies up a process that in reality was experimental and potentially horrific. When performing the destruction of motion, electricity also produced a mobile and at times unwieldy death. In 1888, at Edison's lab, Harold Brown displayed (with Edison's dynamos) to the Electrical Control Board his ability to instrumentally cease vital functions. Along with electrician Arthur Kennelly (then employed by the Edison Co.), Brown astonished his audience with a battery of tests, which he performed at various venues over the next two years, including at the trial concerning the "cruel and unusual punishment" of William Kemmler, the first human executed with AC. In one experiment for Elbridge Gerry at Edison's lab, Brown began by shocking a small dog with DC charges at increasing intervals (300, 400, 700, 1,000, 1,400), with the animal reacting more fiercely at lower resistance levels (from 15,000 to 2,500 ohms); he then switched to a 330 voltage of alternating current, and the animal fell dead on the spot. Brown moved on to heavier calves. The second, weighing 145 pounds, was zapped with 750 volts, but there was excessive motion afterwards: "Death was instantaneous, the heart stopping at once, but reflex movements upon excitation were observed for one and a half minutes." That is quite a bit of posthumous motion. Brown finished with a standing horse weighing a ton. Describing the horse execution, Brown mentions Edison in his write-up: "Connections were made by mapping cotton waste saturated in water around each foreleg, and holding that in place with bare copper wires. This was suggested by Mr. Edison's plan of execution by electricity, in which the criminal was to be held in metal wristlets for electrodes."[60] Leaving the current on the horse for twenty-five seconds, Brown convinced spectators of AC's lethal speed: "The result was fatal. In this, as well as in the other cases, death was instantaneous and painless."[61] His assurance that AC was immediately destructive assumed death to be a single bodily event, of course. Brown and Kennelly moved on to a public demonstration at

Columbia College in Manhattan, where some seventy-five spectators looked on. He produced a seventy-six-pound mongrel, and once again displayed the difference in sustainable thresholds between DC and AC by incrementally increasing voltages. A disturbed ASPCA officer eventually interrupted the show.[62]

Dying animals provided the stage for electricity's theoretical instantaneity to play out. But human executions proved just as grisly. Newspaper summaries of William Kemmler's 1890 execution by electric force, the first ever, famously differed in their accounts: some were glib and procedural while others were drenched in excess. Particularly harrowing is Dr. Carlos MacDonald's account of several installments of electrical force after the desired fatal jolt left a burning, and still-alive, body in its wake. After the first shock of Kemmler's body "there occurred a series of slight spasmodic movements of the chest, accompanied by the expulsion of a small amount of mucus from the mouth," leading to another closure of the circuit, desiccation, and the odor of burnt skin.[63] For film to take an interest in the process and to reenact real electrocutions required the apparatus to situate the switch's instant on the surface of a new dying body, setting the stage for the conflict between the apparently instantaneous death heralded by the state and a gradual act still happening while we watch. Premised on the same instantaneity as alternating current, cinematography would also reveal the consequences of the instant's breakdown.

SEEING DYING

when we forget how
the wires were fastened on her
for the experiment
the first time
and how she smoldered and
shuddered there
with them all watching
but did not die
—W. S. MERWIN

In 1903 the Edison Company finally got its chance to make good on the reenactment's promise of actual death, and in the process revealed just how noninstantaneous electrical death could be. On January 4, 1903, a camera was present for the execution of a Coney Island elephant. Topsy—dubbed a "rogue" elephant for killing three circus workers—was electrocuted before a crowd of some fifteen hundred witnesses, a spectacle in line with previous Barnum and Bailey animations.[64] The subject of the film was thus racially coded ("Topsy" was the name of a slave girl in Harriet Beecher Stowe's *Uncle Tom's Cabin*). But the camera was more than just another invited guest.[65] *Electrocuting an Elephant* begins with the animal's being led into position for a fixed long shot, framing her entire body to maximize the visibility of its destruction. Profilmically, the animal was manipulated to die in eyeshot of the camera. In the film, smoke emerges from her feet, and Topsy jolts slightly askew, collapsing sideways and then toppling over. As the downed body twitches, the footage jumps at least twice, well short of a single take. One could say the film itself twitches. Hardly is this a neat one-shot continuum from jolting to inertia. Unlike the body of the actor playing Czolgosz, Topsy's undergoes a differential change. As she falls horizontally to the ground, her convulsions all but resist the completion of the film as a total document of her final movement. She is still sliding to inertia at the end of the film.

Edison's film is always referenced as the footage of an elephant's death. But keeping in mind the tension between instant and process, we might reconsider. Doane has already pointed out "a break in the film where the camera is stopped and started again." Indeed, a splice bridges the elephant's first appearance (as she is escorted into a long shot) to her second (as she stands unassisted with electrodes intact). Doane writes of the completely noticeable cut: "This visibility of the cut is in contrast to a later execution film, *Execution by Hanging*, in which a camera stoppage is the condition of possibility of the representation of a death. . . . In *Electrocuting an Elephant*, there is no attempt to conceal the break or to deny its existence. That break functions to elide time that is perceived as 'uneventful'—the work of situating the elephant and binding her in the electrical apparatus." Doane refers to such an elision as a marker of "dead time," or time deemed

uneventful by the action filmed. Both the splice films and the elephant footage include some dead time, and in my view, the latter's elided footage is just as much a "condition of possibility of the representation of a death," in this case electrical death, as is the former. In other words, Topsy's death moment is just as synthetic. As I have intimated with a reference to snuff, it is all but impossible to find a "pure" or unmediated encounter between death and the camera, and when we do find one, suspicions of fakery or controversies over causality almost always surround it.

But even more revealing is evidence of missing footage during the elephant's dying. Looking closely at Topsy's throes, we can see more stoppages where the camera was turned off, then back on again, then back off—as if the operator were unsure whether her convulsions had concluded or, indeed, what might constitute a conclusion. The elephant's death appears unruly even for a camera complicit with electrocution; still convulsing, she does not seem to die fast enough. Unable or unwilling to keep the camera on until Topsy's body finally stops obviously moving, the camera operator wrestled with moving image technology to picture the end of life. Not much appears to invoke registration. Once the elephant has fallen, and lies horizontal on the ground, a suited figure enters the background from screen left, and while he does appear to compensate for an ending the image could not materialize, he does not embody any recognition (fig. 1.5). Even her dying evinces "dead time."

In this spectacular case the camera alone attempted to register the death of a living being without waiting for human cognition. No larger mammal could evidence electricity's destructive power.[66] It was assumed, however, that her death would instantiate itself. The retrospective clarity of the edits indicates that dying exceeded the single take that had become the favored technique for reenactments like *Shooting Captured Insurgents* and *Execution of Czolgosz*. Electricity lent the medium an instant that was so durable in practice it exceeded the limits of the frame. Unlike in *Mary*, in the animal footage we can tell the time of dying exceeds the film's deployment of the cut.

As I stated earlier, the real of the human is on loan from the animal. Topsy's electrocution drives home a point that *Mary*'s proxy splice

FIG 1.5 The fallen elephant and the grounds man behind her in *Electrocuting an Elephant* (Edison, 1903).

began to make clear: both electricity and cinema expand death beyond a conventional, and vain, conception of a moment. This connection becomes a stark contrast when we consider that the elephant does not foresee her execution, cannot bodily or facially express anticipation, and thus does not voluntarily participate. The animal emerges within the context of filmmaking's pursuit of dying as an involuntary act caught on camera. Animals cannot fake dying the way the actor playing Czolgosz can (although they can play "dead," or perform "thanatosis," in an act that ranges from defensive to sexually aggressive, though this reinforces why we should be concerned so with *dying* on film). If the animal poses a serial existence in its unknowingness of death, as Akira Lippit has claimed and philosophy has insisted, then its serial repetition here suggests that the "real" emerges as that which does not get registered by human perception. By 1903, cinema

death and real death had become intertwined with one another. In the absence of registration the spectator must supply that sense of an ending and, in the process, become commensurate with the object. It is as if the film must wait for the elephant. Animals may not know death, but neither does the human-operated machine of the camera. The phantom instant is missing, and no one is there to project it for us.[67]

By the time the Edison Company recorded Topsy's execution, the new death moment for humans was defined and under operation at three hundred AC volts. I say "moment" when talking about voltage because the original humane dream of its application was to render the body instantaneously dead, to eliminate the painful conversion between two states. But as we can see, electricity did not visualize the moment as much as it produced a new body for visual culture—a convulsive and lively body whose return to stillness could signify cessation but whose failure to do so could present an irruption of lived time. In the face of technology this irruption marks a kind of *durée* that will not play by the rules. Cinema and electricity multiply the observable death moment: there is the theoretically instantaneous change from alive to dead; there is the act of registration that organizes and recuperates time not lived by the body; and there are the multiple posthumous shocks of replay. Even *Mary*'s trick murder comprises two bodies—the one hidden so that the other can gain credence. Technology's timed death could be both imitated and undone by the cinematic apparatus.

Earlier films foreshadowed the elephant footage. We have already seen the actor playing Czolgosz convulse thrice in response to three electrical charges. These charges translate as three phases of a single process: (1) going to die; (2) dying; (3) dead—for reasons having as much to do with the cognitive responses of viewers as with Czolgosz's actual response. In state-run practice jolting was an unpredictable spectacle, potentially horrific. Eyewitness Carlos MacDonald disavows the temporal process of dying in his account of William Kemmler's electrocution: "Synchronously with the onset of rigidity, bodily sensation, motion, and consciousness were apparently absolutely suspended, and remained so while electrical contact was maintained."[68] Not so movie descriptions. In 1900 American Mutoscope and Biograph's *A Career of Crime, No. 5: The Death Chair* displayed

a model electric chair from Sing Sing. A catalog description of the film reads: "One of the group [of spectators] is placed in a chair, tied hand and foot, and a bandage is put over his eyes. He can be seen struggling against his body, as if charges of electricity are coursing through his body."[69] "Struggling against [the] body" sounds a different note from the "apparently absolutely suspended" vital forces. Apparently, making the alternating current visible on the body allowed dying to be seen in a condensed form; jolting could be understood as dying.[70] The Edison Company in particular seemed to want to explore the present participle of "dying"—to see some process between alive and dead, exactly to find out how un-neat that process might be, to record the visible somatic spectrum otherwise hidden by two mutually exclusive states. And if they could record it, they could replay and rewatch it, slow it down, even reverse it. The display of multiple jolts on both humans and animals repeats the feint of instant death. Reiterating circuitous attack renders fatality less rather than more clear. Mary and Czolgosz resolve their endings with registration. Topsy's jolts, however, surpass prior movie logic, and the environmental traces in the picture disseminate her solitary act throughout space.

These films testify to a wish that there be no real calculus behind death, a wish that "we" (audience/camera) be the real calculators. For one thing, the elephant's collapse makes clear two different framed positions. Her body topples like the wall in Louis Lumière's *Demolition of a Wall* (1896), here eradicating the tactile gesture of the registrant. And all official operators are absent from the scene, as though to clear out a direct encounter between dying and the apparatus. Even so, the progression of her dying undercuts the punctual logic of both the switch and the cut. Editing poses a different relation to the animal's death than to the human's: the cuts carry the traces of a time that cannot be perceived by any one embodied human spectator. The posthumous shocks of these breaks in the footage reinforce a gaze complicit with a quick death that now must face the truth of a slower one. These little posthumous shocks—these irruptions of *durée* that contain the traces of an embodied gaze—are more accurately pre-posthumous. The elephant embodies the breakdown of punctual death. It is important that Doane looks at the reenactment and actuality side by side,

but she connects them through their mutual interest in screening contingency and organizing time, missing a key difference in their forms. Recalling a Bazinian notion of cinematic repetition, and invoking the language of life support, Doane claims that "Topsy and Czolgosz are kept alive by the representations of their deaths."[71] But this is misleading. Unable to invoke a clear bodily sign of death's difference, and without a registrant to produce such a gesture, the footage comes up short of eternal life. Eternal repetition doesn't keep the elephant alive; it keeps her dying. The camera doesn't see dying; it will always *be seeing* dying.

REVERBERATIONS

"That's my job, the left leg."
—*DEAD MAN WALKING* (1995)

What Edison's footage captured was at least one mammal's activity in a mortal recoil that perpetuates over time. Dying did indeed have an extended present tense, years before narrative feature films would stage, edit, and prolong the last moment. A dying whose elimination had been vainly attempted regains, with Edison's apparatus, its full-body implications. No matter how spectacular the means of destruction, cinema death remains indebted to the registrant's touch. Subsequent Hollywood executions negotiate themselves as objects of a voyeuristic gaze, a gaze that is ready to marvel in the surplus of the moving image but understands the humanizing strategies of the camera as a means of observation. The gaze fluctuates between the state victim and the seated spectators in the "theater" of death. Like the wardens who return the gaze that Czolgosz could not, these diegetic spectators witness the proof of life's end. Early cinema previewed this scenario in its gradual move away from the quick fix toward the progression of predying, dying, and registration. Though admittedly registration is not fully elaborated in the early films, it becomes the pivotal moment in Hollywood executions. In service to the psychological focus of narrative action, the registrant becomes an intimate of the condemned

rather than an anonymous sovereign, a sympathetic spectator rather than an extension of the state.

The kid-turned-adult-gangster who stands to be condemned by his boyhood friend is a story told in many classical films, including *Manhattan Melodrama* (1930), *In Old Chicago* (1938), and *Angels with Dirty Faces* (1938). The execution scenes in the first and last on this list pair up the condemned with his former mate—an adult with symbolic power (governor, priest)—who sits with the condemned and witnesses the proceedings. Invectives against crime, these films employ execution as a narrative device to mobilize identification with the transgressor (always the more likable of the male pair) so that we see crime's origins as social. This leads to a nearly paradoxical project: to understand state-sponsored murder as justified without allowing our identification with the condemned to undermine the sanctity of the state, that official gaze tapering the edges of the Production Code. Partly, this double standard is met through the condemned's own acceptance of his fate. In *Manhattan Melodrama* Edward Gallagher asks Jim, his governor friend, to be executed: "If I can't live the way I want, at least let me die when I want." In *Angels with Dirty Faces* Rocky Sullivan shows Father Connolly he is ready to face the chair. But in the latter film, state appeal doubles as vilification. Father Connolly anchors our gaze within a sympathetic diegetic witness who is also a part of the state apparatus.

Rocky is idolized by the "Dead-End Kids," a group of delinquent boys he and Father Connolly had mentored. The boys expect him to spit in the face of the legal surrogates present. The film provides good reason to do so: a guard moments before the walk brings the issue of process over instant to the fore, telling Rocky, "I'm going to ask the electrician to give it to you slow and easy, wise guy." When Connolly enters the cell, he asks Rocky for one last favor: to "have a heart," that is, to fake fear and to "cry out for mercy" during the execution, "to turn yellow." This gift places the executed man at the center of the proceedings only so that he can perform the melodrama of fear for the public gaze. The expressionistic electrocution scene is particularly effective in canceling out our identification with Rocky. While escorted to the chair, he is screaming in terror, clinging to a radiator, and eclipsed in shadow;

once seated, he undergoes electrical jolts while the camera focuses on Connolly's beatific face, looking upward in gratitude. The light dims twice, cutting off Rocky's screaming protest. The film cuts from Connolly's face to the next day's newspaper headline, held by one of the kids: "Rocky Dies Yellow; Killer Coward at End!"

The registrant short-circuits our voyeurism by retaining focus. However, in Robert Wise's *I Want to Live!* (1958) a female condemned is freely gawked upon by a crowd of male witnesses assembled in the execution room (they peer through the glass wall of the chamber behind her, in fact). The execution in question is the historic one of Barbara Graham, the first female executed with gas at San Quentin. Based on *San Francisco Examiner* reporter Edward Montgomery's articles and Graham's own letters, Wise's film takes us through Graham's exploits, arrest, and last hours while she is detained at San Quentin. This last process foregrounds the wait for legal clearance and is replete with an object-shot of the "DW," or "Death Watch Log," a file for female guards on duty who must attend to Graham while she is in the waiting cell. We expect, following Foucault, this act of supervision: when you are set for execution, you become an object of internalized surveillance. This means that your death is made visible against your will, but of course, the technological production of your death exceeds the ostensible time of its appointment. As we have seen, modern execution theory has wanted the instant to clean up the visible process; here, a guard tells Graham to count to ten after the pellets drop and hold her breath. "It's easier that way," he says, to which she responds, "How do you know?"

This deathwatch is the state version of the modern hospital's incremental stages of cessation of care. The legal process, in short, resembles technological dying.[72] What is interesting is the female guard, also named Barbara, who wants Graham's respect because she passes no judgment and exercises no disciplinary power. As a potential registrant (she is in fact not present in the room during the execution, presumably because female guards are not permitted) she is indeed Graham's mirror: her moral status is checked by Graham who returns her sympathetic gaze by passing on to her the stuffed tiger she holds as a keepsake for her son.

The presence of the (all white male) reporters and witnesses in the last room extend the film's general denigration of the disembodied production of legal events—verdicts, appeals, reprieves, and sentences. The legal process is documented more thoroughly here than in early films, of course, and that process seems to surround Graham rather than involve her. Disembodiment rules the film's presentation of the gas chamber as well. The chamber is lovingly displayed in partial shots while it is disrobed in preparation. Its pieces are lingered over in object close-ups: sulfuric acid is poured; phones are tested; gas pellets are bagged. But Graham's death is dispersed and effaced. For one, shots cut up the space to show us pieces of the scene of observation—onlookers standing, a doctor monitoring vitals through a stethoscope connected offscreen to Graham, the second hand of the clock ticking past 11:36. For another, Graham is wearing a mask she has requested to guard her against returning the external gaze. She literally cannot return the gaze while dying, and the spectator must occupy a voyeuristic position.

Given the dissection of the room, it is not surprising her body is cut into pieces, too: different parts of her are seen dying—first her head falls forward, then her hand slides to inertia. To invoke the mechanics of execution, decoupage presents an itemized assembly of part-objects that comes up short of a synthesized whole. Once again film technique mirrors execution technique, but here that resemblance is so endured that the film makes room for a critique of execution. The final shot is not of a human registrant but of a lone lightbulb on the chamber's ceiling. Against its stillness, wisps of poisonous smoke rise by, a movement that contrasts with stillness over time. This lightbulb, a probably unintentional invocation of Edison's dual investment in electricity and cinema, affords us the last impression after Graham's apparent death.[73] Edison helped divine the visible limits of technological death, producing, on the one hand, an instrument to reduce dying to an instant and thus to hide it (the chair) and, on the other hand, one that could make such a death visible again (the cinema).

The human registrant has no room in *I Want to Live!* because the film criticizes the execution as unjust (Graham's last words in the film, uttered to a priest in a barely audible whisper, are "I didn't do it").[74]

But reciprocity between condemned and witness moves center stage in *Dead Man Walking* (1995), a film that presents the lethal injection of a self-confessed killer. As such, its sympathetic registrant must deal with both the execution and the first murder, eventually avowed by the condemned. Sister Helen Prejean develops a relationship with Death Row inmate Matthew Poncelet; their conversations take place through a window in shot/reverse-shots. But Prejean is also busy in many reaction shots while visiting with the victims' families, who narrate to her their last memories of their children. The film is thus split between victim and criminal rights, uniting the two under a critique of capital punishment.

The filmic registrant witnesses death in an act that surpasses its bureaucratic function. *Dead Man Walking* focuses on Prejean's decision to return the condemned's gaze and the hatred she faces for having agreed to be Poncelet's spiritual adviser (one victim's father protests, "He's not a person"). The execution follows suit but not without affording Poncelet a memorable opportunity to speak. Earlier in conversation Poncelet confesses to Prejean both murder and rape. On his way to the last room, she tells him to look at her so the last face he sees is a "face of love."[75] But Poncelet's "performance" all but reverses the effect of Rocky Sullivan's in the Code-era *Angels with Dirty Faces*. Though the decoupage of gadgets and operators during the execution scene is by now customary, the speech Poncelet gives to the families of the victims, asking for forgiveness and condemning all forms of murder, is anything but.[76] The reciprocity of gazes during the execution ends between Poncelet and Prejean's "face of love," the face of a sympathetic seated member in the theater of death. The final gesture is Poncelet's sudden opening of his eyes: a dimly heard mechanical bleep sounds in the background, followed by a pan shot of the crime scene at daybreak and a rotating overhead shot of Poncelet's body.

Always bordering on the salacious, non-Hollywood executions would be conceived around the reciprocity of gazes. An entire court case was fought over just this issue. In 1991 a public television station in Northern California—KQED—sued Daniel Vasquez, the warden of San Quentin, for the right to bring a television camera into the witness area during Robert Alton Harris's gas execution. The courts ruled in

favor of Vasquez, citing an issue of prison security as the reason—the fear of riling inmate emotions. Wendy Lesser suggests that another factor played the decisive role, one having to do with the nature of the televised gaze as an uninterrupted (indeed, noncinematic) look at the spectacle object with no recourse to identification through reciprocity. During the actual proceedings Robert Harris silently apologized to Steve Baker, Michael Baker's father. Lesser describes the unrecorded execution with this note: "When he was strapped into the gas chamber chair for the last time, Robert Harris craned his neck to look around at the witnesses . . . [meeting] the eyes of Steve Baker. . . . Harris held Baker's gaze with his own, and then mouthed the words, "I'm sorry." Baker nodded stiffly in response. . . . Whatever their motives, the two men had managed to acknowledge each other in a way that would not have been possible if television had been their intermediary."[77]

The unsolicited gaze of the camera intrudes on whatever dispensation of gazes might occur in the execution room. Without recourse to this dispensation movie executions would forge a too-telling intimacy between condemned and spectator. While overtly sadistic, the 2002 footage of American Daniel Pearl's beheading confirms the power of the camera's gaze to force audience complicity. In *Electrocuting an Elephant* the turning away/off of the camera marks a sign of human presence; in the beheading footage that appeared on the Internet, the refusal to turn off the camera becomes a political act of terrorism. Pearl's death footage lacks reciprocity and focuses on the slowness of the throat's cutting.[78] The ideological function of display we find in Edison's mutual involvement in electrocution and cinematography leads to a politics of torturous death. Any such politics cannot be conceived without acknowledging the American apparatus of beheading called the cinema and the American penchant for producing moving images of dying.

2

POSTHUMOUS MOTION

THE DEATHWORK OF NARRATIVE EDITING

To spread out the last moment so that it lasts almost through a whole act has been the ambition of many a master of the film.
—BÉLA BALÁZS

AT THE END of D. W. Griffith's *The Country Doctor* (1909) Little Edith goes limp in her mother's arms while her father—previously called away on a house call—is en route back home to treat her. Edith's mother falls over the child's body in grief just before Dr. Harcourt arrives home too late. Feeling for a pulse, he recoils, eyes open in shock, disbelieving arms loosed. Harcourt nestles himself in his wife's bosom as they pose behind their daughter's recumbent corpse. The film could end here. But Griffith keeps looking for an image of closure. He chooses a panoramic shot that starts with the home's exterior and moves left across the still landscape of "Stillwater." We have seen this landscape before. The coda reverses the film's opening shot that pans left to right across Stillwater, introducing us to the home and its bourgeois inhabitants as they emerge together through the front door. Griffith's final shot concludes the death—and the film—outside the home, outside the family circle, and indeed, out of sight of Edith's body.

By 1909 the techniques of narrative film portend an emergent cinematics around the death shot—or the image of apparent loss of

embodied vitality. Pier Paolo Pasolini could have told us we would find it here. Recall his point that the hindsight of editing, and hindsight alone, can render the passing of a life, or life passing, into a meaningful synthesis of partial views: "Editing therefore performs on the material of the film . . . the operations that death performs on life."[1] The cut carries the trace of a later time, a threshold from which the apparent present was seen more clearly. Extensive editing affords multiple partial views, and those views influence the production of life's end. By 1909 filmmakers have begun to trace death's reverberations in other images, spaces, gestures, and landscapes. Griffith's narrative films at Biograph Studios (1908–13) are a kind of crucible for this emergent cinematics. What we find is an elaboration of the techniques of repetition and dis-embodiment at work in the earlier one- or two-cut death shots. Con-sider just three principal strategies in *The Country Doctor* alone: first, the use of the cut controls the rate of dying, not just in the single shot, as with Mary Stuart's beheading, but across numerous shots, seeing dying as a rhythm of diachronic progression. The cuts are "palliative" or "curative," depending on whether a second party manages to help deliver the body from illness or danger. Second, the death moment is registered not just once but multiple times, in more than one picture of registration, as bodies (mothers', fathers') accumulate. And third, the posthumous shot outside the home remembers a body in its absence. The film is not satisfied with picturing merely the fact of onscreen stasis. In short, narratives brought with them more elaborate scenar-ios of registration, and again, what matters is not simply content but also form. The narrating camera functions as a death technology—it stages dying between spaces, it times death in relation to other actions and images, and it senses life's absence in space.

When narrative enters the picture, the moving image opens up for exploration—disconnected from the body, it gets suspended in time, held hostage by narrative, and exploited for its spatial trajectory. In earlier films we saw how the camera finished death outside the body through the figure of the registrant. Such disembodiment, and the repeated recognitions that attend it, find new and powerful expres-sion in the early silent features. This chapter is about that new expres-sion, especially the inclination that an object, a pan, or a natural vista

translates death more powerfully than watching it happen, or watching it *be seen*. The posthumous markings we find in the early narrative film point to the limits of human observation and the cinema's ability to compensate for those limits in moving form.

DYING TIME

Writing after cinema's conversion to sound, Béla Balázs describes the "scene" as a synthesis of partial views rather than a lone embodied action: "What is done is not to break up into detail an already existent, already formed total picture, but to show a living, moving scene or landscape as a synthesis of sectional pictures," Balázs tells us. These pictures "merge in our consciousness into a total scene although they are not the parts of an existent immutable mosaic and could never be made into a total single picture."[2] Sensitive to the rhythms of silent film editing, Balázs points us in the direction of a linguistic model of film shots. Popular wisdom would have it that a death scene shows us the lone body perish, but Balázs's remark on the synthetic whole rather than the "immutable mosaic" suggests additional pieces play into the impression of a "single picture." What pieces mattered for the overall impression of early death scenes? How was dying extended and brought to an end? We find that the shot in which someone apparently dies is one among others that compose the scene—the "synthetic whole." These other shots feature anticipation and reaction, and not just of the central figures. What counts as the final gesture becomes ambiguous, too, as figures, objects, and vistas carry the trace of the body into surrounding space.

One early narrative film that stages a new connection between the camera and the body is Griffith's *Behind the Scenes* (1908). In this fourteen-shot film Mrs. Bailey is forced by an unsympathetic theater manager to leave her sick daughter at home so she can perform in his stage show. (The mother holds up a clock to her bedridden daughter, a gesture of time's foreboding that will be echoed in many later films.) The unyielding manager twice shoves her into her dressing room. In shot 4 a doctor arrives at home to tend to the child, setting up a

contrast between home and work. Twice in the film Griffith cuts from mother to daughter, alternating between the onstage guardian and the bedridden child. The grandmother, or house help, runs to the theater and, in shot 8, holds the mother while they stand among congratulating performers side-stage. Her appearance reinforces the proximity of death, filling the frame with a kind of paralysis. Placed between Mrs. Bailey's second stage dance and her return to the wings is a shot of the child's last twitching gesture—what I have earlier called the "slide to inertia." She goes limp in the arms of the doctor, who then places her in a recumbent pose, one hand at a time. In the next shot Mrs. Bailey flings an arm toward offscreen left as if prescient of her daughter's death—though the moment, she fears, is nigh, it has in fact already passed. When she finally returns home, the doctor intercedes to tell her the news, but she persists, moving toward her daughter. A number of final touches can be found here: first, she pulls down the sheets to move in closer and then talks to her daughter while stroking her hair and hand. As she bends in for a kiss she recoils in horror, shakes the doctor, then grabs her daughter's buoyant body and (rather violently) picks her up, shakes her, puts her down, flails about, then collapses over the body, only to rise again flinging her hand through her hair, collapsing again over the body.

The mother's psychological dilemma ushers us into and away from the body event, keeping it in check.[3] Her dilemma becomes at one point absurdly ironic when she is forced to perform a skirt dance before a tropical backdrop while her daughter struggles at home. The visual parallel between sick daughter and working mother forms a node of contrast that Griffith can extend across a number of shots, commenting on the condition under which the two are separated (the edict of the stage manager). This and so many other Biograph films mobilize narrative through the commentary provided by the contrast edit. The device plays a dominant role within Griffith's developing narrative technique, more than camera movement and more than the close-up, that device he is often wrongly credited with having invented.[4]

The appearance of the contrast edit in this film has particular force in prolonging dying, and for this reason I think of it as "palliative" in nature—not restorative, but delaying the inevitable. Through the cut

back home, Mrs. Bailey appears to sense her daughter's demise even though she is not physically present. Gesturing offscreen beforehand, she "learns" of the event through what we might call an omniscient narrator. Only *after* her prescient offscreen look does she return home to see and feel for herself. The first implied death prepares us for the mother's painfully late reunion with her daughter. The death shot, then, is doubly eventful: it shows the child's last movement, and it depicts this as a direct consequence of the mother's inability to be home by her side, possibly to help her. Separation dictates that we return to the bed to bring the child's dying to an end; she cannot leave the film without her mother.

In *Behind the Scenes* the cut underscores the potential for Mrs. Bailey to witness her child pass in an early version of what many Griffith scholars refer to as a "false eyeline match," a cut that connects the sightline of a character to another place though logic tells us it cannot be so.[5] The film extends dying across several images, switching between possibility and certainty, where gestures of registration and not the slide to inertia provide ultimate knowledge. We *think* it will be too late, but we do not *know* until she registers this for us. (This raises the crucial question of whether unregistered fictional deaths strike us as complete, a point I will return to.) In this early sequence the idea of the mother's inadequate gaze focuses the film's ability to picture dying with incremental images, to see a process she cannot. Life fades, and "rescue" fails, diachronically through editing. Each shot heralds a successive image for comprehension. Here we can understand Balázs's insistence that the operations of montage produce not spatial continuity but an "architecture of time."[6]

The cutaway from bed (or battlefield, or wheat mound, or wherever dying is unfolding) that prepares us for the registrant's late arrival is common in Griffith's films. This use of the cut to forge causality points to what Tom Gunning has termed the "narrator system," a complex of editing strategies developed in Griffith's films that supply meaning to individual shots through the relations between and among them.[7] Gunning is careful to look beyond the biographical Griffith for this "absent narrator." In summing up the creative, industrial, mass cultural implications of authorship before moving on to Griffith's films,

Gunning states, "The starting point is a series of specific films from which a particular narrative stance and address can be abstracted: the narrator system that casts the shadow of D. W. Griffith onto the field of American film history."[8] Much like Peter Wollen's conception of the auteur as a construction of texts and not human biography, Gunning's narrator is a discursive formation, not a flesh-and-blood director. The narrator emerges from the work of editing and may not be encountered outside of films.[9] The term he espouses is telling—narrator *system*. Occasionally I will refer to this system as part machine, which possibly stretches Gunning's intention but nevertheless does point to the "vital" energy with which the cut animates screen figures. Indeed, the narrator system introduces a new technology of death. It is a machine of vital flow, staging life through the finitude of crosscuts.

But it is equally important that the films wait for the registrant to return before they conclude the scene of dying, even if the last twitching gesture seems to have occurred. The body event—that is, the enacted final movement, usually in the form of a collapse or slide to inertia—takes place in relation to the registrant. *Behind the Scenes*, for example, *places* the death moment between mother's worried trajectory from stage and wings, and it *times* that moment between her encore and leave-taking. Griffith borrowed plenty from the theater but not this emplacement. Working to distinguish cinema from the stage, Hugo Münsterberg praised film's "omniscience," the capability of crosscutting to create a larger structure and to involve the spectator's attention: "The soul longs for this whole interplay, and the richer it is in contrasts, the more satisfaction may be drawn from our simultaneous presence in many quarters."[10] In *Behind the Scenes* the death moment implies a point of view that cannot be ascribed to any one character's experience. Often, two places are synthesized when grievers stand over the corpse. Griffith's frequently repeated final image—the tableau of grief—underscores a temporality of late discovery that often illustrates ideas of social injustice.[11] The greedy capitalist's death in *A Corner in Wheat* (1909) goes one up on this, tripling our vantage point. The Wheat King's hand trembles from within the wheat pile that buries him before he is brought to the surface and grieved; his final gesture is also alternated with the frozen tableau of

farmers protesting the bread prices his despotism has caused. What Gunning calls Griffith's "melancholic ending" is an object lesson on specific social constraints, but it also lectures on cinematic timing.[12] In other words, the possibility of time running out is more than just a possibility. In some instances it does run out, the perceived corpse at film's end the evidence.

The ubiquity of Biograph films that spring from or conclude with a character's late return/arrival home who thereupon registers someone has truly died suggests that the temporality of early narrative death is strongly connected to someone's late timing, and it is no coincidence this is so. Linda Williams has suggested "too late" as the temporality of the fantasy underwriting melodrama, perhaps the most popular of those "body genres" (along with horror and pornography) that provoke visceral reactions from spectators.[13] Certainly, Biograph scenarists favored scripts with high "heart interest," and child suffering (and death) must have ranked high on any list of extremely pathos-inducing events. Evidenced by his print sources, Griffith was steeped in Victorian traditions, including child death. But there is more to this timing than antecedents in sensibility. To clarify the structure of film melodrama's pathos, Williams builds from Jean Laplanche and J.-B. Pontalis's work on the temporality of fantasy. She suggests that the melodramatic film concerned with permanent separation and irreversible loss, especially the mother-daughter weepie, "endlessly repeats the trauma of our melancholic sense of the loss of origins." Contrasting melodrama to the other body genres of pornography and horror, Williams concludes that the temporality of melodrama's pathos is that of "too late!" (as opposed to horror's "too early" and pornography's "on time").[14] Although Williams at first restricts her examples of melodrama to the maternal subgenre, Dr. Harcourt (*The Country Doctor*) would tell us of gender equality. "Too-lateness" suffuses reunions between living and deceased in a variety of gendered pairings, especially the late reunions that punctuate or end many a Biograph film.

What is more striking is the fundamentally late nature of the human encounter with mortality in these films, as if a death could not be considered a powerful enough subject lest it trigger someone else's tardy dramatic recognition. Unable to supplant the medium's

deferred relationship to death as a singular occurrence (recall that the stand-alone tricks and substitutions in early films revealed the excess of recognition), Griffith employs deferral for psychological effect. Editing assures that there will be another final gesture—the registrant's embodied grief—after the apparent loss of life. Biograph films faithfully relay the focus from the dead to survivors in other parts of the story world; living characters immediately replace the corpse as centers of our attention. And their trajectory allows the camera, and the spectator, to witness the dead body more than once, to repeat an encounter first offered by the camera.

Rarely do we find solitary deaths that satisfy in these films.[15] Pairing the deceased with an onscreen observer who could have intervened (whether or not their reunion occurs too late) forms a veritable habit. In *Musketeers of Pig Alley* (1912) a feeble mother spasms and slides back to an inert seated position alone at home, but she does not leave the narrative until her daughter, the "Little Lady" (played by Lillian Gish, one of the busiest registrants of American silent film), returns to find her. In *The House with Closed Shutters* (1910) a daughter's death has been kept secret from the public and is finally registered at film's end by her suitors, even though she has long since been absent from the diegesis.

The problem with applying the temporality of the lost origins fantasy to all Biograph melodramas should be clear: in addition to painfully late reunions, we also term "melodramatic" those films that feature successful rushes to the rescue. Films like *The Lonely Villa* (1909) visualize separation of husband and family across shots of locations dangerously isolated from one another, connected only by machines—car, telephone. "Borrowing" a gypsy camp's wagon, the father manages to make it back home in time to save his family from the home invaders. The flip side of "too-late" is the nick-of-time, where rescue, or reconciliation, prevails. In either case, impending finitude increases with each cutaway. As Jacques Aumont has said, "in Griffith's cinema, 'partir c'est toujours mourir un peu' ('to leave is always to die a little') and leaving the scene signifies at least potentially the death of the character."[16] Griffith uses even the two-shot version of this effect to suspend outcomes and produce tableaux, or

posed arrangements of bodies. *The Barbarian, Ingomar* (1908) shows the barbarian's sword drawn over Parthenia's head, switches to Ingomar's rescue attempt, and returns to Parthenia as her rescuer arrives to stop the fatal blow. Clearly, not all films that employ parallel editing end with irreversible loss. Hence Williams's reformulation of the temporality of melodrama in a later essay as "a dialectic of pathos and action—a give and take of 'too late' and 'in the nick of time.'"[17] But Griffith's earlier Biograph films do not balance "too late" with "in the nick of time" the way that a later film like *Way Down East* (1920), according to Williams, does.[18]

The effects of time in the scenarios of failure, and the affect experienced by the spectator, are qualitatively different. For loss of life is also a certain loss of screen energy: the film stops cutting; parallel editing comes to a halt.[19] Balázs's "architecture in time" becomes frozen. The body's inertia stops the pulsation of cuts from gaining further momentum. One suspects that if parallel editing did not show failure every now and then, it would not be quite as thrilling in its depiction of a successful race against the clock. Since they win some and lose still other contests with the clock, Griffith's films develop an ambivalent relationship to time, and death marks that ambivalence clearly.

As Aumont's earlier remark suggests ("partir c'est toujours mourir un peu"), many of Griffith's films create the overarching sense of time as an edited and finite number of shots; Gunning refers to parallel editing in particular as an "armature."[20] Building this "armature" of film narrative depended largely on the ability to show the ensuing threat of time running out, the capacity to weave together multiple shots into a synthetic net rather than a series of "linked vignettes."[21] In the latter the temporal designation of each shot supplies no relation to other shots except the barest of a before and after. By contrast, Griffith's films rather viciously arrest characters in a finitude of crosscuts. The clock is often ticking.

Biograph films visualize dying through the pulse of crosscuts. Cutting gives the shot a fingerlike touch, as if on a pulse. It recoils, stalling when the pulse cannot be felt. Unlike the offscreen switch that induced electrical jolts in *Execution of Czolgosz*, techniques of narrative editing control the rate of dying through visible alternation. The

final gesture materializes from the absent narrator's arrangement of the pieces, from elsewhere and not from the body's changes. Resorting to more than one image takes the burden off any *one* and allows the search for more or less "effective" images—the moment the death scene "peaks" in emotional force or the moment a configuration of grief congeals. The peak might be the registrant's collapse over the body or the tableau of grief, but there is more variety to such moments, including shots of objects or nature.

Rich variety can also be seen in the scenarios of "too late." In *Romance of a Jewess* (1908) a father and daughter reconcile their relationship on her deathbed just as her body gives out in front of him and her little girl; they both kiss her good-bye. But arriving on time to allay past misgivings (in *Romance of a Jewess*, Ruth's father abandons her when she decides to marry a poor bookseller) makes too-lateness digestible, not obsolete.[22] Earlier in the same film, Ruth's husband, Solomon, falls off the bookstore ladder to his death; she prods his body on the floor and reacts in horror with mouth in an awestruck *o*. Ruth frantically runs out of the shop and brings back with her a doctor and other men. The doctor puts on his spectacles and bends down over the body, feels for the pulse and touches somewhere on the head, then stands up and says something to the room. We know that it is a death pronouncement because of the moving bodies reacting to it: Ruth covers her face and another man takes his hat off and looks toward the floor. The scene's rising pathos, its ascent of grief, has not yet peaked: the woman convulsively hugs the body on the ground and raises both arms up to the ceiling before collapsing again. Such collapses in Biograph films rival death throes in number and force.

Solomon's fall, his death pronouncement, and Ruth's reaction form a continuous thread of action that is enframed in a single take. Nonetheless, the final gesture is one of grief, not of dying. The temporality of "too late" favors the momentum of survival, of moving on, even if those survivors are paralyzed by sadness.[23] Two deaths are registered in *The House with Closed Shutters*, by objects more poignantly than by people. Charles leaves home to fight for the Confederacy but soon retreats a "drink-mad coward," running home to his mother. This leaves his sister to approach the front lines to protect the family's

honor. Picking up the fallen flag from the battlefield, she is killed. Her mother decides to keep this news secret for fear of ignominy. She orders the servant to close the shutters, keeping her son and secret locked away. Years later, two suitors continue to show up at the front door with flowers, asking after the daughter, believing her to still be grieving. In a fit of desperation Charles flings open a window and, apparently, suffers a heart attack. The suitors enter and stare at the body. Following the mother's cue, they both take off their hats, but to honor the sister whose sacrifice is now belatedly acknowledged, not the son. (In a way, the daughter was still "dying" rather than "grieving" since the film had not produced a registration service.) This final shot provides a delayed registration that makes use of the recurrence of place (house), as well as objects (the windows go from open, to shut, to open). Though Charles dies "twice," both times his death is registered through an object that commemorates his sister and in the absence of her body.

Whether or not registration is filmed separately, the single-shot death moment remains the norm during the silent era beyond Griffith; likewise, the registrant remains the mobile figure to whom narrative focus is bequeathed. In some instances bequeathal is quite literal, as with the death of Pauline's guardian, Mr. Marvin, in the first episode of *The Perils of Pauline* (1914). He endures his last convulsion in bed but not before completing his living will, in which he leaves his fortune to his son, Harry, and places Pauline in the custody of Koerner, "a man with a tainted past." Dominating this shot is the question of who inherits what. We might not notice the final breath were it not for Pauline's reaction: she watches Marvin's spasm and urges the doctor to check his vitals. Holding up a mirror to the mouth, the doctor stands up and visibly reports: "He has died." Both Pauline and Harry fall over the body, and the will is passed around the room. The founding dilemma of the serial is established in this death shot: Koerner will lie, steal, or kill his way into Harry's new fortune. Here the final gesture is clouded over by the reading of, and reaction to, the will. In these last examples we are reminded of the old-fashioned means of determination, still very popular as part of the melodramatic language of expression, but we also see the old

ways overlapping with cinema's introduction of a precision based on the speed and timing of the shot.

Coming into view is a template for the Biograph death scene, a formula that can then be applied to subsequent fiction films. Typically, the scene can be divided into three stages: (1) alternation between dying and some other event; (2) confirmation of the body's absent vitals; (3) resumption of narrative posthumously. Of course, much elaboration is needed. Not all the scenes indicate death as a somatic event (in *And a Little Child Shall Lead Them* and *The Avenging Conscience*, for instance, it has already happened when the scene begins; it is an item of the *syuzhet* rather than *fabula*). Therefore, the body event need not take place onscreen for a shot or scene to process and be fundamentally "about" it, which is why it does not merit its own numerical iteration (it would amount to 1b). The scene can begin without moment 1.[24] And not all stages are of equal importance or screen time. Increasingly in the early fiction film, the second phase, or registration, lengthens in duration and increases in dramatic significance. It is not the static occurrence it would seem to be. If the slide to inertia and the arrest of cutting announces that death might have happened, a kind of stasis would logically follow, bringing a paralytic, photographic death. But this is not quite the case. Motion persists, though—both in and around the dead body and through those figures that converge around it to react and pose. The corpse is still dynamic onscreen. Stillness is not easy either to perform or to film. The tableau of grief offers not just a second look but also a second death that elaborates on the first. It is to this second death that we must now turn.

FINAL TOUCHES

Whether or not the survivors make it home in time to exchange words, there is still work to be done when they do arrive. This work goes largely unnoticed or else is dismissed as part of the hysterical "overacting" of silent film performers. I am referring to the way they confirm the fact that the body is dead, usually by feeling for a pulse on the wrist or the neck. But I am also signaling the way the survivor(s) embody

stillness through a series of stylized gestures that culminate in the tableau. Even the gesture of grief, which echoes the stillness of the actor already playing dead, is a curiously mobile, unfinished pose in cinema. The registrant's second "death"—freezing, fainting, collapsing, or the like—presents another approximation of stillness.

On loan from the melodramatic stage are both an acting and a visual style. Roberta Pearson has traced Biograph acting to the emergence of a performance style on the nineteenth-century stage, especially common in vaudeville and lower-class venues. Pearson argues that this old-style acting couched in the expressive terms of the Delsartean school fell out of repute as realism became the dominant goal for legitimate theater.[25] It survived in the Biograph shorts in part because silence and camera distance compelled actors to compensate for illegibility by employing a body language already established. The tableau also comes to Griffith from the stage (though its history is longer); in fact, as Ben Brewster and Lea Jacobs argue, it did not disappear with the advent of cinema but underwent a transformation.[26] One of the central functions of the tableau, on both stage and the early screen, was to heighten the scene of a death's confirmation.[27] But the tableau is an embodied, not a medial, pause, and it deserves to be thought about more clearly in relation to a mobile death.

Brewster and Jacobs argue that tableaux became less autonomous in narrative cinema than on the stage—meaning not that they became more chopped up and edited, for that would imply that they became pictorial in a new sense, but rather that they seized on relations (between characters, between locales) accumulated in other shots and posed an interesting caesura for the *moving* image. I would add to this that cutting brings the tableau *to* the corpse; therefore, films must time the former pose as well as the latter. In one sense the tableau persists in early narrative films as an effect of crosscutting, for as Martin Meisel has pointed out, the cutaway "arrests the flow of the narrative so as to produce a heightened sense of its significance."[28] The interruption of an action by a cut (for example, to a rescue attempt) sometimes leaves the actors posed in rigid bodily form and thus uses the tableau to construct suspense.[29] Formal opposition was always a point of the stage tableau. When in one stage version of *Uncle Tom's Cabin* the tableau

appears after the death of Loker, it emphasizes the conflict between the slave trader and the loyal wife on opposite sides of him. Brewster and Jacobs deduce, "A good tableau, then, brings a set of meaningful units—the conventional postures or attitudes assumed by the actors— into relation with one another."[30]

The gestures of registration and grief in Biograph films return us to Roberta Pearson's model of histrionic acting as digital communication. Pearson explains how the histrionic acting style favored precise and predetermined poses to express emotional states. Pearson has found this style inherently discontinuous like digital time, wherein discrete number units express change, as opposed to the analogical communication of gestural speech, wherein the hands on a clock flow from one moment to the next.[31] Given the tableau's oppositional structure, it is interesting that Pearson writes of the appearance of "opposition" in the histrionic code in terms of choices actors could make. These choices include the length of time a gesture might be held, the stress and speed of the body movement, and the distance of the arms from the core.[32] Seeing the verisimilar code as a set of oppositional terms (short and long, fast and slow, far and near) allows Pearson to identify further this highly gestural acting as speech (the privileged lack for which silent cinema compensates), viewing actor choices along a synchronic/diachronic axis. The move to what Pearson calls the "verisimilar" code is thus a move away from the speech-like precision of gestures to an acting style that allows for improvisation and flow.

Traditionally, the stage tableau interrupted the action to produce a highly charged schematic opposition—illustrating a conflict not soon or easily resolved. By far the most common narrative motivation for tableaux was surprise or astonishment, often at fatal news. And dead bodies were specifically posed around; onlookers would stop to recapitulate the stillness of the corpse. Pearson argues for film's "modified tableau"; the dramatic pause continues in movies, although poses are not held nearly as long as they were onstage and are not followed by the strong effect of a curtain's close.[33] It follows that the death tableau undergoes a similar adjustment. Indeed, the screen tableau of grief— or, for that matter, any movie recognition of fatality—is structured by

the limits of the shot, an image with a curtailed rather than discontinuous photographic temporality.

To play dead is to strike a pose, and to register the corpse is to strike another. The dead body and the tableau are both transformed by the cinema. The second pose of recognition absorbs the static body that will not again move. The stillness of the registrant within the tableau repeats the slide to inertia of the actor dying—registrants fall, thrash about, or hold tight to other grievers before hugging or collapsing on top of the corpse. In film this second stillness feels compensatory for the first. An unmoving body contrasts with the moving image in a way it does not contrast with movement on the stage—and since we know the pictured corpse is not really still, our gaze moves out to the second still figure. Griffith's movies encountered the breathless, or inert, body—that human figure so contrary to the pleasures of eminent vitality originally envisaged by the apparatus—as a kind of asymptote. The significant action in a death scene would *seem* to be the body event, and confirmation would *seem* to be visible stillness, but the rhythmic "life force" of editing tells the story differently. Despite what can be spectacular performances of dying, there is an overwhelming sense that the camera is always either too early or too late to focus on the body's final gesture. It is too invested in other screen activity. Inflecting Bazin, I use the word *asymptote* because the stillness of death cannot speak for itself in the analog moving image; it must be spoken for by another body—still endowed with motion—that approaches the first to confirm for the spectator that it is, in fact, not breathing.

We do find breathing, moving corpses in Biograph films, which suggests that the corpse is not a visible terminus. *Musketeers of Pig Alley* and *The Painted Lady* (1912) exhibit almost comical problems of the mobile excess of stillness. In both films, bodies whose vitals have been registered as absent through touch betray clear stasis. For instance, after the female protagonist shoots the burglar in *The Painted Lady*, he falls laterally near the camera with covered head near the bottom edge of the frame. On his still body we can see the rise and fall of his jacket. After the mother-in-law dies alone at home in *Musketeers of Pig Alley*, the Little Lady comes home to provide registration: but the older woman's body has moved, for close inspection reveals her sitting

in a slightly different position in the third shot than she landed in the first. Owing to their reference to theatrical codes, Biograph films provide an opportunity to watch out for such unconcealed movement as an indication of the not yet fully "fictionalized" corpse. One problem for filmmaker and actor alike continues to be how to eliminate the breathing corpse while playing still onscreen. Embodying a corpse did not imperil the theatrical proscenium since that space was avowed as a stage on which to play dead without competing with a fundamental fact of continuous movement.

Given the vagrant movement we find in some Biograph films and the obvious fact that death is not audibly pronounced in these silent pictures, the stillness of the registrant speaks volumes. The tableau of grief reiterates stillness of the dead body and seems to naturalize such a pause and extend it longer than the body event. When in *A Corner in Wheat* the Wheat King falls to his doom in the grain shaft and is then raised up on an elevator, the rest of the players gather around his body as it is laid out horizontally in the frame. The operator checks his vital signs through touch, and the crowd forms a tableau around him. Again, Griffith films death and registration separately, making clear the different roles for each. Whereas the camera does not need to scrutinize the dying before it cuts away but merely has to prepare us for death as a possibility, the registrants above take a rather lengthy pause to perform the same function. It is as if we do not believe that the Wheat King is dying in the preceding shot where his hand peeks up through the wheat mound—we believe what other people believe for us. Our emotional center is not in the body that might stop for good but in the bodies that stop for the moment, to listen, touch, and react. The tableau is not a stop, a dead end, but rather a pause that draws attention to itself as halted movement, triggering in fact another mental operation in the spectator who savors this depiction of the character's having departed (more movement).

In addition to timing the tableau in relation to the body event, Biograph films transform the tableau through detailed, "verisimilar" reactions. For example, in *The Painted Lady* we can see Blanche Sweet recoil from the body outside so earnestly she leaves the shot; she literally jumps out of the frame, stricken by the idea that she has killed

her suitor.[34] Registration becomes quite powerful when the camera allows the actor's face to demonstrate the stages of recognition. A more deliberate registration shot will inspire memorable bits of acting, as in *The Mothering Heart* (1913), when the young wife stares toward the camera, facially processing her baby's death—a reaction that exaggerates her knowledge as a form of noncommunicated feeling, a melodramatic "text of muteness," to borrow Peter Brooks's language (fig. 2.1).[35] Our only access to the corpse is through the mother's face; media for mute gestural speech, the face and body communicate the strongest of feelings, often of helplessness and victimized passivity. Dr. Harcourt's reaction in *The Country Doctor*—as opposed to his wife's, as I will discuss later—is clearly more verisimilar, opting out of the frenzied motion of the usual "hands-to-heaven" pose for a more controlled gesture with arms closer in toward his body. Perhaps most memorably, in *The Birth of a Nation* (1915) Griffith extends the registration shot, composing the registrant's face behind that of the dying figure, as the Little Colonel kneels down by his sister Flora's body after she has jumped from the cliff. He stares out, roughly toward the camera, for ten seconds before embracing her. The look dramatizes the narrative transition about to come—the rise of the Little Colonel's Klan (fig. 2.2).[36] All these examples culminate in too-late embraces, moments of sustained posthumous sorrow, often long-sustained.

That the films organize death around onscreen perception does not mean the camera should take all the credit. Some actors received particular acclaim for dying. David Miles, for one, was praised for his portrayal in *The Faded Lilies* (1909) of an unwanted lover who mistakes flowers for a gift from the woman he loves but who is engaged to another. He lifts up the flower and drops it, while he topples over into a chair, suffering from an apparent heart attack. His last gesture received this glowing review: "The death scene is so realistic that the audience scarcely breathes when the man is passing through the mental agonies attendant upon his discovery of the deception which has been worked upon him and the physical agony of approaching death."[37] Lillian Gish offered a legendary performance later in the silent era in King Vidor's *La Boheme* (1926), a scene recounted by Vidor as exemplary of Gish's craft. Having studied stages of tuberculosis at Los Angeles County

FIG 2.1 Registering toward the camera in *The Mothering Heart*. (D. W. Griffith, 1913).

FIG 2.2 The Little Colonel stares vengefully after registering Flora's death in *The Birth of a Nation* (D. W. Griffith, 1915).

Hospital in order to play the tubercular death of Mimi, Gish arrived for the scene pale, lips three-days parched, voice weakened to a whisper, having learned how to breathe invisibly. Staying still before Vidor's camera (the director later explained he was too "frightened" by her pallid appearance to cut), Gish achieved a visible inertia over time. Biographer Charles Affron writes that Gish "seemed to have stopped breathing; the movement of her eyes and eyelids was suspended. The cameras continued to grind away and, for what seemed like minutes, Lillian was inanimate."[38] Gish may well have practiced such preparation for death while filming Griffith's *Broken Blossoms* (1919), in which she dies in a thirty-second medium shot. In it she breathes uneasily and forcefully while her body is distributed laterally across the frame, forking her mouth into a feigned smile before sliding to inertia with eyes cast askew (a particularly grisly endeavor). Certainly Gish, and others, savored this slide. But as my examples have shown, registration more generally provides the actor with an emotional spectrum—and time frame—that at least matches that of dying.

The tableau reminds us that the moving image can hover at the boundary between movement and stillness, between aliveness and deadness, but it cannot quite cross over.[39] Death qua stillness (i.e., Barthes's photographic rigor mortis) is problematic in film because motion filters stillness as the result of what does not change onscreen. Consider Protazanov's *The Departure of a Great Old Man* (1912), in which the indexical footage of Tolstoy's corpse at his wake contains an interesting detail—a fly that can be detected silently buzzing around the room, an agent of motion that proves this is a *moving*, not a *still*, image of the still body.[40] What goes for the corpse goes for the tableau; both embodied pauses run against the grain of the moving image. When characters seem to perish alone onscreen, before their vital signs are read as having ceased, something like an alarm goes off. The cut sends us away quickly to a would-be-registrant, filling in any doubt left in the body's wake with the emotional certitude of loss.[41] The film supplants the dead time of the body and recuperates, or revives, its narrative meaning in other movement, even the movement into another pose. The poses struck in tableaux attribute to the corpse a stillness the medium has not yet achieved: the "dead" do not

own stillness, but the living do, in the form of the long pause that absorbs what has happened.

The corpse, the frozen griever, the posed survivor—not one of these figures defines death as the opposite of motion. What we see as deathlike stillness is defined as a moving image that does not change, so stillness is predicated on mobility. Also, this stillness requires a chunk of durable time for it to be perceived onscreen. Like the warden's immediate look out at the camera to confirm Czolgosz's closed circuitry, diegetic deadness must be spoken and stopped for to conceal its inherent fiction. In *Execution of Czolgosz* one can feel tension at the threshold of motion and stillness, a threshold that interested several early filmmakers. The pose, and the freeze-frame that in some ways is its progeny, create a moving image of continual stillness. Philippe Ariès sees in cinema a uniquely "living image" that poses a new kind of representation within the history of death imagery.[42] Replace "living" for "moving" and we have yet another aphorism: cinema is the living image of deadness. The moving image redefines "being dead" as the observable motion of stillness, and this motion contains a degree of perceptual excess that must be accounted for to ensure diegetic coherence. The excess is temporal as well, for in the term *still* itself we find the double valence of movement and time. *Still* pertains to states of both physical being and temporal dilation. Screen "deadness" concerns us because, if expressed in terms of *durée*, it never ends. (Previously I described Topsy the elephant as "still dying," obliquely capturing Bazin's sense of cinema's *remorts*, or *remoriens*.)

Rewriting the sentence of cinema's death is tantalizing, but before getting lost in aphorisms, I would like to underscore the general point here that it is often not the actor but editing that formulates the final touches. In *The Sealed Room* (1909) Griffith demonstrates clearly that the single shot and the actor's dying are not enough. Here we know there can be no movement between the locales—the whole point is that the vengeful king has sealed with bricks the door to the anteroom where his queen is enjoying a tryst with her young suitor. The cuts between the two sets are motivated by a narration beyond the limits of the frame. Blocking the passage sets up asphyxiation next

door, out of eyeshot. In the final four shots we see (1) wife and suitor grabbing at their necks for air; (2) the husband adjusting his neck collar and taunting them by knocking on the wall; (3) the queen collapsing, upside down, over a chair with mouth ajar, as her suitor falls out of the lower frame; (4) husband declaring victory to the door. In this film the rate of edits controls the pace of dying and leaves the sealed room before it is clear that the lovers have expired. To confirm the fatal ending, Griffith cuts to the king and does not return to the other room where the suitors lie crumpled. The cutaway seals the deal and stops parallel editing—that life force, that invisible finger that feels the absence of a pulse. The film registers death not only through the king's reaction but also, and more importantly, through the way the final shot cancels out further images, suggesting the end is ultimately not in the king's but the editor's hands.

The dying or imperiled body is not the emotional center of screen death, but the juxtaposition of that body with other moving figures that can touch it (or otherwise become aware of it, as in *The Sealed Room*) for us in a kind of synesthesia. To be sure, registration in actual experience involves mixing senses; detecting absent vitals combines sensory registers—what cannot be heard is rendered through sight, what cannot be seen through noise, what cannot be felt through sight and sound. Since melodrama is typified by the pathetic death, it is inviting to look at the corpse as constituting a text of muteness itself, a body whose final gesture is communicated by others.[43] It is not clear which body speaks muteness more loudly, though—the corpse's or the registrant's—and I tend to think of the embodied pain of the registrant as more impressive, or at least, more enduring. The search for peak points of stillness (death) brings into view the process that occupies the interim (dying), and vice versa. In many of the first fiction films we find the continuing habit of opting for some external means of screening the corpse, suggesting it was not as easy to "sate" the spectator as Sobchack suggests.[44] However you slice it, dying does not conclude without external registration.

That these early narrative deaths are confirmed by screen figures, sometimes in elaborate detail, underscores the general clarity between cause and effect that Griffith maintains through editing.

An inconclusive screen stasis points to an explicit response. Gilles Deleuze suggests that in Griffith movement leads to results, causes lead to effects, and interruptions are resolved to restore unity of the whole. Writing of the interrupting cut, Deleuze surmises: "It is the third aspect of montage, concurrent or convergent montage, which alternates the moments of two actions which will come back together again."[45] It might follow that death is just another response-generating action, no different from, say, walking offscreen right. But it is different: it halts narrative flow, arrests embodied movement, duplicates and repeats that arrest. Death is "about" cinematic cause and effect. To paraphrase Philippians, death passeth all understanding, and in diegetic film it pressures the boundaries of narrative vision, of what can be seen and known at or about the moment. Death reveals the energy released by the cut.

The corpse's stillness exceeds cinematic parameters. Once filmed as dead, there is no end to being dead. The frenzied movements around the corpse, however, remind us that the genealogy of the term *tableau* conjures up a mixture of movement and stillness. The word designates a still image tradition, an embodied pose onstage, and recreations of historical paintings, but it also refers to processional lines that connote familiar narrative movement, like certain sequences from the New Testament. Tableaux can likewise involve environmental mobility if staged outdoors. The tableau of grief constitutes an important moment in the development of American narrative film. The registrant that strikes or falls into a still pose recapitulates the corpse viewed, and this indicates not only a mobile stillness but also a *scene of death* in which the beholder becomes internalized. The registrant figure is not optional or supplemental; it is requisite. Without it death would not look the way it does onscreen.[46] What is more, the spectator identifies with that figure's spatial trajectory, so the spectator doubles the dying act, too, and comes to be located within the scene. This internality becomes even more pronounced when the registrant figure is not a human being at all, but an object, or plant, or piece of sky. As an example of this dispersed and disembodied registration, I must return to *The Country Doctor* once more for a fuller discussion.

POSTHUMOUS MOTION

We have seen that bodies and cuts can register, but so can objects, spaces, and landscapes, perhaps even more evocatively. A spectacular example of the landscape as registrant concludes *The Country Doctor*, one of Griffith's early masterpieces. This film seizes the techniques of composition, parallel editing, and tableau previously discussed, but since it moves beyond these techniques to a level of nonhuman abstraction, it deserves a special discussion of its own. The film concerns the story of Dr. Harcourt, a country physician whose daughter succumbs to diphtheria (a rather more realistic ailment than we have seen so far). Harcourt is called away to attend to another girl—poorer than his, not chaperoned by a father, and also fighting diphtheria. What might have been a contrast between Harcourt and his daughter through palliative cuts becomes a convergent story of two dying girls.

The film begins unusually with a pan right of a natural landscape ("the peaceful valley of Stillwater"), a shot that ends with the exterior of the Harcourt house. Through the front door exit the Harcourts (father, mother, and daughter) together. The pan is remarkable because it harks back to earlier attractions but here escorts the viewer into the story world by introducing the fictional characters. In the two shots that follow Griffith shows us the family in the bosom of nature, first obscured by tall weeds as the father's top hat bobs toward the camera, then emerging one by one nearer the camera as they enter into a sunlit field of daisies. The girl picks one for her mother. The intertitle "Little Edith is suddenly taken ill" introduces disease as a radical intrusion. We see Edith lying down horizontally across the frame in bed. Even without the intertitle the bright outdoor shots contrast markedly with the windowless interior of the family room. The cut is obtrusive, producing a bodily contrast that is as devastating as a failed rescue—to leave is to die a little, indeed.[47] Griffith's cut marks the celerity of disease.

Edith's bedridden status seems self-contained at first, her parents doing their best to tend to her. But knowing Griffith's interest in parallel stories, we suspect a relational outgrowth from this shot. This occurs with the development of the second story, cued by the intertitle

"meanwhile another child is taken ill" and a shot of the other interior, this one featuring another child laid horizontally across the frame, fighting the same disease. Behind the second child stand her mother and a nursemaid. The latter leaves the house for help: we see her first outside her own cabin, then approaching the Harcourts' now familiar front door. She pleads her case to the Harcourt maid. The doctor is at first unwilling but concedes, for "duty beckons him on." As the doctor joins the servant, Griffith cuts from the parlor to the front door (shot from a different position than the end of the earlier panoramic opening), then to an exterior shot of the second home, then finally to the interior shot of the second house. The contrast between the two interiors—one neat bourgeois family room and another more barren one—repeats the social divide that looms large throughout. The cutting between the two locales, especially the two exterior shots "in between" them (the two location shots of the homes), reinforces that they are spatially separated but not too far from one another, the distance between them still traversable (they are two shots/three cuts away). The spatial orientation structures the suspense as the doctor tries to tend to both girls, impossibly, at once.

The film hosts parallel dying with shots that alternate between two horizontal girls. Upon each image of one daughter is imprinted the condition of the other. The curative/palliative opposition becomes quite pronounced here, motivating the narrative and gathering power as their conditions change. In *Behind the Scenes* the mother is separated from her suffering daughter; here, in fact, two lives are in the balance, and two "dyings" are mutually unfolding. Each cutaway from Edith imperils her but might bring relief to the other child: palliative for one could be curative for the other. Time is a vicious factor: at one point, the doctor tells his maid that he will be five minutes more, and we can see Mrs. Harcourt mouth the words "five minutes" while reinforcing this with a handheld clock. The Harcourt maid is sent twice to retrieve the doctor. On her second trip she reaches out for him—she is standing screen left, while the equally desperate second mother holds the doctor's arm to his right, striking an oppositional tableau that visualizes his dilemma.

Harcourt's incision into the throat to unblock the passage restores the other girl's health; with hat in hand and "his duty fulfilled" he

exits to return home. Between the exterior shots of the houses Griffith places Edith's death shot. Its placement *between* the two homes (rather exactly) corroborates with the spatial continuity already established.[48] In this shot Gladys Eagan performs dying with incremental precision— she darts her unblinking gaze toward the upper right edge of the frame before collapsing back. Registration is likewise powerfully delivered: her mother's reaction lasts more than forty-five seconds and includes at least three stares vaguely toward the camera, plenty of hand clutching, pulling gestures aimed at the ceiling and walls (which have the amazing effect of drawing attention to the frame, as if grasping its edges and shaking them), and a hands-to-heaven gesture followed by a collapse over the corpse. Harcourt appears before the house's exterior and, once inside, bends down over Edith's body, which the mother has apparently moved into a customary position of the recumbent figure—the child is in a state of repose, with hands folded over her chest. Harcourt, of course, believes she is sleeping. When he feels her pulse, he freezes and stares vaguely toward the camera. Mother finally draws him to her bosom. This tableau struck by the family, both living and dead, contrasts with the mother's previous histrionic performance, and it brings all frantic movement to a quiet end (fig. 2.3). It also effectively absolves the father of any guilt; though he is too late, he will mourn together with his wife.

The film has stopped cutting and seems to be at rest. The inertia in this frame contrasts poignantly with the earlier parallel edits and the impending finitude of each cut. This would be a familiar melancholic ending if the film stopped with the tableau, but Griffith cuts instead to outside the house, now barren of exiting bodies, front door shut. This shot begins to pan left and reverses the opening one, which both introduced us to the characters and moved us from a stand-alone attraction to a piece of narrative. Returning to the semblance of that shot raises a surfeit of possible meanings.[49]

For one thing, its transition away from loss in order to remember a character qualifies this pan as a moving posthumous image, perhaps the first of its kind. As Jay Ruby explains, the nineteenth-century posthumous mourning portrait portrayed the dead infant or child as if alive, "with 'disguised' death symbols" such as "a willow tree in the

FIG 2.3 The deathbed tableau in *The Country Doctor* (D. W. Griffith, 1909).

background, or a wilted flower in the child's hand," although some paintings placed the figure in his or her former habitual environment, often the front lawn of the home.[50] The second pan joins two other traditions, one theatrical and one cinematic: the theatrical tableau for dramatic highlighting and the panoramic shot. Of course, the shot only evokes the tableau, for it is not still and does not figure embodied stillness. However, the very name of the valley—"Stillwater"—clinches the dilemma of cinema's momentum in death's aftermath. The lingered-over valley wants to play still, not only as a mnemonic for Edith but also as a reverberation of the stop induced by grief. It is a *moving stillness* (fig. 2.4). As a posthumous *moving* image, it departs from its theatrical, painterly, and photographic precedents to show an animate response to death, using cinematic flux to luxuriate in moving (on or away). Unlike the nineteenth-century posthumous painting that depicted the deceased as still alive in his or her former environment, Griffith's pan takes Edith out of the picture; but like this previous tradition the shot does bring a "disguised" death sign, the closed door, into the former scene of habitation.[51]

FIG 2.4 The end of the concluding pan of *The Country Doctor* (D. W. Griffith, 1909).

The last shot also recalls the important use of the pan to introduce spectators to the enacted death in *Execution of Czolgosz,* endorsing that film's claims to authenticity by combining the chair hoax with the actuality footage taken outside the prison and thus outside the body event.[52] Instead of reassuring the spectator of the camera's whereabouts, Griffith's pan turns to an image of nature for the purpose of pathos. This shot does not reassure us with a recognizable human form. Thus Griffith moves from the histrionic and verisimilar body performances of actors to the emotional resonance of a landscape emptied out of such performances. We have seen actors emote, gesture, and play still, but their drama is markedly contrasted with this final shot of human absence. The landscape unfurls through the narrator-editor's hands, but it does not contain embodied action.

The Country Doctor's repeated opening pan gives the film a classic circular aesthetic structure, what Gunning calls an "aria de capo."[53] Consider this three-part format: characters emerge from nature; one of them dies; they "return" to nature. Genesis 3:19 comes to mind:

"In the sweat of thy face shalt thou eat bread, till thou return unto the ground; for out of it wast thou taken: for dust thou art, and unto dust shalt thou return" (KJV). The common burial invocation also invites an element of hysteron proteron, effect leading the cause, thus challenging Deleuze's notion that causality remains untroubled in Griffith's cinema. The pan generates its response, the second shot, which makes room for a second cycle, another trip around. Circles repeat.[54] As Vertov understands in his later *Man with a Movie Camera* sequence that connects birth with a funeral procession, there is no clear beginning or end to cinema's vitality.[55] Here, the final gesture pictured marks a kind of continuation that exceeds any clear punctual moment.

To whose gaze can we ascribe this final shot? Recall how in *Behind the Scenes* the death shot drew attention to a figure outside the frame. In *The Sealed Room* we never "see" the death because it is registered in another room. Aptly titled, these films refer us to spaces with limited access as the places where dying occurs. What Scott Simmon has called Griffith's "death-haunted pan" belongs to the larger tradition of registering death for spectator knowledge, but it goes beyond registration by marking a time unclear in relation to the body.[56] This last trait counts as a fascinating part of the narrator system. The image belongs to the story tradition, to be sure, but it points to an order of shot relations that can be glimpsed beyond, or behind, the story. Edith's death is marked not on her body but as visible difference within the fictional environment. Only the spectator has eyes for this earlier image, so its repetition nearly directly addresses his or her own experience of the film—it emanates from outside the place-holding bodies. We can ascribe this image to an omniscient beholder more freely than the scene of registration. On the one hand, the circle intimates repetition and transcendence; on the other, the pan shows the mark death makes in the diegesis.

It may seem like a spectacular case, but posthumous motion, whether shot from a moving or static camera, has become a staple for the movie death scene. What I call posthumous motion may be defined as the use of the cutaway to another image—usually one that reframes the body or else infuses part of the environment—to extend the scene

after the death moment has apparently occurred, that is, after registration. Whether or not the camera is itself moving, the image is. Prolonging the scene to wait for a shot of diegetic change becomes a common convention in movies because it allows a character's death to conjoin characters, other lines of action, and even other locales, making good on the medium's visible flux for purposes of expiration. Seen in various forms throughout American film history, the posthumous shot has become one of the more interpretive shots in genre films, often indicating the solemn passage of time—medium close-ups of flowers or shots of wreaths (*The Magnificent Ambersons*), low-angle shots of the sky or trees (*How Green Was My Valley*), and funeral processions come to mind. If death evades focused cinematic concentration, then this supplemental release of energy, this slow and consequential expiration of screen focus, becomes an essential element. Even freeze-frame images of bodies frozen just before the fatal moment—in films such as *Butch Cassidy and the Sundance Kid*, for example, or *Thelma and Louise*, or even *Gimme Shelter!*—recall the tableau's rigid but still-moving energy.[57] The freeze-frame is indebted to the tableau as much as is posthumous motion.

This is certainly not the only time Griffith would explore shots in which the body is out of sight in order to trace death's environmental traces. In *The Sands of Dee* (1912) a seaside-dwelling farmer's daughter falls for a painter who dumps her when his wife reappears, and she flees to the sea after her disciplinary father kicks her out of the home. In the final shots Griffith stages her exit from the film as a visible recess into the medium shots of the sea, taken from the shore. First, she is running across the frame and sea vista, then, she is lying immobile on a rock while waves crash about. A piece of clothing is left behind and picked up by a worried former suitor. He runs after her, but the following shot is of the water only, lapping the shore. This nonfigural image is followed by text inspired by Charles Kingsley's eponymous poem: "The creeping tide came up the sand, and o'er and o'er the sand, and round and round the sand, and never home came she."[58] Cut briefly to a body washing ashore, back home to worried parents, then back to her rescuer who is dragging her body out of the tide and into her parents' arms. The four bodies form a tableau by the water while Mary's

arm dangles buoyantly in the middle. This ends the shot, but the scene is unfinished. Two boatmen who "hear her call the cattle home across the sands of Dee" stand peering offscreen right at the sea. The reverse extreme long shot depicts a white-clad female figure on rocks gesturing to her mouth. The angle at which the boatmen look runs opposite to previous angles at the sea and at Mary, suggesting that the reverse-shot redirects the film's action.

Different types of posthumous motion produce different affects. There are instances, for example in *The Country Doctor*, in which the concluding shot echoes previous images. Posthumous motion as a repetitive trope can be categorized into roughly three types. Griffith's last image rhymes with the first but is *not* that image and is not meant to "revive" it. Let us call this *renewal*. Griffith's *A Corner in Wheat* returns to the image of a wheat field after the Wheat King's death, but the second time we see a lone farmer framed in the distance rather than several. Thus, it renews that image after an important death, echoing the composition of Millet's painting *The Sower*.[59] *The Country Doctor* adds a variation in that it introduces the idea of reversal, not just repetition. Second, there is the shot or shots that revert back to film images from earlier in the story, that is, extracting and replaying them. The image repeated posthumously may include the person who has now departed. Let us call this image *posthumous replay*; such an image may or may not provide a clear loop that ties end to beginning.[60] Replay intimates hysteron proteron generally, but images may specifically echo or repeat the movements, words, or images of absent ones. A third category involves repetition with a difference—a shot that seems diegetic but is not exactly what we saw. The final images in John Ford's *How Green Was My Valley* (1941) are exemplary: on the death of the young protagonist's father, Ford first recycles images from earlier in the film (as replay) but concludes with images we have *not* previously seen—for example, an image of father and son walking on a hilltop away from the camera. We might call this the *retrofit replay*—retrofitted, that is, to produce closure in someone's absence. All three types are employed in a posthumous shadow. This imagery stages our last encounter outside the body, beyond beholders, to provide a kind of confirmation that no

diegetic character is capable of performing—leaning on transcendence, repetitive posthumous motion tends to frame death within a higher order of important instants, reviving earlier ones or recuperating lost ones.

That "higher order" wants illumination. Death in *The Country Doctor* is prior to the concluding pan and generates it, which means the entire structure of the film deals with Edith's death. This film allows us to see the significance of a shot's relation to the whole. Merleau-Ponty's notion of the psychology of film perception comes to mind, especially his point that the phenomenology of perception is holistic, supported by what is not seen or immanent in the current cognitive act. "The objects behind my back," he writes, "are present, they count for me, just as the ground which I do not see continues nonetheless to be present beneath the figure which partially hides it." Merleau-Ponty appreciates both the frame's inner relations and the selection of what to show and what to hide, valorizing film's melodic structure, the "tempo of the narrative," and the "choice of perspectives." The movie signifies itself as a whole consisting of parts relating to one another; thus its meaning cannot be glimpsed by isolating one shot, nor can the whole be perceived at any one moment. Each image remains open to the influence of the whole system, creating "not a sum total of images but a temporal *gestalt*."[61] *The Country Doctor*'s final image reveals an emptiness lurking behind the fullness of the first. Griffith suggests death changes the diegetic whole.

Concluding the film with a shot renewed also underscores the traditional attempt to find the right mnemonic for commemoration. As a posthumous memory image, the pan reminds us of the creation of mnemonic placeholders in the ancient art of memory, as Frances Yates has explained.[62] In the surviving Roman text on memory known as the *Rhetorica ad Herennium*, an anonymous speaker instructs the rhetor on how to memorize speeches by placing words and phrases within a specific place, such as a house, with different loci, such as doorways. Deposited at the loci, they can later be retrieved by the speaker in various orders. Here, Edith, or perhaps the entire Harcourt family, is deposited in the landscape so that they might be remembered in their absence. The film offers its own

memory image of the Harcourts, returning to their "origins." When it externalizes or disembodies death within space, and particularly as it repeats and alters sections of a movie in a commemorative act, posthumous motion moves film in a direction different from rapid visible change. Its serenity, at least to me, does not invoke Siegfried Kracauer's "blizzard of photographs," that conveyor belt of views that allows for no introspection.[63]

Although the pan functions as a mnemonic, it also has the extraordinary characteristic of representing a moment of perception beyond that enjoyed by the screen human, for no one in the film sees or appears in this shot. We do not know how much time has transpired between the final two images. The pan visualizes time's end as unfurling, stretching over time and space. It is hard not to connect the steady unraveling of this pan shot to more contemporary images. As it scans an image to derive human absence, the movie, we might say, "flatlines." That is, it produces the lull of absence's uninterrupted output, similar to the hospital monitor's repeating scan of absent bodily activity. This pan's out-of-body technique echoes the EKG's readout (the earliest form of the EKG appeared six years before this film), and it anticipates the now-familiar flatline on a hospital monitor. We may read this final shot "thematically," as an element of poetic naturalism. It may also be a statement about the relationship between human beings and the natural world, the fact that we may not be at the center of vibrant life. And finally, it can be read as a further exploration of the interplay between affective experience and machine precision. (Might it also be an invitation to reconsider the flatline as itself evocative?) The flatline as we know it—a graphic expression of absence *over time*—entered public discourse in the form of a movie.

STILL DYING

Throughout the silent era the slide to inertia remains the strategy for visualizing quiet deaths, and editing and registration remain the focus. But filmmakers continue to explore space, physical objects, diegetic

change, and other forms of posthumous motion. Arthur Dimmesdale's death in Victor Sjöström's *The Scarlet Letter* (1926) is nothing short of spectacular. Again, Lillian Gish carries the registrant role, holding Lars Hanson close to her as he performs Dimmesdale's death. In a medium close-up Gish's left arm bolsters Hanson; behind them we can see the unfocused presence of the crowd of town gawkers. She kisses him but recoils, flashing open her eyes. Some twenty-seven seconds later she visibly yells his name, producing a long pause that brings her face to the center of the frame. When a water pale is brought in to revive him, she utters: "It's too late. He's dead." Two shots later, she turns to face Arthur in her arms. In the next shot facing out from the platform, the crowd forms a visual mnemonic, as first one, and then all the men slowly take off their hats and bow their heads. The sea of rustling hats turns its tide to stillness, again. Gish stares up and out of frame, an image that overlaps with the final one: an extreme long shot from the crowd's perspective of the platform, a formal diversion that marks visible diegetic change in the fabric of the images. Arthur's death is registered by the crowd as they fill the final frame and absorb his body; this crowd returns us, of course, to the social injustice that has killed him (figs. 2.5, 2.6).

Also, in the last several shots of F. W. Murnau's *Tabu* (1931) Matahi desperately attempts to swim back to Hitu's boat as it sails away with his beloved Reri. Matahi's body weakens in its strokes and gradually descends below the water's surface, a bobbing that reads as dying. Rather than picturing an isolated drowning, these shots of the swimming lover are intercut with images of the receding boat on the open sea, establishing a silent discourse between the two. Matahi is swimming toward the camera with no framed land, suggesting he is being watched from, or "by," the boat. Finally he sinks lifelessly below the surface until he is not visible in the frame. Following the logic of this shot/reverse-shot, we expect his last gesture to be returned by the triumphant boat as registrant. But in fact, two more images return the missing gaze showing crashing waves of a bodiless sea. The film's title then appears as if out of the current. Hitu's boat cannot register because it is retreating from the seashore; as an image, it occupies a

FIG 2.5 The crowd gathers in front of Arthur and Hester in *The Scarlet Letter* (Victor Sjöström, 1926).

FIG 2.6 A sea of removed hats in *The Scarlet Letter* (Victor Sjöström, 1926).

place only visible from land. It moves *away*. In its place images of the sea absented of bodies wash over the protagonist.

But if I earlier focused on *The Country Doctor*, it is because it strikes me as more than just exemplary. Gunning writes of the final shot: "The closed door, the empty landscape, become signifiers of death, more powerful than actress Florence Lawrence's histrionic collapse or Egan's staring *rigor mortis*." It is a clear moment of disembodiment: "Griffith has discovered the power of a cinematic gesture and structure to express emotion, beyond the actor's craft."[64] As Bazin would tell us, nonbodily signs instruct that we may not be prioritized by the cosmology animated by the movie camera. Bazin introduces the idea of the camera as a "non-living agent," unique in the history of arts in the fact of its mechanical functioning. The "objectif" of the camera lens inserts a nonhuman eye into the world.[65] Accordingly, it picks up traces of the environment rather than centering on the individual. We do get a sense of the world and its rhythms around death—perhaps not the "right" ones but influential ones nonetheless. Griffith organizes time around the body, but he also looks past the clock, responding to death as more than a punctual appointment. Bazin's distinction between directors interested in "image" and "reality" is important here, even if it becomes more complex. The environmental traces, the cascades of registration, and the spatial dispersal of diegetic difference might be considered elements of the "reality" tradition, yet we have seen that they are born of editing, suggesting that Bazin's implicit distinction between a mechanical and a human recorder may not always be clearly demarcated. What a machine sees, an embodied gazer can read. The give-and-take between machine and human is certainly still part of end-of-life care: although technology increasingly times death, humans (doctors, family members, intimates) still want to put on the final touches. Editing technique makes death more legible by giving the spectator some sense of command over time, but the slowness and flux of registration submits human process to machine precision. The fact that a machine—the camera—provides this registration, or makes it possible, reminds us that humans can use machines to augment their conceptions of what death might be.

As for the possibility that some 1909 spectators were moved to tears—a suggestion Gunning raises in his essay on the film—we can now try to understand the formal dimension of this affect. In his essay "Melodrama and Tears" Steve Neale looks closely at film's "ability to *move* its spectators and in particular to make them cry." He begins with Franco Moretti's work on boys' literature in which, as Moretti explains, "particularly moving moments" result from "a structure in which the point of view of one of the characters comes to coincide with the point of view of the reader as established by the narrative."[66] Another way to see Mrs. Bailey's false eyeline match in *Behind the Scenes*—the "palliative" cut—is an occasion for her later view to match our foreknowledge. Moretti acknowledges the issue of timing in his model of two subjects coinciding, but Neale takes up timing more extensively. Film is especially equipped to move, in two senses— it moves as a facet of its own duration, and it times the melodramatic recognition of "too late" accordingly.

Unlike Moretti, who sees the death of a character as proof "that time is irreversible" and thus as the narrative occasion par excellence that marks the permanence of the past, Neale prefers to say that tears can be triggered by less permanent events: "Tears can come whether the coincidence comes too late or just in time, provided there is a delay, and the possibility, therefore, that it *may* be too late."[67] Neale reminds us that we can cry tears of joy and sadness, sometimes at the same time. Spectators are positioned to wish "if only," says Neale, yet "these narratives themselves do not fully account for the existence or nature of the wish. They construct a position from which to wish, but not the wish itself."[68] Linda Williams echoes this claim when she acknowledges that body genres are able to "address" but "never *really* to 'solve'" their attendant problems.[69] Mortality is not a problem that can be solved.

But death places limits on the moving image as a sign of vitality. It is the substrate for all agnition onscreen. Evoking the "loss of union of mother and child," Neale makes the more uncomfortable point that "separation and loss have always already occurred" for all of us.[70] One need not think only of birth to agree with this point. If Neale is right, and ultimate conciliation always comes too late, then the pan

that terminates *The Country Doctor* cements the lost chance to return to origins while cutting us off from Little Edith. Thus too-lateness can describe the temporality of the cinematic apparatus as it tries to encounter the end of life *in time*. Were it not already too late, cinema would presumably not keep trying to pull it off.

The point is that if the pan concluding *The Country Doctor* represents death more powerfully than the body event, it is partly because it tells us something about cinema's relationship to mortality that the body does not. Griffith's camera searched the theater of nature to redeem the paucity of visible death signs. It looks as though cinema were trying to externalize the absence of vital signs—the heart's silence and the pulse's stillness, for example. Cinema was making death visible in new ways because of its own inadequacy as a registrant. Premodern techniques of registration are met with cinematic techniques of repetition and dispersal.

What I am suggesting is that narrative death urged cinema to explore space, to let go more slowly, to luxuriate in the process of expiration. Biograph films develop a basic grammar of the death scene in two ways: by juxtaposing motion with stillness (tableau, objects) and by inserting the posthumous shot that begins as a cross-back to a previous location but becomes an expression of space. Fictional films produce death at least "twice" to compensate for a moment that hurries past us and cannot be inhabited, no more on the screen than in real life. Griffith found and exploited a mobile sign as one of cinema's great gifts to the repository of death imagery.

The second person, the beholder or registrant, does the work of responding to the dead body as an inert object of the gaze. We are thus brought into the fatal scene; we have a place to go within the final tableau. And we are often taken there by someone intimately related to the deceased, by love or by blood. The screen beholder naturalizes the corpse by feeling, hearing, or attending to the lack of vital signs. We, the audience, cannot attend to them because we cannot feel the absence of a pulse. Neither can the camera, for that matter. But the movie screen gives us a sense of the dramatic loss of a pulse through the attenuated rhythms of editing. Posthumous motion does not end cinema's search for mobile death signs outside the body. Two decades

after *The Country Doctor*, synchronized sound enters Hollywood film production, and when it does, it immediately inspires nonbodily death signs. Synchronization itself functions to disconnect the living observer from the critical body. It is therefore to the early sound film that we turn next.

3

ECHO AND HUM

DEATH'S ACOUSTIC SPACE
IN THE EARLY SOUND FILM

At the end his suffering eyes filled the screen, the sound of
incoming water grew deafening, up swelled that strange '30's
movie music with the massive sax section, in faded the legend
THE END.

—THOMAS PYNCHON, *THE CRYING OF LOT 49*

For the ear is precisely that organ which opens onto the interior
reality of the individual—not exactly unseeable, but unknowable
within the guarantee of the purely visible.

—MARY ANN DOANE

IN A December 2002 *British Medical Journal* article a number
of doctors, clinicians, and bioethicists were asked to nominate music
they would play while facing their final moments. "People say that
birth and death are lonely events," write the editors. But "music can be
a birth or death companion piece."[1] Choices in the study range from
the predictably classical (Rachmaninoff and Handel) to the unortho-
dox (Velvet Underground and Nico's "Heroin"). Imagining a terminal
playlist is an exercise in fantasy that suggests an intimate connection
between melos and dying. Funerals, of course, have long been musical
events and are frequently personalized through song. In a scene from

High Fidelity (2000) a record-store owner, Rob (John Cusack), lists three songs he'd play at his funeral, adding this to a series of similar "Top-Five" lists of different ranked categories (breakup songs; side one, track ones; etc.). But music can be projected into the before and after. Those questioned in the medical journal were asked to score their future deaths as observers, underscoring Freud's point that we cannot imagine our own deaths, that we are mere spectators—or auditors—at best.[2] The soundtrack's musical theme has certainly become a standard presence in the Hollywood deathwatch. Figures perish to nondiegetic music, and it is a custom to certify death has happened with the soundtrack. Soft accompaniment of strings, for instance, tells us about the fallen and immobile soldier; a thunderous drone triggers the shocked discovery of a horror corpse. What is cued in these scenes, in fact, is what I have been calling registration: the onscreen beholder begins a process of comprehension as if following the soundtrack's lead. In well-attended dyings, music envelops the body at its threshold, too, so that death appears a little less "lonely." The watcher (on the screen, in the audience) is brought closer to the terminal sign—closer, not to its visible evidence, but to a kind of aural symbol.

What appears conventional to us now—the nondiegetic soundtrack as registrant—was not the norm established early on by the talking film. It would seem the microphone would present filmmakers with another on/off device with which to organize the instantaneous impression of life/death. In theory the sound camera can capture the last audible breath or spoken utterance, and it can produce the medial equivalent of such a stop. The body has an acoustic "off" switch, and the continuity of sound can be suddenly muted. But, once again, the theory of an instant does not translate well to screen practice: final words are reinforced by the slide to bodily inertia, and sudden silence leaves an echo. This is certainly not to suggest that music did not accompany silent film deaths. But it is important to listen closely to the source of a sound that is often understood by the films themselves as coming from the world onscreen. The audible intensity of certain deaths in the early period of Hollywood's transition to sound (1927–31) suggests that filmmakers were trying to figure out where to place the microphone within the scene of dying. Rather than synchronize

the body with its terminal sounds, early films experimented with a range of techniques of disembodiment, placing the origins of sound outside the body. Many early sound films define death as the *lack* of synchronization between sound and image, and this lack unfolds over time, much like the body's stillness in earlier silent films.

This chapter listens to disembodied death sounds in the transitional period. Though Béla Balázs would famously bemoan the sound film as "speaking photographed theatre" interested only in synchronized speech, early sound films often explored gaps between sound and image.[3] Several filmmakers resisted sound's encroachment on the art of silent cinema, and some worked through the microphone's potential as a new sensory instrument for the death sign. This is perhaps not surprising. Because cameras and early microphones were bulky to use, many films appear slow or static, characteristics I have ascribed to the deathwatch.[4] And film sound has often been described as less concrete, less locatable than the image and more conniving in its impact. Mary Ann Doane suggests "the ineffable, intangible quality of sound . . . requires that it be placed on the side of the emotional or the intuitive," rather than on the side of knowledge, culturally and cinematically linked to vision.[5] True to form, the soundtrack extends the emotional range of the death scene beyond the duties formerly performed by the silent film registrant. It evokes what cannot be seen at a moment when vision breaks down, comes up short, or otherwise lacks precision. It draws our attention to the world outside the image, and there it supplants the registrant's tactile and bodily response. Persistent sound takes on the former role of parallel editing to articulate relations between otherwise noncontiguous spaces. Supplementing vision, the soundtrack binds spaces, emerging as if *between* them, changing the spectator's reliance on outer forms as the sole media for death. As a companion piece, the acoustic context alters the mood of the scene by participating in the erosion of that slash between Life/Death.

Let us continue, then, to uncover the cinematic image from its connotations of immortality and resurrection. Now we do so by listening more carefully to recorded voices and sounds. Invariably in this we invoke Edison's early wax cylinder recordings of human speech that inculcated the impression of the phonograph as itself a "speaker."[6]

The disembodied voice has an important role to play in ending life onscreen. I turn now to consider the microphone as a death technology. Not only *seeing* dying, in this chapter we will be *hearing* dying, but what we hear does not emanate from the screen body but rather from the external space surrounding it. In a move that introduces a new temporality, the sonic aftermath (that is, the musical or vocal registration) is synchronized with the death moment itself. Offscreen sounds of singing, talking, and crying registrants pave the way for Hollywood convention; nondiegetic music will later be placed where diegetic sound was at first, and once there, it will cue registration. What later goes unnoticed is hereby brought to the foreground. The soundtrack continues the course of silent film's production of death through disembodiment, repetition, and posthumous motion, but it also changes the fundamental *flow* of the deathwatch.

SONIC GLUE

Always troubling, "firsts" are illuminating even if what they introduce is a projection back from the future. We can see, and hear, something new in the long dying scene found in Alan Crosland's *The Jazz Singer*, the first feature-length, part-talking film and the first to use diegetic sound to terminate life. Its story concerns Jakie Rabinowitz's dilemma between pursuing his own career as a Broadway performer and following his Jewish father's footsteps as a cantor—a dilemma intensified by his father, who demands that he choose. Moments before the opening of his stage debut, Jakie is confronted at home by a family friend, Moisha Yudelson, who begs him to sing as a cantor, in place of his dying father, in the synagogue adjacent to the cantor's sickbed. A window in the bedroom bridges the two spaces. Singing will spread "sunshine," Moisha insists; it might restore his father's health. Jakie's girlfriend, Mary Dale, a coperformer responsible for his big break, is present. Standing by also are Yudelson; Jakie's mother (the cantor's wife), Sara; and the show's producer. This gallery of witnesses later attends to the dying cantor when Jakie is absent from the room.

All present know that Jakie performs his stage act in blackface; only his father in the next room presumably does not. Much has been written in the last couple of decades on *The Jazz Singer*'s extraordinary racial and ethnic dimensions, but my interest here lies in another matter.[7] The film's use of offscreen music at the dying moment marks a number of conversions in the film that have not yet been placed in relation to the death scene, one of which is Jakie's return to the religious music of his upbringing. When Yudelson confronts him, Jakie is torn, looking desperately from Mary Dale and the producer (who in intertitle says, "You'll queer yourself on Broadway, Jack; you'll never get another job") on his left to his pleading mother (again in intertitle: "If you sing and God is not in your voice, your father will know") on his right. Back and forth, the film cuts accordingly. This dilemma seems more like a litmus test of Jakie's godliness than of his fidelity to his earthly father. But before this moment of indecision the break between father and son has developed in a pair of scenes in which the offscreen music of the synagogue is heard within the apartment. When offscreen music returns in the death scene, it echoes these previous scenes of separation.

Earlier, when Jakie is a kid singing with a club pianist, Yudelson spots him and reports this injunction to the cantor, who arrives to snatch Jakie away from his performance. At home he spanks him offscreen after the child insists that if he is whipped, he will run away for good. Leave he does. At this moment the light inside the synagogue is turned on, as seen through the apartment window, illuminating the window and its Star of David. At the Yom Kippur service across the way, the cantor leads the Kol Nidre, the song of prayer for forgiveness performed on the Day of Atonement. While mother and father worship, Jakie reenters the house. His movements are accompanied by the sound of the prayer song; his father's voice emanates from the synagogue offscreen. As he moves through the darkness lit by the adjacent window, his gaze rests on a photograph of his mother that he picks up. The film cuts again to his father singing, and then to his mother crying "underneath" the song, fearing she will permanently lose her son. The use of offscreen, or asynchronous, sound reinforces Jakie's separation from his father and his mother's private grief. Despite the cantor's

recent interdiction on modern music, the song binds the father's off-screen voice to the son's onscreen figure through a technical arrangement. We hear the union between two characters in separate places when we cannot spot it in the image.[8]

In a famous scene occurring later, the up-and-coming "Jack Robin" returns home to New York for a chance at a Broadway career. Sitting his mother down, he sings "Blue Skies," accompanying himself on piano, first a midtempo, then a faster and more syncopated version. Arriving home, his father enters and interrupts the performance, silencing the voice and shutting off the sound with the shouted command "Stop!" Live sound disappears, and the film resumes silently. The father's power to kill Jakie's live voice has been plentifully observed.[9] In his important work on the film's use of blackface, Michael Rogin reads this moment ruefully in the Oedipal context of the son's eventual replacement of the silent film father: "Jack's father may have the power to stop speech in this film, but it will cost him and silent movies their lives."[10] The two men have an argument they could not have had earlier, when Jakie was a boy. Jack insists jazz is the voice of God but fails to convince his father, leading to a second and more severe reprimand: this time, he must leave home and never come back.

These scenes illustrate the cantor's association with both musical types (secular, religious) and prepare us for his sonic departure from the film. The cantor is also the first to sing when he is not onscreen, audibly reminding the audience (and Jakie) of the son's musical roots. Whether Jakie registers this influence is not clear, but the cutting between apartment and synagogue certifies that the voice is not enacting a sound bridge, joining two impossibly contiguous spaces. It is the actual singing voice next door that pervades the apartment.

The power of the cantor's voice to fill the adjacent room with his presence evokes, and complicates, Michel Chion's notion of the "acousmatic" voice, or the "acousmêtre"—the voice, that is, that speaks (or sings, in this case) but whose source is momentarily offscreen and not seen by the spectator in the moment of projection. This mismatch creates a moment of perception "in which we don't see the person we hear, as his voice comes from the center of the image, the same source of all the film's other sounds." The acousmatic voice builds

to particular effects in film; in fact, Chion claims it is "the cinema's invention."[11] Chion usefully distinguishes between "complete" and "partial" acousmêtres. The former is the more hard-core version, the voice whose origin is held in suspense from the viewer for the majority of the film and produces a long buildup to potential revelation, as in the screen wizard's booming voice in *The Wizard of Oz*. The partial acousmêtre, soft-core by contrast, has only momentarily lost its bodily source and is closer to the more common term "voice-off." He explains: "The already visualized acousmêtre, the one temporarily absent from the picture, is more familiar and reassuring."[12] In keeping with Chion's distinction, the cantor's voice is clearly more of a partial acousmêtre: its source is locatable in the room across the alley, but it is nonetheless a voice that fills the image, as if emerging from its "center."[13] It is in two places, and thus not fully in either place, at once. The momentarily offscreen voice "can acquire by contagion" the complete acousmêtre's godlike powers of ubiquity, panopticism, omniscience, and omnipotence. When the source of the voice is revealed (for example, when Toto snags the curtain aside to reveal the mortal man at the wizard's mouthpiece), these powers dissolve. The effect of the singing voice "that wander[s] the surface of the screen" to guide our attention to the world unseen inspires Cantor Rabinowitz's passing, all the more compelling given it comes so soon in the transitional period.[14] Another acousmatic power, dimly outlined at this moment, has something to do with the funerary dirge.

In fact, the overlap of one man's voice with another's body is repeated, roles reversed, during the cantor's dying. Jakie manages to make it back home in time to share intimate shot/reverse-shots with his father. The older man says (in intertitle), "My son, I love you," and touches his face with a trembling hand, the first and last such gesture. Jakie decides to sing the Kol Nidre, but we don't see him make the decision: a cut intervenes first, taking us to the stage where his premiere has been canceled. Cutting back to the cantor's bedroom, we find out why. The first shot contains the four figures arranged in a tableau: father lying horizontal on the right, mother standing behind the bed and over him, Miss Dale standing by the window, and Yudelson sitting far left at the end of the bed. No one moves at first in the frame.

This stasis feels suddenly strange because, emerging from the "center" of the image, Jakie's voice begins the song of atonement. The effect of this tableau, then, is a pause to *listen*. If we count from here, the death scene consists of twenty-three shots, but breaking down the scene into parts fails to capture the soundtrack's continuous flow, which is crucial for understanding the visible impressions of death.

Jakie's out-of-sight voice leads the Kol Nidre that floods the tableau. After Miss Dale walks to the window, a couple of two-shots of the parents follow. In the second the father's face shines with recognition of Jakie's voice and what he takes to be its signal of religious and familial fidelity. A few images later, we see a long shot from inside the synagogue of Jakie singing in a position occupied previously by his father; two images later, a cut-in to a medium shot demonstrates that his lips are synchronized with the song we hear. Lips and sound are previously *not* synchronized in this same sequence, which is why we notice *this* synchronization. (Alan Crosland, the film's director, lacked access to postsynchronization, a device we will consider later.) As if cued by the audiovisual match, the film returns to the father in bed, who stares up and beyond the top of the frame as Sara looks on. Three more shots of window or synagogue follow, and then the father (in intertitle): "Mama, we have our son again" (fig. 3.1). Crosland cuts back for his body throes and the reaction of the mother. His slide to inertia occurs in two steps: he calmly closes his eyes as if entering sleep, and he tilts his head back. Sara at first holds him. A return to the establishing tableau witnesses Sara's histrionic hands-to-heaven gesture and her collapse onto the dead body—movements familiar to us from Griffith's melodramas. Invoking the language of melodrama's temporality, Linda Williams writes that Jakie sings "just 'in time' to make his father die happy but 'too late' to save him from death."[15] I want to emphasize the music associated with the "happy" dying man.

At first glance, this appears a silent film death with music simply played over it.[16] The registrant's repetition of the cantor's apparent death does not end the scene, any more than it did in our earlier silent scenes that employed posthumous reframings or pans to lament a loss through spatial dispersal. But here the song supplies that residual effect, bringing the camera to it. Promptly we cut back to Jakie singing

FIG 3.1 Cantor Rabinowitz recognizes his son's offscreen voice in *The Jazz Singer* (Al Jolson/Alan Crosland, 1927).

in the church and then to male members of the congregation. The song goes on. Miss Dale makes the point of these shots clearer: "A jazz singer, singing to his God." The image of Jakie's Jewish congregation recalls the earlier comparison he made between his father's and his own audiences. He really gets into things during the Kol Nidre's finale, improvising gestures that have been read as an incorporation of his "jazz" side with his Jewish sound. Williams in fact argues that the music in the film synthesizes two ethnic musical expressions.[17] Improvising passionately, Jakie neither knows nor seems prescient of his father's death having just occurred, a point that deserves more consideration (fig. 3.2).

The fact is that an important registrant—perhaps the most important—never appears in the death shot. Jakie is absent from the tableau, but his voice is present, breaking from convention. The silent film often organized the speed of dying through crosscuts between the body event and the (would-be) registrant. In *The Jazz Singer*, activity

FIG 3.2 Extemporizing arm gestures of rapture in *The Jazz Singer* (Al Jolson/ Alan Crosland, 1927).

inside the scene—that of singing and listening—becomes the focal point. In light of the son's paternally condemned syncopations within the plot, we should note that rhythm seems less important to the scene than duration. The father's death moment, after all, is placed within the context of images that run together along a single thread of time—strung together by "live" singing—rather than a synthetic time construed through edits. Griffith placed the death moment within a higher order of shots, allowing the spectator to arrive at certainty when a survivor found the body. Here, a religious song provides that "higher order." It is Jakie's singing that orchestrates our visual attention, stitching together synchronized and asynchronous sound images, bridging bedroom and synagogue, father and son.

This doubling of the voice makes quite a difference, and two of Chion's insights help us grasp its effects. The first has to do with the soundtrack's usual privileging of the voice over all other sounds. In the hierarchy of film sound, says Chion, the voice comes out on top.

Chion's acousmatic voice is almost exclusively a talking voice. That we are talking about a *singing* voice, though, only buttresses his claim: in this novel part-talkie the voice functions as a musical sign of synchronization within the diegesis and its use opens up a perceptual ambiguity in the shot. The second evocative point is Chion's designation of the acousmatic voice's origins in partial places—"neither entirely inside nor clearly outside" the image.[18] "Inside" the image of the cantor's tableau, voices make no şound: the figures register and pose as in a silent film. But "outside" this same image, Jakie is singing in the synagogue in a reprisal of his father's teachings. Any attempt to find a formal break in vitality is swallowed up by a second cinematic signifier—the song. While the father is onscreen passing from life, his son's voice is passing from one building to the next. The Kol Nidre makes present Jack's religious feeling at the moment the cantor slides to inertia, reassuring the older man that it is time to let go. The scene synchronizes the visible death sign with the ear—both our ear and the cantor's.

One consequence of the song's flow between rooms is that Jakie's voice *outlasts* the onscreen registration in the bedroom, where concerned parties are gathered. It does not turn "off." Exceeding the image, the voice, instead of the registrant's touch, confirms the final impression. Jakie's melody replaces the body and the registrant. Of course, singing can be heard and filmed outside the body, so it exceeds the body's limits. Thus, the Kol Nidre begins "on time" for the cantor to hear it and proceeds into the domain of posthumous motion. The song encourages the camera to mark finality within diegetic space and outside the body.

But, at the same time, it feels odd to call Jack a registrant: he does not "see" or react to what happens in the bedroom. In fact, he seems to conjure the corpse's replacement—a spirit version of the cantor appears behind him to mutely acknowledge the son's deliverance. Where is the center, and when is the peak, of the cantor's screen death? Jakie registers by overwhelming the scene, absorbing the impact of what happens in the bedroom across the alley. Because it can travel through space, says Doane, "the voice has a greater command over space than the look—one can hear around corners, through walls."[19]

Singing, in fact, replaces here the melodramatic specialty of lamenting over the dead body, an act that would seem to encapsulate melodrama's temporality of "too late." This song reaches the dying man's sensorium, however. The film acknowledges the age-old practice of singing dirges, hymns, or lamentations at or after death moments. As another fold in its synchronization project, *The Jazz Singer* reconfigures the funereal temporality that basks in "too late." Here the dirge is "on time."[20]

Considering too that dying previously piqued the imagination as something the camera could not finish without people's reactions, it should not surprise us that the soundtrack was seized as further useful for the task. Here we see a "good death" accompanied by the "live" voice enveloping it, as if a well-attended dying requires lively participation on the part of the cinematic signifier. Onscreen singing affords a vital presence that was by definition remote to silent cinema's inherent muteness.[21] And onscreen *heard* sound also brings our attention to the acoustic environment inside the scene. Balázs, for one, championed the sound film's potential discovery of our acoustic environment: "The meaning of a floor-board creaking in a deserted room, a bullet whistling past our ear, the death-watch beetle ticking in old furniture and the forest spring tinkling over the stones. Sensitive lyrical poets always could hear these significant sounds of life and describe them in words. It is for the sound film to let them speak to us more directly from the screen."[22]

The conversation between film and spectator ("speak to us") opens up a secret world of unheard presence. Balázs's examples hover around an animate source of life that lies dormant because isolated from the perceiver, unheard because solitary with respect to the human observer. It stands to reason that Balázs sensed that the important death sounds to be discovered would emerge from *around* and not *in* the body when he wrote of the "death-watch beetle" in the "furniture." Gathering environmental traces, the sound film can stage death without placing its sole focus on the sickbed tableau. Indeed, it can place death within more than one location. (This multiple placement was done in the silent film, but not simultaneously.) *The Jazz Singer*'s offscreen singing creates the impression that he who is absent (Jakie) "sees" death.

The added presence of what cannot be seen expands on the medium's temporal dilation of dying. Borrowing again from Williams's dialectic of melodrama, I would say the Kol Nidre's "live" spatial dynamic in turn changed "too late" into "on time." Crosland completes the death scene outside the body, not with Sara's registration but with Jakie's conclusion of the Kol Nidre—all the more striking considering that Sampson Raphaelson's 1925 stage version of *The Jazz Singer* had Jakie sing the Kol Nidre offstage for his "already-dead father."[23]

But we must return to the racial dimension of Jakie's live performances in the film, and his appearance in blackface in the very next scene, to understand the use of this evocative song. Singing absolves his own guilt over causing (perhaps even wanting) his father's death. Clothed in a cantor's skullcap and robe, he becomes the center of attention, and his performance ends the scene. It is Jakie whom we see last before the elliptical fade-out, and it is his blackface performance (the only one in the film performed onstage) of "My Mammy" for his own seated mother that follows quickly and resumes narrative focus. The film substitutes Pappy with Mammy. Given its deus ex machina for Jakie's dilemma and its catalyst for his ethnic reprise, the Kol Nidre can be read as both lethal and conversional. It cannot function in the film without associating itself with death. Doane's "ideological truth of the sound track" strikes a new note.[24] Sound finishes a sentence begun by the body, but it remains invisible and thus not wholly locatable. The concept of sound production seizes the erosion of death as an instant, allowing us to perceive that the instant dims, fades, reverberates. In *The Jazz Singer* synchronized sound proves to be made for the cinematic dispersal of the death moment (as Jakie's erasure of his father makes narratively clear). In its own terms the film suggests that screen sound and screen death may share a common terrain, a domain that is "not exactly unseeable, but unknowable."[25] The touching appearance of the ghost-cantor merely manifests what is already heard. Jakie replaces his father in the one way that the older man can allow—by taking his place and duplicating his role.

Rogin has pointed out how the film breaks from its silent film ancestry by staging the death of the father, a figure here deeply invested in protecting tradition. The Kol Nidre's enveloping of the still-dying

father blends modern sound technology and tradition. It is diegetic sound that functions to give the cantor a good death, but it is the Kol Nidre, not jazz or the syncopated music of the American melting pot, that offers peace. One could say it "kills" the father. This is where my account differs from that offered by Rogin, who makes much of the fact that the film concerns the conversion to sound and the Jew's conversion to popular mainstream entertainer. Rogin claims that Jakie can only overcome his father through the assimilation afforded him by blackface: "Blocked from overthrowing the father directly, he regresses to blackface's imaginary realm of music, image, and the specular, histrionic self."[26] Yet this is not exactly true. It is not blackface, but the Kol Nidre, that successfully gets rid of the father without guilt or remorse. For the moment, it seems Jakie is trying to make good on the perceived lack of his Jewishness. His father's death gives him a chance to be center stage while embodying a musical style that to him is outdated.

As I mentioned earlier, Linda Williams suggests that the film's "jazz" and the Kol Nidre are infused, so that when Jakie holds our attention as a cantor and extemporizes arm gestures of rapture, we are to find somewhere the incorporation of black *melos* in his performance. But, first of all, there is no purely black *melos* in the film, and one cannot put quotation marks around the Kol Nidre in the same way nearly every critic has done around "jazz" or "black" music. In other words Williams does not account for the undeniable ethnic specificity of this particular Hebraic song, and to argue that Jakie as cantor sings jazzily resorts to reading the scene merely for its visual stereotypes— that is, to not be listening to a film that wanted so much to be listened to, as Williams herself points out. Passing for white throughout, Jakie allows his father to pass as Jew. The film, the assimilation afforded by blackface, and the conversion to sound all depend on it.

This will not be the last time the voice overlaps so prosaically with the dying. Chion tells us that "particularly in the cinema, the voice enjoys a certain proximity to the soul, the shadow, the double—these immaterial, detachable representations of the body, which survive its death and sometimes even leave it during its life."[27] For practitioners at the time, sound was already a sort of parallel dimension that usurped

(Chion says "supplant") the role of superimposition in silent cinema, which could visualize what someone heard or thought by laying it on top of an image of the person hearing or thinking. Superimposition was also the tool to produce images of the spectral world, employed at least as early as Porter's *Uncle Tom's Cabin* (1903) to represent death beyond the registrant's touch.[28] But the idea of flow connotes dispersal and projection rather than superimposition's palimpsest. If we were to sketch death based on the template of sound, it might resemble concentric receding waves that move away from a nodal point.[29] It would take place by moving through space.

The cantor's death moment is broken apart into several moments, and more than one "passing" is noted: first there is Mary Dale's comment "A jazz singer, singing to his God"; then the cantor's "Mama, we have our son back"; then Sara's hands-to-heaven gesture and collapse over the bed; then Jakie's improvisational Kol Nidre climax; then the appearance of the father's ghost behind him; then the completion of the song. There is quite a cascade of registration in this scene—many people get to do it, many times it gets done, and it is hard to say if Jakie's faith or the cantor's death is being registered. This relay of beheld transformations makes palpable the *peak* moment; the film seems to offer up Jakie's impassioned climax as that moment, though the point is that there are dramatic options. Finally, it is difficult to mark a boundary between external and internal experience.[30] Who can say, when viewing the senior Rabinowitz's pallor, if death is that terminal? The actor's physiognomy qualifies both the music subsuming him and his emotional state. Around the cantor, inside appears to meet outside. The external appearance of death is sheltered by the *melos* enveloping it. Cinema continues to insist that our deaths take place elsewhere and not just in our bodies.

SEPARATE LIVES

Theorists have turned to metaphor to determine the surplus value of the soundtrack. It is often imagined as an additional stream of information that brings vitality and duration to the image. As Doane

explains, "Sound is the bearer of a meaning which is communicable and valid but unanalyzable."[31] In fact, the soundtrack was thought of as a continuous vital *flow* by early technicians who employed life-and-death metaphors to express its potential to reverberate through space rather than get killed, or absorbed, by stage materials.[32] If vitality is enlivened by sound, we might say that "being dead" is enlivened as well, a condition supported by the ubiquity of undead creatures roaming around the early transitional period.

The concept of flow takes us away from the synthetic edits of the silent film; something persists on the visual level that cannot be broken down into fragments (shots). For this reason, says Christian Metz, we must say that sound, unlike the image, does not turn "off" as clearly, for it is not enframed like the visual elements we do or don't see. Whereas the cinematic image frequently refers to a visible world just outside the frame, a sound whose source is for the moment not seen is only just that—momentarily not *seen*, but not un*heard*.[33] And unlike the screen that can fade to black to render darkness, film sound cannot as easily "die"—if by that we mean erase itself, for even silence emanates a sonic presence and the reverberation of echo.

Yet another conception of sound is as a third dimension beyond the width and height of the flat, two-dimensional image. This added element "presupposes a certain *depth*" and "is in contradiction with the flatness of the two-dimensional image."[34] Literal sounds produced from within the diegesis can make palpable the space before the camera.[35] Early American film theorist Rudolf Arnheim put it this way: "Sound arouses an illusion of actual space, while a picture has practically no depth."[36] The more we ponder sound's capacity to make present the unseen, the more "it" (focused sound, the devoted voice or instrument) appears a good "companion piece" indeed for our final moments.

Listening may be crucial for those present in the dying chamber in *The Jazz Singer*, but in other films a concerted sound is not easy to find. *High Fidelity*'s Rob can score his funeral with Aretha Franklin and Gladys Knight, but cacophony is a disconcerting possibility. The connective sonic glue between bodies can come unglued at this last lived moment, which is, after all, a moment of separation. Rouben Mamoulian's *Applause* (1929), a film praised for its systematic use of

asynchronous sound, offers that inverse scenario. If *The Jazz Singer* presents death "on time" with the bonus of the added voice that lulls the central figure into crossing over, *Applause* presents just noise. The former, an Oedipal father-son melodrama, contrasts pointedly with the latter, a melodrama of maternal sacrifice.[37] Content is, as always, matched with form.[38] The films' respective protagonists—Jakie Rabinowitz and Kitty Darling—represent clear psychic roles that for Peter Brooks epitomize melodrama's polarized play of signs.[39] Their relationship to music extends these roles. It is no coincidence that their death scenes are so audible and so rousing.

Rather than entertain or feature vocal talent, the musical numbers sung by *Applause*'s female leads elicit our pathos for their entrapment in a patriarchal theater system, from the stage numbers filmed from the animalistic points of view of male spectators in the theater to Kitty's "What Wouldn't I Do for That Man," hummed to herself more than sung aloud. Rick Altman has suggested that the backstage musical proved a convenience for filmmakers interested in showing off "the full range of the sound technology." The tone cast by many early backstage musicals was one of sorrow, and Altman suggests that its decline in popularity by 1931 or 1932 may have been due to this: "It is tempting to conjecture that it declined not because the public wanted more variety . . . , but because the public tired of the equation of music with sadness."[40] But before wearing out the audience, that equation was made with exuberance.

Applause tells the story of an "over-the-hill burlesque queen," Kitty Darling (Helen Morgan), who struggles to maintain her own rank while making sure her daughter, April, does not follow in her own footsteps (the opposite trajectory parentally desired in *The Jazz Singer*). She sends the girl away to a convent. Years later, an adult April returns to live with her mother, but she begins to fight with Kitty's abusive lover, Hitch Nelson.[41] April falls for a sailor named Tony, temporarily docked in New York. The two make plans to marry, but when April sees her mother will be abandoned by the industry, she decides to turn Tony down and stay to help Kitty.

Melodramatic too-lateness is none too kind. Before April can tell her mother that she is ditching Tony, Kitty spots a bottle of pills in her

medicine cabinet and ponders them in a suicidal frenzy. Meanwhile April is dumping Tony: she finishes a glass of water as Tony remarks, "You'll be late," and a dissolve shows Kitty downing the poison. She sits at first in her armchair staring out the window, juxtaposed with an urban ambience of car horns on the soundtrack. In a later shot Kitty appears to be driven by the offscreen sound of a siren to pick up her daughter's picture from the table. Besieged by regret, she cries April's name, grabs her housecoat, and leaves to find her. The digestion of pills sets up another possible combination of too late / on time.

April and Kitty are united backstage; April lays her down in her dressing room.[42] She tells her mother about backing out on Tony, and a horror-struck Kitty screams, "Oh my God what have you done, what have I done?" Kitty poignantly "cries out" her recognition that she is too late to save her daughter from the world of burlesque, translating silent film's gesture into an audible cry. We realize it is doubly "too late"—for Kitty alone, and for April, whose attempt to take care of her mother (the whole point of her return) is thwarted. Mamoulian cuts to a high-angle shot that reveals the positions of (another instance of) four people in the room: Kitty lies diagonally across the bottom of the frame, with April near her feet; the stage manager and Hitch have entered and stand on either side. The daughter gestures at them to go away, but the stage manager persists: "Kitty Darling is finished." Another cut takes us back again to a medium long shot at eye level. The room's acousmatized voices intensify the image of Kitty's claustrophobia: offscreen, the managers and April argue over Kitty's doomed career as Kitty whimpers softly.

Rather than as sonic glue that coordinates passing to an elegiac tune, Mamoulian records sound as atmospheric weight. More generally in the film, overlapping and poorly heard sounds reflect a lifelike sense of our hectic everyday acoustic worlds. "Unlike other directors of the period," Lucy Fischer tells us, "he recognizes the inherent spatial capacities of sound and, furthermore, understands the means by which they can lend an aspect of depth to the image."[43] Accordingly, Mamoulian builds layers of sound during Kitty's dying.[44]

First, we hear Hitch convincing the stage manager that April can save the specialty show. He says to April, "Come on baby wake up,"

which resonates ironically with what we see: a medium close-up of the mother with eyes closed, convulsing. Following an offscreen drum roll—and in unison with April's proclamation: "Oh, I'll be good all right. I'll go out and give them what they want. I'll show them. I'll show them."—the camera blurs Kitty's image entirely out of focus (fig. 3.3). This, it would seem, is the visual representation of her death, one that we have not yet seen, in fact. Cut to the room: the manager says, "Now you're talkin'!" (recalling *The Jazz Singer*'s "You ain't heard nothin' yet!"). April leaves the room. Then, the camera does something rather intense: it tracks in to a close-up of Kitty's motionless, upside-down head as we hear April begin singing from the distant stage. If we look close enough, we can see a sudden stilling of the wobbly camera; perhaps a freeze-frame was added to connote stillness. Could this be farther from *The Jazz Singer*? Rather than binding them, the soundtrack separates. Diegetic music plays throughout the

FIG 3.2 Kitty Darling's body, out of focus, in *Applause* (Rouben Mamoulian, 1929).

scene but shrouds Kitty's condition. The camera, not a living character, returns to the bed to register Kitty's death.[45]

The voice-off is distinct from the ways Mamoulian's camera otherwise works with visible space through tracks-in and -out, rack focus, and a cluttered mise-en-scène. Mamoulian broke from then-current conventions of recording directly with a single mike in a static shot. Arthur Knight explains that Mamoulian "felt that the camera could and should move," "fought against the prevalent notion that the source for every sound must be seen," and used the camera as "*more than a passive observer* looking on while actors recited their lines" because he thought it should "help the audience find what was dramatically significant in a scene, picking out what was important with his camera."[46] Mamoulian was an early explorer of film's acoustic environment. Given the mobility of his camera and its relative autonomy from the soundtrack, it is perhaps not surprising that he would employ the camera itself as a registrant.

As with *The Jazz Singer*, *Applause*'s death scene fits into the film's larger aural logic. During Kitty's convulsive last movements the moving camera blocks out all present. Since it is produced by the lens, the image of Kitty's death cannot be perceived by the fictional characters and is not registered by their offscreen voices. Even if they were looking, they wouldn't see it. Those present continue their dispute over who will fill the star's role. But the spectator witnesses these convulsions and the camera effect. We are forced to perform as a registrant, denied the usual gestures of grief. With synchronized diegetic sound, it becomes possible for figures in the scene to talk and not to pay attention to what the camera picks out as important.

But is the camera "more than a passive observer" of death? The ironic friction between sound and image creates a half-registered moment that slides into posthumous dance. Specifically, April decides to take her mother's place in the number under way, taunting that she will "go out and show them," though she is blind to what has just happened. While we are being signaled visually toward the mother's death, the sounds that emanate from beyond the frame's limits do not signify human registration but its failure. The camera moves in and does not take the talking bodies with it, marking an unobserved death.

The spectator's registration is even more interesting given Fischer's account of Mamoulian's spatial world as one "that seems visually and auditorially *perceived*."[47] Mamoulian's death scene—constructed through what Rick Altman terms "sound space"—provides merely a partial view.[48] To represent death without registration, Mamoulian blurs then refocuses the still body. What the world needs to absorb Kitty's death is more than the camera, or the spectator, can offer. The scene hovers on the verge of diegetic absorption.[49]

There appears no external agent to confirm that death has really happened—but Kitty is not quite alone, for her body is enveloped in a chatter that forces us to project her ending. The unregistered death continues to haunt the film. Instead of leading to reunion or arrival, the reaction shot and the body event never join—April never returns to the dressing room. Instead, we see first a brief shot of April singing and dancing superimposed over her still mother, the effect of which is rather base with Hitch looking on, licking his chops (fig. 3.4). After performing the routine she earlier watched Kitty perform and from which she recoiled in horror, April rushes to the wings, where she finds that Tony has returned to her; the two embrace in front of a large poster of Kitty from her "Parisian Flirts" show. Tony and she decide to move to Minnesota and take Kitty with them, where "we'll always be together, all three of us, all three of us." As their heads (and lips) drop out of the frame, the camera pans up to rest on a medium shot of the poster's face (fig. 3.5). The movie ends by fading to black.

Certainly this is anything but satisfying closure. Mamoulian finds in the soundtrack a metonym for the insatiable, male-driven desire running the burlesque show. In fact, he seems to suggest that sound technology is forever "on" and has no "off" switch, that it, like show business, is incommensurate with death. Too-lateness emerges in *Applause* as an effect not so much of editing as of the spatial compositions in the frame and the narrating agency of the mobile camera. This does not eliminate repetition and disembodiment but merely alters their appearance. The final image of the talked-over poster mirrors the death scene, communicating the mother's absence by showing a body that can no longer dance or sing (corpse, poster). The poster is opaquely commemorative. In the film's final shot Kitty is pictured in

FIG 3.4 April hits the stage, over Kitty's dead body, in *Applause* (Rouben Mamoulian, 1929).

FIG 3.5 Ironic nonrecognition of the dead in *Applause* (Rouben Mamoulian, 1929).

the poster but muted; April is heard but not seen. The film leaves us longing for the union of body with voice.

Here, then, are two films that stand on opposite ends of the spectrum of synchronization. Both employ asynchronous sounds at the dying moment. One—a religious song—helps a cantor let go. Another—a frenetic conversation among three heard over a background band—cannot stop for death. The first we might say is sacred, the other profane. The former leads to a cascade of registration whereby Sara passes to Jakie who passes to the cantor who appears behind Jakie who has stepped in to fill his place. The latter leads to a series of ironic nonrecognitions: April fights with the manager over her dead mother's body, performs the mother's song onstage, rekindles her relationship in the wings, decides to take her mother with her as she moves away, and talks of her mother under a poster of her. Each moment remembers the absent mother though April does not know it. Here, again, the soundtrack extends registration to where it wishes to carry it. As the medical experts in the *British Medical Journal* surveyed at the beginning of this chapter suggested, the type of music played at terminal moments does indeed have a significant effect. Duration of the voice replaces the alternating cuts that glued together separate locales. The perception of *when* death occurs is no longer only linked to someone else's visible body but to other voices that infuse the event with a sense of how it fits into the world.

Doane tells us that the voice-off "deepens the diegesis" to an extent that "exceeds that of the image, and thus supports the claim that there is a space in the fictional world which the camera does not register. In its own way, it accounts for lost space."[50] In service of the construction of space more than the image, the voice-off articulates a sensory presence that the image cannot. According to Doane and Pascal Bonitzer, the depth of the unanchored voice can be a frightful thing, potentially disrupting the spectator's seated mastery over the onscreen synchronization of voices with bodies. For Bonitzer, the film noir voice-off, that "dark prophet of the end of the world," thematizes this disengagement.[51] Kitty's seems a "bad" death compared to Cantor Rabinowitz's partly because the voice that flows momentarily away from its bodily source does not get absorbed by the dying body, thus leaving the

spectator's own bodily experience incoherent—"a body" that is usually "positioned as unified and nonfragmented."[52] This fragmentation represents the other side of synchronization and expresses an entirely different sensibility.

That early sound films make use of acoustic space at the dying moment is not a break from sound style. As Lucy Fischer has pointed out, Balázs saw sound in general, and especially silence, its absence, as a spatial experience. Since "there is never an absolute auditory void," silence "can only be rendered when sounds are present."[53] Silent films produced no true void of sound. Whereas silent films circumvent stillness, sound films approach silence. The camera's link to related sound encourages it to navigate around the void—death emerges not at the presumed borderline between motion and stillness but in a series of spoken passages between rooms and speakers. The very edge between sound and silence is hard to imagine, perhaps impossible to produce. Sound always leaves an echo, gets absorbed by other substances, before it "dies."[54] Voices fill the rooms in which the cantor and Kitty leave the diegetic world: though they still die silently, their rooms do not.[55] In the language of the first sound technicians, the dead body absorbs and keeps alive, thus does not kill, its surroundings.[56]

Mamoulian's *Dr. Jekyll and Mr. Hyde* (1931) also uses offscreen sound at dying. Having once more turned into Hyde (a transition he cannot himself control), Jekyll is caught and cornered by the police in his own laboratory. Monstrous Hyde is fatally shot and transforms back into Jekyll through a stop-motion sequence. It is the only such transformation in the film (from monster to human): death ensures the final erasure, and not merely the suppression, of Hyde. While we look at Jekyll's head laterally framed by vials on his desk, we hear "Doctor" spoken by Poole on the soundtrack; then, "Jekyll" matches a cut out to a long shot in which Poole mourns standing among the police and Jekyll's once-friend Lanyon.[57] The camera reveals a larger space in a beautiful iteration of posthumous reframing. The death occurs silently and is not registered until the soundtrack cues this shot of public recognition.

Kitty Darling's persistently unregistered body is not a unique instance when the early sound film withholds synchronization to

explore the borderline between vitality and its lack. Robert Spadoni argues that the quiet but "persistent corporeality" of Bela Lugosi in the title role of Tod Browning's 1931 *Dracula* makes use of audience memory of earlier slow-moving sound films to enhance the screen effect of a walking dead figure. This "re-estranging" of synchronized sound, Spadoni writes, builds over the course of the film as Dracula's voice becomes more removed from his screen body.[58] Of course, the silent film corpse figured a "persistent corporeality" that did not speak its status but was spoken for by the registrant. Dracula gradually disappears and stops speaking, as if the film loses its ability to track him, drawing our attention to others in the film to account for his body, vitality, and power of influence. Losing synchronicity makes it more difficult to account for the body (the opposite of the acousmatic voice that builds up to synchronization). It's also difficult to kill someone—for example, Count Dracula—who is defined not by one body but by many (and not just forms of the same body, like bats and wolves, but other people under his spell, like Mina and Renfield). At the end of the film Dracula carries a catatonic Mina to his coffin, with Van Helsing and Harker on their heels. Dracula's death is represented by Mina's offscreen scream, signaling her return to normalcy, and Van Helsing's proclamation that "Dracula is dead forever," spoken while he is holding the stake he used offscreen on the vampire. In neither case do we see the vampire's body.

The corpse lacks a voice, and the offscreen or acousmatic voice lacks a body. Horror plays with the formidable border of synchronization between corpse and sound. In *The Mummy* (1932) Imhotep is destroyed by a spoken curse, and a makeup transition turns him back into a mummy, invoking Bazin's "change mummified" without the change. Since deadness is not certain in the image, the unseen voice possesses a panoptic power not mentioned by Chion—the power to see the body's interior state. Synchronization falters at death: what one body loses (its voice), another body projects. The fact that the soundtrack plays such an important role in attending the deathwatch—whether live or postsynched, as in my next example—underscores the audiovisual image as "undead."

CRYING TIME

In the transitional period synchronicity drifts at or near death moments. In the previous couple of examples, the registrant's or survivor's voice becomes a kind of spatial vector that the camera traces in order to embed death within space, triggering not just multiple reaction shots, but multiple deaths. The moment sound leaves the body in the sound film mirrors the moment that movement leaves the body in the silent film. Both tableau and registration compensated for the incomplete stillness of the silent film corpse. Silence, by contrast, is more relational, connected to the production of sound in a particular place. If silence is defined as the absence of sound, it is also not enough to signify death as an instant. When sound extends into space, it fades; even when it is suddenly cut off, it echoes. Space is opened up near the body at its terminal moments, and as a consequence, registration proceeds with or without the body in sight.

With the trend toward asynchronous effect, early sound death scenes explore an emotional range of registration. In many cases the power and mobility of the grieving voice replaces the pose, or tableau, of grief with a "live" reaction that travels over separate images, prolonging and enlivening recognition in the immediate aftermath. Emotional outpourings overwhelm the impression of an event, not to mention an instant, of death. There is the potential to synchronize the death moment *with* its funeral reception, as reactive sounds coincide and overlap with the still body.

Registrants don't just sing or quibble; they also cry. Wails of grief remind us of Peter Brooks's sense of melodrama's "most transparent, unmodified, infantile form" of self-expression. As he remarks, "Desire cries aloud its language of identification with full states of being."[59] Sometimes this emotional language becomes centerpiece to the scene of registration, to the extent that it confirms death beyond referential contact with the corpse. King Vidor's *Hallelujah!* (1929) provides an example.[60] *The Jazz Singer* made specific use of Jakie's singing the Kol Nidre—that piece of music so charged in the film as the sound of Jakie's own ethnos, the origin he has left but now revisits, that of his now-dead father. Only after singing the Kol Nidre is Jakie able

to occupy the position of the mammy singer, fully integrating himself into that role in front of his own mother. In Vidor's film, one of the first screen musicals with an all African American cast, Mammy possesses preternatural knowledge, registering her son's body before we even see it. Vidor had recourse to postsynchronization, allowing him to freely stitch images to a soundtrack. Visually, Mammy's pathos becomes a rapidly disembodied response, as she herself drops out of the picture. Jessica H. Howard has argued that characters generally sing the songs in the film to catalyze their own transformations. Guided by the competing forces of religious zeal and sexual desire, Zeke and others build—over the course of singing—toward more and more ecstatic states. Since transformation through song creates an audiovisual "present" for both the singers and the spectators, the latter are in turn able to identify with the former and in some cases join in. Building from Altman's point that audiences of the film would in fact have been familiar with many songs and encouraged to experience it as a sing-along, Howard comments that "one knows that it is precisely one's act of joining in the musical present that renders the emotion inclusive and unmediated, perhaps—it seems—even by the medium of film."[61] Spectators were prompted to participate "live" in the musical dilemmas onscreen. "Live" death, too, is very much at issue in the early period, as the spectator is drawn closer to the lack of synchronization as a terminal sign that plays out in his or her own time.

Vidor's film was praised in the trade press on its initial release for its realistic representation of black life in the rural South. And a *Variety* review mentions black noise—"moaning," "crooning," "carefree, syncopated singing"—as exemplary of that realism. The asynchronous sound of "the harmonious voices of the Dixie Jubilee Singers" (returning to the screen four months after their *Show Boat* debut on the stage) was "especially necessary . . . in the spirituals."[62] Ruth Morris, who ironically condemned the film as a successful matinee picture for women spectators and praised it for its intelligence and "composition," suggested that "the dialog in itself is a musical accompaniment."[63] Musical accompaniment seemed the attraction, hanging on to images and surrounding them with an intended aural authenticity.[64] That point was certainly made by the all-black musical *Hearts in*

Dixie (1929), praised for its infusion of sound technology with (black) "personalities . . . ideal for this medium." As Alice Maurice explains, the early sound film fetishized the "black voice," not because such a voice was indeed naturally suitable for legible recording but because it brought "expectations regarding authenticity, the alignment of internal and external characteristics, and the evidence of the senses."[65] Of course, the expressions of "black" grief in *Hallelujah!* are influenced by stereotyped codes already present; an embodied and expressive pathos is reaffirmed by sound technology. Mammy's pathetic wails read as an older presumption about the black body as an overabundant physical presence. But if we listen and watch closely, they also point to an affect that the moving image can explore in interesting ways.

Hallelujah! tells the story of Zeke Johnson's call to ministry in the wake of accidentally killing his own brother, Spunk, in a juke joint brawl. Spunk's death scene constitutes another interesting step forward in the transitional period. Once again, determining the components of the "scene" moves us, along with the persistence and duration of sound, to the outside of the body. At a juke joint, where the seductive dancer Chick eggs him on, Zeke fights with Hot Shot over money owed him from a rigged craps game. Zeke pulls a knife, Hot Shot a gun. The two men wrestle, the gun goes off, the crowd flees. Zeke ends up with the gun and shoots haphazardly around the room, twice in a synchronized close-up (a shot whose omission from the film was unsuccessfully urged by Jason Joy of the PCA), then three more times. After the crowd disperses, Zeke hears his brother whimpering offscreen and bends down close to attend to and hold him. On the left of a medium close-up, Zeke crouches in shadow as he holds his brother's lateral body, cast in light. The cut-in of the brothers marks the scene with an audible desperation, as Zeke pleads for the younger man to talk ("Speak to me, Spunk") and the other agonizes ("Hold me, Zeke; I'm gettin' cold"). After stepping outside to shout for offscreen help ("Someone help me! My brother's dying. . . . O won't somebody help me?"), Zeke returns to Spunk in the medium close-up, this time his face fully eclipsing his brother's: "I'll take you home to Mammy. She'll help me." He carries Spunk, still alive and mumbling, outside the juke joint.

As in Mamoulian's film, talking here is synchronized (the conversation between the two men) but the death moment is not (no gurgle or rattle). Vidor's postproduction, postsynch soundtrack, as Arthur Knight tells us, "explored the possibilities of the sound track to evoke mood and atmosphere" in a film shot for the most part silently. Vidor builds a tonal atmosphere through such things as "the rhythmic swell of Negro spirituals, a woman's scream or a barking dog heard in the distance, the sounds of the swamp and the river."[66] In both *Applause* and *Hallelujah!* the microphone listens for confirmation from the world outside the body. Because we do not see Zeke's brother die, the film must eventually address his condition (or come to an end, as in *Applause*). It does so with Mammy Johnson's piercing wails. Mammy's crying all but thematizes sound's capacity to extend grief beyond the usual scenic limits of the framed registrant.

First, the film damningly cuts to Hot Shot and Chick arguing over how to divide the money. Then, in a close-up we see Mammy wake up and look right: the reverse shot reveals an empty bed. Vidor cuts to a medium shot of Mammy—we might call this the first "reaction" shot, yet she is reacting not to the fact of death but to her son's conspicuous absence. In the role of Mammy, Fannie Belle DeKnight intones, "O Lord, have mercy on my children," over a reverse shot of the full line of children's beds with the empty one at the end (a rather poignant composition). In a medium shot the family gathers around crying Mammy, soothing her and bowing their heads, pleading with her to stop crying, in a tableau of grief with no corpse. These sounds and gestures recall the earlier scene in which Mammy gathers the younger boys around her to pray at bedtime, singing each one to sleep cradled in her lap. Wailing reaffirms the "cliché whereby blacks sing out of misery and religious sentiment."[67] Here, the static camera reinforces the tableau while human voices explode from its tightness. Whereas silent cinema cornered the conflict between movement and stillness, here we are aware of the conflict between voices and silence.

It is Mammy who is surrounded, not her soon-to-be-dead son: "O, my children ain't come home. . . ." As the death wagon approaches, the family emerges into the yard. Mammy sits down in a folding chair where the voices continue, with one child's "Please, Mammy, don't

cry" and Mammy's "Have mercy on my soul, O Lord." This last "Lord" breaks from the single-note stream of Mammy's singing and enters the stratosphere. Once Pappy steps in to pray, we hear several voices, one over another, producing a cacophony of emotions ranging from pain to humility. Zeke, the wicked messenger, arrives: we see that he hears the sounds of his family's grief, his face contorting slightly in recognition. Of course, reaction shots to offscreen sound throughout the film visualize emotional effects the music has on its listeners: earlier the younger sons smile at the beauty of Mammy's singing, or Zeke stares lustfully with outstretched arms at Missy Rose while she plays an organ wedding march.

The cut-in to Zeke's face shows his reaction not so much to death but more to the pain it causes in familiar voices. Zeke's head and shoulders are framed from a low angle against a blank sky, lending a naked expressivity to his face. Stepping off the horse, Zeke approaches as we hear Mammy continue: "Look what I hear." It is like an instruction to the spectator, for we are exactly looking at what we hear. Vidor cuts to the family's tableau; Zeke enters finally from offscreen left while Mammy releases "O . . . O . . . O . . ." I do not quite know how to write the sound of Mammy's grief. (It is striking that rewriting the sentence of cinema death from instant to process must accommodate emotional expressions that are grounded but inarticulate.) Zeke kneels down, hat off, and bows his head on his mother's lap. Still no registration. With the last "O" Mammy collapses over Zeke's body. Ned asks Zeke, "Where is our boy? Where is Spunk?" to which Zeke responds by pointing offscreen left. Unlike the rest of the family, Zeke does not open his mouth once. He never delivers the message. Mammy supplies the mute Zeke with a vocal release and emotional expression. Her voice is not always localizable and travels freely across shots, uncovering emotional depths in images of the wagon's approach and of Zeke's physiognomy. The rising intensity of Mammy's "O"s highlights the power of sound to chart increasing intensity.[68] This whole scene represents the crescendo of the voice. Mammy transmits the certitude of finality without translating death into a registered fact.

We cut to Ned, who is approaching from the rear of the wagon and looking. His point-of-view shot begins from Spunk's feet and

extends along an imaginary z-axis into the frame, accompanied by the only modulated nondiegetic sound in the entire film—a soft drum roll announces the final revelation (without words) of the corpse. The quietness of the body's unveiling contrasts poignantly with Mammy's wails. Again Balázs: "After a sequence of a hot dance music the stillness of a sick-room affects us differently than if the preceding picture, too, had been a quiet one. Sounds which, as the saying goes, 'still resound in our ears,' may deepen and interpret the silence that follows them."[69] In the momentary quiet that follows Mammy's "O"s we hear the echo of grief catch up with its source. Mammy's chant-singing "O"s repetitively, Jessica Howard tells us, "allows the 'true' bodily expression of Mammy to emerge (i.e., piety, grief). For example, repeating the words 'Lord, have mercy . . .' over and over again does not enhance their meaning or propel the plot forward." Indeed, Spunk's departure from the film has not been confirmed before—and, one could argue, without—her chants. The words she says in this peak moment do not convey a narrative message, Howard argues, but rather a sensory presence: "Thus, its meaning is unfixed and ultimately transformable. The chant, then, prioritizes the presence inherent in aural expression."[70] The "other world," part of Mammy's vision, seals her authenticity.[71]

Throughout this sequence, those heard but not seen "impress us," Balázs might say, with the "inevitability," "approaching catastrophe," and helplessness of a situation, guiding our dreaded movement in closer to the corpse. Because it is already outside the image, sound extends the act of registration beyond sight of the body. And because Mammy is made present through repetitive, nonnarrative expressions, she acts as an endless mortuary device. Voices usurp the spectacle from the body and the tableau. Because sound is not synchronized around Kitty's death in Mamoulian's film (as with Vidor's), it remains an incomplete event still hovering between attraction and narrative, between the spectator's act of observation and that performed by the usual onscreen beholders.

With the above reference to the cinema of attractions, I have in mind Stephen Best's observation that the earliest film representations of African Americans denied narrative access to the black figures, framing them as performing subjects on display. Best points out that this technique of display—though clearly not unique to black subjects

in early cinema—contained any kernel of black narrative mobility within an endlessly repeated action going nowhere, a "sea of representations of a temporally arrested blackness."[72] Not surprisingly, Mammy's reaction to death temporally forestalls narrative registration for reasons having as much to do with her racialized expressivity as with Spunk's narrative departure.

It is certain, however, that aural grief—of whites as well as blacks—is a lasting Hollywood habit. Like the singing caveats throughout this musical, Mammy's wails in *Hallelujah!* do not supply narrative mastery; they are spectacular on their own. They lengthen the spectacle of death and stall narrative progression, continuing the static tableaux of grief to prolong the interval between the body event and the narrative's resumption. Sound commands incompletion: it is not completely seen, its source not always fully defined. The early losses in the sound film have no clear coordinates because they do not focus on the body. To compensate for the death scene's omission, Mammy's desire literally "cries out."

What we hear on the soundtrack outlasts the familiar bodily gestures around the body, and Mammy's cries are central. The images of the processional and of the family's approach to the wagon almost luxuriate in the late encounter cried out on the soundtrack. *Applause* and *Hallelujah!* withhold the union of the living and the dead, and they lack a tableau or pause to bring the observer near the body. Their dramatic peaks are located elsewhere—in the longing for synchronicity of sound and image. Mammy's voice travels, but it has nowhere to go, no place to stop and rest. It envelops the body that has lost its voice for good. The Mammy figure has long been coded as a fantasy of coherence and origins; here, she offers a durable vocal expression at the end of her son's dying, one that banks on the audiovisual image's funerary qualities.[73] Is it a coincidence that two of the three singing acts on Rob's *High Fidelity* funerary list are African American women?

GRAVE SOUNDS AND NOISES

The soundtrack affords a new means of participating in the act of dying for all present (including the spectator), as well as a new rhythm

of proximate starts and stops—a perdurable effect, judging by the ubiquity of nondiegetic musical scores in later cinema. The silence of the body is not the way sound films define death—some other music/ sound enters the scene, draws the camera to another place, picking up cues from the acoustic environment, moving death from the shot to a world beyond eyeshot. We could say that death occurs asynchronously, and it very often does, but this is because with the addition of sound to moving pictures, dying cannot come to an end without leaving some last impression on the soundtrack. In Hollywood films that last impression does not come from the silenced body.

Quiet bed deaths hardly exhaust the early terrain—note in passing the machine-gun killings that flooded the gangster genre or the offscreen screams of horror films. Spadoni looks to offscreen sound to rethink the impact of synchronization on the horror film, identifying "unseen bumps and offscreen screams" as constitutive of the genre rather than merely characteristic of it.[74] Offscreen screams point to the spatial dynamics of diegetic sound. When in *The Bride of Frankenstein* (1935), Henry's assistant, Hans, is pushed by the monster off the top of the castle, his death is represented almost exclusively on the soundtrack as his scream pierces then fades while he falls. In other words the soundtrack conveys a sense of space that allows dying to unfold—albeit quickly in this film—as a progression into silence. Death here is the aftermath of a silenced continuous voice.

And earlier, in *Frankenstein* (1931), a film that literalizes posthumous motion in the figure of the monster, the death moment and process of registration are also sonorous. Both Fritz and Dr. Waldman die offscreen—the former after two piercing screams heard throughout the castle, and the latter after a cut to a conversation between Henry and Elizabeth. And after little Maria drowns, her father carries her corpse through the town's musical wedding festivities for Henry and Elizabeth. The music contrasts poignantly with the silent stupor of his face and stride, as do the clanging wedding bells, which in this case double as a death knell. As Maria's father continues his procession, the townsfolk gather in behind him (fig. 3.6). In one shot the camera tracks by three windows in which appear faces of townspeople. Maria is delivered to the Burgomaster's front step. The town transforms from

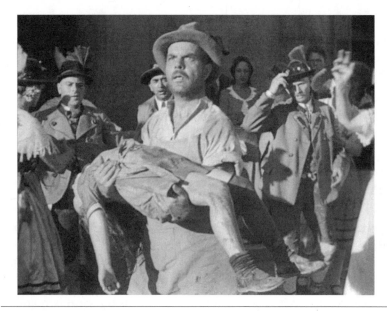

FIG 3.6 Maria's father carries her body through the bridal celebration in *Frankenstein* (Tod Browning, 1931).

a party crowd to an angry mob as they become witnesses to the public registration of Maria's death.

So convincing is the soundtrack as an unseen registrant that it is used to "kill" when sudden effects are cued to the impression of ballistic attack. Perhaps the close-up of Zeke's hand, pulling the trigger of a gun, synchronized to a big bang—a type of close-up used by the early sound gangster film and many thrillers besides—was objected to precisely for its auditory fullness. The gun close-ups, as well as the sound of the scream from somewhere in the room, may have identified Zeke too strongly with the position of the physical assaulter because they embodied the acts of situational violence. At any rate the gun produced a new violent trick that worked with sudden sound. The death scenes in *Little Caesar* (1931) and *Scarface* (1932) all feature the newly available in-film sound of gunfire, but not surprisingly, not a single body is visibly punctured. Missing are "visual details" like "disfigured, dismembered, bloodstained and mutilated bodies, close-up views of

dying men," as Olga Martin, former MPPDA employee, observed in 1937.[75] If we see them at all, the actual performances of dying are quite standard (grasping of chest, falling over). Sounds associated with early violent death are acute; they do not *continue* to be heard throughout registration. They are sharp and instantaneous. In *Little Caesar* it is Rico's "rocket" and its automatic eruptions that get the most attention. We do not see his first victim, Crime Commissioner Alvin McClure, die. He merely drops to the floor in unison with a gunshot, and we are told in a subsequent scene at the gangsters' lair that he was "knocked off."

In *Little Caesar* we do see, very rapidly, Otero and Rico drive by and shoot Tony on Father McLean's church steps: the car drives past, and three puffs of smoke accompany three audible gun shots as the body falls down the stairs. But the composition of Tony in depth marginalizes this moment with the car's foreground clearing of the frame and the sounds of the gun. Bodies die immediately. In short, the gun immediately announces a violent act from outside the body but does not indicate death or dying.[76] It is the liveness of the image that shows up in the wording of the PCA eliminations: "gangster shooting man," "man being thrown out of car," "man falling in doorway," "men falling."[77]

The violent acts in *Scarface* are spectacularly choreographed: appreciate the bowling alley scene where in a deceptive single shot (there are two shots dissolved into one, continuing the tradition of *The Execution of Mary, Queen of Scots*) we hear the offscreen sound of a round of bullets as Gaffney releases the ball; the camera follows the ball away from the body until it knocks down nine pins, leaving the last one hanging. Then a second round of offscreen gunfire makes the point quite clear that the pin—which successfully drops on synchronized cue—continues the body event fully relegated to offscreen space. He first rolls a spare that then barely becomes a strike; the pin wobbles before toppling over. We may infer spasms from the pin: its falling, not the body's, completes dying.

The "strike" completed outside—and as an extension of—the body event contains the X that appears throughout the film as a kind of signature of completed death. This Hawksian "grotesquerie" of

Xs formed around or with besieged bodies emerges not through the means of violence but through the commentary the camera provides after the body event.[78] Hawks maintains for himself some of the flourish of gangster killing through his posthumous remarks—a whimpering offscreen dog after the Valentine's Day Massacre; an offscreen screaming crescendo like a teapot after a booze truck is busted; a corpse forms an X with the shadow of a street sign that itself reads "Undertakers." The camera takes away from the embodied performances of dying (which are short and sweet) to register the final configuration and "meaning" of the deaths. It is where the deaths occur that supplies commentary, not merely what we see the bodies do. Hawks's camera connects an urban architecture of apathy to the visual and sonic immediacy of murder. As Richard Maltby reminds us: "The inventiveness may be the auteur's; the discretion, however, belonged to the institutions regulating Hollywood's regime of representation."[79] Registrants still appear and are instinctively needed, whether provided by beholders or by the camera itself, but they do far less work than in nonviolent deaths, for the dyings to which they attend are significantly less protracted and ambiguous. The sound effect's impression of instantaneous ballistics can be faked, too. In an early scene from Ernst Lubitsch's The Love Parade (1929) a quarreling couple of adulterers is interrupted by the woman's husband. Upon his entrance she holds a handgun to just below her breast and pulls the trigger, and a bang on the soundtrack causes her to fall over. When the husband takes the gun to his wife's suitor and shoots, the second man stands still. Together, they eject the full cartridge from the gun, and the second man laughs. Looking back at the corpse, they see her with eyes open, glaring. Lubitsch is poking fun at the soundtrack's verisimilar ballistic effect, all the more ridiculous given the earlier cutaway to an approaching street-side crowd when the gun goes off.

The early films explored in this chapter are not indicative of Hollywood standards of sound editing. Produced in an experimental era, each features its own uncommon novelty, from Crosland's part-talkie (itself a rarity), to Mamoulian's use of two microphones and a mobile camera, to Vidor's access to postsynchronization. Rick Altman

explains that at first sound technicians disputed where to place the microphone in the shot. One idea was to link sound to the image track each time there was a cut in the latter, for it was believed that if sound remained constant throughout different images the result would be unintelligible and a deviation from the way we experience sounds in real life. The first impression of sound-image match was, as Altman says, of "the constitution of a monstrous spectator."[80] Monstrosity became the norm, however, with the standardization of the continuous-level soundtrack in 1930s Hollywood. As James Lastra argues, the model for sound recording in classical Hollywood "tends almost uniformly from the early thirties on toward the telephonic," foregrounding the intelligibility of dialogue.[81] The dominant two-shot of dialogue over the deathbed, and the ubiquitous soaring nondiegetic score through-out such scenes, would eventually create their own expectations and habits of viewing.

Asynchronous deaths continue in Hollywood, used to particularly good effect in Lewis Milestone's *All Quiet on the Western Front* (1930), in which Paul dies in a close-up showing his hand as it reaches for a butterfly. Having returned home and remembered catching butterflies for his sister when they were children, Paul returns to the trenches to find all his friends dead or gone. In a momentary lull in battle, he spots through a hole in the barracks a butterfly and reaches for it. As an unseen enemy shoots Paul, the hand that has almost touched the insect recoils, and the camera quickly shifts right to separate (forever) the hand from the little creature. This all occurs with no musical accompaniment, and at the moment of impact the diegetic sound cuts off as well and does not return. What we see next is the memorably posthumous epilogue of retrofit replay in which in line the young friends walk away from the camera, one by one looking back at it, superimposed over a battlefield of marked bodies. *In Old Chicago* (1937) begins with Patrick O'Leary's death in front of his Chicago-bound family while the youngest son sobs offscreen throughout the final speech. After his last sentence ("Let Chicago come to me as I couldn't come to it"), Patrick sighs and closes his eyes, while on the soundtrack a wind begins to blow audibly. There are calls without response in the last two images: "Patrick!" and then, "Ma!"

Nondiegetic strings float throughout Marguerite's last scene with Armand in *Camille* (1936), even as he tells her that "nothing shall ever separate us again." But there is a momentary pause as she slides to inertia. Armand, holding her, calls, "Marguerite, Marguerite," and the strings resume as her limp body leans away from him, lifeless. He embraces her but the camera moves in on her separately before fading to black, as the orchestral score rises.

By the 1940s, nondiegetic music scores death as a companion piece, but it reminds us of the earlier discovery of sound space as an unseen force, an acoustic impression, that converts a singular occurrence into a posthumous flow with separate momentous peaks. If sound space is often a social space, so the loneliness of death can be abetted by marking a connection to other bodies, present or absent (but nearby). But asynchronous deaths do not disappear. In Joseph Lewis's *The Big Combo* (1955) Mr. Brown and his minions do the double-crosser Joe a "favor" by removing his hearing device as they execute him so that he won't hear the guns. The soundtrack drops out completely, and we see an unaccompanied "silent" murder scene as Joe is riddled with bullets. The spectator is positioned at Joe's point of audition during the dying moment. His death is registered, interestingly, not by the continuation of the silent scene or by transitioning away but by the resumption of noise on the soundtrack. Mr. Brown's footsteps are heard as he approaches the body from offscreen. The gangster's power is manifested on the level of filmic discourse, but if we crossed a line with the dying/dead man, we only certify such a boundary crossed in the past, for the film does not leave us in the silent chamber but returns to normal with the antagonist's strides.

At the risk of being reductive for clarity's sake, let me suggest four categories of "death sounds" that follow from the previous examples, a schema that may be found helpful. Roughly, the categories refer to shared music, white noise, crying, and violent sound effects. (1) In *The Jazz Singer* the sacred music is directed at the dying cantor's ears. Sounds thus directed support and envelop the body in a transcendent live flow. Directed sound provides community, enlivening the tableau, "on time." (2) Asynchronous chatter, the white noise of *Applause* for instance, connotes a failed exchange between the dying and the

beholder, the opposite scenario to that above because it predicts a funerary separation at death. (Here, for some reason, I am reminded of a doctor friend's claim that most people die the way they lived.) (3) Crying, as in *Hallelujah!*, is the *melos* of release and desire. Like directed sound it suggests community, but unlike the elegiac music, it does not transform the image and is already "too late." Wails and sobs hover between registration and narrative resumption, bordering on the last category of sharp noise because they can come piercingly close to offscreen screams, which leaves us with our last category. (4) Screams, gunshots, and other cutting noises produce sudden auditory assaults that overwhelm those present (the dying, the onlooker, the spectator), marginalizing the body and its registration. The sounds of murder connote "too early." They "kill," cutting rather than enveloping bodies because they are so edge-like. If made by machines, they have no feelings.

The soundtrack's flow of vitality exceeds not only the notion of an instant but also the barriers of the frame. Because it hovers on the outskirts of the image and ultimately cannot be visually contained, sound returns us to the cinema of attractions and its emphasis on display and sudden presence/absence. This is especially evident in the quick deaths that occur in violent films, but it is no less true or important in slow or static dyings. So memorably do many early sound scenes foreground the weeper/mourner/dirger's specific racial or ethnic identity—arresting that identity against the fluctuations of narrative—that it is impertinent to think of death's *melos* without connecting it to this marked difference onscreen. We have seen, then, a return to the racist stereotypes in the earliest Edison shorts, but there are ethnic stereotypes as well. The otherness of *The Jazz Singer*'s Hebraic Kol Nidre is precisely that ancestral influence that supplies Jakie, under the sign of the father, with the power to offer a kind of grace. Despite Balázs's earnest chagrin, sound is never fully integrated into the story world. It easily joins other powers of the image-maker to signify outside the bodies of actors. Because it is heard outside it, it can approach and recede from the body. A matter of connection and disconnection, the soundtrack can prepare us by binding separate bodies, or it can ring in our ears before what we see with our eyes catches up. Sound

can produce the final barrier or the window that opens. This counts as another instance of give-and-take between precision and flux, between mechanical precision (the fact that technology produces the illusion of synchronization as well as its absence) and the human need or desire to put on the final touches.

4

SECONDS

THE FLASHBACK LOOP AND
THE POSTHUMOUS VOICE

"I was [murdered]."
—*D.O.A.* (1950)

IN THE EARLY SOUND FILM (1927–31) the soundtrack enveloped the dying body, connecting it to its environment. But in the examples we have considered, the camera itself has yet to be identified with a dying character's gaze or voice; rather, it has so far been associated with the present or absent registrant and, behind that figure, the director, image maker, or "narrator system."[1] But the mobilizing, offscreen voices in the early talkie period are not lost to practice: starting in the 1940s, speaking voices hover prosaically over the process of dying, drifting in their status from obituary to posthumous, from third-person to first. Flashbacks appeared in the silent era, of course: what concerns us now is the timed *overlap* of a talking voice and images of dying— an innovation made possible by postsynchronized sound and one that extends the *durée* of the movie deathwatch. This chapter deals with the dying/dead voice-over narrator—that tenured, disembodied, offscreen speaker who reorders and repeats the past to render its inevitable outcome intelligible. This voice anchors narrative's engagement with death as something that happens *in time* but whose precise temporal designation is unclear, if not worrisome. And like Frank Bigelow,

in the 1950 film noir *D.O.A.*, who claims to have been murdered and to tell us how, it often involves a cinematic play with circular time. Voice-over narration in the fiction film confuses registration with posthumous motion, blending the process of dying with that of retrospection.

Voice-over seizes the soundtrack's elsewhere as a temporal and spatial remove, placing in that stream a voice that "sees" from outside the diegesis, and thus combines a relatively new technology (post-synchronization) with an age-old and far-flung medium (narrative). It was only a matter of time before filmmakers and scriptwriters would intuit the power of the flashback from near-death, as it had emerged in nineteenth-century literature, to convey something of the personal, confessional nature of dying or to dilate an experience of temporal compression (as in Ambrose Bierce's 1891 short story "Occurrence at Owl Creek Bridge"). As we turn to voice-over at or near dying moments, we will need to look closely but also to listen again, to sentences and tone, to one who breathes as the screen shows us someone—sometimes the same person—whose breath is expiring. We must attend to what the films both show and tell.[2]

Wondering what it might be like to die has inspired literary innovation, since long before movie voice-over, subjective camera work, and flashback tackled the question. Robert Detweiler draws on twentieth-century literature to pinpoint some of the challenges of writing prosaic descriptions of the dying moment. Based only partly on direct experience, the writer's projection of prose death is revelatory, depicting one's sentience at death, and *ex nihilo*, or an independent metaphorical creation.[3] Modern shapers of the death moment, from Henry James to Ernest Hemingway and William Faulkner, provide details of the dying character's sensorial experience while maintaining perspective from the outside. By housing direct experience—"of astonishment, [of] a curious sense of the invasion of the mundane at this time of heightened reality, [of] a confusion of time and the senses"—within third-person restricted description, the author places the reader inside the mind of the dying person and relays concrete or "outsider" information.[4] Take, for example, this sentence from Houston's death in Faulkner's *The Hamlet*: "Then he saw the blank gap, the chasm somewhere between vision and where his feet should have been, and he lay

on his back watching the raveled and shattered ends of sentience and will projecting into the gap."[5] Restricted narration does not detain the absent observer on the outside of the body. Rather, it fuses subjective and objective elements into what Detweiler calls "center-of-consciousness" narration, naming Henry James as its predecessor, which "gives the author control over a double perspective" that produces both sensorial details from the inside and a detached matter-of-factness from the outside.[6]

By contrast, sustained first-person narrations of dying are rare, and narration from the grave infrequent, in large part because the posthumous voice draws too much attention to its own fabrication. Infrequent, but not obsolete: two luminous examples, both poems, are Robert Browning's "The Bishop Orders His Tomb at St. Praxed's Church" (1845) and Emily Dickinson's "I heard a fly buzz when I died" (1896). "Dying in state and by such slow degrees," the bishop contemplates the future visitors to his tomb and entablature, whereupon he will be forced to ask "'Do I live, am I dead?'" The child speaker in Dickinson's poem narrates in past tense a final sentience: the only sign of vitality within the room of the speaker's exit seems to have been the buzzing supplied by the fly. The fly's noise—originating from no certain place—articulates a final barrier of consciousness:

> There interposed a fly,
> With blue, uncertain, stumbling buzz,
> Between the light and me;
> And then the windows failed, and then
> I could not see to see.

Of the two, Dickinson's dead child speaker provides a fuller sense of narrative by splintering off the past-tense tale from the present-tense act of telling it.

Instances of the posthumous voice like those found in Browning's and Dickinson's poems figuratively occupy the space between life and death, a space of unknown dimensions and sensory evidence. But the buzzing of that fly, the process of hearing the world fade, is something cinema tries to both "show" and "tell." Images rather convincingly

send us back to witness the past *as* present. The screen body draws a much more intractable border for center-of-consciousness narration, or so it would seem: the screen divulges the body that the page keeps secret. So good is the camera at relaying past as present, so vital are its anterior images, we often forget the initial orientation provided by the voice. In fact, we may forget the speaker altogether if he or she does not return frequently enough during the tale to remind us of its telling. A flexible device that stretches or condenses time, flashback narration both relays the temporal evidence of dying and provides a safe place in time from which to view it. This becomes especially pertinent to instances of first-person reflections on dying. The flashback before death, endemic but not exclusive to film noir, departs from literary antecedent in its inevitable insistence on the relationship between sound (the voice that returns to the past) and time (the images moving forward). The voice looks back to prepare for death, even posthumously, suggesting cinema offers something that evades us in life—a chance to die more than once. It is to film noir, and to noir-type plots that revisit or encircle a break in vitality, that we must now turn, to see how they "second" death—because such films elaborate on the instant through temporal layers afforded by postsynchronization. These films inevitably posit breathlessness or silence as narrative's momentous appointment with death, but they turn that instant back into a process—never fully completed—composed of hindsight, repetition, and perhaps most important, moral recognition.

LOOPING BACK, OUT

The premier use of the obituary voice in fiction film may be John Ford's *How Green Was My Valley* (1941), a film in which a son recalls his childhood in a story that concludes with his father's fatal mining accident. Earlier voice-over was envisaged as a defense against time. In the recently restored *The Power and the Glory* (1933) the protagonist tells the story of a dearly departed friend, talking over images from the past that reset the now-soiled reputation of the deceased. The flashback structure in Preston Sturges's script for the film devised a kind

of posthumous testimonial.[7] When Philip Dunne was commissioned to write the screenplay for John Ford's *How Green Was My Valley*—a film that "may well have set the mold," as Sarah Kozloff puts it, for voice-over flashback—he followed Sturges's earlier model, which he termed "narratage."[8] Originally conceived as a voice speaking over a silently playing film, narratage afforded Dunne and Ford the strategy of making the past present as a frame narrator (Huw Morgan) recollects his childhood experiences in a Welsh coal mining village. Huw's voice strikes up the story of the valley "as it was when" he was a boy, when it was "possessed of the plenty of the earth," before the sludge of the coal blanketed the hillsides. His voice courts us into, and then back out of, the past.

Huw's memory and the film are correlated by the narrative as techniques to ward off mortality. The film's theme would seem to be, as Kozloff writes, "the power of memory (which is explicitly linked to the power of God) to defeat death and loss."[9] A pair of deaths occurs toward the end of the film, both foreshadowed by the warning whistle (a knell that spells approach rather than death's aftermath) blown from the mine's entrance. With the first, Huw's father, Gwilym, ascends from the mine depths on the service elevator, positioned in a tableau of grief. His son Ivor lies across his lap; Gwilym's hand rests on his son's arm, and the preacher, Mr. Gruffydd, places his hand on Gwilym's. They hold their pose for several seconds in a tableau that ascends. Later, Gruffydd's departure from town is interrupted by the familiar sound of the alarm whistle. The crowd gathers again around the mine's open mouth, fearing that Gwilym has not escaped the explosion.

After Huw enters the mine and holds the hand of his still-breathing father (a descent that gives time for Gwilym to utter his final words to Huw: "That is a good old man you are"), we cut to his mother, Bess, standing with his sisters, Bronwyn and Angharad, awaiting the outcome of the rescue attempt. Bess tells the women that she has just had a vision in which Mr. Morgan appeared to her.[10] (We may be reminded of Mammy's premature registration of Spunk's death in *Hallelujah!*) Returning to the elevator shaft, the last two shots of Gwilym in the flashback alternate between movement and stillness. The first repeats

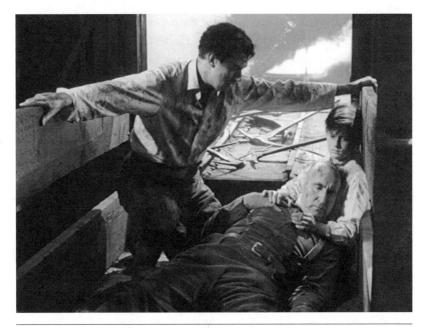

FIG 4.1 Huw, his father, and the ascending elevator tableau in *How Green Was My Valley* (John Ford, 1941).

the earlier tableau of grief: the top layer of the elevator becomes visible, framed by the static and passive camera, with the rescuers posed motionless, some with hats off. Then the elevator moves again, bringing the bottom level into view, this one of Huw (occupying Gwilym's earlier seated position) with his father in his lap (occupying Ivor's) and Gruffydd with arms outstretched as if holding himself up by using the elevator walls (fig. 4.1). Cutting in to a medium close-up of Huw's face, the camera establishes a more intimate reaction. Fires swell in the background; intimations of Ivor's village choir sound from outside the diegesis.

Immediately Huw's adult voice resumes its narration, breaking the spell of the tableau's dramatic stasis and rescuing us from Gwilym's permanent absence, with the following phrase: "Men like my father cannot die." With the same breath, Huw denies his father's mortality and registers his passing. Then something quite interesting happens:

Huw repeats, "How green was my valley," which kick-starts a set of images extracted or adapted from earlier in the film, recycled in the father's aftermath. This repetitive posthumous motion includes several images: the Morgans are gathered for dinner at home; Huw greets Bronwyn; Angharad steps through a gate to wave to Huw and Gruffydd. Now the bodies move before us but are not granted narrative immediacy. Kozloff writes: "As at the beginning when the picture flashed back to the unspoiled valley, the image cuts now from the sad and ugly scene at the mine entrance to a montage of shots from happier days."[11] Equally important, the voice-over escorts us into these reprised images from that temporal and spatial elsewhere inhabited uniquely by the offscreen narrator. From the loop of replayed images, the coda unexpectedly jumps to a fresh set of images that approximate an otherworldly reunion of father and sons. Two shots are of Huw and his father on one hillcrest, and one is of the five brothers reunited on another. The sense of a posthumous—or, better yet, a "postdiegetic"—reunion is enhanced by the top-quarter horizon line and blue sky in the shot of the arriving brothers.

Kozloff and Brian Henderson agree that the coda does not actually return to the frame space from where and when the narration began.[12] Instead, the film ends by leaving the flashback floating in a suspended time that cannot go forward. Kozloff keenly notes this denouement "loops back again in time, or rather loops back, out of time."[13] "Back, out" of time, indeed: the end restarts the act of flashing back with Huw's phrase "how green was my valley," a refrain of Huw's founding utterance that began the main flashback. The movie flashes not *back* but *out* of itself when the father's death forces Huw to recognize what has been lost and what can no longer be.

The suspended temporality of what we can call Ford's "postdiegetic" coda (Kozloff remarks that the "figures are suspended in fluffy clouds as if in heaven") recalls the final shots of Griffith's *The Country Doctor* and *A Corner in Wheat*, with the difference that Ford's movie does *not* end by renewing an image from earlier in the film. Ford varies Griffith's strategy of repetition: first, we do re-view scenes from earlier in the movie, snippets taken out of the past again like the memories they constituted the first time around, preserved in motion; but then

we have the truly postdiegetic images of the reunion on the hill, images no one in the movie sees or remembers. Only the spectator has eyes for this second set of pictures.

Kozloff's reading stresses the happy ending, that is, the apparent success of animated memories to keep the dead "alive": "As long as the film endures, [Huw's] family is immortal."[14] But the stress points in the movie's visual rhetoric, in its fantasy, are of special interest. The loop and coda are not evidence to me that as long as the film endures it keeps the family around; actually, they suggest the movie can only start all over again to ensure "men like my father can never die," and when repetition struggles to produce closure in a world truly devoid of the father, it must conjure a reunion beyond the earthly purview of Huw's gaze.[15] (That is, it must leave the diegesis.) The uncanny repetition of the originary flashback undercuts a clear sense of permanent absence, covering it by skipping over the hole left in the world in the father's wake.

Huw's omniscience—his ability to thwart mortality by reanimating the past—is in the end muted, splintered off in the final three images by an absent narrator. These are nobody's memories and, in fact, illustrate that cinema may not be God's gift to preserving the past in the face of death. Huw's flashback only repeats Mr. Morgan's life-before-death in a perpetual loop. Ford's film does not keep the dead alive; it comes closer to keeping Gwilym dying over and over.[16] Ford provides closure by breaking outside of the diegesis altogether, outside of memory, even the memory of the film.

Films in which a character repeats the past to come to terms with his or her *own* mortality—through the flashback, the posthumous voice, or some combination of the two—retain some of the tension uncovered by How Green Was My Valley's rhetoric of transcendence, proving that voice-over narration leaves registration partly unfinished and dying still under way. The trend of subjective dying enters perforce with the film noir cycle of the 1940s, a genre known for derailed, even suspicious, narration. Subjective camera work appears often enough in film noir to achieve the status of a generic staple.[17] Besides first-person point-of-view experiments like Lady in the Lake (1947), the camera often simulates the protagonist's experience of "going out,"

that is, of losing consciousness. A case in point occurs in *Murder, My Sweet* (1944) when Philip Marlowe is knocked out—the image blurs and fades to black, while Marlowe guides us through to the other side: "I caught the blackjack right behind my ear. A black pool opened up at my feet. I dived in. It had no bottom." This scene visualizes the movement out of and back into consciousness through a character's point of view, while his voice keeps us anchored in the narrating consciousness. (Though Marlowe finds "no bottom," we do.)

Besides the overtly expressionistic use of the camera to supply a distorted viewpoint of a character under duress, the stories of film noir concern male heroes fated to repeat something bad in the past, usually some prior offense. Passively waiting to die, the Swede in *The Killers* (1946) sums up the general predicament: "I did something wrong— once. Thanks for comin'." The genre is replete with men waiting— near electric chairs, police cars, lynchers, armed assassins. Bigelow's claim to have been murdered fits squarely within the tradition of noir's ensuing pasts: he has been poisoned, and soon the poison will "catch up" to him and stop him where he sits. (The police station does not provide safe harbor from mortality.) *Sunset Blvd.* (1950) goes all the way and posits the space and time of Joe Gillis's act of voice-over narration after life, affording him a posthumous seat of presumed authority and omniscience over all diegetic events.[18] Looking ahead from the verge of death triggers a bout of storytelling in which previous events converge with the opening precipice.

As the protagonist narrates and thus "produces" the screen action, his speech confers to him a modicum of control over time and, by extension, the time of his own death. He wishes to die only after he has first confessed some prior tort. What the dying have to say outweighs all the witty language of the living. Like us, Kitty Collins knows the worth of a dying man's words in *The Killers*, begging her expiring husband, Big Jim Colfax, to tell the police, "Kitty was innocent." Lieutenant Sam Lubinsky intervenes: "Don't ask a dyin' man to lie his soul into hell." Dying seems to present the least interference of the censoring psyche, delivering a speech act uncommonly trustworthy and binding. As final words, stories told *in extremis* are particularly loaded: the flashback arrives at the end of life via the detour of a personal narrative. Death

cannot arrive without the storyteller's expenditure of energy. Catching up with the man who borrows narrative agency for the moment, death might occur "on time" rather than "too soon."[19] We get closer to death through psychological anticipation and reference, but we are removed from it at the same time, since it has already happened. What we often find in film noir and its successors is a circular death—one that happens as much in the past as in the future. While ostensibly responsible for closure, the voice-over narrator spins dying in a perpetual loop. Registration—that process whereby film confirms a living figure has indeed died—takes the form here of (nearly) the entire movie, addressing the seated spectator's relationship to filmic structure itself.

DEAD MAN TALKING

"He's dead now, except for he's breathing."
—*THE KILLERS* (1946)

"Who was murdered?" inquires the homicide captain. "I was," claims Frank Bigelow, whose well-known rejoinder sparks his flashback explanation of how he came to be poisoned by a mysterious other. From this, the first scene in Rudolph Maté's *D.O.A.*, Bigelow leads his interlocutor back into the recent past, to reconstruct the events leading up to his fatal poisoning. Bigelow's flashback eventually returns to his present but unfinished dying in the police chair.[20] The sentence "I was" certifies a past death that will rejoin its parent body in the future. The flashback leaves Bigelow "behind," as it were, to endure a screen time protracted by finitude. His claim to have been murdered brings to mind many similarly condemned males in film noir who, full of mortal thoughts, come to accept death as the consequence of some ethical line they crossed in the past. Dying generates an act of storytelling that restages an instant of past transgression, one that mirrors the death moment waiting in the future.

Temporally compressed between two deaths (the claim to have been murdered and the last gesture), *D.O.A.* takes the form of a desperate plotting of Bigelow's own life-before-death, its content the very

absurdity of that plot. Bigelow's story of how he was "murdered" starts in the small-town "space of innocence" of his insurance company and moves to San Francisco, where he takes a short rest cure.[21] From there it spins dizzyingly out of control. He is poisoned in a nightclub by a faceless figure with a striped scarf. Diagnosed the following day, he sets out to track down his murderer. Starting with the phone call from his girlfriend, Paula, who tells him that a Eugene Phillips had tried to contact him before himself mysteriously popping up dead, Frank goes through many permutations of the "plot" before arriving at what appears to be the correct version, just at the moment when the spectator is torn out of the flashback and brought spiraling back to the police chair. In the final stages he barges in on Mrs. Phillips, all but forcing from her the scenario that she and her husband's associate, Halliday, were covering up their affair by killing off those who knew the paper trail of the "uridium" sale. This last iteration of the plot seems particularly forced, shaken out of the widow by Frank's physical wrangling. To duck the threat of Majak and the boys downstairs, he hobbles through a parking garage, reminding us of his quickly worsening condition, and returns to Halliday's office, where he finds Halliday, wearing the striped scarf and top hat, exiting.

Taking his "final" steps in another milieu besides the police station, a milieu projected onto the past, complicates the external boundary between "alive" and "dead" drawn by the cinematic body. Bigelow's flashback suffuses his own end with an increasingly schismatic plot— a series of near-encounters and partial revelations held together by his increasingly physical efforts at coherence. The story of the flashback, spanning from one office (Bigelow's own) to a second (Halliday's), projects his true condition, sitting in the police chair (in yet a third office), onto the outside of his body. The relation of flashback images to the locutionary act of their voice-over narrators has long bothered critics. To sort out this relation, film scholars often echo Eric Smoodin's claim that the speaking subject inaugurates a flashback that remains a present elocution: "Once the presence of the voice-over narrator has been established, the entire film serves as a sort of linguistic event, as the narrator's speech even when there is none."[22] Though it begins clearly as Bigelow's speech, the flashback in D.O.A. (like many

others) drops his parent point of view and opts instead for a fuller view of his environment, a picture that fatally evaded him the first time around. At the Fisherman's Club the camera finds the cloaked figure clad in a striped scarf. As Frank tells the bartender to fetch him his drink abandoned at the bar's opposite end, the camera cuts to frame the mysterious assailant as he replaces Frank's glass with another in his possession. Catching a glimpse of the enigmatic figure that poisons the drink, the camera objectifies the flashback with details his memory can't possibly contain (if it did, they wouldn't be there). The camera moves outside his body and mind: it is omniscient in post.[23]

Just as the flashback shows more, it may also show less than the narrator knows. We don't actually see Bigelow kill Halliday; instead, as gunshots are hastily fired, we twirl back to Bigelow in the present, interrupting this last piece of incriminating visible evidence. Typical of noir flashbacks, Bigelow's story refuses to indict him where fault may actually be most palpable. This isn't that shocking for a protagonist who has told us he was murdered. After being diagnosed in the flashback, Bigelow's speech to Mrs. Phillips masks his present condition: "I'm not alive—sure I can stand here and talk to you. I can breathe and I can move, but I'm not alive because I did take that poison, and there's nothing I can do."[24] What he does not say, of course, is that he is *going* to die, that he is still *dying*. As such, Bigelow insists on an "on/off"-switch model for what others—and we—see as a process, as though cinema here is staging a "debate" that has dogged its own history. Noticeably silenced by Paula's questioning, he publicly behaves like a man for whom dying has become a horrible secret.[25] Maureen Turim describes the noir voice-over as a weapon against full admission of guilt, if not an excuse for out-and-out lying. Rather than making the hero vulnerable to the law, the confession "serves to protect the hero, as it never exposes his psyche to examination nor allows for his own responsibility in desiring to kill off his rivals." Carefully censored, self-revelation "is a consistent disavowal."[26] Certainly we do not see Bigelow's assailant at the abandoned warehouse, firing shots at the running man; nor can we possibly believe that Bigelow recognizes the scarf on Halliday the way we do, for he certainly did not see the man the first time around at the Fisherman's Club. It

follows that the flashback screens the truth about mortality as well.[27] Bigelow's stake in being already dead certainly allows him to evade the fuller truth that he also committed murder. "I was [murdered]" covers over "I killed." But it also covers over the future "I'm going to die." It is easier for Bigelow to have been murdered than to face his own near but unpredictable end. The flashback's visuals face death for him.[28]

Because the police station brackets the past story, forming a fatal loop, Bigelow's cinematic body gains curious qualities of presence. For one, the flashback's objectivity (the switching of drinks, for example) modifies the divide between Bigelow's external form and his internal past, a past only he knows and can narrate to the police. In other words, the body's outside/inside barrier becomes a separation between present and past, where "outside" maps onto the speech act begun in the police station, and "inside" maps onto the trip to San Francisco. Of course, one could argue that it runs the other way, with "inside" the act of remembering, or voice-over, and "outside" the sequence of events in time. A second transposition is that death, the event that ends life, becomes existentially doubled, placed both in front of and behind Bigelow. Both transpositions move the protagonist outside the clutches of mortality and the law. Like Turim, J. P. Telotte sees circular noir flashbacks as dodgy, "as if they represented but one more variation in an endless round of speculations about the past," not the one "true" version.[29] The flashback at once approaches and avoids the truth about death as one of several public admissions from which we are shielded. The true condition of the protagonist's body, therefore, is not made visible throughout the movie. It is failing in the present tense of the telling, and in the case of *Sunset Blvd.* it has already failed. Desks and countertops, not deathbeds, frequently stage the act of recollection, reminding us there are legal stakes to these late admissions.

The flashback's shield protects narration against screen images, including, as we will see, images of dying. We know from Christian Metz that the cinematic present can never be a full present; likewise, the voice produces only the illusion of a safer time outside of diegetic time. The storyteller's delay reminds us that all cinematic images are past images on the delayed "mirror" of the screen.[30] But the illusion

that the current image is the present tense continues to be convincing. By contrast, the voice-over "present" ranges widely, from a critical evening (as in Walter Neff's spoken confession into a Dictaphone throughout *Double Indemnity* (1944), wherein we see his bloodstain widening over time) to an eternal domain (as in Joe Gillis's posthumous narration).[31]

Projecting death's imminence into the past keeps the emphasis away momentarily from the hero's waiting for an unwanted future. The flashback bequeaths these men (and the spectator) more time to see death on its way.[32] The first time around, death's approach is denied the hero and catches him off guard. By the time he is finished, it will appear the conclusion of a predestined chain of interlocked incidents. In what seems an exercise in Freud's notion of the compulsion to repeat, the noir flashback binds the prior traumatic events into a narrative form that can be at least sequentially comprehended. Not only is the flashback a means by which the narrator tries to master the events of his past by repeating them, injecting into previous trauma an anxiety that could not then have been present, but it is also a temporary escape valve to secure more time before death. (We will see more clearly later that these two energies are in fact much the same.) By gathering onlookers and auditors, the narrator injects more future into his death, almost relishing the moments in his near-past that have yet to turn into his future-death.[33] As Vera says in *Detour* (1945), "We all know we're going to kick off someday; it's only a question of when."[34] That question of "when" is exactly what worries many male narrators—and cinema more generally. The unknown "when" motivates the noir hero's unremitting efforts to place death at the end of his expert testimony, offered on the subject of himself. Telling a story allows the hero to do something with time besides passively receive its effects. Thus, flashback offers cinema a new instantaneous barrier (the moment the voice stops talking) that will unfold as a process— sometimes the voice never stops talking, and sometimes it has already stopped and we don't know it, but either way, it leaves us behind with more, not less, to question.

Though voice-over and flashback offer some protection, mortal concerns are usually displaced onto the female body or some other

agent of sexual threat. In *Detour* Al Roberts notices Vera's frequent coughing spells:

> ROBERTS. You've got a mean cough; you oughta do something about it.
> VERA. I'll be all right.
> ROBERTS. That's what Camille said.
> VERA. Who?
> ROBERTS. Nobody you know.
> VERA. Wasn't that the dame that died of consumption?
> ROBERTS (*looks away, nods*). Yeah.

Or take a scene from *D.O.A.*, a film that covers over the unknown duration of future pain. In a scene that aligns homosexuality with sadism (and thus doubly delivers a masochistic punch to the audience), Majak's henchman Chester provokes Bigelow by intimating how he will take care of him "nice and slow—that's how I want to see you go, Bigelow, nice and slow."

Most often the flashback pins male anxiety onto the nearest female object. As she highlights the gender inequality of the voice in classical cinema, Kaja Silverman points out that male, not female, characters gain access to the elsewhere of both third- and first-person disembodied narration. Losing the voice constitutes an exclusive privilege for the male; the female voice, on the other hand, is usually contained by a framing device in the narrative "such as a painting, a song-and-dance performance, or a film-within-a-film," or else it is made so theatrically present as to be an uncontrollable extension of the woman's body.[35] In *Letter from an Unknown Woman* (1948) a female voice-over is employed as a strategy to present, and register, a death that has already happened. The movie opens with Count Stefan Brand, who, dodging a duel with an unknown man, opens and reads a letter that is in turn read aloud for our ears by its female sender—Lisa Berndle. Here I offer an abbreviated version of the letter's intro: "By the time you read this letter, I may be dead. I have so much to tell you and perhaps very little time. Will I ever send it? I don't know. I must find the strength to write—now, before it's too late. . . . I think everyone has

two birthdays—the day of his physical birth, and the beginning of his conscious life. Nothing is vivid or real in my memory before that day in spring when I came home from school and found a moving van in front of our building. . . ."

Flashback to Lisa's first encounter with Stefan, and the story of how the two were brought together and then separated, only to reunite later when Stefan, tragically, no longer recognized her. We see Lisa suddenly drop over the letter she is writing in the flashback, and the corresponding mark on the paper Stefan is reading where she stopped writing. The camera moves down to reveal the following typed postscript: "This letter was written by a patient here. We believe it was meant for you as she spoke your name just before she died." And then below, in cursive: "May God be merciful to you both. Mary Theresa, Sister in Charge." Realizing, then, that he was indeed too late, Stefan registers the nurse's official registration of Lisa's death on arrival.[36] The usual coda of posthumous shots follows—we see Stefan lifting Lisa's veil, approaching her on the street, the two dancing in a long shot, and so on. Having now found "what was never lost," Stefan decides he can meet his fate at the hands of his unknown dueler and steps out into the early morning. We might mistakenly align this film with *Sunset Blvd.*, in which the male flashback produces a belated reprieve from death. However, Lisa Berndle is not the one who plots and recollects; she is plotted and recollected by the man *who reads*. Registration catalyzes the male's frame decision to face his own fate—this is *his* story in the end, not hers.

The female flashback "framed" above only reminds us of how the recognition of male virtue in classical cinema usually functions as a homosocial exchange between men. For one thing, the sympathetic ear to which the confessor addresses his tale belongs to a man with higher symbolic power—such as a boss, mentor, or police sergeant—who supplies missing moral recognition in the nick of time, just before punitive forces step in. This was presaged in early cinema's frequent depiction of registrants with symbolic power functioning on behalf of the state, but here it informs narrative structure. Second, this higher power of registration, as with the stamp of "D.O.A.," combines human and bureaucratic confirmation. After all, these tales are often pleas to a higher power. What makes them interesting in this regard is their

dispersal of the subject throughout the objectified flashback, a cinematic correlate to what Peter Brooks says, writing elsewhere on the nature of confession as a speech act, about the extent to which confession *produces* (rather than *erases*) guilt: "We want confessions, yet we are suspicious of them" in part because they tend to produce guilt, and "the more the guilt produced, the more the confessional machine functions."[37] And finally, because the spectator has been involved in the relay of the plot as well, he or she arrives at registration after the appropriate expenditure of plot. "On time" deaths, on one hand, tend to be social, as we saw with *The Jazz Singer*, in which audible music creates a space for moral recognition. "Too soon" deaths, on the other hand, are rarely communal and often require replay to be absorbed. Without the homosocial context and the listening public, the flasherback would die alone.

But Bigelow's flashback courts us into believing it will reveal the secret to his undoing. His detection drives toward identifying his assailant, but once Halliday is implied as the killer and we return to the police station, the revelation holds no force. It is brief, pointless, and immediately discarded—Bigelow strains to say something intelligible about Paula and collapses behind the inspector's desk. Rather than be guided by the voice to the heart of the diegetic mystery, we get lost in the plot along the way. Writing of *D.O.A.* and *The Big Clock* (1948), Telotte claims that "in such films time becomes not only the propelling imperative of the narrative, but its antagonist as well, a force that promises to shut it down, to end the individual's history before it can be fully written." All noir plot for Telotte foregrounds the "precarious nature of the individual human story."[38] Plotting itself, especially when the product is labyrinthine, becomes a form of dying; putting together the pieces of his recent past is what Bigelow is doing at a rapid clip just moments before his time runs out in the police station. Spinning webs of narrative as an act to cover over the present is literalized in the aptly named *Detour*, in which Al Roberts is heard narrating his "future" capture as it occurs right before our eyes. In this sense the voice-over complements the early impression of Edison's phonograph as a speaker, a machine with a "voice"; here the cinema allows the phonograph/speaker to stop talking when it/he wants.[39]

The actual plot converts waiting for death into a release of energy through storytelling. For Peter Brooks this conversion is the driving force behind all narrative. Readers strive to reach the story's death, the end, expecting it to rhyme with, be similar to yet different from, the beginning that drew them in. For readers the beginning promises to bring "final coherence" at the end in the form of "that metaphor" for the beginning "that may be reached through the chain of metonymies" offered by the plot. In fact, the middle pages of plot extend, and dilate, the difference between beginning and ending to enact the reader's desire to fulfill an initial promise: "We might say that we are able to read present moments—in literature and, by extension, in life—as endowed with narrative meaning only because we read them in anticipation of the structuring power of those endings that will retrospectively give them the order and significance of plot."[40] Brooks's point is that all plots ensure the death drive, that they in fact "pre-enact" dying.

As the reader moves toward the climax of the story, he or she must follow a metonymic question-and-answer relay to continue seeking the ending as the final revelation of the meaning of the plot, or life, that came before. At the same time, the plot, or what Frank Kermode calls the "middest" between the moment of prediction and the projected ending, must also guarantee enough local satisfaction to provide the illusion of progress.[41] Walter Benjamin has observed that the protagonist's death allows for a cathartic encounter with mortality otherwise denied the reader in life; narrative structure is afforded life exclusively by death.[42] Only when life concludes can biography be narrated confidently toward its end as destiny. The ending structures and restructures the beginning throughout the midsection. Bigelow must derail us from and return us to the police station to watch him die.

A story need not be about dying to be "about" dying more fundamentally. Brooks employs Freud's *Beyond the Pleasure Principle* (1920) to provide a model for how ends relate to beginnings. Freud draws on both the returning war veterans plagued by repeating traumatic dreams and the child's *fort/da* mastery of his mother's absence to describe the psychic work of the compulsion to repeat, a description that proves especially relevant to cinema. By repeating (not simply remembering), the patient produces the sense of being perpetually

subjected to the prior traumatic occurrence, even to "suggest pursuit by a demonic power."[43] Because flashback brings memories to life, so to speak, and replays them in time, it seems an urgent occasion for Brooks's Freudian "masterplot." It also reminds us of Telotte's point that noir narration is but a desperate attempt to come to terms with the past, but not finally by mastering the prior events.

Along narrative's route, says Brooks, plot repeats a central set of character relations or events. Each event takes meaning by virtue of its recall and variation of prior items from the story (or *fabula*). For example, Bigelow's second encounter with the scarf-clad assailant triggers the spectator's memory of that scarf's earlier appearance, with the difference now that Frank believes he has learned that Halliday is the killer. Gathering its energies into usable bundles through repetition, the text delays the final discharge of energy, turning away from the momentary quick fix to ensure that the final discharge of energy (upon novel's or life's completion) is satisfying.

And more individuated. Brooks elaborates on Freud's claims that "the aim of all life is death" and the organism must "follow its own path to death, to ward off any ways of returning to the inorganic which are not immanent to the organism itself."[44] Likewise, plot must avoid the lure of reaching its goal too soon. Bigelow cannot tell Paula, or anyone else, that he's going to die, because he is saving that for us, later, when the end is imminent. In this vein Brooks sees the pleasure principle and the death drive as overlapping: the plot is "beyond and under the domination of" the pleasure principle. Repetition manages two forward-moving operations.[45] It provides the "sensible or audible" (cinematic) pulsations that keep us coming back to the text. But it is also a recurring blockade, for "repetition also retards the pleasure principle's search for the gratification of discharge, which is another forward-moving drive of the text."[46] Brooks arrives at a dynamic model of reading plot similar to the conflicting drives toward pleasure and death: "The desire of the text (the desire of reading) is hence desire for the end, but desire for the end reached only through the at least minimally complicated detour . . . which is the plot of narrative."[47] That minimally complicated detour becomes especially clear with voice-over narrations of dying.

Brooks's masterplot seems to apply to all genres—it is narrative's general aim to put us through the process of anticipating the end. For Brooks all plots are mini-dyings. But his model is especially relevant to flashbacks *in extremis*. Such stories delay death, and prolong dying, long enough to make possible that the end comes at the right time. (The question of whether it does arrive, or as an instant, must remain for the moment.) Thus biography emerges from the throes of dying. Bigelow is invested in the compensatory work of the masterplot, driving toward his end through a detour back through his past. Fabricated or automatic, conniving or sincere, this is the past of his future death. Ending becomes contingent upon storytelling. Having threatened to come too soon, the end of life is put back in the future, where it belongs. Or we could say that *D.O.A.*'s plot—the trail of events from Bigelow's trip to San Francisco through his poisoning, diagnosis, coping, and revenge—is *about plot itself*. The moment of death is placed at the end of the narrative that Bigelow helped write. Perhaps a bit shy of a "good" death, Bigelow makes closure more plausible through his eighty-minute metaphor of end for beginning.

The public dimension accompanying these death narratives recalls the medieval *ars moriendi*—a genre of illustrated woodcuts and later texts that represented dying over a series of images. Here in these dark-lit films we have something like a modern version of the medieval ritual of dying. Intended to instruct laity on how to prepare for the final moments, the *ars moriendi* emerged in the fourteenth century to allay an anxiety that the Final Judgment occurred at the end of life and not at the end of time with Christ's resurrection. Alberto Tenenti characterizes the deathwatch as a "deadly struggle between angels and demons who are perched like vultures over his deathbed."[48] Interestingly, Tenenti, Philippe Ariès, and Michel Vovelle continually emphasize the passivity of the scene: the dying, or *moriens*, watches the spectacle, lying in wait while the future of his soul is fought for by invisible forces over him. Yet subsequent historians disagree: Richard Wunderli and Gerald Broce see the *moriens* play an active role in the final moment that "became the final determinant in salvation because a man could lose his salvation through a mental slip, or gain it by dying with the proper mental composure."[49] As one bishop of

Bangor claimed in 1612: "An hour well spent when a man's life is almost outspent may gaine the man the assurance of eternall life."[50] The final moment in premodern England, as Wunderli and Broce insist, was so much in control of the *moriens* that later Enlightenment critics brushed it aside as a superstition of old. Making good use of the hour before death prepared the *moriens* for eternity by affirming his intimate worldly relations and securing a countenance of acceptance for his beholders. The ritual involved both wrestling with fate and producing a model of faith for the onlookers around the deathbed.

Having once been perceived by both Protestants and Catholics as the moment when all could be "gained or lost," the "final moment" is ritualized in Hollywood through repetition, hindsight, and disembodiment. Heaven does not seem to be on Bigelow's mind, nor salvation his avowed goal, but saving his last hour—or eighty minutes—for his police interlocutor reads as an attempt to save face. This countenance does two things: it clears his mind of any guilty deed, and it turns his sudden and meaningless poisoning into a movie attended by a moderate public. Rather than die alone, Bigelow dies in our good company; his eighty-minute hour of death is well spent. The rate of increasing desperation inside his flashback takes the place of the angels and devils fighting over his soul. The flashback is his fight. Like the Christian in reformer Miles Coverdale's nineteenth-century account who, if attuned to the *ars moriendi*, would know "that in his death he is not alone, but very many eyes look upon him," Bigelow has learned how not to be alone: he talks.[51] Publicly performed, the final moment ensures that it is never too late to be pious and save the soul.[52] Death will not come too soon.[53] The point, feared by Enlightenment skeptics, is that it is never too late to die on time.

The fact that some noir films employ flashback narration from the electric chair, as with *The Postman Always Rings Twice* (1946), shows that the modern tradition is still at work. The reprieve offered the condemned man is given not by the state but by the time of narrative delay, and the dead man walking becomes a dead man talking, allowing him to exert some semblance of control. Cinema has long favored the approach over the quick fix. Narrative delay recalls Edwin Porter's

multishot reenactment of Leon Czolgosz's electrocution discussed in chapter 1. I draw attention now to the middle item of that film's three-part structure, namely the shot in which Auburn state officials enter the jail cell to escort the condemned to the chair. Dead men have been walking since cinema began—earlier examples where execution is stalled can be found in a series devoted to the subject titled *Reprieve from the Scaffold*.[54] Noir's legal structure of pre-posthumous confession offers a new venue for the "undead," another item in its list of debts to German Expressionism.

Registration, too, has long been preferred as a process. We have looked at movies that provide confirmation outside the body, finishing dying in some process that circumvents the body. This may be provided by fictional beholders representing the symbolic agency of the state or by lay registrants, like mothers and fathers, whose experience of loss structures the time of death. Flashback's delay is but another form of approach—a longer walk to the scaffold, a momentary escape hatch, a spoken detour. But it also doubles as confirmation for a social death. As we take the long way to the gallows, we round the final corner *with* our guide. Of course, these flashbacks feel like they devise the best possible case for the defense at the moment of indictment. But something else is gained by rounding that last corner, something that exceeds the legal parameters of the films. Like the dilatory space of Griffith's parallel editing, though personified as an effect of a dying man's psychology, the flashback avoids death only to place it at a specific narrative moment.[55] To the spectator's surprise this placement may itself be a fantasy from the grave.

I am referring, of course, to already-dead narrators, not just playfully posthumous ones like Bigelow. Of particular interest are films in which we realize our narrator is dead when at first we don't know. In *Sunset Blvd.*, voice-over narrator Joe Gillis is floating in Norma Desmond's pool throughout the whole film. Because it is so prosaic, Wilder's film is worthy of a longer look. Joe narrates the flashback from outside or "above" the diegetic images, including the image of his own corpse. These two temporal zones cannot coincide, their overlap denied by Joe's mediation and the fact that the film begins after his death. If it has already happened, it seems, it will keep happening.

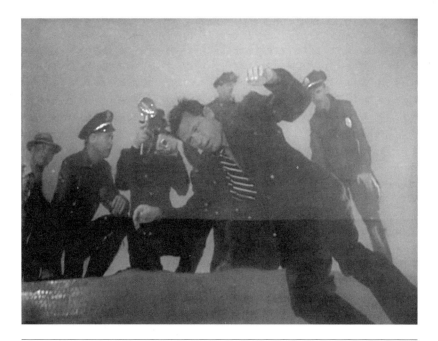

FIG 4.2 The floating corpse of Joe Gillis in *Sunset Blvd* (Billy Wilder, 1950).

From the start the camera approaches a floating corpse only to circumnavigate it. A stream of police cars speeds toward the camera (reminiscent of Walter's reckless approach in *Double Indemnity*), and our rather acerbic narrator quickly orients us: "That's the homicide squad, complete with detectives and newspapermen. A murder has been reported." Standing poolside, police and paparazzi gawk at and photograph the floating body—a veritable registration, but not the right one (fig. 4.2). Joe's voice, whose origin remains unseen, mobilizes the story of what he calls "the full truth" at just the moment when reporters are securing their version for the "late editions." Throughout, Joe's vocal tonality remains smug, itself marked as unusual (dead!). His voice strikes a similar chord to previous narrating voices. Jumping off the body like a springboard from the moment of its public inspection, Joe's voice enacts a detour through the past that arrives back at the end and, along the way, plots his own defense.

The "full truth" to which Joe alludes includes both the plot surrounding his floating body and the social suicide to which he submits himself, driving home Slavoj Žižek's popularized Lacanian distinction between biological and social death.[56] Rather than defer his exit by escaping to the past, he defers its "full" registration by not quite facing it or owning up to it. As in *D.O.A.*, *Detour*, and *Double Indemnity*, the voice-over shields the protagonist from any unnecessary admission of his own failings. Joe's verbal scrutiny turns again to that nearest female object—here, the (aging, occasionally corpselike) body of silent film star Norma Desmond. Before Norma's first appearance in the flashback, Joe has already hit rock bottom as a Hollywood scriptwriter, with one story waiting "dead as a doornail" at Paramount. Even Joe's baseball script *Bases Loaded* contains noir undertones: he outlines to an industry executive its story of a "poor kid . . . once mixed up in a hold-up" who is "trying to go straight except there's a bunch of gamblers that won't let him." Throwing curve balls with rehashed formulas, Joe struggles to maintain integrity in an industry based on generic reproduction at the level of plot—indeed, on making vacuous star vehicles. The executive finishes the pitch for him: "So they tell the poor kid he's got to throw the World Series, or else." Joe concedes: "More or less, except for the end. I've got a gimmick that's real good." Betty Schaeffer, a reader in the department, chides him for not making good on his talent: "So you take Plot 27A and make it glossy, make it slick." Later, when these two are coauthoring "Untitled Love Story," Betty predicts that the story of Joe's relationship with Norma involves "a multi-millionaire" who "leaves him all her money." Joe's response: "That's the trouble with you readers; you know all the plots."

It turns out the plot Joe is currently busy spinning—that of *Sunset Blvd.*—avoids formula with a novel "gimmick," namely, the revelation at the end that he is already dead. Joe gains access to Norma's home via detour, just as we gain access to the "full truth" through his belated voice. Blowing a tire, Joe ditches his car in Desmond's garage. As he stares toward the house a voice-off calls out from the upper balcony: "You there, why are you so late? Why have you kept me waiting so long?"[57] Norma repeats this neediness throughout, especially later as

she premeditates Joe's murder: "No one leaves a star." Death becomes Joe: he is at first mistaken for a funeral director (Norma's dead chimp requires a service). When Norma shoots him, the film repeats this original encounter. Norma's centrality is doubly lethal; it seems Joe is late for his own funeral. He regains autonomy and authorship only through his posthumous narrative, arriving at last as a scriptwriter.

When Joe's bullet wounds return us to the pool, the spectator names the nameless corpse—"two shots in his back and one in his stomach" match what we see visibly inflicted. But his voice, relapsed into silence, provides no inner lining near the actual death moment. Even later, as the police fish him out, he only offhandedly identifies himself with the corpse in the first person, but still only in the past tense, at a moment when we are watching again in the present. The two times should coincide here, and we should resume with present narration. That we are still hearing a past-tense narration means that our omniscient narrator is no closer to himself after death than before. As he falls into the pool, the camera cuts to and then follows Max the butler as he runs first to the water and then across the yard to Norma, standing by the house's entrance. This tracking shot is the longest of a human figure in the film, as if the narration of images slips from the orienting grasp of the dead man's touch. For the moment gone from the soundtrack, Joe's reassuring presence returns, under his dead body, when it is too late: "Well, this is where you came in, back at that pool again, the one I always wanted." This moment is telling, as the camera waffles before attaching itself to the next secondary point of identification. Max physically traverses the delay in narration, the moment when the film's present is revealed as posthumous. It is Norma, not Joe, we see last in the flashback. This focal relay occurs once more: when we return to the dispatchers outside Norma's house, we move from Joe's body to Norma's stunned and frozen reaction, her descent from the stairs into police custody, and her final speech that ends the film.[58]

Generally, the belated realization that a filmic protagonist has already died tends to produce an uncanny knowledge in the spectator, a moment when the meaning of the Brooksian metaphor of ending for beginning is glimpsed just before disappearing into the credits. An

intellectual scrambling for the correct order of incidents, this realization occurs when we fully recognize that the dead man floating is Joe himself, in a kind of curve ball that Joe, working against narrative expectations, would have appreciated. Such a late registration forces us to look back again for clues to something that we did not suspect was missing the first time around, to replay in our minds what Joe has already replayed for our eyes and ears. Describing the effect on the spectator of *The Sixth Sense*'s late revelation of Malcolm Crowe's death, Erlend Lavik writes that there "is simply too much previous syuzhet information that appears to contradict what we are now being asked to accept."[59] We are compelled to return to the film, but death comes awfully close to becoming a joke (on us).

Joe's covered body is carted away by the police: over this moving image his voice is active, deflecting attention away from himself again by constructing Norma's possible future defenses: "What would they do with Norma? Even if she got away with it in court, crime of passion, temporary insanity . . . those headlines. 'Forgotten star a slayer.' 'Aging actress, yesterday's glamour queen.'" His tone, like that of Bigelow, is vengeful. Similarly, a policeman walks to the house phone and tries to call the coroner, only to be interrupted by Hedda Hopper, who, already on the phone upstairs, is busy reporting live on the star's psychosis. "This is more important," she says. Norma's muteness outweighs Joe's death, registration, and posthumous motion. Even Joe's dead body is upstaged by the silent film star's iconic one, perhaps a suggestion that the enlivened sound image (Joe's voice-over) cannot compete against the crypt and mummy of silent cinema's imaginary (Norma's psychosis). Under the sign of Norma's mummy, Joe's voice-over becomes the sound film version of eternal dying.

Subsequent viewings of the film from the point of view of the dead man remain consistent with the general dictum that flashbacks convey subjective experiences objectively. What stands out in *Sunset Blvd.*, however, is that strange moment—brief indeed and best relished on initial viewing—when we realize we have been aligned all along with the dead man's perspective and have really gone nowhere since the movie began. A part of the self remains unchanged, and as a consequence,

death seems not to happen before us in space but before and behind us in time. *American Beauty* (1999) repeats the noir idiom of a corpse's belated narration but lets us know up front that Lester Burnham's dead: "In less than a year, I will be dead," he tells us knowingly. But the opening aerial shots of Lester's hometown make implicit, if not explicit, what the point of view of the dead offers cinema—the intimation of a postdiegetic afterlife or purgatory. Whatever change the body undergoes onscreen, the voice-over keeps alive the illusion of vitality. In excess of Joe's and Lester's visible bodies, their voices remain in a state of perpetual revision. Separating voice from body fantasizes transcendence, but the liberated voice is stuck on rewind. Cinema's posthumous voice contains an element of liveness missing from its literary counterpart. The speaking dead in movies bring together the posthumous time they inhabit (voice-over's elsewhere) with the time of projection, aligning spectators with the corpse and not, as in the early sound period, with the dying person or the mourner. The secular afterlife's repetition toward death replicates the spectator's reflex to re-view the film when these belated unveilings so central to the apparatus occur. The moment of death emerges in the field of vision after the fact.[60]

It is not just Frank Bigelow, but the cinematic signifier per se, that is dead on arrival. All reception of screen images is delayed. The film body is always potentially posthumous. If it isn't yet, it will one day be. This possibility is realized by any epilogue sequence that tells us that a fictional character dies after the diegetic story elapses.[61] The posthumous voice and the textual obituary frequently furbish documentaries with certification that otherwise evaded the camera. From Luis Buñuel's *Las Hurdes* (1933) to Michael Roemer's *Dying* (1976) to Frederick Wiseman's *Near Death* (1989), mediation by what we might call the "voice-after" or "text-after" supplies registration missing from the visuals. When watching a film like *Sunset Blvd.*, we become aware that all film plot is delayed and carries the trace of a future burial (another kind of "plot"). We are always watching from a later position that is unusually commensurate with a posthumous one. *Sunset Blvd.* and *American Beauty* personify this posthumous potential through the voice-over narrator; in the former, says Telotte,

the main character confesses to us as though to "an audience of fellow ghosts."[62]

As for how and whether these films arrive at death, we are ready to make a few claims. A series of individual frames tossed against the screen, cinema is dead on arrival, leading both Garrett Stewart and Scott Curtis to equate cinema with the perpetual condition of being undead.[63] Film arrives dead, they might say, but on the condition that it never fully arrives, for the photographic element beneath the illusion of movement is deferred. Yet, again, what underwrites these aphorisms is the equating of photography—the secret ingredient inside the impression of motion—with death (though Curtis does elsewhere move toward complicating the equation).[64] But there is another conceptual direction to take, one that acknowledges the history of medial innovation in the cinema, a history that includes the voice-over. We are always in both the presence and absence of the images, and these voice-over films figure a switch between one side and the other. The very fact of replay, however, suggests that what we experience is not the pulling of the switch itself but rather the process that leads up to then away from it. The shift from bodily to moral death (then back again) marks another cinematic "switch." Because it wants to coordinate a social death with the same breath it exceeds the body, the voice speaks from an afterlife in flux that is only really a liminal space. It is a time that keeps returning to revise the past in a perpetual loop, but without death this return can have no ending (or, indeed, beginning). Like the films themselves, voice-over both acknowledges and denies mortality.

THE POST-NOIR LOOP

Noir's pre-posthumous narration moves the death moment closer to the space of projection where the spectator watches the images. Encroaching on the spectator's own space and time, the voice-over nestles closer to our position, as if to compensate for the fact that the camera will always arrive either too early or too late. The voice-over's elsewhere translates to a place in time that allows for a dynamic

transition from the proleptic "Within a year, I will be dead" to the future perfect "Within a year, I will have died." (Neither of these remarks, however, owns up to the full truth that one *will* die, placing the emphasis, like Bigelow, on either side of a perceived break.) The future death is already past in the Brooksian sense; it must have already happened for it to become knowable. Like Dennis Porter's theory of detective narrative as backformed from the ending revelation of the opening crime, voice-over moves backward toward death as it moves forward away from it. Invoking *D.O.A.*, we can say that death's arrival in cinema occurs in layers of revelation and unveilings of time—never *that* time onscreen, but *this* time before us, whence we looked back.

Self-narrated dying continues beyond noir, popping up in unexpected places. Hindsight need not be provided by the voice-over or voice-after, though it continues to be so employed; indeed, the voice-over drops out of the loop, but the loop's double effect persists in a range of films, including *Seconds* (1966), *All That Jazz* (1979), *Jacob's Ladder* (1990), *Carlito's Way* (1993), *The Sixth Sense* (1999), *Donnie Darko* (2001), and *The Jacket* (2005). An unlikely instance is the part-musical *All That Jazz*, which employs the posthumous gaze from a kind of backstage area, adding a new twist to the backstage musical. Usually, backstage romance is infused with an onstage performance, production, or couple formation. As Rick Altman tells us, a fundamental "love = art" syntax stabilizes the genre, pairing onstage and offstage happiness.[65] *All That Jazz* uses a variety of theater spaces for extradiegetic commentary. From the beginning offscreen bandleader who, over the opening credits, commands, "One more time, from the top," the film places Joe Gideon on a threshold from which he can ponder the life he has already lived (his work, his womanizing ways, his addictions). Immediately replaced by the offscreen sounds of a man's cough, the soundtrack is then taken over by the yellow tape playing in Gideon's bathroom, serenading him through his morning ritual of showering while smoking, popping Dexedrine, and watering his red eyes. After this we see in near darkness a tightrope walker, over which Gideon pontificates: "To be on the wire is life; the rest is waiting." "That's very theatrical, Joe," a musical female voice answers. We see a long shot of a cluttered stage—it is difficult to tell if it's a stage

or auditorium, our only clue a row of footlights. Seated amid the array of machines is a figure in white with a halo-and-winged headpiece, the figure whose voice we just heard, credited as "Angelique." Throughout the film Joe and Angelique discuss Joe's life as a choreographer and director (based largely on writer/director Bob Fosse's own life) from the slightly blurred-out white, blue, and black world of these other spaces—at times a makeup room, at others a cluttered stage, at still others a milieu containing a hodgepodge of figures and objects from the diegetic story (in one episode, Joe's mother tells the camera about her boy's innocent vaudeville beginnings, while behind and around her we see something like a reenactment of the flashback). These imaginary spaces are like the desktops of noir, and moral status is very much at issue.

Over time the recurring after-diegetic spaces transmit signs of Joe's acute health problems and set the stage for his death scene—a condensed description of which will follow.[66] A second nod to mortality is stand-up comedian David Newman, whose previously filmed routine on "death and dying" must be edited by Joe in nightly sessions for his upcoming release *The Stand-Up*. Newman jokes plenty about Elisabeth Kübler-Ross's then-current work on the terminally ill, dramatically enacting each of her five stages of dying. Together, these two forms of mediation—the after-life and the comedian's recurring words in Joe's head—begin to encroach on the diegetic images of Joe.[67]

Even though Newman's voice can be explained as coming from Joe's tape and not his mind, the film thoroughly surrounds Joe's diegetic body with audiovisual invocations of illness. Played against the backdrop of Gideon's hunched-over and pain-wracked body, the comedian's dark humor plays like a violent assault on Joe's inability to take his condition seriously and his desire to throw himself into show biz to cover it up. At one point unable to authenticate his visions of this world, Joe invokes Browning's bishop: "Am I alive?" he asks. A healthy version of Joe appears in his mind's space to direct a series of dance routines, and since these all take place in front of another double (this one of the bedridden Joe), they suggest that he's directing his own death scene. Healthy Joe asks sick Joe: "You wanna shoot it now?" Sick Joe mumbles something. Healthy Joe

can't understand his response and moves on. This "other" healthy Joe allows the sick one to orchestrate his death. He joins a list that includes Bigelow's homicide captain, Joe Gillis's ghost-voice, and Norma Desmond's paparazzi.

Turning to what Leonard Maltin refers to as the "interminable ending," it is a series of numbers choreographed by Gideon/Fosse, performed by Gideon and his girls, in front of a theater of patrons. (This funereal fantasy could in fact be a posthumous one, given that Joe is already dead when the movie begins.) Joe says good-bye to his ex-wife, Audrey, hugs his daughter, waves to topless women. Accompanied by an African American television host, Joe's farewell performance gives more than a nod to the racial dynamics of *The Jazz Singer*—here, Gideon is accepted by the black entertainer, just as his singing and dancing with a black nurse minutes before dying shows him in a good light and garners audience sympathy. Gideon spends his acute moments on an imaginary stage until he is moving down a long corridor, shot from the waist up, toward Angelique who stands waiting at the end. In a series of alternating shots that staggers and resists, Gideon reaches the end from within an acousmatized corridor that echoes his own song around him. Suddenly, this gradual beckoning (which culminates with a close-up of Gideon's eyes) is interrupted by a cut to an overhead and soundless shot of his body being bagged up in the hospital. Much audited by the insurance men and producers for its profit margin, Joe's death still occurs abruptly.

If the backstage narrative supplies *All That Jazz* with a retrospective death, other films move the death moment still farther away from the illusory present tense of diegetic events—indeed, farther away from the screen body. In *The Sixth Sense* death "occurs" posthumously. Dropping the voice-over and flashback maneuver, nearly the entire film becomes a delayed message that child psychologist Malcolm Crowe is already dead and doesn't know it. *The Sixth Sense* moves beyond the diegetic loop to represent difference in a postdiegetic time—the same delayed registration that we find in *The Others* (2001) and *The Jacket*. Though it takes place in his "head," Malcolm's second death is at least acknowledged, and his process of realization at film's end becomes a form of dying.

In the opening moments Malcolm's former patient Vincent Grey breaks into his home, strips down to his underwear, and reproaches Dr. Crowe for failing him as a boy. Pulling a gun, Grey shoots Malcolm in the chest before taking his own life. This assault shows just how tenuous cinematic registration can be. First, the camera captures Malcolm's bed from above while his wife Anna comforts him while he is still dying, then a fade-out brings us to a daytime outdoor shot of a neighborhood street, with the intertitle "The Next Fall." There, we see Malcolm sitting on a park bench; dutifully, we assume he has survived. In this film's purgatory Malcolm must help a second boy, Cole Sear, who is plagued by visions of corpses. We learn that Grey was haunted by this special sense as well but remained undiagnosed by Malcolm. The doctor's second chance to believe leads him to the realization that he himself is one of those "dead people" Cole sees "all the time."[68]

Malcolm's realization that he is dead occurs with the help of a montage sequence that evokes the tradition of the replay since *How Green Was My Valley*, with images repeated from earlier in the film. Two in particular are memorable long after the film expires: in one we catch a glimpse of ghost-Malcolm sitting apart from Cole's mom, Lynn, at just the moment before Cole comes through the door. (The frame holds a secret relay between present and posthumous.) In the other we see Anna's anniversary restaurant dinner, a ritual to which Malcolm shows up late. Reaching for the check, his hand nearly grazes hers (another secret nonencounter). Rewatching each scene, we realize we previously misread its significance, that the film has granted us (and is always potentially granting us) Cole's ghost-vision. The flashback stages the uncanny recurrence of an earlier missed insight, thus creating a posthumous potential within the "present" of the diegesis. Perspective is not available after Malcolm's first death. These two shots, figuring Malcolm's distance from Anna and Lynn, suggest that diegesis itself must be broken through, rendered transparent, reread, mixed up, and rearranged for death to emerge in hindsight, a post that only truly occurs after the film itself concludes, reminding us again of Pasolini's remark that only hindsight might convert death into a meaningful event.[69] Here meaning is won through editing—the montage sequence—and not the body event.

Malcolm's epiphany takes the form of a replay of images we've already seen and sentences we've already heard. *The Sixth Sense*, then, does not fully register Malcolm's death the first time and stages one long deferral of registration. But whereas Malcolm is quite like our noir heroes and Joe Gideon, who seem to participate in their dying by plotting or performing it, Malcolm differs in that his posthumous position affords him no distance from time. He can't quite get past his screen body, even in death. Both patients (Vincent and Cole) lead Malcolm to a confrontation with death, the first violent and too soon, the second loving, in the presence of his wife, and on time. The second one makes all the difference.

The Sixth Sense may surprise us by aligning our experience of the film with that of ghost-seer Cole, but we are always potential ghost-seers, viewing cinema from its future. Buying time to die again also appears, not surprisingly, in the subgenre of time-travel. A film like *Donnie Darko*, full of paranoid talk of time machines and parallel universes, is perhaps best understood in the context of our dead men talking. Donnie's room is hit by a phantom jet engine, but he happens to be on a nearby golf course at the time, talking to Frank, a man in a bunny suit. One version of the story, the one heavy with science fiction tropes, goes something like this: returning home, Donnie finds he has dodged death by being led away by Frank, who tells him the world will end in a month; later, he "learns" that the crash opened a one-month time portal between two universes that will expire on Halloween; Donnie, whose new hallucinations allow him to perceive the immediate future paths to be taken by moving bodies, "realizes" that the plane carrying his mother and sister home must crash again and that he must die in the second crash to close the one-month time portal of worldly overlap.

Other readings of the plot, however, are encouraged by the history lesson of cinema's double death. In his counseling sessions with Dr. Thurman, Donnie expresses his fear of being alone. A former teacher and time travel expert, Grandma Death, whispers to him after nearly being run over: "Every living creature on this earth dies alone." Donnie repeats this phrase to Dr. Thurman, who pushes him: "The search for God is absurd?" Donnie replies, "It is if everyone dies alone." In an

excised scene (available in Richard Kelly's 2004 director's cut) in which Donnie's English class discusses Richard Adams's *Watership Down*, Donnie explains to Miss Pomeroy why he cannot empathize over mass bunny death:

> The rabbit's not like us. It has no . . . keen look at something in the mirror, it has no history books, no photographs, no knowledge of sorrow or regret. I mean, I'm sorry, Miss Pomeroy, don't get me wrong; y'know, I like rabbits and all. They're cute and they're horny. And if you're cute and you're horny, then you're probably happy, in that you don't know who you are and why you're even alive. And you just wanna have sex, as many times as possible, before you die. I mean, I just don't see the point in crying over a dead rabbit, y'know who, who never even feared death to begin with.

Donnie may be saving the world, but Grandma Death and his psychiatrist also know he is saving himself from a solitary death. What he needs to ensure he dies meaningfully is a plot to bind him to the living. In this spirit the midsection of the movie, the entire science fiction plot, is a fantasy concocted by Donnie in a flash of recognition when he was caught unawares by the engine the first time, cut off by an ending with no room for anticipation. Rather like Frank Bigelow, Donnie goes back in time to inject a future into his death.[70]

There is one final shot of Donnie sitting up in bed and laughing after setting the universe straight, an image that seems to endorse this reading. He laughs as if privy to the death moment just before it happens (again). Donnie is not laughing the first time around. Whatever the reason, and however else it may be read (cosmic overlap, wormholes, Kundalini, masturbatory fantasy), we know Donnie's ending is more satisfying the second time than it could have been the first time. I have tried to show in this chapter what happens when dying characters make use of cinematic hindsight and repetition. Dying once prepares us for a second death—the hesitation before which becomes the movie. It seems fitting to conclude with this bit of character wisdom, the idea that getting a second chance lets you become a deathbed hero. Steeped in fantasy, *Donnie Darko*'s finale also expresses a fundamental

insight into the cinema as a funerary device. How many deaths will it take to get it right?

This is a new trigger point to consider: cinema can time the return to synchronization of voice and body just before death (as with the flashback delay) or right after it (the posthumous voice). But either way, return, revision, and repetition take over from there. Of course, the camera remains the image-producing machine: any supplemental first-person account on the soundtrack yields to the production and narration of images. In that regard voice-over narration resembles the center-of-consciousness description typical of Henry James and the modern death moment; unwilling (or unable) to break the outer mold of bodily forms and the camera's position on the outside, flashback narration and especially voice-over attempt to fill in a missing interiority of dying. Rather than bringing us closer to the actual borderline between life and death presumably experienced by the *moriens*, the voice-over moves the death moment closer to the apparatus and the spectator and further away from the screen body. These films seize the posthumous potential of the film image. They are exercises in posthumous motion and fantasize a specific response to mortality, a kind of "redo" from the coffin, both for the subject and for the spectator.

Rather than the speaker, it is the apparatus that employs flashback to compensate for sudden death, as in *How Green Was My Valley*, or stages posthumous epiphany composed of filmic bits, as in *The Sixth Sense* and *The Others*. Malcolm Crowe's flashback returns us to when he was still dying; the second time, his body does not actually cross over, because it has already crossed. But what is "crossed" is more like a barrier on penitence. The talking dead man moves his final bout with moral legibility away from *this* moment before us now, turning it back into *that* process of moral recognition, always already in progress. Just a few breaths shy of transcendence, the dead man expires just before getting the chance to relive his past. The footnote of dying has become unmoored from its parent bodily text.

5

TERMINAL SCREENS

CINEMATOGRAPHY AND ELECTRIC DEATH

"It's alive! It's alive!"

—*FRANKENSTEIN* (1931)

"Her EEG is flat—flat."

—DR. RONALD CRANFORD ON TERRI SCHIAVO

IT IS TIME to consider an overlap in popular imagery to which I have until now made only passing reference—the similarity between what plays out on the cinema screen and what plays out on the hospital monitor beside a terminally ill patient. This chapter's title refers to two screens—the movie and the monitor. We have been watching how the cinema camera clinches the end of dying—by picturing human witnesses, or "registrants," that recognize it is over; by imaging nonhuman forms that stand in for that gaze (including objects, doorways, valleys, oceans); by cuing death as the stop, pause, or fade of a particular sound (talking, crying, singing, music); and by using filmic techniques like pans, aerial shots, cut-ins, and voice-overs. The camera locates death's stillness and silence within a visible and audible flux—not because it defines death as these tropes of nonbeing but because it insists that it occurs once temporal and spatial limits are perceived. The hospital monitors we watch in movies and in real life recall some

of these earlier movie techniques (even specific scenes) that enfold the activity of dying within a rhythm of multiple shots or a larger sound space. The monitor's unchanging, "flat" line, and its steady bleep, are reminiscent of filmic devices.

The electrocardiograph (referred to as the EKG, or ECG) and the electroencephalograph (EEG) create new mobile death signs, but they also change the way we detect absent vitals. It is this dual change in registration that I now want to take up in relation to the cinema. Traditionally, registrants have felt for a pulse, held up a mirror, or otherwise made tactile contact with the body. The observer of cardiac failure and the examiner of brain death, however, can mediate with a screen image. The electroencephalograph (first used for a human patient in 1924 by Hans Berger, a device he called a Hirnspiegel, or "brain-mirror") is a diagnostic tool used by medical professionals to test for disorders such as epilepsy and to produce partial proof of brain death. Attached at first to a polygraph machine and then later a video monitor, the machine works by placing painless electrodes on the scalp to amplify, record, and measure brain waves. Following on the heels of William Einthoven's electrocardiograph (1901), the EEG measures a truly remote vital force—the electrical activity of the brain. Confirming brain death especially challenges traditional registration, as the EEG's referent evades sight, sound, and touch. But in their projection of moving images, both machines draw attention to a "representational" impulse. The flatline reigns supreme in the popular imagination as the telltale sign of vitality's lack, in part because it translates the body into legible signs. We look to it for a commutative report on a mysterious and increasingly complicated process. Because the monitor reduces a gradual transition into a sequence of clearly marked stages, it is hard not to focus on it instead of the body. Despite medical evidence to the contrary, we continue to believe that life and death are separated cleanly, as if by a line. The monitor's immediacy—the fact that it works in our presence—gratifies the desire to believe so. Equally gratifying, the flatline reduces a longer duration into a short visual narrative, a neat little "movie." Recall Dr. John Murray's note, quoted earlier, that the "television screen" in the ICU often becomes the center of attention: "People become obsessed watching the electrocardiographic

squiggles that announce each heartbeat marching across the screen."[1] Because they are beholder-friendly, hospital monitors make medical registrants of us all, competing with the body formerly at the center of the deathwatch.

In this chapter we will "become obsessed," at least a little. The visual contours of the brain scan are not new but are the most recent iteration in a longer cinematic tradition that pictures the death sign outside the body as a moving signifier. The monitor is *already* there, on the outside, picturing life as if a projection from the body. Its lines and waves place it within the context of medical machines used to determine death with greater precision, but its function raises new concerns as well. The terminal body is at once inscribed in the monitor's scene of representation as the presumed source of information, but it is also strangely excised from it because it is immobile. This incomplete body hovers over flatline scenes in American cinema, where it becomes especially clear that the dying body loses some of its centrality. In some scenes we don't see the body; in many others it is ignored or carefully avoided. The monitor encroaches on the dying body in the final tableau, but it also elbows in on the human registrant, frequently reinforcing a failed reciprocity between the two. It performs registration by obscuring the body from the beholder's gaze. When resorting to the flatline as a kind of rote shorthand, cinema, in turn, invites the monitor's spectacle of disembodiment and dispersal. Because cinema insists that there *is* a body and space for death, it plays out some of the cultural anxiety surrounding the monitor while borrowing its visual agency.

THRESHOLD BODIES:
STILLNESS, VISIBILITY, AND *2001*

One of the monitor's first appearances on the big screen—in Stanley Kubrick's 1968 film *2001: A Space Odyssey*—surfaced during an era of pointed concern about technology's role in the end of life. As a response to improvements in life-support technology starting in the 1930s (such as the widespread use of respirators), and the pursuit of

organ transplants as a viable practice, the medical profession sought outside resources for guidelines to determine when death had occurred and a patient could be removed from equipment. The first recourse was to consult the papacy: in 1957 Pope Pius XII advised unplugging a severely brain-damaged patient if authorities agreed death was inevitable. In such cases removing a patient from life support was seen as a primarily compassionate act to end prolonged suffering, leading to death only as a secondary effect. The pope made use of the principle of "double-effect" already established in Catholic moral philosophy.[2] But in 1968 an ad hoc committee from Harvard Medical School went further and defined the flat EEG as partial grounds for determining death: the test required the presence of the flatline, as well as other criteria, such as apnea (no breathing) off the respirator and no response to light or ice water, all to be observed over a twenty-four-hour period. Patients were then declared dead and were unplugged.[3]

The committee's guidelines served mainly to protect doctors from litigation when removing organs from patients still attached to ventilators. M. L. Tina Stevens has argued that the Harvard ad hoc committee's redefinition of death was less a response to problems raised by resuscitative technologies, or the blurry line between life and death, than a strategic move to enable doctors to harvest donor organs. One physician defined brain death as the "new definition of heart donor eligibility." For good reason: the transplant industry has become a $20-billion-per-year industry.[4] Before 1968, doctors had to wait until old-fashioned criteria of death (no breath or pulse) were met, by which time it was too late to procure functional organs. With the possibility of measuring the brain's function while a person was still attached to machines, doctors could safely remove the organs without waiting for bodily failure: "Otherwise, the physicians would be turning off the respirator on a person who is, under the present strict, technical application of the law, still alive."[5] The guidelines ensured patients were declared dead before they were removed from artificial respiration.

Because it can assist respiration and metabolism after severe or irreversible brain damage is suffered, life-support technology troubles the neat distinction between life and death, between animate and inanimate bodies. (Versions of the mechanical ventilator and feeding tube

have been used since the early nineteenth century, and the first clinical application of the iron lung was in 1928.) Throughout the 1960s the machine-supported body appeared in popular culture more frequently.[6] According to a 1968 article in the *Journal of the American Medical Association* (*JAMA*), cardiac transplants had given the diagnosis of death "a new public dimension."[7] Physicians bemoaned the possibility that "a heart could be kept beating . . . for hours or days after 'death' using artificial means."[8] Ambiguity was not exactly eked out by practice. Though a flat electroencephalogram observed within a twenty-four-hour period generally indicated irreparable brain damage, the application of this rule wavered. Doctors reported cases in which patients recovered after the machine registered inactivity for days. One doctor suggested the guillotine as the only surefire way to define the precise moment at which cerebral function stops.[9] In 1972 *JAMA* published its "Refinements in Criteria for the Determination of Death: An Appraisal," which summarized: "In a small but growing number of cases, technological intervention has rendered insufficient" the "traditional signs as signs of continuing life."[10] Once again, machines apprehended and failed to deliver a legible edge between life and death.

The electroencephalograph played an important role in the Harvard committee's definition, but if the perceptual crisis of registration was subservient to doctors' legal concerns, it remained a problem not easily resolved. In 1974 the New Jersey Supreme Court reversed the ruling of lower courts to allow the parents of Karen Ann Quinlan to have their daughter removed from her ventilator. Quinlan had fallen into a "persistently vegetative state" (PVS)—a condition first coined by Dr. Fred Plum of Cornell's Department of Neurology, describing a brain-damaged patient with internal functions intact but with no awareness of one's self or surroundings.[11] Involuntary actions like blinking continue, controlled by the still-functioning brain stem. Publicly misrepresented as brain dead, Quinlan fell victim to the 1968 criteria. Though the Harvard guidelines—subsequently picked up by state statutes, New Jersey's not among them—had provided criteria for the legal definition of brain death, they offered little help for people like Karen, who still had brain function but remained indefinitely in an otherwise motionless state.

The brain stem has continued to plague decisions to withdraw life support. In 1989 another difficult case emerged—this one involving the removal of a patient from her feeding tube. Nancy Cruzan had brainstem function but her cerebral hemispheres were badly damaged and deteriorating. Her parents, Lester and Joyce Cruzan, filed for permission to have their daughter removed from the tube, an act that would lead to starvation. The Missouri lower court gave them the go-ahead, but the Missouri Supreme Court overturned the ruling, claiming that testimony offered by Cruzan's sister Christina, detailing two conversations they had had while she was alive, did not amount to "clear and convincing proof" of Nancy's desire to have hydration and nutrition stopped. The United States Supreme Court upheld the Missouri request for clear and convincing proof. Though the Cruzans remained steadfast throughout years of legal proceedings, the Court argued that "not all incompetent patients will have loved ones available to serve as surrogate decision makers" and that stringent requirements (written permission, living will) would ensure the lesser of two evils: "An erroneous decision not to terminate results in a maintenance of the status quo, the possibility of subsequent developments such as advancements in medical science, the discovery of new evidence regarding the patient's intent," and natural death.[12]

As with Karen Ann Quinlan, media images of Nancy Cruzan's body entered the public. On a two-hour *Frontline* special aired after the case was argued before the Supreme Court, viewers could watch as Lester and Joyce spoke to her blinking body. Occasional close-ups concentrate on Nancy's face, but these last only seconds and are bracketed by a majority of long shots that foreground the tableau of the living figures bedside. Nancy's parents relay to her updates from the trial procedure and offer her verbal comfort. An expert in PVS, Dr. Ronald Cranford, walks in to perform a "test" for the lawyers of both parties. Shouting at the body, "Karen! Karen! Can you hear me?" he tells Nancy's father that she's not really looking at him ("it's scary when she does that"). This scene of failed reciprocity aired on television.

In the 2005 media coverage of the debates surrounding Terri Schiavo (diagnosed with PVS), the need to demonstrate the EEG to the

public once again brought Ronald Cranford onto the playing field. The doctors involved in the case contested one another's diagnoses of Schiavo's brain condition. Terri's husband, Michael Schiavo, who wanted to remove her from life support, hired Cranford as his expert. Cranford claimed there was "no electrical activity coming from her brain," whereas Governor Jeb Bush's authority on the matter, William Cheshire, wanted more time before persistent vegetative state was determined in the first place, despite the flat EEG.[13] The machine could not speak for Schiavo; it was attended to by the usual variety of experts to produce court testimony, creating a frenzy of interpretation that grew increasingly contentious.[14] The flat EEG is far from a conclusive registrant. As a precise reading of the body's interior, it is also perhaps the most litigated death sign.

The first of many similar patients, Karen Quinlan hovered indefinitely between life and death, with attributes of both conditions. This new class of "phantom beings," wrote New Jersey's attorney general after *In re Quinlan*'s reversal, reminded the world how "technology has obliterated the distinction between life and death."[15] One journalist compared doctors to Victor Frankenstein, with Karen as the monster.[16] But Karen's perpetuated condition was yet another moment in a much longer history of technological dying, a history that includes the cinema. The Edison Company's 1903 recording of an elephant's live death caught the trembling spasms of her body, and for moments it is difficult to say whether Topsy is fully alive or definitively dead.[17] This intermediary condition leads to some anxiety, in both medicine and popular culture, over what visible or aural signs constitute evidence of vitality's lack.

ICU machines may have officially put the quotation marks around "life" and "death," but the flatline recalls the history of visual mediation previously explored by filmmakers. Hardly new, the flatline evokes contours of cinematic representation. One, the machine registers death outside the body, like so many cinematic registrants that compensate for an incomplete stillness onscreen. Two, the steady bleep from somewhere in the room, surrounding and joining all present, produces an out-of-sight flow similar to film sounds that traverse the edges of the frame. And three, the steady line represents death as

a continual absence, much like a panoramic instance of "posthumous motion." The flatline retraces cinema's acousmatic and mobile effects.

This is not surprising, given that cinematography and body-imaging techniques share a common genealogy and were spawned in nearly the same glimmer from the same scientific interest in physiology. As Lisa Cartwright has shown, nineteenth-century studies in physiology actively penetrated the body's interior to record and monitor the dynamics of motion, like muscle and organ function. Many scientists in the 1880s and 1890s seized the cinema camera and its earlier iterations to acquire frame-by-frame quantitative data about the inner body. Jules-Etienne Marey, regarded as a protocinematographer, had connected the kymograph—a stylus tracing onto a rotating drum—to air-filled ampules inside a horse's heart before cinema proper was invented.[18] Early on, cinematic technology was used to study the movements of the body because it was understood as a competent temporal index.

Because it is time-based, cinema allows and thwarts the search for a momentous event. Brain death's terrain is more spatial than narrative, as the diagnostic tool of the EEG is used less often for monitoring the body in the present tense. Looking for the center of vitality's lack envisages a synecdoche of whole body for innumerable part bodies. The conception of the brain as the control panel for the body's integrated whole continues to be reformulated. Most recently, President Obama's bioethics committee published its white paper revision of Harvard's criteria and disambiguated whole brain from higher brain damage. It is now only whole brain that counts, which begs the question of how to determine whether the brainstem is destroyed.[19] It is no longer simply a question of when death occurs but also a question of which death, of when to terminate life support, and of who gets to make that decision.

Unlike the flat EEG, which remains a tenuous sign at best, the cardiographic flatline reassures onlookers that technology has some authority over death because it represents an *event* occurring within our space and time. The impression of the monitor's readout as reliable is further corroborated by countless film and television episodes that can show the flatline moment when they choose, in any narrative

context, thereby distilling it from its real-life contingency. When the line appears and the bleep pierces all, it is hard to deny feeling as though we have witnessed the fatal moment because it has been translated into an audiovisual occurrence—especially given the stillness and silence of the body beside it. In films, a window of emergency often appears after the flatline, leaving open the possibility of resuscitation as a melodramatic rush-to-the-rescue. It could hardly be clearer in these cases that our attention turns quickly to the would-be registrant when the screen body can no longer be read. When death does occur, the registrant offers us a performance of hysterical pathos in the face of technology's failure, not the body's. But asystole, or cardiac arrest, is frequently misrepresented as survivable, the flatline not the fatal sign it would seem to be.[20] Movies borrow the flatline, then, to clarify the problem of screening the terminal body, but they in turn explore this sign for visual and narrative effects. What comes to cinema as singular and oracular is once again multiplied and dispersed.

Let us move, then, from the 1968 redefinition of death to *2001: A Space Odyssey*, which premiered the same year as the Harvard guidelines. Kubrick's film is based on Arthur C. Clarke's novel, itself expanded from an earlier short story. The novel and the film are staples of science fiction, and it is not surprising that we find thoughtful treatments of monitor deaths in this genre, given its concerns about the imbrication of human bodies and machines.[21] Bioethicist Thomas Shannon claimed in 1974 that the Quinlan trial "more than Hal in *2001* may have revealed the relation between humans and technology."[22] The comparison seems innocent enough, but it is telling that Hal and Karen Ann Quinlan could be thought of together, as though real-life brain death litigation echoed the movies.

The film's chronology is elliptical, starting with the unexplained appearance of an obelisk-shaped monolith amidst prehistoric hominoids, moving to the era of space travel, then to the spacecraft *Discovery*'s Jupiter mission in particular, and finally to crewman Dave Bowman's personal trip to Jupiter. On board, the computer Hal is "unplugged," as are three hibernating astronauts. Crewman Frank Poole's death occurs outside the ship in endless space. Even Dave Bowman experiences something like a bed death while on Jupiter. And

these dyings are mediated by "cinematic" machines. In addition to its ostensible interest in the slowness of space travel (as demonstrated by the pace of editing and movement inside the ship), Kubrick's film considers various forms of technological dying.[23] It is not hard to imagine that biotechnology was on someone's mind—if not Clark's, then Kubrick's.

The first death scene involves the three hibernating astronauts, whose vitals are being monitored on screens above each by the main computer system. Earlier, when these crewmen are introduced, we learn the names of the vital processes traced by six separate vital graphs: "cardiovascular," "metabolic levels," "central nerv system," "pulmonary function," "systems integration," and "locomotor systems" are each being monitored (though this last never moves since the astronauts never move). Each graph's contour is unique: the heart and nerve graphs closely resemble their real-world EKG and EEG counterparts, the others more fanciful derivations. Earlier we also learn from the delayed broadcast of a BBC interview with Dave and Frank that these "comatose" crewmen are dreamlessly sleeping—to be revived later as *Discovery* approaches Jupiter—in order to "achieve the maximum conservation of our life-support capability, basically food and air." Poole explains that being in hibernation is "like being asleep; you have absolutely no sense of time, except you don't dream." Even more incredible is the interviewer's description of Hal, "the sixth member," as the "brain and central nervous system of the ship," whose responsibilities include "watching over the men in hibernation." It is unclear from the start where the bodies of these men end and the machine Hal begins. Hal is dispersed throughout the ship but controls the outward projection of their inner processes as well. Hal, as the vengeful autonomous brain, fits squarely within the tradition of brains that never die in 1950s science fiction; here there is a cinematic apparatus associated with the brain, so there is also a visual dimension to its power.

The astronaut deaths are depicted in a symmetrical sequence that begins and ends with one of Hal's lens-eyes. There is no embodied movement in this sequence. Because the first eye is followed by a point-of-view shot from Hal's perspective, we read the ensuing shots as extensions of that gaze. What we witness seems to be a murder scene

in which Hal terminates life support. After the reverse shot we cut in twice to one astronaut's face, seen through the incubator window. We also see the screen with all six indices, differently colored, happily functioning, signaling with their repeating graphic contours. After a ten-second pause (each of the preceding shots lasts about that long), a sudden close-up of the illuminated panel that reads "Computer Malfunction" is accompanied by double-bleeps. Before this, only the hum of the ship's motor fills the space, heightening the contrast. The cutting between shots, each devoid of a human figure, makes more present Bowman and Poole's absence. The first of the displays to register a flatline is that of "metabolic levels." After shots of incubators and Hal, a sharper and faster bleeping anxiously interrupts the lull of potential machine breakdown, and the readout changes to "Life Functions Critical." On each graph we can now see, one at a time, the beginning of linear outputs, six lines stacked. Quite realistically, the heart index imitating the EKG registers something close to the erratic reading of ventricular fibrillation moments before flatlining. "Central nerv system," more suspiciously, goes from the normal recurring spikes to one isolated ascent in the graph, and then to a line, as though the brain's death were not a gradual sliding into electrical silence but rather the aftermath of some event occurring elsewhere (fig. 5.1). "Life Functions Terminated" then appears on the red readout, returning us to the Discovery's quiet hum and the familiar presence of Hal's eyes, as if nothing happened.

The monitors and video signal remain the only indicators of change throughout this sequence. Besides them, and a peek here and there at an unmoving face, there is no bodily contact. Michel Chion is right that the "murder is shown indirectly." More dubious is his claim that the bodiless murder "is never corroborated by words," for words do appear, but no one speaks them.[24] We can follow with our eyes the relay from "Life Functions Critical" to "Life Functions Terminated." Death occurs before us, but the hibernating bodies are not moving to signify it. We have no choice but to watch the screens above them. Death is registered *on the screen inside the film*, that diegetic "film" above the astronauts' bodies. It is an event in which no body participates, but it is nonetheless quite visible.[25] The depth of the three-dimensional

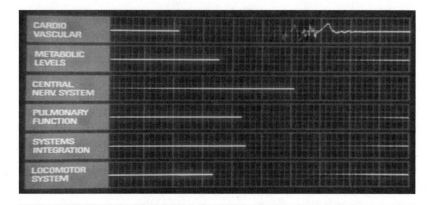

FIG 5.1 An astronaut begins to flatline in *2001: A Space Odyssey* (Stanley Kubrick, 1968).

acoustic space collapses into a two-dimensional index, recalling pro-tocinematic experiments in body imaging that used photography to visualize movement as a graphic trace.[26] There is a strange moment of contact here between the two screens: which one, we might ask, is visualizing death for us? The camera marks its punctual appointment with the last visual mark, but it has missed the body altogether.

The rather instantaneous, commutative announcements of "criti-cal" and "terminated" that appear on the diegetic screen deny us the opportunity to see any physical change, self-recognition, or slide to inertia. Instead of the sloppy cinematic turbulence of dying, the com-puter produces an incremental exactitude. In place of bodily process we get a precision of analogical and digital changes. The stack of flatlines threatens the legitimacy of any one of them. These mul-tiple registers indicate the film is grappling with the problem of synecdoche—if not *this* vital sign's lack, then maybe *this* one. That we need the message "Life Functions Terminated" itself suggests that the flatlines are not enough—or, perhaps, that they are too much. Like the body, time seems barely to enter the picture: "Death is inflicted like an act outside of time," writes Chion, and "nothing has changed."[27] Certainly the frame shots of Hal's eye lend evidence to the idea that "nothing has changed." And when Chion writes "outside of time," he likely means the event occurs outside of *bodily motion*. The process of

dying peaks on the machine, but the body assigned to it is so dispersed across the space and gadgetry that it is difficult to compute *who*, or which body "part," died. We are warned against a dying that is too mediated by machines, because the machines "do" it for us. The astronauts are not present for their deaths, and without the registrant's body as the locus for our gaze, we must assign confirmation to the closest stand-in for the registrant—and that is Hal.

The computer postulates an "other" sensorium that sees, hears, or touches in the registrant's place: for the first time, confirming vital cessation conceals the whereabouts of a human beholder.[28] "Hal's gaze seems to induce organic cessation," understates Robert Burgoyne.[29] Hal's "reaction" heightens the paranoid tone previously established with the first sight of Frank jogging and shadowboxing in a centrifugal walkway as the camera follows oddly behind, then in front of, then behind again. Along the way we see the "electronic sarcophagi" of the sleeping astronauts; their inert bodies are often punctuated with a shot of one of Hal's monitoring lenses.[30] Burgoyne remarks that the "all-seeing, all-knowing attributes of HAL" contribute "an effect of paranoia" to the film's rational tone.[31] Of course, the earlier mysterious appearance of the monolith precedes Hal's panopticism, so there is something missing from, or prior to, Hal's agency: "a gap is introduced, a lack, something not seen."[32] The monolith may be the "source of the look which comes from outside, a look which cannot be seen," but Hal is the closest approximation to that unreturned gaze, especially prominent when it/he imprints the last look at the murdered astronauts.[33] If Hal's "consciousness is noplace," then the astronaut deaths do not really start in their bodies but begin "noplace."[34]

Though the readout bar grasps the instant of cessation, this precision does not eliminate the human labor of registration—words still translate; we still watch (and we are quite alone in this, for Dave and Frank are missing). Projecting the act of recognition onto Hal captures the amazing extent to which cinema concludes dying with a human (in this case an anthropomorphized machine) beholder. It is not a stretch to say that the computer is partly humanized through its registration of death. It looks here as though technology has created a spectacle that the observer completes just by watching it—not

by performing or deliberating. The only thing left to do is register the screens; there is no other embodied action to watch. Here I'm reminded of Teresi's interview with Dr. Michael Baden (medical examiner and host of HBO's *Autopsy*), who ruminates that most hospital patients die in the morning because that's when more people are around.[35] Despite the machines, bars, and graphs, someone must be there to witness and record.

Frank's death a little later also goes unregistered by a human figure. When Frank comes unmoored outside the main ship, Dave enters his space pod to grab the free-floating man. Horribly, Dave must "let go" of Frank to maneuver his own way back into the ship. As Dave operates the pod's outstretched arms to release him, Frank disappears as a human dot receding into blackness, exiting the film in a linear progression toward the limits of perspective. Again, machines intervene, for Dave's contact with Frank is mediated by the mechanical body of the pod. This time, the camera is positioned outside the ship, so no sound—that is, no trace of occupied space—enters the death shot.[36]

But perhaps cinema's ruling scene of disembodied death comes next, with Dave's dislodging of Hal's memory banks from inside his "brain." This scene continues to trace dying's linear progression, but audibly more than visibly. Hal's slow, unremitting exit occurs on the soundtrack as a gradual lowering of tone and slowing of speech. The acousmatized voice returns in mechanical form: everywhere flooding the interior of the ship, Hal's voice possesses those superior qualities of omniscience we normally attribute to the acousmêtre. As a "Machine-Being" he belongs in Chion's category of the "acousmachine," along with other hidden mechanical voices.[37] But this ubiquity is finally located in the computer's memory banks, and it is here that he is "unplugged."

As Dave approaches Hal's "Logic Memory Center," his heavy breathing on the soundtrack positions us intimately inside his helmet. Against this, Hal's steady voice first registers plaintive panic ("I can see you're really upset about this"), and as Dave unscrews and dislodges cartridges 1 through 6 from the memory and logic centers, Hal expresses a painful awareness: "There is no question about it. I can feel it. I can feel it. I can feel it," he says without inflection, more and

more slowly. Anxiously, Dave darts glances toward the eye of Hal: "I'm afraid" is followed by "Good afternoon, gentlemen" and a report on his own genesis. When the computer sings the song "Daisy," his voice drops to a gravel, and we see the red dot in his eye has diminished. The dying is a vocal descent, like a gradual loss of the capacity to speak. The camera looks straight on Dave, whose face registers consternation in perhaps his most expressive moment. But then we hear *another* man's voice: "Good day, Gentlemen" comes from another diegetic screen, this one inside the memory chamber. Dr. Heywood Floyd reports on the "evidence of intelligent life" found off Earth and the monolith, whose "origin and purpose" remain "a total mystery."

Hal's voice "slides inexorably downwards to indicate . . . death," but it is also an incomplete bodily experience for the spectator.[38] Hal's perceptual apparatus is diffused throughout the ship—in what Chion calls a "noplace" but what we might call a noplace-in-particular or an everyplace This dispersal haunts the death scene, placing a kind of burden on Dave, the lone animate figure whose face becomes the visible center of Hal's dying.[39] It feels something like an act of revenge taken out on technology, considering the emptiness and flatness of the founding machine-registered deaths. In one shot a buoyant Dave is floating inside the red memory chamber, but it is only a reflection on the lens of one of Hal's eyes, which seems to be turned inward toward his own brain to witness its destruction (fig. 5.2). Hal and Dave are eerily connected. Registration of technological death, again, is like the completion of a spectacle by an outside beholder, even though all the facts are there. And Dave's silence forces the spectator to complete the activity of dying, even though it is lusciously portrayed.

For Chion Hal's death is a "commutation . . . with no trace, no body."[40] And Dave, who is "greatly upset" and "feels empathy and remorse," has little time to process, for Floyd resumes narrative action with news of the Jupiter mission on which we next see Dave, willingly or unwillingly, embark.[41] But watching Dave's frustrated, even guilty, glances at the dying computer locates for us the visual center of a melodramatic dying—he is the traditional registrant. Pathos almost keeps Dave from going through with the unplugging. In fact, this scene elicits more empathy than do the previous deaths of the four

FIG 5.2 A buoyant Dave inside the dying Hal in *2001*.

astronauts, because there is an aural movement present, as well as a degree of self-recognition.[42] Further complicating matters, the "other" that perceives Hal's exit comes from within "him": he emits a series of prerecorded messages that arrive from the past to their auditor. In a sense Hal's audible descent externalizes the presumed human activity of conscious dying, impossible to retrieve from the outside, aurally compensating for a visible dying we have been missing.[43]

For Chion the disembodied and commutative deaths connect the cinema to other informational screens: "the movie screen shows itself for what it is: a surface on which none of what lives and pulsates upon it becomes imprinted."[44] Like a hospital monitor, the screen leaves behind no vital trace once the projector is turned off. This notion of a screen that becomes mere surface rather than holding on to a material reality resonates with the graphic inscriptions from the precinematic era in which any iconic representation was avoided for a two-dimensional index. Physiology wanted the differentials between the frames to get at incremental change over time, thus chronophotography was used not to project a moving image with depth but to trace movement across a series of still, flat images.[45] The monitor's flat surface, its graphic trace and signs, predates the movie screen. Chronophotography is part of the nineteenth-century rise of visual technologies that Jean-Louis

Comolli has argued improved on human faculties and strengthened the connection between vision and knowledge. Machines potentially see better than we do, and as a consequence the "human eye loses its immemorial privilege," as do presumably the human ear and finger.[46] The death sign has long evaded human mastery, but Comolli's comment about the fall of anthropocentric perception suggests that proto-cinema devices also placed a greater demand on vision by insisting the death sign be visible in time.

If cinema, then, participates in what Comolli calls the "frenzy of the visible," a drive for legibility that includes grappling with the process of bodily dying, then the scenes of flatlining must be read as compensatory for the incoherence of the body, opting for a noniconic index over a bodily one. The cinema screen uses a bodiless diegetic screen at its will. Flatline scenes provide a fantasy of accuracy, and they seem to offer a more precise determination of when we die, but they only do so by covering up something of the monitor's function. In tracing the electrical impulses of the heart and brain, the monitor intimates an insider's touch. We trust the monitor's other sensorium partly because it subtends any known act of perception; we cannot see the contact between electrodes and brain, for instance, but we can imagine that such a contact is made. Turning the body into a set of bleeps or waves clinches an instantaneous passage (the moment the line appears, or the moment the bleep steadies or silences). The cardiograph especially reduces for the spectator a gradual and uneven unfolding into a sequence of clearly marked stages—ventricular fibrillation (the speeding up of the bleeps) reads as dying; the steadied or silenced bleep and flatline read as death. We see not what the monitor "sees," however, but what it projects of what it sees. This hidden vision would seem to be a step forward, but it is also a step back. Recall the earliest iterations of the EKG were not hooked up to a screening device but rather to a tangent object—kymography traces with a stylus onto paper. The impression of accuracy is won, but by retracing a form of the image previously established, that is, the *moving* image. The monitor fits into a tradition already established by the cinema of screening death as a punctual event outside the body. Comolli speaks of the "submission of the camera to the dominant ideology of the visible," the need to

valorize only those facets of cinema that secure the reality effect and to suppress any invisible parts that constitute the work of illusion.[47]

A similarly unseen sensorium is implied within monitor deaths in cinema—the missing contact between monitor and body gives filmmakers a chance to ignore the usual trajectory of the body in search of a mobile sign. In filmed flatlines—that is, in moving image representations of screen (EKG/EEG), or electronic, deaths—we see a double act of projection. Not only is the bodily moment of death confusing and evasive, but the process of visual representation is not seen as well. What covers over this second lack is the camera's search for the usual means of recognition (faces, gestures, posthumous motion) near the body/monitor.[48] The obfuscation of the monitor's gaze eliminates the dying body from the proceedings, and in this sense, the monitor partly dehumanizes the process at hand. No wonder the deaths in *2001* are all someone's "fault"—where self-operating technical registrants encroach on the body, the fear of malfunction is nearby.

Machine-monitored death introduces new fears, as we see in *2001* and in another science-fiction boilerplate film—James Cameron's *Aliens* (1986). When the crew descends into the abandoned station, each soldier carries a camera that projects a live feed back to the ship, monitored by Ripley and Lieutenant Gorman, among others. Here the heads of operation are made observers of the military affair gone awry. When the soldiers are slaughtered by the aliens, the screens projecting their "vision" go black, and a set of four flatlines appear. First Crowe, then Dietrich and Frost are cut down. Their flatlines block out the registrant's sightline, as the monitoring technology only affords a partial view of the event. What the operators see is a flurry of activity that is impossible to understand in what becomes a horrific sight of a bodiless, incomprehensible death—not just because it is violent but because it is pictured by an unwieldy source. The monitors disembody death so completely it cannot be understood, a series of lapses that reads as technology's failure in the face of an alien threat.

The monitor points to technologies both before and after the cinema. Its information is bodily referential, but that information is projected onto a video or computer screen and often supplemented with digital readouts (the number values generated by a computer). These

machines thus combine the analog and the digital, and, technically speaking, they carry over this adumbration when they appear on the big screen. Thus an element of digital technology has entered the history of analog cinema death. But it is not always easy to determine what has changed, or what is new. Scott Curtis has argued that the digital revolution in medical imaging—including echocardiogram screen shots and repeated cycles of magnetic resonance imaging—has not overthrown its cinematic predecessors. Film is often still the medium that is processed digitally; the way physicians read digital medical images harks back to the cinema ("Not much has changed," writes Curtis).[49] Digital techniques such as the looped cycle of an MRI are often used to still, or fix, the moving image in order for physicians to study and to demonstrate physiological processes. Like anatomy before, which studied the cadaver to apply information to the living body, new media seizes visual information about the moving film. Death relates to the digital through the figure of the corpse—the still body affords clinicians time for analysis that the moving body does not. Practitioners interpret medical moving images the way anatomists tried to interpret the human body—by stalling movement. For example, fluoroscopy emerged in the late nineteenth century a short time after the X-ray, providing a real-time and simultaneous image of the patient on a translucent screen. For decades the footage of the fluoroscopic film could not be captured. The image intensifier enabled this in the 1950s, allowing a still camera to be attached to take "spot films." The radiologist views the moving image on the monitor while punctuating the footage by taking stills at what one physician calls "determinate moments."[50] The still image of the film provides the possibility of sharing the visual document with patients and other doctors.

The flatline's immediacy reminds us of the use of fluoroscopy to visualize the inner body in time. Similarly, radiologists have recourse to the pause button on a videotape player and digital screen shots for MPEGs. Repetition is not new but more easily accomplished. Cineloops—or any digitized movement that has been set to repeat—are most often used in cardiology. CT scans record still images of the heart that are then converted into a loop (later the loop is recorded on a videotape or MPEG). But the loop film has an earlier history as

well. Early kinetoscopes were often looped for continuous play, and by 1912, complete heartbeats were filmed and converted into repeating footage. Curtis ruminates that if digital technology carries any concern for death, given its missing contact with the mortal body, then it is in its infinite manipulability—the ability to cut, paste, and replace at will; the ability to create copies without degeneration. Curtis claims it offers, in a word, "convenience."[51]

Even though referential contact is made, the computer does introduce something new to screen death—the abstract and integer readouts of/during the death moment. "Life Functions Terminated" in *2001* is a further mediation than the appearance of the flatline—a sharper line, a linguistic report. Such a message occurs, and we are not even looking at the body. In an actual flatline moment during Frederick Wiseman's documentary *Near Death* (1989), a monitor signal goes off in the nurse's station, beckoning assistants to the hospital bed. But we understand the monitor to be imbricated with the body, so these signals are not heard as alien intrusions. Hardly new, this imbrication speaks to Eugene Thacker's notion of "biomedia" as a particular intersection of technology and the body, one that converts biology into computational data with the goal of applying that information back to the body. The electrocardiograph would seem to indicate an instance in which our bodies are biomediated, or translated into information (heart rate, for instance). Certainly, the flatline is a form of embodiment and not the body itself, and one of its most striking features is its combination of both the patient and the observer.[52] But there are a few problems with its designation as biomedia. Most obviously, the observational tools of the EKG/EEG do not produce a new code that reimagines the body. Marey's and Braun's efforts to record a live moving image of physiology predate the projection of the inner body onto a proximate screen.[53] Perhaps most important, the monitor registers a continual inactivity over time, so it offers a time-based index, as well as a medial translation. Of course, cinema never allows us to get at the body itself, so we cannot see the encounter between inner process and external technique. The fact, however, that we have always in cinema an interaction between bodies, or between the dying body and its external space, underscores the fact

that the movie camera has always been dealing with human observation and the flux of experience. In movie flatline scenes this spatial relationship is still there, although now it is developed in relation to the monitor and not to the dying body.

Biomediation does help us grasp the monitor as a translation of the body and the cinema as a second translation of the monitor. The hospital screen is obviously smaller and more portable than a movie screen, addressing spectators televisually. But the flatline never entirely leaves the cinematic realm of indexicality and contiguity. When cinema refers us to the flatline or one of its derivations, it remediates the computational readout of the body, combining the computer's information with activity in physical space (between doctors, intimates, etc.). Whether the death machinery is analog or digital, the reverberation through space is still felt and the registrant still needed.

The movie flatline, while a fantasy, allows us to see the monitor behave as a registrant and to think about what is missing from its pronouncement. Both movie and monitor screens register by concealing the looker but to different degrees of obfuscation—with the movie it is the camera that is hidden, though we accept its omission as a necessary precondition for the image; with the monitor it is the electrical contact between body rhythms and machine, a contact that is remote and dispersed. When a movie shows a flatlining monitor, the latter enters the space formerly occupied by the human registrant. What is registered onscreen is not the body as much as the monitor itself, which both "shows" and "confirms" dying has ended. Consequently, human registration responds to another technology that registers for us.

The reverse shot of Hal effectively turns a mechanical eye into a fictional beholder.[54] We would expect the usual human beholder to appear outside the diegetic monitor with the flatline, but in *2001* no one is there—only the computer. Hal can "be there" for the motionless death because his dispersal throughout the ship authorizes him to perceive any of its mediations. But Hal's omnipresence only underlines the tenuous relations among the triptych of man, machine, and camera as they triangulate around the bodies. The monitor makes possible the registration of death with no one present; it supplies the camera with the illusion that *its* gaze—and not the obscured gaze of

the monitoring apparatus or that of a more benign human figure—is the anchoring one.

The withheld point of view of the monitor certainly threads through *2001* to Dave Bowman's memorable transformation into the star-child, that floating gestating being that concludes the film. After docking at a royal bedroom on Jupiter, Dave engages in accelerated aging through the reverse shots of himself until he lies dying in front of the monolith. For example, a shaking Dave looks out from his pod, and a reverse shot shows from within the pod an orange-clad astronaut standing in the room; yet two cut-ins reveal the figure as Dave, now radically aged, with lines on his face. Such reversals move Dave forward in time as an object of his own gaze. Standing in the bathroom, he hears a cutting noise from the other room, yet its source turns out to be a white-haired Dave who enters the area from which we believe the younger man was looking but which turns out to be devoid of his presence.[55] And so on, until he appears in bed, apparently near death. This relay of impossible time-warps concludes with the appearance of the monolith at the bed's end, which "looks back" only to see the gestating star-child in bed where the dying man used to be. The shot is a pivotal one: it represents something like the point of view of a nonhuman agent—the monolith—at the moment of rebirth. This death/rebirth goes unregistered by a human figure; the missing look lingers even at Dave's end.

Concealed gazes preside in Kaja Silverman's analysis of Marion Crane's shower murder in *Psycho*, a film without a monitor but whose cinematic operations illuminate the connection between the monitor and the camera's gaze. Marion's glances at the stolen money on her bed as she is undressing, and the reverse shots of the envelope, endow the package with a transcendent gaze that exceeds Marion's. Silverman expresses this excess with the psychoanalytic language of suture: "The castrating Other always sees guilt, its gaze can never be returned."[56] While the camera cuts on each thrust of the knife in the shower scene, the dissected film fails to reveal who the killer is, postulating its mastery by forcibly removing us from our own. We are thrust into unknowing with Marion. That guiding identification would seem to hinge on Marion's being alive. In fact, we learn "it is sustained up until the moment when Marion is definitively dead, an inanimate eye

now closed to all visual exchanges." What follows is the memorable tracking shot around the hotel room. Norman's eventual appearance only informs us that "we've been submitted to an even more powerful Other" in the meantime.[57]

The tracking shot searches for its secondary protagonist to close the gap left in the fiction by her open eye. Silverman claims this comes with the envelope: "Our investment in the fiction is made manifest through the packet of money which provides an imaginary bridge from Marion to the next protagonist."[58] But is this substitution so successful that we do not feel the urge to close the gap? The recovery of narrative after the protagonist's death, midway through *Psycho*, surely hovers over that envelope, but the length to which the camera must go—the post-humous motion that drags and stretches over space—drives home the delay between solitary death and narrative resumption. This amounts to the same thing as saying that Marion is *not* "definitively dead," that no such comfort is afforded the film body, and to pin the burden on her open eye is to simplify the various techniques of registration that cinema has found are its own. Arriving at "definitively dead" is more a problem whose solution movies must continually invent than an obligatory result of the cancellation of gazes.

As the primary screen registrant, a hospital monitor (or any of its cousin devices) does not completely close down the scene without leaving behind the trace of a gaze that cannot be embodied or returned. Like Marion's open eye, the flatline suspends temporality while the movie keeps going. The monitor's presumed inner deaths, hidden from the naked eye, may seem decisive in their screen presentation, but their effect is far from absolute. For evidence, consider the amazing recoveries performed in medical dramas by doctors who continually rally against the flatline and defibrillate patients (often before gelling up the pads, a big no-no in practice). Bodies are forever coming back from the dead in the cinema: the horror genre, with its serial logic, nearly depends on resurrection. Science fiction also plays with the bor-der: *Inception* (2010) announces the death of a character then defi-brillates him back to life without anyone so much as blinking an eye. Cinema has an instinctual interest in reversing the seeming irrevers-ible.[59] The fact that the flatline is undone as terminal exactly suggests

it is ultimately no more trustworthy or binding than any prior form of embodied death in the cinema and needs to be witnessed and recorded for it to finish dying. Gazes of watchers in the room must regard the information provided by the screen inside the screen. The monitor's unreturned gaze looms over the proceedings and calls on former cinematic strategies of identification, gesture, and vocal release. Because the monitor performs the activity formerly attributed to the screen registrant, it raises anew the question of whether screen death is a matter of human or machine perception. Now there is the matter of figuring out what feels human and what feels mechanical. The monitor may provide us with a new "face" of death, but that face is always registering and "other."

MONITOR EXPRESSIONS

A look at a variety of films will help us understand the perceptual and cultural anxiety surrounding the monitor. In *The Matrix* (1999) one of the team's members, Mouse, dies inside the matrix, and we see his mortal body writhe in pain while reclining in the chair on the mother craft, the *Nebuchadnezzar*. The matrix body is a virtual projection from the program running on the ship. Since it is not clear where the body on the screen "is" in this film, Mouse's "real" body's writhing offers no clearer a sign of dying than the matrix body being riddled by machine-gun bullets. A flatline briefly appears on a ship monitor above the body to confirm for the spectator that his material body is dead, followed by a shot of the central operator's anguished face. The flatline does not act alone, but it trumps the virtual body. This first flatline is later reversed, of course, when Neo is shot point-blank multiple times inside the matrix. He flatlines while Morpheus and Trinity look on (fig. 5.3). "It can't be," says Morpheus, since he believes Neo to be "the one" that can alter the matrix code and offer a kind of salvation from the unseen forces harvesting human bodies. Back in the matrix Agent Smith tells his minion to "check him," and the latter bends down and feels Neo's neck for a pulse: "He's gone." But this is the matrix, or virtual, body—that is, it is the "mind" part of the body/

FIG 5.3 Neo's misleading flatline in *The Matrix* (Andy Wachowski and Lana Wachowski, 1999).

mind dichotomy earlier established by Morpheus when he explains to Neo "the body cannot live without the mind." The fact that the same body is registered in two ways confounds the efficacy of either one. It is Neo's biological body—presumably dead—that hears Trinity's pronouncement of love and feels her kiss, stirring back to life. Neo can be "dead" according to a machine, because he is the one messianic figure that can rewrite the code inside the matrix defining physical laws. In short, he can beat the machine and what it says about what is real. The flatline is "real," representing a limit case for Neo; but it is also "virtual," aligned with the technological and thus reprogrammable world of the matrix.

Another instance of a future visual technology thought to bring death closer to the viewer appears in Kathryn Bigelow's *Strange Days* (1995). Lenny (Ralph Fiennes) is addicted to wire-tapping, or watching other people's experiences on discs that have been virtually recorded with a device called a squid. Friends are concerned that Lenny is doing way too much playback. On one disc left for him by a woman who has disappeared, Lenny watches the virtual first-person experience of an unknown man who enters the woman's apartment, rapes her, and jacks his squid feed into her so she can watch herself get strangled. The camera's gaze is at least tripled: what we the spectator watch is what the unknown assailant watches/does and what the victim watches/suffers.

FIG 5.4 The registrant in the eye of death in *Strange Days* (Kathryn Bigelow, 1995).

Her death is understood as the moment she can no longer watch what we are watching. Clearly a technophobic message rings out: the man gets off on inflicting death while recording it, watching it being watched. The assault combines the assaultive and introjective gazes that for Carol Clover represent horror's sadistic and masochistic viewing positions.[60] Registration comes first with the realized possibility of a film unwatched, then with propping open the poor victim's dilated, unmoving eyes (into which the camera zooms to finally reveal, in the left eye, the vague shape of the perpetrator, in a move reminiscent of Hal in *2001*). The open eye becomes a mirror at death (fig. 5.4). The camera cannot penetrate further into the body. It seems the point of filming such a sequence for the rapist/killer is to deliver to the embittered Lenny a closer view of someone's death (earlier, while watching someone fall from a building, he wakes from the virtual trip as the playback footage terminates). Magnifying the death moment with a novel technology forces the gaze to become helpless and complicit.

The film *21 Grams* (2003) offers a thoughtful dramatization of the effects of organ donation on individual death. The film traces the effects of an automobile accident on three lives that become variously entwined. Cristina Peck, a suburban housewife, loses her husband and two daughters in the hit-and-run; Jack Jordan is the culprit, an ex-con

who has since turned to Jesus. Cristina authorizes her husband's heart for donation; its recipient, math professor Paul Rivers, tracks down Cristina. They begin an affair, and he helps her find and try to kill Jack. The film begins and ends with Paul enmeshed in ICU tubes, poeticizing in voice-over.

Paul is ruminating on the borders of individual life while we witness his death on the monitor: "How many lives do we live? How many times do we die?" This last question defies the deathwatch. A shot up at the hospital fluorescents changes to reveal it is Paul's point of view: "They say we all lose twenty-one grams at the exact moment of our death—everyone." Paul's phrasing slows down to carefully pronounce "exact moment of," as if preparing us for the monitor. A side shot gets his attention, but instead of leading to a reverse shot of the monitor, we see a montage sequence—extracts replayed from the film, revelations of previously suppressed plot points (like the missing reverse shot of Cristina's friend flipping her off in the pool), or moments of epilogue (like a shot of Jack coming home to his wife, Marianne). Past, present, and future converge at the deathbed. Paul then measures the contents of twenty-one grams: "the weight of a stack of five nickels, the weight of a hummingbird, a chocolate bar." On the monitor we see the red line and digital readout "43," then a flatline and a bottom arrow, respectively, in close-up. The reverse shot is of a dead man with eyes open, but an exterior shot of an unkempt winter pool, snow falling, offers a little posthumous motion before the movie comes to a close, contrasting with the movie's initial orienting image of black birds rising into the sky.

Paul's poetic images convert the great leveler into an incremental measurement, corroborated by the monitor's precise readout. Earlier we also learn the exact time of Cristina's husband's death.[61] But an integer proves a barren signifier in the exchange of organs. For one thing, Paul's heart is Cristina's husband's. In the film's opening scene Cristina is telling a drug rehab group about hitting bottom in the hospital where she herself flatlined (this is not meant as a metaphor). And then there is the hospital voice-over of Paul, whose temporal alignment with the death moment is posthumously confounded. Not much

clarity about death, then, at least not as an end point, for a film all about it. The monitor provides limits that the film contextualizes as inadequate. Only the monitor registers—but then again, *whose death is it*? Having found its precise moment beyond the purview of an onscreen beholder, the film turns an instant back into process with Paul's voice-over that exceeds the punctual flatline. In one sense the monitor death reads as nearly virtual—not quite a biomediation but a sign that has lost its clear reference to any one body.

Steel Magnolias (1989) offers a more conventional melodramatic tableau of death. Another organ donation is involved: M'Lynn gives her own kidney to save her daughter, Shelby, who suffers medical problems from giving birth that plunge her into a coma. The death scene unfolds over a series of elliptical shots in which only two sentences are spoken. As the camera pans her IV injection and moves to M'Lynn looking on through a glass window inside the hospital, we hear offscreen a doctor quietly telling the males that "her coma may be irreversible." Later, M'Lynn sits bedside showing family pictures to Shelby amid steady bleeping, pleading "open your eyes Shelby, open your eyes." She reads to the unresponsive body from a boutique magazine. M'Lynn becomes a stalwart for waiting: her maternal sacrifice is made clear when her husband, Drum, tells her to go have dinner. "What if she wakes up for two minutes and I'm not here?" is the response. Bleeping steadily, the monitor fills the hospital room. We see Jackson sign the legal forms to stop life support. These silent gestures seem decorous against the monitor's constant music.

Shelby's death shot is carefully planned, beginning with the turning off of the monitor by an unseen hand. The moment of unplugging from life support disconnects the spectator from those who perform the lethal action, relegating them to offscreen space. The camera moves left, and we see (the hands of) a doctor remove the tube from her mouth; the camera continues past the monitor's HP readout of "34" and normal cardiograph to Drum (framed in a medium shot), who leaves, to Jackson, who walks right and seems to bring the camera back with him. He kneels down out of sight, presumably to kiss Shelby one last time. As he does this, he clears our gaze of the monitor that now shows a gradually lowering number for heart pressure from

"32" to "25," one digit at a time. Standing up, he leaves. The monitor remains at "25" for a moment; beside it, we see the line that shows no cardiac activity, and the bleeping stops. After this pause on the diegetic screen, and after clearing the men from the frame, the camera begins to move again, this time down to capture M'Lynn in a close-up profile as she shakes slightly. Here the monitor indeed substitutes for the presumed corpse, as the camera moves away posthumously, only to end its gesture with the mother figure. One final camera movement extends down M'Lynn's arm to reveal her holding Shelby's hand with one of her own and stroking it with the other.

In such charily choreographed movement we can easily find the emotional peaks in the death shot. The first pause comes as the monitor captures the slowing down and inactivity of the heart. The second and third pauses are more traditional stamps of registration—M'Lynn's reaction shot and the juxtaposition of her moving hand with Shelby's still one. It is that first pause, its invocation of a reaction shot, that we must attend to—that is, the flatline on the screen inside the screen. As in 2001, we find both an analogical and digital representation: the heartbeat's linear peaks disappear, leaving behind a steady flat trace; and the numerical HP readout jumps from "24" to "8" to "4." Men clear the frame with heart still beating to leave the mother behind with the flatline, which is thus intimately connected to the maternal gaze.[62] No one in the film looks at the monitor, but it gets the most attention from the camera. *Steel Magnolias* avoids cutting to emphasize the passive suffering of the mother, ensuring that the maternal gaze takes over for the machine's.

Traditionally, the unreturned gaze of the corpse turns fictional beholders into registrants. The monitor changes this in at least three ways: (1) its audiovisual output confounds rather than clarifies "definitively dead"; (2) it takes the place of both the dying body and the registrant, combining the two (shades of Hal); and (3) it adds a new decorous set of gestures to a scene in which the dying need not even participate.

The monitor catches the final trace of the body that is otherwise not moving in the frame, giving deadness a perpetual stillness outside the body, an ongoing presence (either in the steadied or stopped bleep).

The confluence of registrant/corpse, of life/death, fills the space in a kind of prewake, because part of the cinematic signifier is caught in between. Registrants respond as if they've seen a movie, thus closing down the gap between registrant and spectator. It is tempting to read the ongoing gaze of the monitor as guilt-inducing in scenes of unplugging. *Steel Magnolias* genders the difference between operators and bedside witnesses. In *Million Dollar Baby* (2005), boxer Maggie Fitzgerald is paralyzed waist-down by a renegade fighter. While in the hospital, she bites off her tongue in an attempt to end her life. This fails, the tube goes in, and her trainer, Frankie Dunn, seeks spiritual guidance for complying with Maggie's expressed wish to be removed from life support. He decides to euthanize her during the night while a nurse on duty is out getting a soda. As Frankie walks into the hospital room to kill Maggie, an overhead shot arranges the three participants—Frankie, Maggie, the monitor—in a triangle. The monitor is a third presence throughout, both acoustically in its bleeps and visually in the background or framed beside Frankie. Here again a voice-over takes us away from the present scene unfolding: it belongs to Scrap Dupris, an African American janitor and Frankie's sidekick, who safeguards the white man's lethal actions. He tells us, "He gave her a single shot. It was enough adrenaline to do the job a few times over. He didn't want her going through this again."[63] The camera, formerly focused on Frankie's injection, refocuses the background screen to show all three vital readouts turn flat, along with the accompanying change to a steady pitch. Frankie's lethal injection is doubly registered by marginal observers—by Scrap, through his familiar voice, and by the monitor, through its bleeps and waves. There is a shot of Frankie's face, a shot of Maggie's, and the offscreen sound of the EKG's constant output. He looks at her corpse but not at the monitor. Its outburst is like a testimonial to what Frankie has done, telling the silent act.

The monitor extends bodily stillness and silence long after they occur or equate to death. Such an excess is old and new—old, because the constant output of the soundtrack in films previously traced reverberations in space through music or dialogue; new, because it is here constant, unwavering. Death's mobile sign is now entirely disembodied, offering cinema a kind of frozen index, an audiovisual representation

of sameness over time. Equipped to render death exactly, the monitor is transparent and commutatively precise. But we must still turn dying into an event of our own. Announcing it is too late, consulting the family, kissing the body, saying good-bye, unplugging the machine, narrating in hindsight—these become actions made in the shadow of the telltale monitor. The lull of staring into the flatline, the "spell" described by Dr. Micco, can only be broken by another action—turning off the monitor if you are a doctor, turning off the camera if you are a filmmaker. The flatline is thus a mobile sign that affords another "off" switch, one that we can pull on the outside of the body. The sign itself must be terminated by the observer who is often commensurate with its production. The dramatic tableau that for so long centered on the dying figure and his or her relationship to the registrant has now become a technological tableau, but not without marking the evacuated human figure with some anxiety.

DEATHWATCHING

After the Harvard criteria, and Elisabeth Kübler-Ross's publication of the five stages of grief, a culture of awareness regarding end-of-life care emerged that included a documentary impulse to publicize terminal illness. Michael Roemer's *Dying* (1976) is perhaps the first such film, a set of interviews with patients that leaves them to die off camera, but Frederick Wiseman's observational documentary *Near Death* is an object lesson on persistence.[64] The film is a six-hour foray into the intensive-care unit of Boston's Beth Israel Hospital, where the problems of truth-telling, caregiving, and determination are of daily concern for medical staff. Wiseman's film documents the decision-making process surrounding four bedridden patients. Here, dying is indeed slow and motionless: the sick bodies barely move over the course of the film. Death appears nearly trivial in the hospital context, but the tension between process and event plays out around the monitor. The one death caught on film is that of a patient who suffers cardiac failure, an event announced by the monitoring system. The remote projection of the EKG includes the transmission of signals to elsewhere inside the

hospital, in this case the nurse's station (as in Dr. Murray's account). Of course, this signal lends itself to cinematic form as it exhibits a chartable progression with narrative peaks that even the documentary camera can follow. Wiseman's camera barges in along with the nurses, but the actual moment evades. Machines hold the deathwatch: "Alarms go off when the quantitative [data] of our qualitative human quiddity indicate dangerous change, or a movement toward death," writes bioethicist Arthur Kleinman. In his review of Wiseman's film Kleinman connects the long process of dying to the temporality of the moving image. Though "the film comes to its own overly prolonged end," it nevertheless leaves behind the impression of "a remarkable intensity of witnessing," one that we can ascribe to Wiseman's seemingly unobtrusive camera.[65]

Submitting dying to a gaze that can be turned on and off exposes the moving image's limitations next to the more perdurable monitor. Kleinman's critique of the film implicitly connects the moving image to medical technology: "Observing families in the MICU, even for a quarter of a day, is not the same as being with them at home, coming to know them, and understanding the impact on their lives of the family member's illness and its treatment."[66] Kleinman speculates the moving image camera is not suitable to apprehend the longevity of the end of life, the *durée* of a slow and uncertain process. He distinguishes between, on one hand, the possibility of a total record consisting of even longer machine-assisted excursions and, on the other hand, a fragmented version that results from turning on and off the gaze. This latter act of watching, intermittent and in need of occasional rests, is that of embodied perception. The former suggests a complete act of recording; the latter suggests a partial and imperfect human gaze, full of holes and blank spots. Wiseman's persistently detached camera can capture the body, reasons Kleinman, even at death, but because it is operated by human hands, it fails to capture the variegated decision-making process surrounding the end of life.

Holes and blank spots are tantamount to human vision; they are constitutive of any embodied act of perception. In fiction films the machine's "gaze" only seems to be shared by an onscreen figure, but that figure does not register death, only the "cinematic" version of it

pictured on the monitor. People still say good-bye, kiss bodies, stroke hands; doctors pronounce patients, record or approximate time of death, attempt to resuscitate or defibrillate. The ceremony (Micco has called it a "charade") goes on under the umbrella and in the presence of an "other" whose gaze, like that of the dead body, cannot be embodied.

In both documentary and fiction, somatic death evades. It passeth understanding. Insofar as it passeth understanding, machines retrieve its integer formation. Who is this "other" that sees death and who is never replaced but only corroborated by a fictional other? The machine cannot trigger a reverse shot to show us what it sees (though Kubrick's POV shots of Hal show us our desire to anthropomorphize such a mechanical eye), so it offers a clean break from previous efforts to manage a mobile sign of bodily death. But this "other" also raises the specter of consent in decisions to stop treatment. Jackson's signing away his permission in *Steel Magnolias* authorizes the termination of life support, and death cannot happen without it; Frankie's covert act of nighttime euthanasia is monitored by the monitor. The switch-turner, tube-remover, or plug-puller is never alone. The vitality each brings to an end is swallowed up by another cinematic signifier. Hollywood execution scenes separate those behind the gadgets from the body spectacle. I'm not suggesting Shelby's intimates are executioners, but it is justified to connect execution and extubation as terminating acts that occur outside the body. The fact that the figures behind the switch and the tube are so carefully avoided suggests exactly that the filmmakers worried that they *are* complicit, perhaps even with the act of recording. In *Million Dollar Baby* the decision has clear social implications: the real evildoers in the hospital (the dirtiest hands) are Maggie's white trash, welfare-abusing family, who try to guilt her into signing away her winnings to them. Frankie's act of euthanasia occurs in the shadows, away from Maggie's family; surely Eastwood and scriptwriter Paul Haggis invented that awful family to justify Frankie's actions.

As the 1968 criteria of brain death made clear, and as subsequent eruptions of controversy continue to remind us, it is difficult for a second party to take full responsibility in the decision-making process.

Most second parties do not want to. The head physician interviewed throughout *Near Death* is forever referencing the "Quaker concept of consensus" to represent democratic process in the hospital, where a concept of truth seems nearly irrelevant.[67] Technological death increasingly occurs as a group effort. That terminating life support hinges on the proper composition of relatives was made clear by the Supreme Court's statement regarding the Cruzan case that not everyone has, or will have, "loved ones." Though medical experts may have eventually embraced brain death, the Supreme Court invented "loved ones" as the limit case for how we might participate guiltlessly in the act of unplugging. Determining *which* loved ones, of course, can be a rather contentious matter.

A horrific view of end-of-life bureaucracy can be found in *Coma* (1978), a film wonderfully attuned to issues raised by life support and organ donation, and one in which "loved ones" are nowhere in sight. A medical doctor on staff, Susan Wheeler, begins to suspect foul play when patients undergoing minor surgical operations in Operation Room 8 keep coming out in comas. She traces their whereabouts to a facility outside the city where the "vegetables" (the film's frequently abused euphemism) are kept. On her tour through the facility Susan sees the giant room where bodies are suspended by strings and monitored by a single "self-regulating" computer system to keep metabolism in check (shades of Hal). The creepy Nurse Ratched–style guide informs her guests, "We don't take part in the debate over whether they're alive or dead." In this fantasized equal-opportunity venue we find the fear of technological death as a financial boom. Behind the veneer of equality we learn of an insipid plot to sell organs on the phone in something like an eBay exchange. All this can be traced back to a tampered flatline we watch at the beginning during an abortion.

I am suggesting that the flatline allows the camera to get closer not to death but to its "cinematic" registration. It is an even more adequate deathwatcher than the camera has allowed us to be. But the main reason the flatline might seem "polygraphic" and self-evident— and this is crucial to its reception—is that it invokes the movie screen as a formerly missed encounter with the death moment.[68] This is how Christopher Buckley recounts his mother's death:

After removing the tube, the doctor said, "It usually goes quickly." I sat beside her, watching the monitor, with its numbers and colored lines and chirps that tracked her breathing and heartbeat and other diminishing vital signs. Her heart rate slowed, then quickened, then slowed. After a time, I realized that I had become fixated on the monitor. I could hear her saying to me, a half-century earlier, "Are you just going to sit there and watch television all day?" . . . Some months later, I read that monitor-fixation is routine at deathbeds. Even at the end, we have become compulsive TV watchers.[69]

Whatever the monitor's effect, it must still be attended to and spoken for. Even if registration has become a charade next to the authoritative machines, it must still be performed.[70] Again, what the flatline might really mean can be read as pre-posthumous, instantaneous, or posthumous. Reducing a long process into condensed cinematic form, the monitor's dying comes to an end when it is turned off. Here I must reinforce the idea of a mobile death sign that does not stop without human touch. The monitor replays countless movie scenes that terminated once the body was registered. Turning off the machine, then, through cutting or unplugging, reminds us of the combination of persistence and flux attending the desire to capture death in time.

Brain death emerged from legal problems in procuring organs, allowing doctors of the future to testify in court that death had been expertly established before otherwise lethal actions were taken. It is not surprising that verifying cessation in the 1950s was primarily an urge inspired by courts of law, not doctors or philosophers. But even the machine is imperfect, as evidenced by the recent contention over Terri Schiavo's brain activity. The EEG must still be interpreted by the bedside attendant (and, significantly, it must be observed *over time*); the machine, like a dead body, is spoken for by the doctor testifying in court (as in Cranford's "It's flat—flat," quoted at the beginning of this chapter). With the mise-en-abyme of filmed flatlines the prehistory of current ICU practice resurfaces. One machine looks at another machine; the result is an unusually punctuated and disembodied activity. One advantage the second machine (EKG/EEG) has over the first (the movie camera) is that it completely abstracts the body into a

set of numbers and lines. It appears to be analyzed already and thus somehow "pre"-filmic. It arrives as if already seen, allowing cinema to represent death as a referential audiovisual moving image—cinema approaching the present tense.

The irreversibility of apparent death has long been cast in the shadow of a doubt—at least since the seventeenth-century discovery of heart resuscitation. Note electricity's dual function since the nineteenth century as both a lethal and resuscitative agent. Brain death's controversial criteria—and the fact that the EEG uniquely can produce false positives in such cases as barbiturate overdose or brain autolysis—lend the EEG a degree of uncertainty. And asystole, or EKG flatline, is notoriously misunderstood, commonly presented as an emergency from which doctors successfully defibrillate hearts before using epinephrine or CPR. The camera takes over and "cinematizes" the flatline to produce a new event horizon—an asymptote it need no longer approach because it is no longer even where the body is.

A film that plays with this bodiless sign is, of course, *Flatliners* (1990). In this most ludicrous (but highly relevant) of movies, everyday medical students stop their hearts to induce near-death experiences so that they can learn about the afterlife. In each case the machine flatlines before the camera takes us "into" their minds to see their suspended trips. Whereas the screen shows us where the body "is," the camera penetrates its shell to show us what we think it is made of. Here we glimpse a reunion of two technologies: the camera starts where the monitor stops. The first to go under is Nelson, the mad scientist behind their experiments. Once "brain death" is (impossibly) pronounced, Hurley is told to "start filming." Through the hand-cam we see first a zoom into Nelson's eye that turns into colorful dream images. After this connection is established, a subsequent zoom moves into the actual flatline that seems to have replaced Nelson's eye. The monitor sees something that no one in the room can see, including the dead man.

CODA

END(INGS)

Step into the light poor Lazarus
Don't lie alone behind the window shade
Let me see the mark death made.
—GILLIAN WELCH

THE HISTORY of cinema death is cumulative, not evolutionary. Movies have compiled an arsenal to go to work on the outside (cutting, framing, registration) and the inside (heard sound, voice, montage of epiphany). There are other supplements than the ones discussed here, of course. Some of these developments, such as the squib, update techniques found in earlier experiments (the use of electricity in early cinema, for instance). But the rhythm, reverberation, and ambiguity in static dyings illuminate the technique and staging of more spectacular ones. Dying has more than one end in the cinema—be it slow or sudden, at home or in hospital, quiet or cacophonous, still or violent. There is more than one ending on the screen because there is more than one ending in life. In cinema and in life: the deathwatch we hold must end by acknowledging multiple endings. In cinema and in life: repetition and disembodiment are tantamount to technological dying.

Though I have organized these readings mostly chronologically, my hope is to contribute to a dialectical model of film history. Each

new technological layer, each medial shift, allows film to approach the end of life with more precision. At each of these turns, a newly imagined "instant" or "switch" emerges as a potential division between life and death. But with each supplement, the Barthesian slash of Life/Death is turned into human process—full of holes and errors, one we can trace most readily in characters' unfinished feelings and wanted reprieves but one that survives in the camera's encounter with death. The interaction between precision and emotion, between the mechanical and the human, mirrors the way we often die on or around machines. This approach/recede model of formal "evolution," then, this technological history of formal emergence, spells out an antievolutionary condition of the medium—cinema does not keep doing it "better."

The ever-sharper edge between "alive" and "dead" envisaged by each medial innovation is, in the end, softened. First, the electric chair's on/off switch invigorates the ideal of an instant death. While the substitution splice functions on a compatible premise, its dying process exceeds the switch's logic, requiring in turn subsequent gestures of confirmation—touching the body, nodding toward officials, addressing the audience, turning off the camera. In the first fiction films there is some tension around death as a one-time occurrence. How frequently it is repeated—sometimes many times—by the figure(s) who returns, acknowledges the body, and grieves. Griffith's films powerfully separate the living gaze (of the registrant, of the camera, of the spectator) and the corpse. Later, the soundtrack expands and enlivens the space around the dying body, but like an echo, the turning "off" of sound reverberates outside the body.

Voice-over delineates past/present and alive/dead, but the fact that the body can lose its voice to an eternal present makes finality ambiguous, if not impossible. Plus, the voice-over narration of the dying/dead protagonist plays with the very notion that his or her moral recognition will occur in the nick of time, switch-like. The flasher-back expands such a moment of moral judgment into a more movie-like process that is suspended in time. The flatline figures the sharp distinction between a changing line and a line that no longer changes, that is, between an index of difference and one of sameness. Yet bedside

human registrants (both lay and medical) must finish the "scene" through participation. In all these variations of dying, and in the posthumous motions they generate, the cinema camera has tried in its own ways to apprehend the meaning of an act that transcends us all.

A historian friend of a friend once referred to the act of witnessing his dog die, in his arms, as a disembodied experience we're all familiar with: it was "like watching a movie." What is the "movie"-ness of our experience of real death? The flatline is part of the answer. When we watch monitor deaths on television and film, we see a moving image of a moving image. On one hand, the diegetic screen promises greater precision; on the other hand, it merely produces a mise-en-abyme, a screen in/on a screen. In 1895 Edison's kinetoscope seemed poised to capture the last movements of the body, as if to inculcate the photographic conception of a sudden break in life. Recall *The Execution of Mary, Queen of Scots*. There was a sense even in that earliest movie that the death moment both was and was not amenable to the flux promised by the new medium. Ready to capture the last gesture, cinema inherits the age-old medical problem of how to determine death. To do this, it looks and listens elsewhere: outside the body, between spaces. These surfaces, faces, and media return the gaze that the body's interior cannot. Such compensations become extraordinary images, and in a way, the flatline is one of them.

We get an account of the screen's disembodiment in Dr. Guy Micco's recollection of a bedside monitor that he had to turn off in front of his patient's family after he pronounced him dead, an account worth repeating again in part: "Mr. Reggie was in some strange liminal state, as were we, for what felt like a very long time." The look and the object resemble one another. Even though we've plugged death into a machine, we still must put on the final touches. The monitor may be experienced as immediate but it is not terminal, even when it flatlines: it does not pronounce, it does not say good-bye, it does not need to leave the room. The monitor represents death *as time*: a domain of nonreciprocal output of the body. Continual proof of inactivity, it figures a persistent vital absence. The monitor features an interruption of *unlived* time that we must *live through* by watching. Time-based technologies grapple uniquely with death because they insist it takes

place *in time*. The EKG, the EEG, and the cinema—these screens picture death as a *mobile sign*.

Given exactly the nature of this one-sided image of duration, I would suggest as an afterthought to the films studied here that in its funereal passages especially, the cinema wants to solve the basic problem of the loneliness of death. It is striking that the registrant becomes so carefully staged so soon. Of course, it is possible to film death without registration. The point is that film potentially reinforces the mechanical isolation of the body, extracting it from a social context. Registration provides a gaze of reciprocity that compensates for the human dilemma of death's loneliness, and as such, it stands in for something like unmerited grace. A final reason the registrant compensates for death, to say it again but differently, is that the camera could film dying without it.

The fact that real death is becoming more and more documented by cathexes of the dying—in films such as Tom Joslin and Mark Massi's *Silverlake Life* (1993), Jan Oxenberg's *Thank You and Goodnight* (1993), Kirby Dick's chain-camera experiment *The End* (2004), and others—would seem to suggest that the moving image can be thought to replace the real dying body as the locus of registration, committing to the present an act of witnessing but one that can be experienced again in the future.

Oxenberg raises the issue of future viewing within her own film. After her grandmother, Mae Joffe, dies, Oxenberg assembles some of her belongings and reconstructs "Grandma"'s apartment (and, of course, films it). She ruminates: "If I put Grandma in the room, would she have to die over and over again?" The lesson is that any frozen memento leads to redying once it reenters the flow of time. A personal filmic record designed for the purpose of working through loss must join the ranks of cinema's posthumous moving images, bringing back up some of the ambiguities of a shot such as the concluding one of *The Country Doctor*. On the topic of saying good-bye, Jan's younger brother shares these insightful words around the dinner table: "No matter how many times you see her, it's still not going to be enough, because you can never say good-bye."

But clearly, making this film (composed of various types of footage, including historical, home video, reenactment, interview) constitutes

Jan's attempt to do just that. Early on, Jan recalls being taken to Loew's Paradise Theater in the Bronx by her grandma when she was five. She reenacts such a trip with cardboard cutouts representing Mae's ubiquity in her life (there's a Grandma cutout for the stewardess, the food vendor, the spectators, etc.). Later, when Mae is dying, Jan asks if she can come visit her where she's going. Mae replies, "Bring your cameras, bring the film, bring everything." Being the subject of her granddaughter's film has brought Mae closer to Jan and vice versa. The unstoppable flow of cinematic representation—the problem of finding a moving mnemonic that does not repeat dying—returns when Jan narrates in voice-over her grandmother's death. Here movement breaks down. Try as she might, Oxenberg cannot film the death moment. She leaves the hospital before it happens, realizing, "If I was in the room, she would not die." During this recollection Oxenberg represents a series of photographic images of Mae's last day in the hospital, as if refusing to play the film because doing so would lose her, and force us to lose her, again. Returning to the hospital at 3 a.m., after Mae's death, Jan is invited to sit in the grief counselor's office, where she does, until morning, unwittingly taking the same photograph seventy-two times—of a white bag with "PATIENT'S CLOTHING AND BELONGINGS" written in red letters. The documentary replays seventeen of these photographs for the spectator, staging the repetition attending the process of registration. Nowhere is it clearer that Oxenberg uses the film medium to restage the death of her grandmother in order to invite the spectator to identify with her process of registration.

Even though Oxenberg might have filmed the death moment, or gotten as close as possible, the fact of human reciprocity stands in her way. Mark Massi turns on the camera just after Tom Joslin's death has occurred in *Silverlake Life* to sing again a song he had sung to him while dying, to say good-bye, and to record the promise to finish the film Tom had started. Later Mark says on camera, "I understood all this was going to happen, but it always happens so fast." Tom cannot finish the film of his dying and allows Mark to resume control of filmmaking when he can no longer leave bed, again affording an intimate encounter between filmmaker and dying person, and between the spectator and the film. Mark apologizes to Tom that death does not

happen like it does in the "movies": "Then I wanted to close his eyes because it's very strange seeing a dead person staring. And I tried just like in the movies to close the eyelid. It doesn't stay closed. It pops back open." That Mark refers to cinema as something that helps him mark his own experience, and that he says so on film, underscores the work of *Silverlake Life* to help (him) register his partner's death.

I would be remiss if I didn't raise the question of whether the camera's gaze is more aligned with that of the human or the machine. I believe the answer is that it leans heavily on the latter's accuracy but that it turns back, again and again, to human qualities of affect and remembrance, to structures of empathy and identification. Built on precision, the camera situates the mechanical time of death within a subjective time measured by hearts, not clocks—the totality of an absence often gradually unfurls, as we see in the final shot of *The Country Doctor*, a shot that luxuriates in the potential for picturing absence. Griffith's death is a bodiless pan. The image of nature exceeds the frame's dependence on the moving human form. The same may be said of the image of the repeating linear output. We call it a flatline. We might also call it a pan shot.

If at the moment of watching a monitor death there is a feeling of strange familiarity, then I hope to have suggested two reasons for why it is so uncanny: the first is that there is no body on the screen, and the second is that we've seen it before.

NOTES

INTRODUCTION: AN ELUSIVE PASSAGE

1. Quoted in Noël Burch, *Life to Those Shadows* (Berkeley: University of California Press, 1990), 23. Gorky wrote three pieces on cinema that can be found in Gilbert Adair, *Movies* (New York: Penguin, 1999), 10–13.

2. See David Thomson, "Death and Its Details," *Film Comment* 29 (Sept. 1993): 13–14.

3. See www.filmsite.org/bestdeaths.html; the website also features other compiled lists for "scariest moments" and "last lines."

4. For the general idea scan documentingreality.com (with a variety of sample menus) and facesofdeath.com (where you can order the eponymous film). I will turn to snuff films in chapter 1, when I discuss execution reenactments. For a historical survey of snuff films see David Kerekes and David Slater, eds., *Killing for Culture: An Illustrated History of Death Film from Mondo to Snuff* (London: Creation Books, 1994), a picture book not without its formalist virtues.

5. Thomson, "Death and Its Details," 13.

6. Marilyn J. Field and Christine K. Cassel, "A Profile of Death and Dying in America," in *Approaching Death: Improving Care at the End of Life*, ed. Marilyn J. Field and Christine K. Cassel (Washington: National Academy Press, 1997), 33–49.

7. See, for instance, the condensed version of Ariès's compendium *The Hour of Our Death* in his *Western Attitudes Toward Death: From the Middle Ages to the Present* (Baltimore: Johns Hopkins University Press, 1974), 85.

8. Robert Artwohl, "JFK's Assassination: Conspiracy, Forensic Science, and Common Sense," *Journal of the American Medical Association* 269 (March

24, 1993): 1540–43. This was not the first autopsy of the Zapruder film published in *JAMA*. John K. Lattimer isolated body movements begun in individual frames to explain the specific wounds suffered by both Kennedy and Senator Connally. See John K. Lattimer, "Additional Data on the Shooting of President Kennedy," *JAMA* 269 (March 24, 1993): 1544–47. For scholarly treatment on the relationship between the Zapruder footage and film more generally see Art Simon, *Dangerous Knowledge: The JFK Assassination in Art and Film* (Philadelphia: Temple University Press, 1992).

9. For Joel Black, the realistic or "graphic" nature of film violence is often borrowed from the techniques of "snuff" footage, that is, purportedly unedited film of actual death. In other words the idea of what real death might look like on film influences the style of fictive scenes. See Joel Black, *The Reality Effect: Film Culture and the Graphic Imperative* (New York: Routledge, 2002). I will deal in chapter 1 with the mixture of real and fake to generate believable executions in early cinema.

10. For a full discussion of the use of moving medical images to read the body, and the interplay between still and moving images in the medical context, see Scott Curtis, "Still/Moving: Digital Imaging and Medical Hermeneutics," in *Sound Bytes: History, Technology, and Digital Culture* (Durham, NC: Duke University Press, 2004), 218–54.

11. The 1984 version was updated and republished. See Vivian Sobchack, "Inscribing Ethical Space: Ten Propositions on Death, Representation, and Documentary," in *Carnal Thoughts: Embodiment and Moving Image Culture* (Berkeley: University of California Press, 2004), 235.

12. Roland Barthes, *Camera Lucida* (New York: Hill and Wang, 1981), 92.

13. Dick Teresi, *The Undead: Organ Harvesting, the Ice-Water Test, Beating-Heart Cadavers—How Medicine Is Blurring the Line Between Life and Death* (New York: Pantheon, 2012), 4.

14. See Minsoo Kang, *Sublime Dreams of Living Machines: The Automaton in the European Imagination* (Cambridge, MA: Harvard University Press, 2011), 172–74.

15. For a discussion of the anxiety provoked by dolls, see Gaby Wood, *Edison's Eve: A Magical History of the Quest for Mechanical Life* (New York: Anchor, 2003), 31. Wood also discusses the possibly apocryphal Descartes anecdote in relation to mechanistic philosophy (1–13).

16. See also Tom Gunning, "Gollum and Golem: Special Effects and the Technology of Artificial Bodies," in *From Hobbit to Hollywood: Essays on Peter Jackson's "Lord of the Rings,"* ed. Ernest Mathijs and Murray Pomerance (Amsterdam: Rodopi, 2006), 319–50.

17. See Annette Michelson, "On the Eve of the Future: The Reasonable Facsimile and the Philosophical Toy," in *October* 29 (Summer 1984): 17–20.

18. See Martin Pernick, "Back from the Grave: Controversies over Defining and Diagnosing Death in History," in *Death: Beyond Whole-Brain Criteria*, ed. Richard M. Zaner (Dordrecht: Kluwer, 1988), 25–27.

19. Plato recommends in *Republic* a waiting period of three days before burying the body. See Teresi, *The Undead*, 57.

20. See Thomas Laqueur, *Making Sex: Body and Gender from the Greeks to Freud* (Cambridge, MA: Harvard University Press, 1992), 1–4.

21. Pernick, "Back from the Grave," 17–74.

22. Ibid., 39.

23. Ibid., 38, 54.

24. See Teresi's discussion in *The Undead*, 125–26.

25. I am grateful to Dr. Micco for making a copy of his paper available to me. His presentation was part of an interdisciplinary conference on death and dying titled "Seeing the Difference" at the Townsend Center for the Humanities at the University of California, Berkeley, on June 1–2, 2000.

26. John Murray, M.D., *Intensive Care: A Doctor's Journal* (Berkeley: University of California Press, 2000), 13–14.

27. See Garrett Stewart, *Between Film and Screen: Modernism's Photo Synthesis* (Chicago: University of Chicago Press, 1999). Stewart reasons that "if photography is a corpse, film is, by contrast, a finality always on the cusp of revival, or otherwise a vividness always in passing" (152). Thinking of death as a spark for medial innovation (form) leads Stewart to privilege cinematic technique, in particular the filmed photograph and the freeze frame, both of which stage stillness as deferred apparent motion, *not* the lack of motion. And while he acknowledges that "the edited gap within a scene—the cutaway, sometimes the reverse shot—is often the decisive inscription of the death moment, where the intermittent nothingness of the strip may for once burst through on-screen as figurative hole in human temporality" (153), it is equally important to *look* at what the cutaway or reverse shot shows us, to feel its rhythmic connection to the body that came before, and to trace the bridge to what can be thought to come next. These cutaways and reverse shots to human beholders, it turns out, are utterly foundational in early cinema (an era Stewart does not discuss), paving the way for more abstract end points. Someone's apparent death does leave a hole, but filling in that "intermittent nothingness" is something moving images undertake uniquely, and to great effect.

28. Laura Mulvey, *Death 24x a Second: Stillness and the Moving Image* (London: Reaktion, 2007), 72.

29. Ibid., 87–88. If it is indeed true that Hitchcock hovers at the "uncertain boundary between stillness and movement," as Mulvey claims, he is also hovering at the uncertain boundary between life and death and must resolve this tension through nonfigural shots that mark Marion's recognition as a corpse.

30. See Kaja Silverman, *The Subject of Semiotics* (New York: Oxford University Press, 1983), 211.

31. André Bazin's essay appears, translated from the French by Mark A. Cohen, in *Rites of Realism: Essays on Corporeal Cinema*, ed. Ivone Margulies (Durham, NC: Duke University Press, 2003), 27–31. Pasolini's essay can be found in *Heretical Empiricism*, ed. Louise K. Barnett and trans. Ben Lawton and Louise K. Barnett (Bloomington: Indiana University Press, 1988), 232–37.

32. It might have been, though, for exactly the reason that the footage was not shown again for several years following the assassination. Of course, the very fact that it could be shown again informed the initial impression of the footage and each subsequent viewing.

33. Though Bazin does not promote editing for certain effects, he does suggest the bullfight film makes good "organic" use of editing. The technique that most concerns him here, however, is the very act of replay, with magnification (close-ups, decoupage) coming in second.

34. Stewart, *Between Film and Screen*, xi, 152.

35. For example, see Bazin's key essays on Italian neorealism, particularly his essay on De Sica's *Umberto D*, which he concludes with the following: "De Sica and [scriptwriter] Zavattini are concerned to make cinema the asymptote of reality—but in order that it should ultimately be life itself that becomes spectacle, in order that life might in this perfect mirror be visible poetry, be the self into which film finally changes it." André Bazin, *What Is Cinema?* trans. Hugh Gray (Berkeley: University of California Press, 1971), 2:82.

36. Mulvey writes that the "photograph's suspension of time, its conflation of life and death, the animate and the inanimate, raises not superstition as much as a sense of disquiet that is aggravated rather than calmed by the photograph's mechanical, chemical and indifferent nature" (*Death 24x a Second*, 60–61).

37. Sobchack, "Inscribing Ethical Space," 235.

38. See Ariès, *Western Attitudes Toward Death*, 88–89.

39. Sobchack, "Inscribing Ethical Space," 234.

40. Lowenstein theorizes horror spectatorship by first returning to the writing of Maxim Gorky in "Living Dead: Fearful Attractions of Film," *Representations* 110 (Spring 2010): 105–28.

41. Elisabeth Bronfen and Sarah Webster Goodwin, introduction to *Death and Representation*, ed. Sarah Webster Goodwin and Elisabeth Bronfen (Baltimore: Johns Hopkins University Press, 1993), 20.

42. The natural bed death "sets up and fulfills its own expectations over a perceived *durée*," which marks "little contrast between movement and stillness." Sobchack, "Inscribing Ethical Space," 239.

43. See also *Silverlake Life* (1991), in which Mark Massi contrasts his lover's death with the death he sees in the movies.

44. Important works on film violence include Stephen Prince, ed., *Screening Violence* (New Brunswick, NJ: Rutgers.University Press, 2000); and Prince's study of classical Hollywood in *Classical Film Violence: Designing and Regulating Brutality in Hollywood, 1930–1968* (New Brunswick, NJ: Rutgers University Press, 2003); and David J. Slocum, ed., *Violence and American Cinema* (New York: Routledge, 2001).

45. One sociological study sampled five hundred films to conclude that "violent death, actually presented or hinted at, dominates all other presentations of death" and points out that "award films" include "significantly more expressions of sorrow and sadness." See Ned W. Schultz and Lisa Huet, "Sensational! Violent! Popular! Death in American Movies," *Omega* 42, no. 2 (2000–2001): 146, 137.

46. bell hooks, "Sorrowful Black Death Is Not a Hot Ticket," *Sight and Sound* 4, no. 8 (1994): 10–14.

47. See Simone de Beauvoir, *A Very Easy Death* (New York: Pantheon, 1985), 65.

48. I am aware of the similarity between my title and Bertrand Tavernier's *Death Watch* (1980), a film about moving image recordings of the death moment. Roddy (Harvey Keitel) has a camera in his head, his eyes the lenses. He is hired by a television company to record footage of terminally ill Katherine for the series *Death Watch*, something like a reality television show. At film's end Katherine asks Roddy to leave her so she can die alone; leave he does, preventing the paparazzi outside from barging into the country home where she has prepared her final moments. Though the film is structured around a "deathwatch" as an extended metaphor for film (and television) spectatorship, it protects private death as the last stand against public demand. In a twist on Ariès, here the "forbidden" death is the good death in the face of a culture of voyeurism. In this book we will not be so demure as Roddy and Katherine, because we are in search of a perceptible break to understand how film technology has helped shape our sense of when death has occurred.

49. Leslie Fiedler argues the emergence of the novel and the emergence of the United States are relatively synchronous; thus, he looks at the Americanization of prior literary forms and genres: "To write, then, about the American novel is to write about the fate of certain European genres in a world of alien experience. It is not only a world where courtship and marriage have suffered a profound change, but also one in the process of losing the traditional distinctions of class; a world without a significant history or a substantial past; a world which had left behind the terror of Europe not for the innocence it dreamed of, but for new and special guilts associated with the rape of nature and the exploitation of dark-skinned people; a world doomed to play out the imaginary childhood of Europe." These "guilts" play out particularly in the American writer's "obsession with violence and his embarrassment before

love." See Leslie Fiedler, *Love and Death in the American Novel* (Normal, IL: Dalkey Archive Press, 1997), 31, 28.

1. MORTAL RECOIL: EARLY AMERICAN EXECUTION SCENES AND THE ELECTRIC CHAIR

1. By "attractions" I am referring to Tom Gunning's model of early film exhibition, characterized by a nonintegrated series of cinematic displays of motion. See "The Cinema of Attractions: Early Film, Its Spectator and the Avant-Garde," in *Wide Angle* 8, no. 3–4 (1986): 63–70. For an insightful revisiting of the attractions model for horror cinema see Adam Lowenstein, "Living Dead: Fearful Attractions of Film," *Representations* 110 (Summer 2010): 105–28.

2. Anne Nesbet, *Savage Junctures: Sergei Eisenstein and the Shape of Thinking* (London: Tauris, 2007), 76.

3. Jonathan Auerbach, *Body Shots: Early Cinema's Incarnations* (Berkeley: University of California Press, 2007), 145.

4. Quoted in ibid., 124.

5. See my own explanation of this film's connection to execution technique in my article "Cut: Execution, Editing, Instant Death," in *Spectator* 28, no. 2 (Fall 2008): 31–41.

6. Charles Musser, *The Emergence of Cinema: American Film to 1907* (Berkeley: University of California Press, 1990), 87.

7. Yet Musser explains that the faltering kinetoscope business by the summer of 1895 was mostly the result of external factors, like low profit margin for the selling of individual kinetoscopes and competition from Britain's Robert W. Paul. See Musser, *The Emergence of Cinema*, 88–89.

8. Note the discrepancy in contemporary responses to the film on www.imdb .com. One reviewer comments that the substitution splice astonished spectators at the time while "for obvious reasons it today looks quite fake." Another curses the effect as "quite pathetic." But a couple of reviewers praised the film for its "effective and believable special effects." Such varying responses demonstrate, among other things, a range of awareness of and respect for film history.

9. See Regina Janes, "Beheadings," in *Death and Representation*, ed. Sarah Webster Goodwin and Elisabeth Bronfen (Baltimore: Johns Hopkins University Press, 1993), 245.

10. Erik Barnouw, *The Magician and the Cinema* (Oxford: Oxford University Press, 1981), 1–30.

11. In fact, Barnouw argues that the film medium absorbed the magician's performance, the act of prestidigitation itself. As such, we should perhaps be more surprised by our own lack of wonder at contemporary magic. See Barnouw, *Magician*, esp. 19–35, 107–13.

12. Based on the model of *The Widow Jones*'s inspiration for the company's 1896 film *The Kiss*, it seems likely that the Edison crew were inspired by the popularity of Mary's trial and execution on the melodramatic stage. Other play versions that adapted Friedrich Schiller's 1800 play *Mary Stuart* pre-dated Blake's, as for example Lewis Wingfield's version. An illustration of the execution scene in this latter play appears in A. Nicholas Vardac's *Stage to Screen* (illustration 29). It should be noted that Schiller's play omitted the execution, opting instead to place a character onstage (Leicester) who hears the execution.

13. Robert Blake, *Mary, Queen of Scots: A Tragedy in Three Acts* (London: Simpkin, Marshall, 1894).

14. See Peck & Snyder, *Nineteenth Century Games and Sporting Goods* (1886; Princeton, NJ: Pyne Press, 2001).

15. Miriam Hansen, *Babel and Babylon: Spectatorship in American Silent Film* (Cambridge, MA: Harvard University Press, 1991), 31.

16. Quoted in ibid.

17. *AM&B Picture Catalogue*, Nov. 1902, 240.

18. Kemp R. Niver, *Motion Pictures from the Library of Congress Paper Print Collection, 1894–1912* (Berkeley: University of California Press, 1967), 240.

19. Mary Ann Doane, *The Emergence of Cinematic Time: Modernity, Contingency, the Archive* (Cambridge, MA: Harvard University Press, 2002), 159.

20. Barnouw, *Magician*, 29.

21. I am referencing Vivian Sobchack's phenomenological reading of the film image in her *The Address of the Eye: A Phenomenology of Film Experience* (Princeton, NJ: Princeton University Press, 1992). Let me quote in full the relevant passage: "The 'Here, where eye (I) am' of the film retains its unique station, even as it cannot maintain its perceptual privacy. Directly perceptible to the viewer as an anonymous 'Here, where eye am' simultaneously available as 'Here, where we see,' the concretely embodied situation of the film's vision also stands *against* the viewer. It is also perceived by the viewer as a 'There, where I am not,' as the space consciously and bodily inhabited and lived by an 'other' whose experience of being-in-the-world, however anonymous, is not precisely congruent with the viewer's own" (10).

22. See Anne Friedberg, *Window Shopping: Cinema and the Postmodern* (Berkeley: University of California Press, 1993), 90.

23. Quoted in André Gaudreault, "Theatricality, Narrativity, and Trickality: Reevaluating the Cinema of Georges Méliès," in *Journal of Popular Film and Television* 15, no. 3 (1987): 117.

24. Ibid.

25. Tom Gunning, "'Primitive' Cinema: A Frame-Up? Or the Trick's on Us," *Cinema Journal* 28, no. 2 (1989): 10.

26. Ibid.

27. Louis Marin, "The Tomb of the Subject in Painting," in *On Representation* (Stanford, CA: Stanford University Press, 1994), 270.

28. Noël Burch, "A Primitive Mode of Representation?" in *Early Cinema: Space, Frame, Narrative*, ed. Thomas Elsaesser (London: BFI, 1990), 224.

29. See Vanessa R. Schwartz, "The Morgue and the Musée Grévin: Understanding the Public Taste for Reality in Fin-de-siècle Paris," *Yale Journal of Criticism* 7, no. 2 (1994): 151–73.

30. This quote comes from an interview with Elfelt published in *Filmen*, June 7, 1926. The interview was quoted in Peter Schepelhern, *100 Ans Dansk Film* (Copenhagen: Rosinante, 2001), 16.

31. The Edison film is (aptly) titled *The Crowd Outside the Temple of Music at the Pan-American Exposition*. I would like to thank Kristen Whissel for first pointing out this film to me. It is possible the camera was recording at the time the crowd was beginning to register the shooting of the president.

32. The momentous occasion of a president's passing funeral cortege heralded this moment of African American self-presence. This will not be the last time we find African Americans prominently featured as registrants for dead whites; I will return to this in chapter 2, when I discuss *The Birth of a Nation*.

33. Consider also Edison's *The Martyred Presidents* (1901), which featured still photographs of Lincoln, Garfield, and McKinley.

34. It seems a passing phrase in Silverman's analysis of the film, but it functions as a crucial turning point in her account. Hitchcock's suturing the spectator to Marion's imperiled perspective gets substituted with a roaming camera that moves away from the "corpse" to wander around the room, pause on the envelope of stolen money, then move up to the window and away from our protagonist in an uncomfortable and incomplete attempt to resume narrative. Kaja Silverman, *The Subject of Semiotics* (New York: Oxford University Press, 1983), 211.

35. See, for instance, Richard Moran, *Executioner's Current: Thomas Edison, George Westinghouse, and the Invention of the Electric Chair* (New York: Alfred A. Knopf, 2002), 75–88; also Mark Essig, *Edison and the Electric Chair: A Story of Light and Death* (New York: Walker, 2003), 92–99. These books are useful partly because their bibliographic traces are more dependable than the notoriously misguiding sources in Thom Metzger's otherwise scintillating *Blood and Volts: Edison, Tesla, and the Electric Chair* (Brooklyn, NY: Autonomedia, 1996).

36. "Report of the Commission to Investigate and Report the Most Humane and Practical Method of Carrying into Effect the Sentence of Death in Capital Cases," transmitted to the legislature of the state of New York, Jan. 17, 1888 (Albany: Argus, 1888), 75–86. Also quoted in Essig, *Edison*, 98.

37. Essig, *Edison*, 119.

38. Ibid., 94.

39. Ibid., 117.

40. See Moran, *Executioner's Current*, 36–62.

41. Kristen Whissel explains the numerous reasons for the "paucity" of war actualities, chief among them the "shifting, unstable" visual terrain in which "smokeless gunpowder and thick tropical vegetation gave Spain the military advantage of invisibility," while "gunpowder smoke coming from the Americans' weapons revealed their position and further obscured their already blocked vision." See Kristen Whissel, "Placing the Spectator on the Scene of History: The Battle Re-enactment at the Turn of the Century, from Buffalo Bill's Wild West to the Early Cinema," *Historical Journal of Film, Radio, and Television* 22, no. 3 (2002): 234–35.

42. The matching of gunpowder with convulsing body appears also in AM&B's *Execution of a Spy* (1902).

43. Several traditions of realistically duplicating historic scenes predated the cinema. Mark Sandberg has chronicled the authenticating measures taken by the late nineteenth-century folk museum, its "fine-tuning of the reality effect" articulated in earlier wax museums such as the Musée Grévin. The war reenactment, like the museum tableau, used background and mise-en-scène to contextualize the body within a centripetal "representational cushion" of "authentic details of costume and setting." Mark Sandberg, *Living Pictures, Missing Persons: Mannequins, Museums, and Modernity* (Princeton, NJ: Princeton University Press, 2003), 23–24. Sandberg's work on museum displays certainly complicates Anne Friedberg's notion that the nineteenth-century flâneur was bound to a virtual and mobile gaze, for he explains that "late nineteenth-century museum practice teased spectators with games of voyeurism that could quite conceivably become games of immersion instead," especially when "the only boundaries separating off display space from spectators were those of social protocol, and not ontological difference."

44. Whissel, "Placing the Spectator," 239.

45. "Only an overly histrionic fling of the arm on the part of one of the victims betrays the firing squad 'shooting' as fabricated theater filmed most likely in New Jersey" (Auerbach, *Body Shots*, 32).

46. Electricity poses another limit case for the camera that encourages filmmakers to develop specific strategies of authentication. Czolgosz's reenacted death mobilized a number of cinematic accoutrements, perhaps the most obvious being the opening pans. These shots could be distributed separately and could be exhibited as attractions in their own right. Combined with the reenactment, they substitute for a direct encounter with the assassin's execution, reminding us of the camera's proximity. At the same time these pans usher us into the staged electrocution. Charles Musser comments on these shots as both actualities and rhetorical devices for the complete film: "These shots distinguish this reenactment film from its contemporaries by

heightening the realism. At the same time, they are part of a drama that leads the audience step by step to a vicarious confrontation with the electric chair and a man's death" (189). Musser discusses the film in depth in his *Before the Nickelodeon: Edwin S. Porter and the Edison Manufacturing Company* (Berkeley: University of California Press, 1991), 187–90.

47. "As he stepped over the threshold he stumbled, but they held him up, and as they urged him forward toward the chair, he stumbled again on the little rubber-covered platform upon which the chair rests" (*New York Times*, Oct. 30, 1901).

48. These three jolts not only rhyme with the three tests performed on the bulbs, but they are also consistent with the *New York Times* eyewitness report. After the first two, Dr. MacDonald "stepped to the chair and put his hand over the heart. He said he felt no pulsation but suggested that the current be turned on for a few seconds again. Once more the body became rigid" (*New York Times*, Oct. 30, 1901).

49. Auerbach, *Body Shots*, 40.

50. See Kristen Whissel, *Picturing American Modernity: Traffic, Technology, and the Silent Cinema* (Durham, NC: Duke University Press, 2008), 156–59.

51. Musser, *Before the Nickelodeon*, 187.

52. Michael Fried, *Absorption and Theatricality: Painting and Beholder in the Age of Diderot* (Chicago: University of Chicago Press, 1988).

53. Doane, *Emergence of Cinematic Time*, 145.

54. Quoted in ibid., 151.

55. *A Career of Crime, No. 5* was described with this detail: "[The executed] can be seen struggling against his bonds, as if charges of electricity are coursing through his body." Rita Horwitz and Harriet Harrison, with the assistance of Wendy White, *The George Kleine Collection of Early Motion Pictures in the Library of Congress: A Catalog* (Washington: Library of Congress, Motion Picture, Broadcasting, and Recorded Sound Division, 1980), 173.

56. Despina Kakoudaki, "The Human Machine: Artificial People and Emerging Technologies" (PhD diss., University of California, Berkeley, 2000), 170.

57. Auerbach, *Body Shots*, 39.

58. Walter Benjamin, "On Some Motifs in Baudelaire," in *Illuminations*, ed. Hannah Arendt, trans. Harry Zohn (New York: Schocken, 1969), 174–75.

59. "Perhaps the execution films circulate around the phenomenon of death, striving to capture the moment of death, in order to celebrate the contingency of the cinematic image, a celebration that is always already too late, since the contingent, in the face of the cinematic apparatus, has already received a 'posthumous shock'" (Doane, *Emergence of Cinematic Time*, 163).

60. Harold P. Brown, "Death Current Experiments at the Edison Laboratory," *Medico-Legal Journal* 6 (1888): 387.

61. Ibid., 388.

62. Essig, *Edison*, 146.

63. See Carlos MacDonald, "The Infliction of the Death Penalty by Means of Electricity," *New York Medical Journal* 326 (May 7, 1892): 506.

64. "With her own life she paid for the lives of the three men she had killed": *New York World*, Jan. 5, 1903. One suspects the stories of Topsy's badness were generated by the film (or the knowledge that a film would be made)—thus, execution first, justification second.

65. See Lisa Cartwright, "'Experiments of Destruction': Cinematic Inscriptions of Physiology," *Representations* 40 (Fall 1992): 129–52, esp. 148–50; and Doane, *Emergence of Cinematic Time*, 159–60.

66. Not having enough electrical power, or gunfire for that matter, did not stop subsequent circus owners from executing rogue elephants. Not, at least, in Erwin, Tennessee, where in 1916 an elephant named Mary was hanged by a derrick chain that lifted her into the air, twice.

67. In Lippit's analysis we are reminded that the difference between human beings and animals has long occasioned philosophical reflection. He tells us that animals have been frequently distinguished from humans as beings that do not die (a claim only humans, equipped with language, can make), but merely perish: "By tracking the animal across the philosophical spectrum, one discovers the systemic manner in which the figure of the animal comes to portray a serial logic: the animal is incapable of language; that lack prevents the animal from experiencing death; this in turn suspends the animal in a virtual, perpetual existence." See Akira Mizuta Lippit, *Electric Animal: Toward a Rhetoric of Wildlife* (Minneapolis: University of Minnesota Press, 2000), 73, 187–88.

68. MacDonald, "Infliction," 506.

69. Quoted in Niver, *Motion Pictures*, 244.

70. Similarly, Linda Williams accounts for the "money shot" of male ejaculate as a substitute for the cinema's desire to visualize the secrets of female jouissance. One should note, however, that dying can be more easily faked than male jouissance; as such, the registrant seems more salient than does the female pornographic body who comes in contact with, even relishes in, the ejaculate. See Linda Williams, *Hard Core: Power, Pleasure, and the "Frenzy of the Visible"* (Berkeley: University of California Press, 1989).

71. Doane writes: "Just as electricity could be activated as a technological control over life and death, the cinema must have seemed to offer the same promise in the field of representation" (Doane, *Emergence of Cinematic Time*, 164). Indeed, the promise seems to have been and still be there, and likewise the failure of that promise of controlling the barrier.

72. Again, the analogy between film and technology sounds a note here with respect to divining a clear death moment. See Sobchack, "Inscribing Ethical Space," 234.

73. As such, the lightbulb reverses the placement of the incandescent bulbs on the chair before the execution in *Execution of Czolgosz*.

74. It goes without saying, but I will say here, that the early execution films are not critical. It would seem that as the history of execution in narrative film continues, it does so as a stronger and stronger invective against execution.

75. The opening words of the film are Eddie Vedder's, singing, "Look in the eyes of the face of love."

76. Nor is the filmic rendition of the rape and murders during the execution, a montage that implicitly connects both acts of killing.

77. Wendy Lesser, *Pictures at an Execution* (Cambridge, MA: Harvard University Press, 1993), 258–59.

78. The footage thus brings moving image technology to bear on a dying that has no technological support.

2. POSTHUMOUS MOTION: THE DEATHWORK OF NARRATIVE EDITING

1. Pier Paolo Pasolini, "Observations on the Sequence Shot," in *Heretical Empiricism*, ed. Louise K. Barnett, trans. Ben Lawton and Louise K Barnett (Bloomington: Indiana University Press), 237.

2. Béla Balázs, *Theory of the Film: Character Growth of a New Art Form*, trans. Edith Bone (New York: Dover, 1970), 52.

3. Tom Gunning writes: "We are also seeing a real, not an imagined event, the death of the child, and, in fact, learning through an omniscient narrator of an event the mother does not know of: the death of her child." See Gunning, "*Behind the Scenes*," in *The Griffith Project*, ed. Paolo Cherchi Usai (London: BFI, 1999), 1:97.

4. In fact, Griffith seems to have been reluctant to provide any cut-ins, including close-ups, early on in his development as a filmmaker. Such a break in the narrative space may have drawn attention to the act of filmic discourse, recalling earlier modes of representation.

5. Thompson describes the false eyeline match that appears in films such as *After Many Years*, *The Golden Louis*, and *A Drunkard's Reformation*: "The character looks offscreen and seems to see something which is in fact in another space; this attempt to convey mental images by cutting to events that are actually taking place within the diegesis was a distinctive device in Griffith's work." See Thompson, "*The Golden Louis*," in *The Griffith Project*, ed. Paolo Cherchi Usai (London: BFI, 1999), 2:25.

6. Balázs, *Theory of the Film*, 52.

7. The "narrator system" is developed in Gunning's *D. W. Griffith and the Origins of American Narrative Film* (Urbana: University of Illinois Press, 1994).

For the disambiguation of the narrator system from other approaches to filmic narration see especially 25–28.

8. Ibid., 52.

9. See Peter Wollen, "The Auteur Theory," in *Signs and Meaning in the Cinema* (Bloomington: Indiana University Press, 1969), 78.

10. Allan Langdale, ed., *Hugo Münsterberg on Film: The Photoplay: A Psychological Study and Other Writings* (New York: Routledge, 2002), 95. Münsterberg's original study was published in 1916.

11. Gunning concludes his remarks on *Behind the Scenes* in this way: "Mourning over a dead body is almost as frequent an ending for Griffith's early Biograph films as the happy re-united family. Perhaps Griffith saw sorrow as a primary means to audience empathy and involvement in the film" (Usai, *The Griffith Project*, 1:98). In 1908, finding a character dead concluded many Biograph films besides *Behind the Scenes*, including Wallace McCutcheon Sr.'s *The Outlaw*, but also Griffith's *For Love of Gold* (which ends, actually, in a double suicide and no living character), *The Girl and the Outlaw*, and *The Song of the Shirt*.

12. The phrase appears in Gunning's discussion of Griffith's *The Girl and the Outlaw*, but it recurs throughout essays in volumes 1 and 2 of Paolo Cherchi Usai, ed., *The Griffith Project*.

13. The first theorization of this concept appears in her essay "Film Bodies: Gender, Genre, Excess," in *Film Quarterly* 44, no. 1 (1991): 2–13.

14. Ibid., 10–11.

15. Or in any film, for that matter. The fact is that we very rarely see characters die alone onscreen; they are almost always accompanied by a human counterpart to at least register that death has occurred, if not convey narrative momentum.

16. Jacques Aumont, "Griffith—The Frame, the Figure," in *Early Cinema: Space, Frame, Narrative*, ed. Thomas Elsaesser (London: BFI, 1990), 354.

17. Linda Williams, "Melodrama Revised," in *Refiguring American Film Genres*, ed. Nick Browne (Berkeley: University of California Press, 1998), 69.

18. Ibid., 72–75.

19. As I will show later in this chapter, Griffith pursued the registration scene for longer than any reunion scene where the family celebrated its being rescued, producing a distinguishable "halt."

20. Gunning, *D. W. Griffith*, 207.

21. Ibid., 67–68. "[Linked vignettes] preserve the essential continuity of the chase but substitute a linked series of gags," like increasingly destructive sneezes, for example, in Hepworth's *That Fatal Sneeze* (1907).

22. Linda Williams makes a similar point about *The Jazz Singer*, a film I will deal with in the following chapter. In a film that very much uses the soundtrack to

explore the scenic dimensions of "too late," Jakie Rabinowitz makes it back to his father's synagogue to sing the Kol Nidre. His father, the cantor, hears him and peacefully passes away. Williams writes that Jakie sings "just 'in time' to make his father die happy but 'too late' to save him from death." Williams, *Playing the Race Card: Melodramas of Black and White from Uncle Tom to O. J. Simpson* (Princeton, NJ: Princeton University Press, 2001), 153.

23. Writing about *Romance of a Jewess*, Scott Simmon suggests that cutting would have added to the power of the husband's death scene: "The relative lack of cutting . . . does render certain plot points implausible, notably in shot seven which includes both the fatal fall of the husband and the doctor's arrival to pronounce him dead." See Scott Simmon, "*Romance of a Jewess*," in *The Griffith Project*, ed. Paolo Cherchi Usai (London: BFI, 1999), 1:133. But such a cut would likely have placed the wife somewhere else at the time of death (or at least the accident that caused it), and this in turn would have altered the meaning of Solomon's fall from an accident to an event we viewed first omnisciently and then through another person's late shock. As we saw in *Behind the Scenes*, separating the dying person from the registrant in this way tends to assign responsibility to the missing figure, thus cementing the melodramatic pathos of too late.

24. In agreement with Garrett Stewart, we can say that what makes a death scene is that death is seen—only, it is not just "seen"; it is also sensed through touch, hearing, etc. See Garrett Stewart, *Between Film and Screen: Modernism's Photo Synthesis* (Chicago: University of Chicago Press, 1999), esp. 151–89.

25. Roberta Pearson, *Eloquent Gestures: The Transformation of Performance Style in Griffith Biograph Films* (Berkeley: University of California Press, 1992), esp. 21–23, 32–38.

26. Ben Brewster and Lea Jacobs, *Theater to Cinema: Stage Pictorialism and the Early Feature Film* (New York: Oxford University Press, 1997).

27. Stage versions of the play featured prominent tableaux, for example at the end of act 2 of *Uncle Tom's Cabin* when Phineas Fletcher has pushed Tom Loker off the cliff, or in another version as Cassy pushes Legree off a high rocky pass. One of the most common tableaux in all versions followed the death of Tom himself, often but not always occurring at the end of act 6, scene 5. Sometimes that scene was broken down into three shorter scenes, divided by multiple pauses for Tom's death or violent attacks that each culminated in a tableau.

28. Quoted in Brewster and Jacobs, *Theater to Cinema*, 41.

29. The stage tableau availed itself of more resources than simply the bodies of the actors. Dramatic pauses might be produced with painted backdrops that would appear, for example, after Tom's and Eva's deaths, concealed theretofore by a curtain. No matter the medium, the theater's tendency to construct tableaux out of opposed elements (including, of course, onstage death

and the transcendence of the soul) underscored a general conception of the actor's pose in symbolic terms.

30. Brewster and Jacobs, *Theater to Cinema*, 41.

31. Though one might object to this clear-cut division, I believe we are encouraged to view the two as opposite ends of a spectrum. Many films include examples of both kinds of gesture, and the point seems to be that we can look more closely at Biograph acting as shades between histrionic and verisimilar.

32. Pearson summarizes that "the histrionic code is always marked by a resemblance to digital communication and a limited lexicon, but performers had to choose the time, stress and speed, and direction of their gestures. And since the performance of gesture could vary, an actor could use various combinations of oppositions to suit the movements to the nature and intensity of the character's state of mind" (*Eloquent Gestures*, 27).

33. Ibid., 39.

34. This early "reaction shot" does not break the tableau framing throughout the film. The cut follows Sweet from one tableau to the next, connecting the room where she drops her protective shawl to the loss of her former identity. In fact, the anteroom functions as a portal to the horror in the other room and also as a pivotal place between the desire to run away and to take care of things herself (the first time to shoot the intruder, the second time to remove his mask). This cut indicates the camera wants to go elsewhere besides the body to finalize a death scene or stamp its dramatic peak. This is not to take away from the performance but actually seems to celebrate it. In his discussion of the film, Russell Merritt rightly praises Sweet's verisimilar reaction. See Russell Merritt, "*The Painted Lady*," in *The Griffith Project*, ed. Paolo Cherchi Usai (London: BFI, 2008), 6:155–56.

35. See Peter Brooks, *The Melodramatic Imagination: Balzac, Henry James, Melodrama, and the Mode of Excess* (New Haven, CT: Yale University Press, 1976), esp. 68–73, on gestural acting.

36. But not the scene. The Colonel carries her body home and lays it out on a couch: one by one mother, sister, and father enter the room to register the body. Griffith seems to even dim the lights of the room as if to enshroud the family in a private darkness. And then the intertitle "And none grieved more than these" leads to a brief shot of the faithful slaves, one crying, the other sitting with head on his fist. Griffith uses the death to confirm his vision of the union of faithful slaves and whites.

37. "Comments on the Week's Films," *Moving Picture World*, June 26, 1909, 872.

38. Charles Affron, *Lillian Gish: Her Legend, Her Life* (Berkeley: University of California Press, 1992), 131.

39. The static images that underlie the illusion of motion can be called forth in the freeze-frame and other such evocations of the photogram. See Garrett Stewart's discussion of the freeze-frame, which he punningly calls the "frieze

frame" to get at the impossibility of film to reveal its frames, in *Between Film and Screen*, 132–34.

40. I would like to thank Anne Nesbet for pointing this film out to me and for her reference to the caesura of the sailor's death in Eisenstein's *Battleship Potemkin*, a related instance of an apparent end that makes room for future movement, a revolution consisting of stasis and change.

41. Special-effects dyings in later classical and postclassical cinema will remove some doubt but are nonetheless influenced by this tradition of confirming change outside the body or beyond what the viewer can see in the body.

42. Ariès concludes a study of Western death iconography by looking briefly at films: "The nothingness of death occupies an important place in one of the arts of our time, which is an art of the image, of the *living* image—namely, the cinema." Philippe Ariès, *Images of Man and Death* (Cambridge, MA: Harvard University Press, 1985), 266–68.

43. "The 'text of muteness' can be considered to include mute tableau and gesture . . . and the mute role," writes Brooks, thus alluding to the preponderance of mute characters in both text and play that must gesture to speak aloud the verities of their moral dilemmas. The corpse plays a mute role, of course, but the immediacy of the registrant's gestural response to apparent death points to the mute condition of witnessing death in silent film. See Brooks, *The Melodramatic Imagination*, 56–60.

44. Vivian Sobchack, "Inscribing Ethical Space: Ten Propositions on Death, Representation, and Documentary," in *Carnal Thoughts: Embodiment and Moving Image Culture* (Berkeley: University of California Press, 2004), 287. As I noted in my introduction, Sobchack writes that "representations of death in fiction film tend to satisfy us—indeed, in some films, to sate us" (235).

45. Gilles Deleuze, *Cinema 1: The Movement-Image*, trans. Hugh Tomlinson and Barbara Habberjam (Minneapolis: University of Minnesota Press, 1986), 31.

46. In his reading of Charles Wilson Peale's 1772 mortuary painting *Rachel Weeping*, Jay Ruby acknowledged the custom to portray the dead child with grieving parents. What is interesting is that it is the mother's face that confirms the baby is not in a state of repose: "It is the mother's facial expression which clearly indicates that the child is dead." Jay Ruby, *Secure the Shadow: Death and Photography in America* (Cambridge, MA: MIT Press, 1995), 31–33.

47. Such a cut demonstrates the difference between the fiction film from the earlier period. With titles like *Execution of Czolgosz* and *Electrocuting an Elephant*, death in earlier films was a foregone conclusion. But here death emerges as a possibility, conditioned on cuts. The earlier films likewise used cuts (the head chop, Topsy's staggered finality) but not to hesitate.

48. In fact, the death shot occurs exactly between the exterior shots of the homes occupied by Harcourt.

49. I say semblance because it is, of course, not the backward projection of the first shot. For one thing, the door is closed, and the family does not walk backward into the house. Also, the first shot contains a moment of editing, for a lawnmower is unwittingly recorded, forcing Griffith to shoot the second half of the shot and splice it to the first. But the effect is very much to repeat the image we have seen, and it is important that repetition occurs as an explicit reversal.

50. See, again, Jay Ruby's work on mourning photography *Secure the Shadow*, especially his discussion of the posthumous mourning painting, 36–49.

51. See Ruby, *Secure the Shadow*, 41. Phoebe Lloyd first pointed out the posthumous portrait as distinct from other mourning images; see Phoebe Lloyd, "Posthumous Mourning Portraiture," in *A Time to Mourn: Expressions of Grief in 19th Century America*, ed. M. Pike and J. Armstrong (Stony Brook, NY: Museums of Stony Brook, 1980), 71–87.

52. Charles Musser, *Before the Nickelodeon: Edwin S. Porter and the Edison Manufacturing Company* (Berkeley: University of California Press, 1991), 187.

53. Gunning, "*The Country Doctor*," in *The Griffith Project*, ed. Paolo Cherchi Usai (London: BFI, 1999), 2:165.

54. Hysteron proteron becomes a crucial possibility of cinematic reversal in the face of death that Peggy Phelan will claim, viewing Tom Joslin's death from AIDS in his 1991 documentary *Silverlake Life*, offers a healing recourse to the problem of a particularly effaced death: "The end of a filmmaker's life is not the end of his film. In the transference enacted across the body of the film, the making of the film, like the making of the memory of the filmmaker's life, continues in the unfolding present. For that continuity to continue, the filmmaker's filmic body, the film itself, must be replayed, revised, reprojected." Peggy Phelan, "Dying Man with a Movie Camera," *GLQ: Journal of Lesbian and Gay Studies* 2, no. 4 (1995): 387–88. Such claims are made in liberating tones about film's actual ability to reverse the effects of time (the "filmic body" lives on), so there is some degree of disavowal about film's ability to show the change left behind in the world in someone's absence.

55. See Annette Michelson, "*The Man with the Movie Camera*: From Magician to Epistemologist," in *Artforum* 10, no. 7 (1972): 60–72.

56. Simmon, "*After Many Years*," in *The Griffith Project*, ed. Paolo Cherchi Usai (London: BFI, 1999), 1:144.

57. Stewart calls attention to this freeze-frame: "The embryonic (photograph) is there as the cellular (cinematic photogram), the origin implicit in the increment. Death breaks the chain of succession, its totalizing force in such contexts transforming the photographic increment to a mark of cessation." Or, we might say, a mark of future cessation, since there is no cut to an additional image posited later in the pre-posthumous "friezes" that end *Butch Cassidy*

and the Sundance Kid and *Thelma and Louise*. See Stewart, *Between Film and Screen*, 49.

58. This film also recalls Griffith's earlier *The Unchanging Sea* (1910), also based on a Charles Kingsley poem, in which the bodies of lost fishermen wash onto shore, moving from left to right and thus reversing the direction of the film's central character left behind on another shore.

59. Gunning, *D. W. Griffith*, 248.

60. The device frequently appears in television soap operas. After a character dies, we will often get a montage sequence consisting of images of him or her taken from previous episodes. In fact, television's temporality favors such a device of remembrance because spectators attach to, and live with, characters over a much longer time than they generally can in movies. The last five minutes of the death-drenched television series *Six Feet Under* varies this format by projecting forward the future deaths of significant characters.

61. Maurice Merleau-Ponty, "Film and the New Psychology," in *Sense and Nonsense*, trans. Hubert L. Dreyfus and Patricia Allen Dreyfus (Evanston, IL: Northwestern University Press, 1964). This particular essay was written in 1945 and evokes the phenomenological thrust of postwar writings on cinema. This may smack of Eisenstein's theory of montage, but Merleau-Ponty's guide is Pudovkin, for whom continuity was essential.

62. Frances Yates, *The Art of Memory* (Chicago: University of Chicago Press, 2001), 1–27.

63. Siegfried Kracauer, "Photography," in *The Mass Ornament: Weimar Essays*, trans. and ed. Thomas Y. Levin (Cambridge, MA: Harvard University Press, 1995), 58.

64. Gunning, "*The Country Doctor*," 165.

65. See André Bazin, "The Ontology of the Photographic Image," in *What is Cinema?* trans. Hugh Gray (Berkeley: University of California Press, 1967), 1:9–16

66. Steve Neale, "Melodrama and Tears," *Screen* 27, no. 6 (1986): 7. See also Franco Moretti, "Kindergarten," in *Signs Taken for Wonders* (London: Verso, 1983).

67. Neale, "Melodrama and Tears," 11.

68. Ibid., 12.

69. Williams, "Film Bodies," 5.

70. Neale, "Melodrama and Tears," 19.

3. ECHO AND HUM: DEATH'S ACOUSTIC SPACE IN THE EARLY SOUND FILM

1. "Music to Be Born to, Music to Die To," *British Medical Journal* 321 (Dec. 23–30, 2000): 1577.

2. "It is indeed impossible to imagine our own death; and whenever we attempt to do so we can perceive that we are in fact still present as spectators." See Freud, "Our Attitude Towards Death," in *The Standard Edition of the Complete Psychological Works of Sigmund Freud*, trans. James Strachey (London: Hogarth, 1915), 14:289.

3. See Balázs's critique of sound cinema in Béla Balázs, *Theory of the Film: Character and Growth of a New Art*, trans. Edith Bone (New York: Dover, 1970), 195.

4. For Robert Spadoni, who traces the foundation of the horror genre through the technological possibilities of synchronized sound, *Dracula* and *Frankenstein* (both 1931) creep and crawl along, inducing an uncanny return to the earlier slow pace of the first sound films. See Robert Spadoni, *Uncanny Bodies: The Coming of Sound and the Origins of the Horror Genre* (Berkeley: University of California Press, 2007), esp. 8–30.

5. Mary Ann Doane, "Ideology and the Practice of Sound Editing and Mixing," in *Film Sound: Theory and Practice*, ed. Elisabeth Weis and John Belton (New York: Columbia University Press, 1985), 55.

6. See Yopie Prins, "Voice Inverse," *Victorian Poetry* 42, no. 1 (2004): 48–50.

7. See, e.g., Michael Rogin, *Blackface, White Noise: Jewish Immigrants in the Hollywood Melting Pot* (Berkeley: University of California Press, 1996); Linda Williams, *Playing the Race Card: Melodramas of Black and White from Uncle Tom to O. J. Simpson* (Princeton, NJ: Princeton University Press, 2001); and Carol J. Clover, "Dancin' in the Rain," *Critical Inquiry* 21 (Summer 1995): 722–47.

8. The effect of simultaneity achieved, and the union between two characters experienced by the viewer, recalls Griffith's earlier use of the cut to suggest the impossible union of a couple spatially separated. Griffith often used such a device to underscore mutual desire as if witnessed, Tom Gunning tells us, by a "transcendent witness": "Griffith transforms the melodramatic tradition of expressive gesture into a discovery in filmic discourse." See Tom Gunning, *D. W. Griffith and the Origins of American Narrative Film* (Urbana: University of Illinois Press, 1991), 113. As we will see, *The Jazz Singer* makes a similar discovery through the union of voice with another visible body.

9. Linda Williams provides perhaps the most accurate description of the effect of this reversion to silence: "The father's prohibition plunges the film back into an intensely embarrassing silence. For a stunningly prolonged moment, it is as if the film does not know what to do. Eventually, of course, it falls back into conventionalized pantomime with recorded background music and picks up the plot as, for the second time, a crestfallen Jakie leaves his father's house, his 'jazz' viewed as a profane (and perhaps even an incestuous) threat to the father's power" (Williams, *Playing the Race Card*, 146).

10. Rogin, *Blackface, White Noise*, 83.

11. See Michel Chion, *The Voice in the Cinema*, trans. Claudia Gorbman (New York: Columbia University Press, 1999), 9.

12. Ibid., 21.

13. Chion focuses much on this present absence: "For the spectator, then, the filmic acousmêtre is 'offscreen,' outside the image, and at the same time in the image." This fugitive voice "wander[s] along the surface, at once inside and outside, seeking a place to settle" (ibid., 23).

14. Ibid., 4.

15. Williams, *Playing the Race Card*, 153.

16. There are some minor adjustments, of course. Were this a typical Biograph scene, the earlier cut-in to the father's important words would probably not be there, and most likely the scene would come to an end once the mother's collapse returned the screen to bodily stillness.

17. She traces such a fusion back to Sampson Raphaelson's original insight into Al Jolson's "true" identity while watching him perform in *Robinson Crusoe Jr.*: "My God, this isn't a jazz singer. This is a cantor!" Thus, Williams argues that Jakie's singing of "Mother of Mine" and the finale, "My Mammy," both in blackface, delivers on "Raphaelson's insight that the two cultural forms— cantor and mammy singer—resemble one another" (Williams, *Playing the Race Card*, 153). I will return a bit critically to her position later in this section.

18. Chion, *Voice*, 4.

19. Mary Ann Doane, "The Voice in the Cinema: The Articulation of Body and Space," in *Film Sound: Theory and Practice*, ed. Elisabeth Weis and John Belton (New York: Columbia University Press, 1985), 170.

20. I recognize there is some slippage between "on time," which first appeared in Williams's "Film Bodies" essay to describe pornography's temporally gratifying encounter between viewer and object of fantasy, and "in the nick of time," or "in time," which appeared later in application to the successful rush to the rescue necessary in many melodramas to purify the otherwise misrecognized heroine. Nevertheless, I find the two experiences offer similar buildup and relief from excitation, and I am generally comfortable with the slippage to describe the timing of events on the screen and the general effect of such timing on spectators, as well as the specific affects or bodily reactions to this timing. See Linda Williams, "Film Bodies: Genre, Gender, Excess," *Film Quarterly* 44, no. 1 (1991): 2–13.

21. For Griffith posthumous motion did not simply recapitulate the dead's change from motion to stillness; it added closure, circularity, and marks of diegetic change. Sound itself soon functioned as an agent of posthumous motion, providing confirmation that a death had been perceived (or not perceived, as we will see next in *Applause*) without resorting exclusively to body gesture.

22. Balázs, *Theory of the Film*, 197–98.

23. Williams, *Playing the Race Card*, 142.

24. Doane, "Ideology," 61.

25. Ibid.

26. Rogin, *Blackface, White Noise*, 116.

27. Chion, *Voice*, 47.

28. Ibid., 136.

29. It might look like Anju's suicide-by-water in Mizoguchi's *Sansho the Bailiff* (1954), traced as the concentric circles emanating from where her body was just breathing air.

30. Balázs drew an interesting conclusion about the effects of seeing a face react to music: "The reflected effect of the music may throw light into the human soul; it may also throw light on the music itself and suggest by means of the listener's facial expression some experience touched off by this musical effect" (Balázs, *Theory of the Film*, 209).

31. Doane, "Ideology," 56.

32. Ibid., 57. See also Lucy Fischer, "*Applause*: The Visual and Acoustic Landscape," in *Film Sound: Theory and Practice*, ed. Elisabeth Weis and John Belton (New York: Columbia University Press, 1985), 240.

33. Metz's notion is mentioned and elaborated in Doane, "Voice," 166.

34. Ibid., 171 (my emphasis).

35. A wonderful example of this occurs several times in Fritz Lang's *M* (1931). In one sequence a newspaper takes up the entire frame, silently. What appears to be an insert turns out to be shot in depth: a policeman's voice resumes on the soundtrack at just the moment a magnifying glass crosses over the newspaper, revealing that this is in fact a paper seen in occupied space.

36. From Rudolf Arnheim, *Film as Art* (Berkeley: University of California Press, 1957), 235. Also quoted and discussed in Fischer, "*Applause*," 245.

37. See the dialogue between Ann Kaplan and Linda Williams on the issue of multiple viewing positions, and points of identification, for the female spectator of *Stella Dallas*, in Williams, "'Something Else Besides a Mother': *Stella Dallas* and the Maternal Melodrama," *Cinema Journal* 24 (Fall 1984): 2–27.

38. Mamoulian's fully talking backstage musical features a sequence that revises the dilemma of separation found in Griffith's *Behind the Scenes* and altered in *The Jazz Singer*, and like both those films it contrasts domestic happiness with a stage career.

39. See Peter Brooks, *The Melodramatic Imagination: Balzac, Henry James, Melodrama, and the Mode of Excess* (New Haven, CT: Yale University Press, 1976), 33–34.

40. See Rick Altman, *The American Film Musical* (Bloomington: Indiana University Press, 1987), 210–11.

41. It is striking that both *The Jazz Singer* and *Applause* introduce us to children who leave home and return as adults. When they do return, they enter a difficult familial arrangement. The backstage musical bordered easily on the family melodrama, in particular the mother-daughter or father-son weepie.

42. Altman explains how the backstage musical divides the world between city and stage. In between lies the space of dilemma: "For the backstage, like Janus, turns both ways. Two doors—one opening onto the street, the other onto the stage. Only there do the problems of life and those of the stage cross" (Altman, *The American Film Musical*, 202).

43. Fischer, "*Applause*," 233.

44. The director's acoustic realism is on the surface surprising given that he had just come to cinema from the theater, but as a stage director he had previously experimented with the layering of sounds. See Fischer, "*Applause*," 237.

45. The death scene formally echoes previous scenes in which a character's destiny is determined by an acousmatized voice. For example, when Kitty's friend Joe King tries to convince her to send April to a convent, the camera moves up close to the girl playing with her new necklace while we hear the two discuss her future. In a later scene in which Hitch talks Kitty into bringing April back to the stage (where he can exploit her youth), his offscreen body casts a large shadow over the seated Kitty as we hear him talk of "one big happy family."

46. Arthur Knight, "The Movies Learn to Talk: Ernst Lubitsch, René Clair, and Rouben Mamoulian," in *Film Sound: Theory and Practice*, ed. Elisabeth Weis and John Belton (New York: Columbia University Press, 1985), 218 (my emphasis).

47. Fischer, "*Applause*," 245 (Fischer's emphasis).

48. See Rick Altman, "Sound Space," in *Sound Theory Sound Practice* (New York: Routledge, 1992), 58–60.

49. The offscreen voices in the rooms throughout the film do have the effect of sealing the fates of the screen bodies. Balázs appreciated immensely the asynchronous voice as having a life of its own: "If the sound or voice is not tied up with a picture of its source, it may grow beyond the dimensions of the latter [picture]. Then it is no longer the voice or sound of some chance thing, but appears as a pronouncement of universal validity." He goes on to suggest that "the surest means by which a director can convey the pathos or symbolical significance of sound or voice is precisely to use it asynchronously" (Balázs, *Theory of the Film*, 209–10).

50. Doane, "Voice," 167.

51. Ibid. For the gendered power of the voice-off, and thus a critique of the earlier scholarship on the film voice, see Kaja Silverman, *The Acoustic Mirror: The Female Voice in Psychoanalysis and Film* (Bloomington: Indiana University

Press, 1988). See also chapter 4 of this book for a fuller discussion of Silverman's work on voice-over.

52. Doane, "Ideology," 60.

53. Fischer, "*Applause*," 240.

54. Balázs had this to say: "Silence is when the buzzing of a fly on the windowpane fills the whole room with sound and the ticking of a clock smashes time into fragments with sledge-hammer blows" (Balázs, *Theory of the Film*, 206).

55. Sound is also edgeless, say critics. Doane tells us that sound "is not 'framed' in the same way as the image" and thus "*envelops* the spectator." Because it is edgeless, Jakie's voice envelops his onscreen father too, who at the moment of death becomes something like an "internal auditor"—that is, a point of imaginable audition whose position we seem to share (Doane, "Voice," 166).

56. For Balázs sounds "throw no shadows" and "cannot produce shapes in space." Unlike the way the offscreen visible world can sneak into the frame through light and shadow, offscreen sounds remain present in themselves: "Sounds cannot be blocked out" (Balázs, *Theory of the Film*, 213, 211).

57. The film also uses sound space in early scenes to represent the conversations between Jekyll and the scientists. This sequence is shot from the "point of view" of the doctor himself, so the first time we hear his voice it is a voice-off. The film's opening destabilizes the viewer's connection between the world of appearance and a world behind, or beneath, it.

58. Spadoni, *Uncanny Bodies*, 62–70.

59. Brooks, *The Melodramatic Imagination*, 41.

60. And like *The Jazz Singer*, *Hallelujah!* features the conflict between jazz and religious music that would become a common theme of the all-black musical. See Altman, *The American Film Musical*, 109.

61. Jessica H. Howard, "*Hallelujah!* Transformation in Film," *African American Review* 30, no. 3 (1996): 441–42.

62. *Variety*, August 28, 1929.

63. PCA file for *Hallelujah!* Academy of Motion Picture Arts and Sciences, Margaret Herrick Library, Special Collections, 2.

64. It is well known that Vidor's use of sound to authenticate his film has come under the criticism of later film historians, including Lewis Jacobs, as part of "all the conventionalities of the white man's conception" (PCA file for *Hallelujah!* 27). But a few reviewers at the time put forward something like this view as well: "*Hallelujah* revealed the conventional viewpoint about the Southern negro, picturing him according to the lowest estimate held him by the white man, a singer of spirituals, a patron of cheap dives, a petty gambler, a fanatical revivalist," wrote B. G. Braver-Mann (PCA file for *Hallelujah!* 27).

65. See Alice Maurice, "'Cinema at Its Source': Synchronizing Race and Sound in the Early Talkies," *Camera Obscura* 17, no. 1.49 (2002): 32.

66. Knight, "Movies Learn to Talk," 214.

67. Altman, *The American Film Musical*, 299.

68. For Balázs such a crescendo of offscreen sound while we view the listener can "impress us with the inevitability of an approaching catastrophe with almost irresistible intensity" in that a "slow and gradual process of recognition can symbolize the desperate resistance of the consciousness to understanding a reality which is already audible but which the consciousness is reluctant to accept" (Balázs, *Theory of the Film*, 213).

69. Ibid., 217.

70. Howard, "*Hallelujah!* Transformation in Film," 446.

71. The racialized depiction of African American figures with a preternatural connection to the dead is persistent. *Ghost* (1990), for instance, is a return to Griffith's separately grieving "faithful souls," such as with the death of Flora in *The Birth of a Nation*. In *Ghost* Oda Mae Brown, a medium, can hear the deceased Sam Wheat and thus acts as another medium through which he contacts his girlfriend, Molly Jensen.

72. Stephen M. Best, *The Fugitive's Properties: Law and the Poetics of Possession* (Chicago: University of Chicago Press, 2004), 256–61.

73. For a psychoanalytic reading of the Mammy figure see Maria St. John, "The Mammy Fantasy: Psychoanalysis, Race, and the Ideology of Absolute Maternity" (PhD diss., University of California, Berkeley, 2004).

74. Spadoni writes, "While no one would deny that such sounds are ingredients of the horror film as we know it, to recognize as much is not the same thing as identifying the major influence of the coming of sound on the genre's initial formulation" (Spadoni, *Uncanny Bodies*, 2).

75. Quoted in Richard Maltby, "The Spectacle of Criminality," in *Violence and American Cinema*, ed. J. David Slocum (New York: Routledge, 2001), 120.

76. In fact, Richard Maltby suggests that murder was not filmed with a "two shot" but rather was broken apart into at least two shots to ensure any key plot information would remain intact after censorship. See Maltby, "The Spectacle of Criminality," 120.

77. PCA file for *Scarface*, Academy of Motion Picture Arts and Sciences, Margaret Herrick Library, Special Collections.

78. The notion is Peter Wollen's. See his *Signs and Meaning in the Cinema* (Indianapolis: Indiana University Press, 1972), 86.

79. Maltby, "The Spectacle of Criminality," 121.

80. Altman, "Sound Space," 49.

81. See James Lastra, *Sound Technology and the American Cinema: Perception, Representation, Modernity* (New York: Columbia University Press, 2000),

139. For a meticulously conceptualized discussion of both fidelity and intelligibility as models for sound in Hollywood see esp. 138–50.

4. SECONDS: THE FLASHBACK LOOP AND
THE POSTHUMOUS VOICE

1. On Griffith's "narrator system" see Tom Gunning, *D. W. Griffith and the Origins of American Narrative Film* (Urbana: University of Illinois Press, 1994), 25–28. For a similar account that finds within the actual formal organization of films a structuring force, or "narrator in the text," see Nick Browne, *The Rhetoric of Filmic Narration* (Ann Arbor, MI: UMI Research Press, 1982), esp. 25–43.

2. Framing voice-over as a solution to the ambiguity of literary realism, Guido Fink explains the device returns film to "telling" after 1940s cinema made "showing" so ambiguous: "Reality, as visually reproduced, looks dark and treacherous; sooner or later we need clarification, a meaning or a moral, which can only be expressed by words." Guido Fink, "From Showing to Telling: Off-screen Narration in the American Cinema," *Letterature d'America* 3, no. 12 (1992): 8.

3. It is *ex nihilo* because "the artist is forced to metaphorize beyond the realm of what can be experienced." See Robert Detweiler, "The Moment of Death in Modern Fiction," *Contemporary Literature* 13, no. 3 (1992): 269–94.

4. Ibid., 275.

5. Quoted in ibid., 274.

6. Ibid., 284.

7. And of course there's also *Citizen Kane*, in which several characters flashback to different stages in the life of Charles Foster Kane, only to come up short in decrypting Kane's deathbed utterance, "Rosebud." *The Power and the Glory* may well have been an influence on Welles. Fink brings up the failure of *Citizen Kane*'s voice-over to clarify the past: "The special obituary issue of 'News on the March' has all the relevant data and figures on Charles Foster Kane, but desperately needs an 'angle,' and [reporter] Thompson's search for such angle(s) leads him, and us, to look for other voices and other points of view, each probably as insufficient in itself as the previously discarded documentary" (Fink, "From Showing to Telling," 15).

8. Sarah Kozloff, *Invisible Storytellers: Voice-Over Narration in American Fiction Film* (Berkeley: University of California Press, 1988), 54.

9. Ibid., 59.

10. Kozloff points out that this scene softens the original impact of the corresponding scene from Richard Llewellyn's novel in which Bess all but blames and turns away from God. If placed in the context of a film so much about

memory's power to resurrect the past, Bess's skepticism would have called overt attention to the frailty of the discourse surrounding death.

11. Kozloff, *Invisible Storytellers*, 60.

12. Ibid., 62; Brian Henderson, "Tense, Mood, and Voice in Film (Notes After Genette)," *Film Quarterly* 36, no. 4 (1983): 16–17.

13. Kozloff, *Invisible Storytellers*, 62.

14. Ibid.

15. The leave-taking inaugurated by the adult Huw (voice by Irving Pichel) from his beloved valley and his report of Gwilym's death (played by Donald Crisp) form a dialogue that comes back in John Ford's wartime documentary *The Battle of Midway* (1942), for which he employed these two actors to provide voice-over commentary. It is possible that the fictional father and son pairing later evoked the sense of separation of soldiers from their home fronts during World War II. See Charles Wolfe, "Historicizing the 'Voice of God': The Place of Vocal Narration in Classical Documentary," *Film History* 9, no. 2 (1997): 158–61.

16. It thus recalls prior instances in which the documentary evidence of dying lacks a clear end point without an onscreen act of registration, as in Edison's *Electrocuting an Elephant* (1903), discussed in chapter 1.

17. J. P. Telotte locates the subjective camera's origins in the silent expressionist sensibility carried into Hollywood by key émigré directors like Fritz Lang to express a character's paranoia and anxiety. Also, he sees it as a cinematic equivalent to the first-person hard-boiled narration like that found in Raymond Chandler's novels. See J. P. Telotte, *Voices in the Dark: The Narrative Patterns of Film Noir* (Urbana: University of Illinois Press, 1989), esp. 40–56.

18. This seat of authority is included by Michel Chion in his list of acousmatic powers. See Michel Chion, *The Voice in the Cinema*, trans. Claudia Gorbman (New York: Columbia University Press, 1999), 34.

19. Here, as throughout, I refer to the temporalities of gratification in the body genres, applying them to the camera's encounter with the dead body. See Linda Williams, "Film Bodies: Gender, Genre, Excess," *Film Quarterly* 44, no. 1 (1991): 2–13.

20. As I mentioned in my introduction, in *Between Film and Screen: Modernism's Photo Synthesis* (Chicago: University of Chicago Press, 1999), Garrett Stewart claims that cinema death is kept in "perpetual abeyance," that it is always "still at work," because of the germ of movement in all moving images. That is, cinema never arrives because it is still moving (past). This chapter argues, in effect, that cinema never arrives—or rather, that it arrives more than once. The films considered here represent a two-death model that allows the narrative to develop out of cinema's inherent movement past death.

21. The phrase "space of innocence" is Peter Brooks's. See his *The Melodramatic Imagination: Balzac, Henry James, Melodrama, and the Mode of Excess* (New Haven, CT: Yale University Press, 1976), 29.

22. Eric Smoodin, "The Image and the Voice in the Film with Spoken Narration," *Quarterly Review of Film Studies* 8, no. 4 (1983): 19.

23. Pasolini argues that cinema can better process death in hindsight—narrative films can approach dying from its future. What matters here is that the voice coincides with the body, and as such, the irreversible one-way flow of time is equipped with a voice that looks back. In other words the voice-over would seem on the surface capable of decoupage. See Pier Paolo Pasolini, "Observations on the Sequence Shot," trans. Ben Lawton and Louise K. Barnett, in *Heretical Empiricism*, ed. Louise K. Barnett (Bloomington: Indiana University Press, 1988), 235–37.

24. Note the remarkable metacinematic quality of this statement. Bigelow is in front of us but not, ghostly in his presence, like all screen bodies. Even the poison extracted from his body for proof evokes the cinema—as the second doctor shows it to Frank, he turns off the light to let the liquid shine its fluorescence.

25. There is many an Ivan Ilyich in classical Hollywood, Judith Traherne (Bette Davis) in *Dark Victory* being perhaps the finest example. Traherne refuses to submit to doctor's orders or to hear her condition discussed. Suffering from a "glioma," or brain tumor, she sends everyone away from the house on the onslaught of her lazy-eye blindness, or "amblyopia," so she can die privately; the camera shies away too, blurring out her final image as she approaches her death, unseen.

26. Maureen Turim, *Flashbacks in Film: Memory and History* (New York: Routledge, 1989), 184.

27. Speaking of denial, we might remember Mary Ann Doane's point that the substitution splice in early execution reenactments is a "denial of process" in its impression of an instant. See Mary Ann Doane, *The Emergence of Cinematic Time: Modernity, Contingency, the Archive* (Cambridge, MA: Harvard University Press, 2003), 159.

28. Recall the correlate scene in *Double Indemnity* in which Walter Neff tells Keyes that he could not hear his own footsteps when walking back home after murdering Dietrichson: "It was the walk of a dead man."

29. Telotte's argument is made with force in his reading of Orson Welles's *The Lady from Shanghai* (1948), whose narrating Michael O'Hara "leaves us with a narrator speaking of those gaps his story seeks to close up—ones the narrative has left open—while visually acknowledging our own desire for closure" (Telotte, *Voices in the Dark*, 71, and more generally, 65–71).

30. See Christian Metz, *The Imaginary Signifier: Psychoanalysis and the Cinema* (Bloomington: Indiana University Press, 1975): 45, 61; André Bazin, *What Is Cinema?* trans. Hugh Gray (Berkeley: University of California Press, 1967), 1:97.

31. Telotte writes: "The bloodstain that gradually spreads across the jacket of *Double Indemnity*'s Walter Neff as he talks reminds us that his life is, in

effect, already spent; however, while he recounts his fatal encounter with Phyllis Dietrichson, he can postpone that inevitable end and even draw some meaning—a cautionary note about the dangers of desire—out of his demise" (Telotte, *Voices in the Dark*, 199). As will become typical of film noir, the female body is the catalyst and source of threat for the male's self-reflections on mortality.

32. One cannot help but recall the line, spoken by the warden, in Oshima's *Death by Hanging* (1968): "Death is real only if we can see it coming."

33. The general care taken by narrators in molding their flashbacks certainly brings to mind Paul Schrader's thoughts on noir narration as romantic. See Paul Schrader, "Notes on Film Noir," in *Film Noir Reader*, ed. Alain Silver and James Ursini (New York: Limelight, 1996), 53–63.

34. *Detour*'s dialogue is full of anxiety about the exactness of a future death. While held hostage in Vera's hotel room, Roberts compares morbid philosophies with his captor. Vera tells him to lighten up: "There's plenty of people dying this minute. They'd give anything to trade places with you. I know what I'm talking about." Roberts rebuts her claimed authority: "I'm not so sure. At least they know they're done for. They don't have to sweat blood wondering if they are."

35. Kaja Silverman, *The Acoustic Mirror: The Female Voice in Psychoanalysis and Film* (Indianapolis: Indiana University Press, 1988), 56.

36. For a discussion of this film as an example of melodramatic too-lateness see Steve Neale, "Melodrama and Tears," *Screen* 27, no. 6 (1986): 6–22.

37. Peter Brooks, *Troubling Confessions: Speaking Guilt in Law and Literature* (Chicago: University of Chicago Press, 2000), 22.

38. J. P. Telotte, "The Big Clock of Film Noir," *Film Criticism* 14, no. 2 (1989–90): 3, 2.

39. See Yopie Prins, "Voice Inverse," *Victorian Poetry* 42, no. 1 (2004): 49.

40. Peter Brooks, "Freud's Masterplot: A Model for Narrative," in *Reading for the Plot* (Cambridge, MA: Harvard University Press, 1992), 93–94.

41. For Kermode the reader is driven into the "middest," from which we desire the union of beginning with ending. See particularly his reading of *Ulysses* in *The Sense of an Ending: Studies in the Theory of Fiction with a New Epilogue* (New York: Oxford University Press, 2000), 58.

42. To quote but one of several passages: "The novel is significant, therefore, not because it presents someone else's fate to us, perhaps didactically, but because this stranger's fate by virtue of the flame which consumes it yields us the warmth which we never draw from our own fate. What draws the reader to the novel is the hope of warming his shivering life with a death he reads about." Walter Benjamin, "The Storyteller," in *Illuminations* (New York: Schocken, 1969), 83–109, 101. For more explanation for why we never draw the warmth of death from our own fate, see 93–94 from the same essay.

43. See Brooks, "Freud's Masterplot," 99. For one film version of this see Alan Parker's *Angel Heart* (1987), in which Harry Angel is haunted by flashback images that turn out to belong to another man, whom Angel earlier devoured but forgot in his vain effort to escape the Devil.

44. Brooks, "Freud's Masterplot," 102.

45. Ibid.

46. Ibid., 103.

47. Ibid., 104.

48. Quoted in Richard Wunderli and Gerald Broce, "The Final Moment Before Death in Early Modern England," *Sixteenth Century Journal* 20, no. 2 (1989): 261.

49. Ibid., 264.

50. Ibid., 266.

51. Ibid.

52. Telotte notes this "recurring noir motif" to "speak 'so as not to die'" and cites *Kiss Me Deadly* (1955) as a late and great example. It is certainly a fine candidate. See Telotte's discussion of that film in *Voices in the Dark*, 198–213.

53. Even when the modern state took over the role of lethal judgment, as with execution, the condemned exerted some autonomy: "The state allowed *moriens* to say his last pious exhortations and prayers and, most important, allowed him to control the final instant of his life by giving his 'sign' to the executioner" (Wunderli and Broce, "Final Moment," 274).

54. There is of course a long tradition of execution movies, starting well before Hollywood and outside the United States, that depict the long process through stages of the condemned's bodily and psychological preparation. Without the flashback later Hollywood films like *I Want to Live!* (1958) and *Dead Man Walking* (1995) show dying as a legal process of decisions made by all but the condemned. See chapter 1 for a discussion of these films in relation to the bureaucracy of decision making.

55. Perhaps unintentionally, Oscar Micheaux's *10 Minutes to Live* (1932) stages the possibility of a character dying in a flashback. Letha is given a note that says she has ten minutes to live, at which time she'll receive another note. The film flashes back to earlier in the day, but strangely, after about ten minutes of screen time expires, a man appears outside Letha's apartment whom she believes may be a murderer.

56. The distinction is Lacan's, from *The Ethics of Psychoanalysis*. See Slavoj Žižek and Mladen Dolar, *Opera's Second Death* (New York: Routledge, 2001), 135.

57. This call from the stairs surely evokes the vampire's first address, from within his castle, to the newly arrived Hutter in Murnau's *Nosferatu* (1922).

58. This traveling shot resembles the camera movement after Marion Crane's shower stabbing in *Psycho*, a shot that Kaja Silverman argues particularly

reveals the apparatus as aggressively selective. See Silverman, *The Subject of Semiotics* (New York: Oxford University Press, 1983), 210–11. I will return to this point in the next chapter.

59. See Erlend Lavik, "Narrative Structure in *The Sixth Sense*: A New Twist in 'Twist Movies'?" *Velvet Light Trap* 58 (Fall 2006): 56.

60. In this it is like the detective's relationship to the scene of the crime, that is, a quest to close a gap in temporality that implicates the detective's own relationship to mortality. See Domietta Torlasco's *The Time of the Crime: Phenomenology, Psychoanalysis, Italian Film* (Stanford: Stanford University Press, 2008) for a discussion of the temporality of the detective's vision in postwar Italian cinema.

61. In the first example I have in mind—*American Graffiti* (1973)—it follows the credits, but in *Stand by Me* (1986), for instance, it is told to us by the voice-over narrator.

62. Telotte, *Voices in the Dark*, 17.

63. "If each frame of a motion picture were counted as a single photogram . . . then cinema, as Bazin implies, is more like a walking mummy, the undead, or the reanimated corpse of Frankenstein's monster. If the photograph implies, in Barthes's terms, '*that-has-been*' and thus death, then cinema only gives the dead a semblance of life." See Scott Curtis, "Still/Moving: Digital Imaging and Medical Hermeneutics," in *Memory Bytes: History, Technology, and Digital Culture*, ed. Lauren Rabinovitz and Abraham Geil (Durham, NC: Duke University Press, 2004), 237.

64. Curtis also links the cinematic image to the process of evanescence and to human dying (Curtis, "Still/Moving," 246–47).

65. Rick Altman, *The American Film Musical* (Bloomington: Indiana University Press, 1987), 78, 85.

66. Leonard Maltin liked the film but referred to its "interminable ending" as a deterrent. I find the death scene, replete with a percussive version of "Bye Bye Love," too long to be discussed *in toto*, so I'll spare my reader by omitting some of its flourishes.

67. At one point we see an after-diegetic image of Joe looking at Angelique in what appears to be a mirror, alternated with a "real life" image of him clutching his heart on the street, then back to the two frowning, then to him holding his chest, street level. One shot is of Gideon's lateral body with a breathing mask, foretelling his stay in the ICU. This continues until we hear the comedian on the soundtrack act out his "Denial" segment: "No, no, that's not me man, somebody else maybe, but not me." This is really a sound bridge to the next scene of Joe in the editing room.

68. It may go without saying, but I must point out, that Cole theorizes in this sentence the film spectator: *we*, too, see dead people all the time.

69. Pasolini, "Observations on the Sequence Shot," 235.

70. I should finally point out that this filmic recoil might also describe the plot of *Vertigo*, especially if we focus on Scottie's passive witnessing of deaths in front of him as the film's disavowal of his own suicidal wish to leap from the tower. A very similar doubling occurs in *Don't Look Now* (1973).

5. TERMINAL SCREENS: CINEMATOGRAPHY AND ELECTRIC DEATH

1. John Murray, *Intensive Care: A Doctor's Journal* (Berkeley: University of California Press, 2000), 13.

2. The principle of double effect originates in Thomas Aquinas's *Summa Theologica* as justification for a homicide committed in self-defense.

3. See "A Definition of Irreversible Coma: Report of the Ad Hoc Committee of the Harvard Medical School to Examine the Definition of Brain Death," in *Journal of the American Medical Association* (*JAMA*) 205 (August 5, 1968): 337–40.

4. See Dick Teresi, *The Undead: Organ Harvesting, the Ice-Water Test, Beating-Heart Cadavers—How Medicine Is Blurring the Line Between Life and Death* (New York: Pantheon, 2012), 144.

5. M. L. Tina Stevens, *Bioethics in America: Origins and Cultural Politics* (Baltimore: Johns Hopkins University Press, 2000), 87–88.

6. And even earlier, judging from a film like *Donovan's Brain* (1953), about a scientist who keeps alive a millionaire's brain that possesses him to commit murder. Curt Siodmak's novel was adapted to the screen earlier, in 1944, as *The Lady and the Monster*.

7. Quoted in Stevens, *Bioethics in America*, 91.

8. Ibid., 89.

9. Edward Shaw's comment is a strange flashback to early movie deaths, particularly the Edison Company's sequences of beheadings previously discussed. Edison's 1895 *Execution of Mary, Queen of Scots*, for instance, hardly proved exact about such an instant; the moment of separation of head from body decoyed for another, cinematic instant—that of the splicing together of two film strips to produce the illusion of beheading. Providing the image of a clear dividing line seems always to lead to an erosion of that line. Shaw is quoted in Stevens, *Bioethics*, 94.

10. Quoted in Stevens, *Bioethics*, 105.

11. Subsequent British and American medical research has shown PVS to be commonly misdiagnosed. A British report stated that of forty patients diagnosed with PVS, seventeen were misdiagnosed, thirteen eventually came out of the vegetative state, and only ten remained vegetative. Stressing that testing for PVS must take time, the article concludes "diagnosis cannot be made, even by the most experienced clinician, from a bedside assessment." See Keith

Andrews et al., "Misdiagnosis of the Vegetative State," *British Medical Journal* 313 (July 6, 1996): 13.

12. Cruzan v. Director, Missouri Department of Health, 497 U.S. 261 (June 25, 1990).

13. A radiologist claimed there were improvements in the CAT scans from 1996 and 2002. Cranford examined Schiavo for forty-two minutes. This was sufficient because he had seen so many similar cases in the past, he claimed. Meanwhile the director of the Center for Bioethics at the University of Pennsylvania, Dr. Arthur Caplan, disapproved of Dr. Cheshire's method: "There is just no excuse for going in and making any pronouncement about the state that Terri Schiavo is in unless you're going to go in and do some form of technologically mediated scanning that would overturn what's on the record" (John Schwartz and Denise Grady, "A Diagnosis with a Dose of Religion," *New York Times*, March 24, 2005).

14. Cranford, a neurologist and bioethicist at the University of Minnesota, frequently denigrated all dissenting medical experts as "charlatans." This doctor who fought the right to life himself overcompensated for his own rhetorical role in the situation. "I am 105 percent sure she is in a vegetative state," he told Joe Scarborough, host of MSNBC's *Scarborough Country*, who in turn registered his disappointment with Cranford's bombastic arrogance: "Too many doctors out there can be bought off by attorneys on either side. And then they come out, instead of telling you facts, you get into debate like you are talking to an attorney." Clearly there was more to the story than medical expertise and knowledge about the EEG.

15. Quoted in Stevens, *Bioethics*, 127.

16. That writer was B. D. Colen, one of the few nonmedical guests allowed into Karen's room (quoted in Stevens, *Bioethics*, 127).

17. "Undead" does have a ring to it, as evidenced, too, by its analogy to cinema in works by Garrett Stewart and Scott Curtis. See Garrett Stewart, *Between Film and Screen: Modernism's Photo Synthesis* (Chicago: University of Chicago Press, 1999); and Scott Curtis, "Still/Moving: Digital Imaging and Medical Hermeneutics," in *Memory Bytes: History, Technology, and Digital Culture*, ed. Lauren Rabinovitz and Abraham Geil (Durham, NC: Duke University Press, 2004), 218–54.

18. Like the "so-called noninvasive diagnostic imaging techniques such as cardiography," Cartwright tells us, "Marey's early recording devices were noted for their lack of intervention in the physiological process under study." Lisa Cartwright, "'Experiments of Destruction': Cinematic Inscriptions of Physiology," in *Representations* 40 (August 1992): 136.

19. President's Council on Bioethics, "Controversies in the Determination of Death: A White Paper by the President's Council on Bioethics," Dec. 2008, http://bioethics.georgetown.edu/pcbe/reports/death/.

20. See Susan Diem, John Lantos, and Jaime Tulsky, "Cardiopulmonary Resuscitation on Television—Miracles and Misinformation," *New England Journal of Medicine* 334 (June 13, 1996): 1578–82. The authors studied episodes from *ER*, *Chicago Hope*, and *Rescue 911* from 1994 and 1995. They found that television increases the rate of first-round and complete survival from CPR: "For short-term survival, the rate of success on television was 75 percent, as compared with 40 percent in the literature . . . and for long-term survival . . . the rate of success was 67 percent as compared with 30 percent." See also the rebuttal by coproducer and former student at Harvard Medical School Neal Baer, titled "Cardiopulmonary Resuscitation on Television," in the same volume. Baer defends the scriptwriters as producers of entertainment, not reality: "On *ER*, we often present cases of trauma, in which CPR is required, because of the dramatic impact. These episodes are fast-paced and visually exciting. If we were to reenact a minute-by-minute account of actual events in the emergency department, we would not have 35 million viewers each week. Real life in an emergency room is often quiet, even boring; a television drama cannot be" (1605). Misrepresentation of CPR on American television is not matched, it seems, by the numbers accrued from a study on British programming. See P. N. Gordon, S. Williamson, and P. G. Lawler, "As Seen on TV: Observational Study of Cardiopulmonary Resuscitation in British Television Medical Dramas," *British Medical Journal* 317 (Sept. 19, 1998): 780–83.

21. And we find Dixie Flatline in William Gibson's 1984 novel *Neuromancer*. The computer-generated construct cannot stop functioning even after its human model has died. See Tom Gunning, "Re-newing Old Technologies: Astonishment, Second Nature, and the Uncanny in Technology from the Previous Turn-of-the-Century," in *Rethinking Media Change: The Aesthetics of Transition*, ed. David Thorburn and Henry Jenkins (Cambridge, MA: MIT Press, 2003), 39–60.

22. Quoted in Stevens, *Bioethics*, 146.

23. Responding to the "prophetic humor" of a moment in the film when a screen monitoring an astronaut's sleep announces the euphemism "Life functions terminated," Michel Chion contends: "But medical progress has given us good reason to use euphemisms: cardiac death no longer sufficing to define the state of cessation of life, what criterion is viable that will not be revised in its turn some day?" Chion, *Kubrick's Cinema Odyssey* (London: BFI, 2001), 132.

24. Chion, *Kubrick's Cinema Odyssey*, 115. Kubrick himself noted that he wanted his entire film to be "essentially a nonverbal experience." Quoted in Peter E. S. Babiak, "*2001* Revisited," *Cineaction* 52 (2000): 65.

25. Without a body the death scene appeals to Chion as an "entirely metaphorical" enactment (Chion, *Kubrick's Cinema Odyssey*, 115).

26. That prehistory is explored in Lisa Cartwright's *Screening the Body: Tracing Medicine's Visual Culture* (Minneapolis: University of Minnesota Press, 1995), esp. 33–46.

27. Chion, *Kubrick's Cinema Odyssey*, 117.

28. Voice-over comes awfully close, especially in the third-person voice, such as Buñuel's, announcing the future perfect death of a documentary subject in *Las Hurdes*.

29. Robert Burgoyne, "Narrative Overture and Closure in *2001: A Space Odyssey*," *Enclitic* 5/6 (Fall 1981/Spring 1982): 175.

30. Babiak, "*2001* Revisited," 64.

31. Burgoyne, "Narrative Overture," 175.

32. The tone is so paranoid, in fact, that Ellis Hanson for one reads the entire film as an invocation of paranoia in the Freudian sense, that is, as a cover-up for unacceptable male homosexual desire, as suggested by Freud in his Schreber case (and later spelled out by Ferenczi). Hanson points to the increasing disappearance of women and reproductive organs as evidence of the film's contraception between men, an act whose homosexual implications are displaced onto the all-too-knowing machine, Hal. Given Kubrick's envisaged sexual revolution in his 1968 *Playboy* interview, the otherness of the machine among men—who themselves are intimately coexisting—is strikingly marked by Hal's touchy-feely behavior. But I find claims about his "faggoty voice" too far beyond the film and themselves paranoid. See Ellis Hanson, "Technology, Paranoia and the Queer Voice," *Screen* 34, no. 2 (1993): 137–61.

33. Burgoyne, "Narrative Overture," 176.

34. "The consciousness is noplace, the source of the voice is noplace, Hal's eye is noplace" (Chion, *Kubrick's Cinema Odyssey*, 83).

35. Teresi's interview with Baden includes this exchange: "'You are dead when death is pronounced officially, by a doctor, or police, or even an EMT. The 'time of death' is when a body surfaces from the lake even though it may have been dead for months. Sometimes the body may have been dead for ten years.' You are dead, then, when someone notices? 'Yes. It's thought that more people die in hospitals in the morning. That's just when the nurses make their rounds'" (Teresi, *The Undead*, 233).

36. The novel's treatment in comparison offers a little more remorse: "For an instant, [Dave] Bowman felt the skin prickling at the base of his scalp. The words he was about to call died on his suddenly parched lips. For he knew that his friend could not possibly be alive; and yet he waved. . . . For a long time David Bowman stared after it into the emptiness that still stretched, for so many millions of miles ahead, to the goal which he now felt certain he could never reach." Arthur C. Clarke, *2001: A Space Odyssey* (New York: Signet Classics, 1968), 142.

37. See specifically Chion's discussion of Baum's prerecorded voice in Fritz Lang's *The Testament of Dr. Mabuse*, in Michel Chion, *The Voice in Cinema*, trans. Claudia Gorbman (New York: Columbia University Press, 1999), 33–34, 36–37.

38. Chion, *Kubrick's Cinema Odyssey*, 103.

39. The computer-human connection recalls the work of nineteenth-century physiologist Claude Bernard, who believed astronomy was a restrictive enterprise because the telescope augmented sight but could not intervene. If, as Lisa Cartwright explains, nineteenth-century observatories employed machines to monitor the telescopes in a "self-correcting system" that minimized the subjective element of embodied perception, then Dave takes back that subjective power in this, his ultimate task of tending to the faulty computer. See Cartwright, "'Experiments of Destruction,'" 144.

40. Chion, *Kubrick's Cinema Odyssey*, 116.

41. Babiak, "*2001* Revisited," 66.

42. I do not agree with Chion's assertion that Hal's death is "purely an effect of editing," for unlike that of the astronauts we are caught up in the duration of something like an organic, sentient failure.

43. Several critics point out how the film approximates point-of-view shots of human characters, but to me only Hal's gaze is anchored in this way.

44. Chion, *Kubrick's Cinema Odyssey*, 116.

45. Cartwright points out that "chronophotography was made to conform to the logic of the kymograph" (Cartwright, "'Experiments of Destruction,'" 145).

46. Jean-Louis Comolli, "Machines of the Visible," in *The Cinematic Apparatus*, ed. Teresa de Lauretis and Stephen Heath (London: Macmillan, 1980), 123.

47. As examples of the "invisible parts of cinema," Comolli lists "black between frames . . . negative film, cuts and joins of editing, sound track, projector." Some of these "invisible parts of cinema," as we have seen, are employed to define death with accuracy. See Comolli, "Machines of the Visible," 125.

48. It may be true that the EKG and EEG machines improved on the sensorium of the human registrant, taking the terminal gaze into remote zones of inner intractable activity, but they always stand at some distance from those present. If impression of reality is the goal of the "dominant ideology," as Comolli claims, these graphic screens help us merely to disavow our lack of knowledge about what counts as the privileged moment of cessation or the visible evidence of inactivity.

49. Curtis, "Still/Moving," 219.

50. This phrase comes from a physician interviewed in ibid., 239.

51. Ibid., 246.

52. See Eugene Thacker, *Biomedia* (Minneapolis: University of Minnesota Press, 2004), 13.

53. Any claim of merely supplementing the human senses should be qualified. Arguing against the position that modernity's subcutaneous exploration of the body called on machines to augment the limited human sense of vision and touch, Lisa Cartwright claims that the technologies produced "graphic inscriptions that effectively subsume the sense-based perceptions of an autonomous subject" (Cartwright, "'Experiments of Destruction,'" 134). And clearly with Claude Barnard we see the invasive techniques of measuring a body's reaction to active alteration from the outside.

54. Kaja Silverman writes that the shot/reverse shot formation "alerts the spectator to that other field whose absence is experienced as unpleasurable while at the same time linking it to the gaze of a fictional character. Thus a gaze within the fiction serves to conceal the controlling gaze outside the fiction." Kaja Silverman, *The Subject of Semiotics* (New York: Oxford University Press, 1983), 204.

55. More than to the image, these reverse shots respond to offscreen noises. The impression that someone is watching him throughout ("us," says Chion), first by Hal, then by some alien observer, only underscores the fact that an unreturned gaze has operated throughout to register death. This last sequence continues what Colette Balmain calls the "refusal of suture" performed by the rest of the film: there is still something missing. See Colette Balmain, "Temporal Reconfigurations in Kubrick's *2001*," in *Enculturation* 3, no. 1 (2000): http://enculturation.gmu.edu/3_1/balmain.html.

56. Silverman, *The Subject of Semiotics*, 210.

57. Actually, his appearance first comes on the soundtrack, as we hear him shout the words "Mother! Oh God Mother, blood! Blood!"

58. Silverman, *The Subject of Semiotics*, 212.

59. See chapter 1 herein for a discussion of irreversibility in relation to early cinema's production of the death moment.

60. See Carol J. Clover, *Men, Women, and Chain Saws: Gender in the Modern Horror Film* (Princeton, NJ: Princeton University Press, 1992), esp. 166–230.

61. Jonathan Romney interprets Iñárritu's representation of this death offscreen as an evocation of September 11: "The event is unrepresentable, but its awful concreteness is underlined by the fact that we later learn exactly when it occurred—at 6:50 pm on 10 October. It is hard not to see in this precise notation an echo of the cataclysm of 11 September 2001, an inescapable reference point in American dramas of bereavement made after that date." See Romney's "Enigma Variations," *Sight and Sound* 14, no. 3 (2004): 11. Iñárritu also made a short film titled *11'09"01*. I might add that the scene where Cristina listens over and over to her husband's last phone message certainly recalls the many stories of such posthumous cell phone messages that emerged after the event.

62. Lisa Tyler argues that the mother-daughter myth of Demeter and Persephone becomes here a family romance in which the death of the daughter binds the two in periodic renewals. Note the film begins and ends on Easter. Unlike the men, who flee the death shot, the mother is there for both birth and death. M'Lynn herself makes this distinction after the funeral: "We turned off the machines. Drum left; he couldn't take it. Jackson left. I find it amusing. Men are supposed to be made out of steel or something." Clearly M'Lynn demonstrates that she can "take it." See Lisa Tyler, "Mother-Daughter Myth and the Marriage of Death in *Steel Magnolias*," *Literature/Film Quarterly* 22, no. 2 (1994): 98–104.

63. Given the film's racial politics, it makes sense that the black man registers the death from afar, enfolding Frankie's ethically ambiguous act within a narration spoken by a figure historically denigrated by cinema. See Robert Sklar and Tania Modleski, "*Million Dollar Baby*—A Split Decision," *Cineaste* 30, no. 3 (2005): 6–11.

64. Mario Falsetto has claimed that Kubrick's depiction of the astronauts' deaths accomplishes something close to "pure cinema" because the monitor takes over the usual role of the camera and of dialogue to enunciate the death moment. This evocation of pure cinema as something produced as if self-evident brings to mind observational documentary's interest in terminal illness. See Mario Falsetto, *Stanley Kubrick: A Narrative and Stylistic Analysis* (Westport, CT: Praeger, 2001), 106.

65. Arthur Kleinman, "Do Not Go Gentle," *New Republic*, Feb. 5, 1990, 29.

66. Ibid.

67. One gets the sense from the *Frontline* special on Nancy Cruzan that the support group for parents of PVS patients encourages them to stay numb so as to not make *any* decision. They watch videos on depression and seem medicated by that genre of self-help videos shown in AA meetings and the like—but the parents of those in a vegetative state are shielded from the fact that they *could* make a decision.

68. See the chapter "Seeing Lying" in Carol Clover's forthcoming *Trials, Movies, and the Adversarial Imagination* (Princeton, NJ: Princeton University Press) for a discussion of the camera's "polygraphic" gaze.

69. Christopher Buckley, "Growing Up Buckley," *New York Times*, April 22, 2009.

70. For a "nit list" of wrongly represented defibrillations see Nitcentral's defibrillator file at www.nitcentral.com/oddsends/defibril.htm.

BIBLIOGRAPHY

Adair, Gilbert. *Movies*. New York: Penguin, 1999.

Affron, Charles. *Lillian Gish: Her Legend, Her Life*. Berkeley: University of California Press, 1992.

Altman, Rick. *The American Film Musical*. Bloomington: Indiana University Press, 1987.

———. "Sound Space." In *Sound Theory Sound Practice*, 46–64. New York: Routledge, 1992.

Andrews, Keith, et al. "Misdiagnosis of the Vegetative State." *British Medical Journal* 313 (July 6, 1996): 13.

Ariès, Philippe. *Images of Man and Death*. Cambridge, MA: Harvard University Press, 1985.

———. *Western Attitudes Toward Death: From the Middle Ages to the Present*. Baltimore: Johns Hopkins University Press, 1974.

Arnheim, Rudolf. *Film as Art*. Berkeley: University of California Press, 1957.

Artwohl, Robert. "JFK's Assassination: Conspiracy, Forensic Science, and Common Sense." *Journal of the American Medical Association* 269 (March 24, 1993): 1540–43.

Auerbach, Jonathan. *Body Shots: Early Cinema's Incarnations*. Berkeley: University of California Press, 2007.

Aumont, Jacques. "Griffith—The Frame, the Figure." In *Early Cinema: Space, Frame, Narrative*, edited by Thomas Elsaesser, 348–59. London: BFI, 1990.

Babiak, Peter E. S. "*2001* Revisited." *Cineaction* 52 (2000): 62–67.

Baer, Neal. "Cardiopulmonary Resuscitation on Television—Exaggerations and Accusations." *New England Journal of Medicine* 334 (June 13, 1996): 1604–5.

Balázs, Béla. *Theory of the Film: Character and Growth of a New Art*. Translated by Edith Bone. New York: Dover, 1970.

Balmain, Colette. "Temporal Reconfigurations in Kubrick's *2001*." *Enculturation* 3, no. 1 (2000): http://enculturation.gmu.edu/3_1/balmain.html.

Barnouw, Erik. *The Magician and the Cinema*. Oxford: Oxford University Press, 1981.

Barthes, Roland. *Camera Lucida*. New York: Hill and Wang, 1981.

Bazin, André. "Death Every Afternoon." Translated by Mark A. Cohen. In *Rites of Realism: Essays on Corporeal Cinema*, edited by Ivone Margulies, 27–31. Durham, NC: Duke University Press, 2003.

——. *What Is Cinema?* 2 vols. Translated by Hugh Gray. Berkeley: University of California Press, 1967–71.

Beauvoir, Simone de. *A Very Easy Death*. New York: Pantheon, 1985.

Benjamin, Walter. *Illuminations*. Edited by Hannah Arendt. Translated by Harry Zohn. New York: Schocken, 1969.

Best, Stephen M. *The Fugitive's Properties: Law and the Poetics of Possession*. Chicago: University of Chicago Press, 2004.

Black, Joel. *The Reality Effect: Film Culture and the Graphic Imperative*. New York: Routledge, 2002.

Blake, Robert. *Mary, Queen of Scots: A Tragedy in Three Acts*. London: Simpkin, Marshall, 1894.

Brewster, Ben, and Lea Jacobs. *Theater to Cinema: Stage Pictorialism and the Early Feature Film*. New York: Oxford University Press, 1997.

Bronfen, Elisabeth, and Sarah Webster Goodwin. Introduction to Goodwin and Bronfen, *Death and Representation*, 3–25.

Brooks, Peter. "Freud's Masterplot: A Model for Narrative." In *Reading for the Plot*, 90–112. Cambridge, MA: Harvard University Press, 1992.

——. *The Melodramatic Imagination: Balzac, Henry James, Melodrama, and the Mode of Excess*. New Haven, CT: Yale University Press, 1976.

——. *Troubling Confessions: Speaking Guilt in Law and Literature*. Chicago: University of Chicago Press, 2000.

Brown, Harold P. "Death Current Experiments at the Edison Laboratory." *Medico-Legal Journal* 6 (1888): 386–89.

Browne, Nick. *The Rhetoric of Filmic Narration*. Ann Arbor, MI: UMI Research Press, 1982.

Buckley, Christopher. "Growing Up Buckley." *New York Times*, April 22, 2009.

Burch, Noël. *Life to Those Shadows*. Berkeley: University of California Press, 1990.

——. "A Primitive Mode of Representation?" In *Early Cinema: Space, Frame, Narrative*, edited by Thomas Elsaesser, 220–27. London: BFI, 1990.

Burgoyne, Robert. "Narrative Overture and Closure in *2001: A Space Odyssey*." *Enclitic* 5/6 (Fall 1981/Spring 1982): 172–88.

Cartwright, Lisa. "'Experiments of Destruction': Cinematic Inscriptions of Physiology." *Representations* 40 (August 1992): 129–52.

———. *Screening the Body: Tracing Medicine's Visual Culture*. Minneapolis: University of Minnesota Press, 1995.

Chion, Michel. *Kubrick's Cinema Odyssey*. London: BFI, 2001.

———. *The Voice in the Cinema*. Translated by Claudia Gorbman. New York: Columbia University Press, 1999.

Clarke, Arthur C. *2001: A Space Odyssey*. New York: Signet Classics, 1968.

Clover, Carol J. "Dancin' in the Rain." *Critical Inquiry* 21 (Summer 1995): 722–47.

———. *Men, Women, and Chain Saws: Gender in the Modern Horror Film* (Princeton, NJ: Princeton University Press, 1992.

Combs, Scott. "Cut: Execution, Editing, Instant Death." *Spectator* 28, no. 2 (2008): 31–41.

Comolli, Jean-Louis. "Machines of the Visible." In *The Cinematic Apparatus*, edited by Teresa de Lauretis and Stephen Heath, 121–50. London: Macmillan, 1980.

Curtis, Scott. "Still/Moving: Digital Imaging and Medical Hermeneutics." In *Memory Bytes: History, Technology, and Digital Culture*, edited by Lauren Rabinovitz and Abraham Geil, 218–54. Durham, NC: Duke University Press, 2004.

Dayan, Daniel. "The Tutor-Code of Classical Cinema." In *Movies and Methods*, edited by Bill Nichols, 1:438–51. Berkeley: University of California Press, 1976.

"A Definition of Irreversible Coma: Report of the Ad Hoc Committee of the Harvard Medical School to Examine the Definition of Brain Death." *Journal of the American Medical Association* 205 (August 5, 1968): 337–40.

Deleuze, Gilles. *Cinema 1: The Movement-Image*. Translated by Hugh Tomlinson and Barbara Habberjam. Minneapolis: University of Minnesota Press, 1986.

Detweiler, Robert. "The Moment of Death in Modern Fiction." *Contemporary Literature* 13, no. 3 (1992), 269–94.

Diem, Susan J., John D. Lantos, and James A. Tulsky. "Cardiopulmonary Resuscitation on Television—Miracles and Misinformation." *New England Journal of Medicine* 334 (June 13, 1996): 1578–82.

Doane, Mary Ann. *The Emergence of Cinematic Time: Modernity, Contingency, the Archive*. Cambridge, MA: Harvard University Press, 2003.

———. "Ideology and the Practice of Sound Editing and Mixing." In Weis and Belton, *Film Sound*, 54–62.

———. "The Voice in the Cinema: The Articulation of Body and Space." In Weis and Belton, *Film Sound*, 162–76.

Eisenstein, Sergei. *Selected Works*. Vol. 4, *Beyond the Stars: The Memoirs of Sergei Eisenstein*. Edited by Richard Taylor. Translated by William Powell. London: BFI, 1995.

Essig, Mark. *Edison and the Electric Chair: A Story of Light and Death*. New York: Walker, 2003.

Falsetto, Mario. *Stanley Kubrick: A Narrative and Stylistic Analysis*. Westport, CT: Praeger, 2001.3

Fiedler, Leslie. *Love and Death in the American Novel*. Normal, IL: Dalkey Archive Press, 1997.

Field, Marilyn J., and Christine K. Cassel. "A Profile of Death and Dying in America." In *Approaching Death: Improving Care at the End of Life*, edited by Marilyn J. Field and Christine K. Cassel, 33–49. Washington: National Academy Press, 1997.

Fink, Guido. "From Showing to Telling: Off-screen Narration in the American Cinema." *Letterature d'America* 3, no. 12 (1992): 5–37.

Fischer, Lucy. "*Applause*: The Visual and Acoustic Landscape." In Weis and Belton, *Film Sound*, 232–46.

Freud, Sigmund. "Our Attitude Towards Death." In *The Standard Edition of the Complete Psychological Works of Sigmund Freud*. Translated by James Strachey. Vol. 14, 289–302. London: Hogarth, 1954.

Fried, Michael. *Absorption and Theatricality: Painting and Beholder in the Age of Diderot*. Chicago: University of Chicago Press, 1988.

Friedberg, Anne. *Window Shopping: Cinema and the Postmodern*. Berkeley: University of California Press, 1993.

Gaudreault, André. "Theatricality, Narrativity, and Trickality: Reevaluating the Cinema of Georges Méliès." *Journal of Popular Film and Television* 15, no. 3 (1987): 111–19.

Goodwin, Sarah Webster, and Elisabeth Bronfen, eds. *Death and Representation*. Baltimore: Johns Hopkins University Press, 1993.

Gordon, P. N., S. Williamson, and P. G. Lawler. "As Seen on TV: Observational Study of Cardiopulmonary Resuscitation in British Television Medical Dramas." *British Medical Journal* 317 (Sept. 1998): 780–83.

Gunning, Tom. "An Aesthetic of Astonishment: Early Film and the (In)credulous Spectator." *Art and Text* 34 (Spring 1989): 31–45.

——. "Behind the Scenes." In Usai, *The Griffith Project*, 1:96–98.

——. "The Cinema of Attractions: Early Film, Its Spectator and the Avant-Garde." *Wide Angle* 8, no. 3–4 (1986): 63–70.

——. "The Country Doctor." In Usai, *The Griffith Project*, 2:162–66.

——. *D. W. Griffith and the Origins of American Narrative Film*. Urbana: University of Illinois Press, 1994.

——. "The Girl and the Outlaw." In Usai, *The Griffith Project*, 1:88–90.

——. "Gollum and Golem: Special Effects and the Technology of Artificial Bodies." In *From Hobbit to Hollywood: Essays on Peter Jackson's "Lord of the Rings,"* edited by Ernest Mathijs and Murray Pomerance, 319–50. Amsterdam: Rodopi, 2006.

——. "Making Sense of Film." *History Matters: The U.S. Survey Course on the Web* (Feb. 2002): http://historymatters.gmu.edu/mse/film/.

——. "'Primitive' Cinema: A Frame-Up? Or the Trick's on Us." *Cinema Journal* 28, no. 2 (1989): 3–12.

——. "Re-newing Old Technologies: Astonishment, Second Nature, and the Uncanny in Technology from the Previous Turn-of-the-Century." In *Rethinking Media Change: The Aesthetics of Transition*, edited by David Thorburn and Henry Jenkins, 39–60. Cambridge, MA: MIT Press, 2003.

Hansen, Miriam. *Babel and Babylon: Speculation in American Silent Film*. Cambridge, MA: Harvard University Press, 1991.

Hanson, Ellis. "Technology, Paranoia and the Queer Voice." *Screen* 34, no. 2 (1993): 137–61.

Harris, Neil. *Humbug: The Art of P. T. Barnum*. Boston: Little, Brown, 1973.

Henderson, Brian. "Tense, Mood, and Voice in Film (Notes After Genette)." *Film Quarterly* 36, no. 4 (1983): 4–17.

hooks, bell. "Sorrowful Black Death Is Not a Hot Ticket." *Sight and Sound* 4, no. 8 (1994): 10–14.

Horwitz, Rita, and Harriet Harrison, with the assistance of Wendy White. *The George Kleine Collection of Early Motion Pictures in the Library of Congress: A Catalog*. Washington: Library of Congress, Motion Picture, Broadcasting, and Recorded Sound Division, 1980.

Howard, Jessica H. "*Hallelujah!* Transformation in Film." *African American Review* 30, no. 2 (1996): 441–46.

Janes, Regina. "Beheadings." In Goodwin and Bronfen, *Death and Representation*, 242–62.

Kakoudaki, Despina. "The Human Machine: Artificial People and Emerging Technologies." PhD diss., University of California, Berkeley, 2000.

Kang, Minsoo. *Sublime Dreams of Living Machines: The Automaton in the European Imagination*. Cambridge, MA: Harvard University Press, 2011.

Kerekes, David, and David Slater, eds. *Killing for Culture: An Illustrated History of Death Film from Mondo to Snuff*. London: Creation Books, 1994.

Kermode, Frank. *The Sense of an Ending: Studies in the Theory of Fiction with a New Epilogue*. New York: Oxford University Press, 2000.

Kleinman, Arthur. "Do Not Go Gentle." *New Republic*, Feb. 5, 1990, 28–29.

Knight, Arthur. "The Movies Learn to Talk: Ernst Lubitsch, Rene Clair, and Rouben Mamoulian." In Weis and Belton, *Film Sound*, 213–20.

Kozloff, Sarah. *Invisible Storytellers: Voice-Over Narration in American Fiction Film*. Berkeley: University of California Press, 1988.

Kracauer, Siegfried. "Photography." In *The Mass Ornament: Weimar Essays*. Translated and edited by Thomas Y. Levin, 47–63. Cambridge, MA: Harvard University Press, 1995.

Langdale, Allan, ed. *Hugo Münsterberg on Film: The Photoplay: A Psychological Study and Other Writings*. New York: Routledge, 2002.

Laqueur, Thomas. *Making Sex: Body and Gender from the Greeks to Freud*. Cambridge, MA: Harvard University Press, 1992.

Lastra, James. *Sound Technology and the American Cinema: Perception, Representation, Modernity.* New York: Columbia University Press, 1999.

Lattimer, John K. "Additional Data on the Shooting of President Kennedy." *Journal of the American Medical Association* 269 (March 24, 1993): 1544–47.

Lavik, Erlend. "Narrative Structure in *The Sixth Sense*: A New Twist in 'Twist Movies'?" *Velvet Light Trap* 58 (Fall 2006): 55–64.

Lippit, Akira. *Electric Animal: Toward a Rhetoric of Wildlife.* Minneapolis: University of Minnesota Press, 2000.

Lesser, Wendy. *Pictures at an Execution.* Cambridge, MA: Harvard University Press, 1993.

Lloyd, Phoebe. "Posthumous Mourning Portraiture." In *A Time to Mourn: Expressions of Grief in 19th Century America*, edited by M. Pike and J. Armstrong, 71–87. Stony Brook, NY: Museums of Stony Brook, 1980.

Lowenstein, Adam. "Living Dead: Fearful Attractions of Film." *Representations* 110 (Spring 2010): 105–28.

MacDonald, Carlos. "The Infliction of the Death Penalty by Means of Electricity." *New York Medical Journal* 326 (May 7, 1892): 501–10.

Maltby, Richard. "The Spectacle of Criminality." In Slocum, *Violence and American Cinema*, 117–50.

Marin, Louis. "The Tomb of the Subject in Painting." In *On Representation*, 269–84. Stanford, CA: Stanford University Press, 1994.

Maurice, Alice. "'Cinema at Its Source': Synchronizing Race and Sound in the Early Talkies." *Camera Obscura* 17, no. 1.49 (2002): 31–71.

Merleau-Ponty, Maurice. *Sense and Non-sense.* Translated by Hubert L. Dreyfus and Patricia Allen Dreyfus. Evanston, IL: Northwestern University Press, 1964.

Merritt, Russell. "*The Painted Lady.*" In Usai, *The Griffith Project*, 6:151–57.

Merwin, W. S. "The Chain to Her Leg." *New Yorker*, Dec. 13, 2010, 62.

Metz, Christian. *The Imaginary Signifier: Psychoanalysis and the Cinema.* Bloomington: Indiana University Press, 1975.

Metzger, Thom. *Blood and Volts: Edison, Tesla, and the Electric Chair.* Brooklyn, NY: Autonomedia, 1996.

Michelson, Annette. "*The Man with the Movie Camera*: From Magician to Epistemologist." *Artforum* 10, no. 7 (1972): 60–72.

——. "On the Eve of the Future: The Reasonable Facsimile and the Philosophical Toy." *October* 29 (Summer 1984): 3–20.

Moran, Richard. *Executioner's Current: Thomas Edison, George Westinghouse, and the Invention of the Electric Chair.* New York: Alfred A. Knopf, 2002.

Moretti, Franco. *Signs Taken for Wonders.* London: Verso, 1983.

Mulvey, Laura. *Death 24x a Second: Stillness and the Moving Image.* London: Reaktion, 2007.

Murray, John. *Intensive Care: A Doctor's Journal.* Berkeley: University of California Press, 2000.

"Music to Be Born to, Music to Die To." *British Medical Journal* 321 (Dec. 23–30, 2000): 1577–79.

Musser, Charles. *Before the Nickelodeon: Edwin S. Porter and the Edison Manufacturing Company*. Berkeley: University of California Press, 1991.

——. *The Emergence of Cinema: The American Screen to 1907*. Berkeley: University of California Press, 1994.

Neale, Steve. "Melodrama and Tears." *Screen* 27, no. 6 (1986): 6–22.

Nesbet, Anne. *Savage Junctures: Sergei Eisenstein and the Shape of Thinking*. London: Tauris, 2007.

New York State Legislature. *Report of the Commission to Investigate and Report the Most Humane and Practical Method of Carrying into Effect the Sentence of Death in Capital Cases.*" Jan. 17, 1888. Albany, NY: Argus, 1888.

Niver, Kemp R. *Motion Pictures from the Library of Congress Paper Print Collection, 1894–1912*. Berkeley: University of California Press, 1967.

Oudart, Jean-Pierre. "Cinema and Suture." Translated by K. Hanet. *Screen* 18, no. 4 (1977–78): 35–47.

Pasolini, Pier Paolo. "Observations on the Sequence Shot." Translated by Ben Lawton and Louise K. Barnett. In *Heretical Empiricism*, edited by Louise K. Barnett, 233–37. Bloomington: Indiana University Press, 1988.

Pearson, Roberta. *Eloquent Gestures: The Transformation of Performance Style in Griffith Biograph Films*. Berkeley: University of California Press, 1992.

Peck & Snyder. *Nineteenth Century Games and Sporting Goods*. 1886. Princeton, NJ: Pyne Press, 2001.

Pernick, Martin. "Back from the Grave: Controversies over Defining and Diagnosing Death in History." In *Death: Beyond Whole-Brain Criteria*, edited by Richard M. Zaner, 17–74. Dordrecht: Kluwer, 1988.

Phelan, Peggy. "Dying Man with a Movie Camera: *Silverlake Life: The View from Here*." *GLQ: Journal of Lesbian and Gay Studies* 2, no. 4 (1995): 379–98.

President's Council on Bioethics. "Controversies in the Determination of Death: A White Paper by the President's Council on Bioethics." Dec. 2008. http://bioethics.georgetown.edu/pcbe/reports/death/.

Prince, Stephen. *Classical Film Violence: Designing and Regulating Brutality in Hollywood, 1930–1968*. New Brunswick, NJ: Rutgers University Press, 2003.

——, ed. *Screening Violence*. New Brunswick, NJ: Rutgers University Press, 2000.

Prins, Yopie. "Voice Inverse." *Victorian Poetry* 42, no. 1 (2004): 43–59.

Rogin, Michael. *Blackface, White Noise: Jewish Immigrants in the Hollywood Melting Pot*. Berkeley: University of California Press, 1996.

Romney, Jonathan. "Enigma Variations." *Sight and Sound* 14, no. 3 (2004): 12–16.

Ruby, Jay. *Secure the Shadow: Death and Photography in America*. Cambridge, MA: MIT Press, 1995.

Sandberg, Mark. *Living Pictures, Missing Persons: Mannequins, Museums, and Modernity*. Princeton, NJ: Princeton University Press, 2003.

Schepelhern, Peter. *100 Ans Dansk Film*. Copenhagen: Rosinante, 2001.

Schrader, Paul. "Notes on Film Noir." In *Film Noir Reader*, edited by Alain Silver and James Ursini, 53–64. New York: Limelight, 1996.

Schultz, Ned W., and Lisa Huet. "Sensational! Violent! Popular! Death in American Movies." *Omega* 42, no. 2 (2000–2001): 137–49.

Schwartz, Vanessa R. "The Morgue and the Musée Grévin: Understanding the Public Taste for Reality in Fin-de-siècle Paris." *Yale Journal of Criticism* 7, no. 2 (1994): 151–73.

Silverman, Kaja. *The Acoustic Mirror: The Female Voice in Psychoanalysis and Film*. Bloomington: Indiana University Press, 1988.

——. *The Subject of Semiotics*. New York: Oxford University Press, 1983.

Simmon, Scott. *"After Many Years."* In Usai, *The Griffith Project*, 1:143–45.

——. *"Romance of a Jewess."* In Usai, *The Griffith Project*, 1:132–33.

Simon, Art. *Dangerous Knowledge: The JFK Assassination in Art and Film*. Philadelphia: Temple University Press, 1992.

Singer, Ben. "Modernity, Hyperstimulus, and the Rise of Popular Sensationalism." In *Cinema and the Invention of Modern Life*, edited by Leo Charney and Vanessa Schwartz, 72–102. Berkeley: University of California Press, 1995.

Sklar, Robert, and Tania Modleski. *"Million Dollar Baby—*A Split Decision." *Cineaste* 30, no. 3 (2005): 6–11.

Slocum, J. David, ed. *Violence and American Cinema*. New York: Routledge, 2001.

Smoodin, Eric. "The Image and the Voice in the Film with Spoken Narrative." *Quarterly Review of Film Studies* 8, no. 4 (1983): 19–32.

Sobchack, Vivian. *The Address of the Eye: A Phenomenology of Film Experience*. Princeton, NJ: Princeton University Press, 1992.

——. *Carnal Thoughts: Embodiment and Moving Image Culture*. Berkeley: University of California Press, 2004.

——. "Inscribing Ethical Space: Ten Propositions on Death, Representation, and Documentary." In Sobchack, *Carnal Thoughts*, 226–57. Originally published in *Quarterly Review of Film Studies* 9, no. 4 (1984).

Spadoni, Robert. *Uncanny Bodies: The Coming of Sound and the Origins of the Horror Genre*. Berkeley: University of California Press, 2007.

Stevens, M. L. Tina. *Bioethics in America: Origins and Cultural Politics*. Baltimore: Johns Hopkins University Press, 2000.

Stewart, Garrett. *Between Film and Screen: Modernism's Photo Synthesis*. Chicago: University of Chicago Press, 1999.

St. John, Maria. "The Mammy Fantasy: Psychoanalysis, Race, and the Ideology of Absolute Maternity." PhD diss., University of California, Berkeley, 2004.

Telotte, J. P. "The Big Clock of Film Noir." *Film Criticism* 14, no. 2 (1989–90): 1–11.

——. *Voices in the Dark: The Narrative Patterns of Film Noir*. Urbana: University of Illinois Press, 1989.

Teresi, Dick. *The Undead: Organ Harvesting, the Ice-Water Test, Beating-Heart Cadavers—How Medicine Is Blurring the Line Between Life and Death.* New York: Pantheon, 2012.

Thacker, Eugene. *Biomedia.* Minneapolis: University of Minnesota Press, 2004.

Thompson, Kristin. "*The Golden Louis.*" In Usai, *The Griffith Project,* 2:24–25.

Thomson, David. "Death and Its Details." *Film Comment* 29 (Sept.-Oct. 1994): 12–18.

Torlasco, Domietta. *The Time of the Crime: Phenomenology, Psychoanalysis, Italian Film.* Stanford, CA: Stanford University Press, 2008.

Turim, Maureen. *Flashbacks in Film: Memory and History.* New York: Routledge, 1989.

Tyler, Lisa. "Mother-Daughter Myth and the Marriage of Death in *Steel Magnolias.*" *Literature/Film Quarterly* 22, no. 2 (1994): 98–104.

Usai, Paolo Cherchi, ed. *The Griffith Project.* Vols. 1, 2, and 6. London: BFI, 1999–2008.

Vardac, A. Nicholas. *Stage to Screen: Theatrical Method from Garrick to Griffith.* Cambridge, MA: Harvard University Press, 1949.

Weis, Elisabeth, and John Belton, eds. *Film Sound: Theory and Practice.* New York: Columbia University Press, 1985.

Welch, Gillian. "I Dream a Highway." *Time (The Revelator).* Acony Records B00009QI3U, 2001, CD.

Whissel, Kristen. *Picturing American Modernity: Traffic, Technology, and the Silent Cinema.* Durham, NC: Duke University Press, 2008.

——. "Placing the Spectator on the Scene of History: The Battle Re-enactment at the Turn of the Century, from Buffalo Bill's Wild West to the Early Cinema." *Historical Journal of Film, Radio, and Television* 22, no. 3 (2002): 225–43.

Williams, Linda. "Film Bodies: Gender, Genre, Excess." *Film Quarterly* 44, no. 1 (1991): 2–13.

——. *Hard Core: Power, Pleasure, and the "Frenzy of the Visible."* Berkeley: University of California Press, 1989.

——. "Melodrama Revised." In *Refiguring American Film Genres,* edited by Nick Browne, 42–88. Berkeley: University of California Press, 1998.

——. *Playing the Race Card: Melodramas of Black and White from Uncle Tom to O. J. Simpson.* Princeton, NJ: Princeton University Press, 2001.

——. "Something Else Besides a Mother: *Stella Dallas* and the Maternal Melodrama." *Cinema Journal* 24 (Fall 1984): 2–27.

Wolfe, Charles. "Historicizing the 'Voice of God': The Place of Vocal Narration in Classical Documentary." *Film History* 9, no. 2 (1997): 149–67.

Wollen, Peter. *Signs and Meaning in the Cinema.* Bloomington: Indiana University Press, 1969.

Wood, Gaby. *Edison's Eve: A Magical History of the Quest for Mechanical Life.* New York: Anchor, 2003.

Wunderli, Richard, and Gerald Broce. "The Final Moment Before Death in Early Modern England." *Sixteenth Century Journal* 20, no. 2 (1989): 259–75.

Yates, Frances. *The Art of Memory*. Chicago: University of Chicago Press, 2001.

Žižek, Slavoj, and Mladen Dolar. *Opera's Second Death*. New York: Routledge, 2001.

INDEX

21 Grams, 204–206

2001: A Space Odyssey, 25, 181, 187–200, 204, 207, 253nn23–24–25, 255n39, 255n42, 256n55, 257n64

absorption: and theatricality, 49, 123

acousmatic sound, 108–109, 113

acting: histrionic style, 7–8, 110; verisimilar style, 78, 80–81

Aldini, Giovanni, 7–9

Aliens, 196

All Quiet on the Western Front (1930), 139

All That Jazz, 171–73

Altman, Rick, 119, 123, 129, 138–39, 171, 241n40, 242n42, 243n60, 244n67, 244n80, 250n65

American Beauty, 169

American Mutoscope, 23, 35, 57

American Society for the Prevention of Cruelty to Animals, 43–44

And a Little Child Shall Lead Them, 76

Angels with Dirty Faces, 60–61, 63

animal tests, 42–44, 52–53

Applause, 24, 118–25, 131, 134, 140, 240n21, 241n32, 241n36, 242n41, 242nn43–44, 242n47, 243n53

Ariès, Philippe, 3, 20, 84, 162, 221n7, 224n38, 225n48, 236n42

Arnheim, Rudolf, 118, 241n36

ars moriendi, 162–63

art of memory, 96–97. *See also* mnemonic

Artwohl, Robert, 4, 221n8

attractions, 27, 29, 133–34, 141

Auerbach, Jonathan, 29, 41, 44, 46–47, 51, 226n3, 229n45, 230n49, 230n57

Aumont, Jacques, 72–73, 233n16

auteur, 70

automata, 6–7

Autopsy (HBO), 192

The Avenging Conscience, 76

Back from the Dead (Science Channel), 10

backstage musical, 171

Balázs, Béla, 65, 67, 69, 73, 105, 114, 126, 133, 141, 232n2, 232n6, 239n3, 241n22, 241n30, 242n49, 243n54, 243n56, 244n68

The Barbarian, Ingomar, 73

Barnouw, Erik, 34, 226nn10–11, 227n20

Barnum and Bailey, 43, 54

Barthes, Roland, 5, 17, 83, 216, 222n12, 250n63

Bazin, André, 14–18, 30, 59, 79, 84, 99, 127, 224n31,224n33, 224n35, 238n65, 247n30, 250n63

Beauvoir, Simone de, 22, 225n47

beheading: and *Execution of Mary, Queen of Scots*, 30–35, 36; in painting, 38–39

Beheading the Chinese Prisoner, 35

Behind the Scenes, 67, 69–70, 88, 92, 100, 232n3, 233n11, 234n23, 241n38

Benjamin, Walter, 51, 160, 230n58, 248n42

Berger, Hans, 180

Bergson, Henri, 14

Best, Stephen, 133, 244n71

Bierce, Ambrose, 144

The Big Clock, 159, 248n38

The Big Combo, 140

bioethics, 187; and President's Committee of Bioethics, 9, 186

Biograph Studios, 23, 35, 57, 66, 68–74, 76–80, 83, 101, 233n11, 234n25, 235n31, 240n16

biomedia (Thacker), 198–99

The Birth of a Nation, 81–82, 228n32, 244n71

blackface, 107, 115–17

Blade Runner, 6

Blake, Robert, 34, 227nn12–13

body genres. *See* melodrama

La Boheme, 81

Bonitzer, Pascal, 125

Bonnie and Clyde, 18

brain death, 183–86, 212, 214

Braunberger, Pierre, 14

Brewster, Ben, 77–78, 234n26, 234n28, 235n30

The Bride of Frankenstein, 135

Broce, Gerald, 162–63, 249n48, 249n53

Broken Blossoms, 83

Bronfen, Elisabeth, 20, 224n41, 226n9

Brooks, Peter, 81, 119, 128, 159–62, 167, 171, 235n35, 236n43, 241n39, 243n59, 246n21, 248n37, 248n40, 249nn43–44

Brown, Harold, 9, 44, 52, 230n60

Browning, Robert, 145

Browning, Tod, 127, 136, 172

Bruhier, Jacques-Jean, 8

Buckley, Christopher, 212, 257n69

Buffalo Bill, 45, 229n41

The Bullfight, 14, 224n33

Buñuel, Luis, 169, 254n28

Burch, Noël, 39, 221n1, 228n28

Burgoyne, Robert, 191, 254n29, 254n31, 254n33

Bush, Jeb, 185

Butch Cassidy and the Sundance Kid, 93, 237n57

Cagney, James, 2

Camille (1936), 140

A Career of Crime no. 5: The Death Chair, 48, 57

Carlito's Way, 171

Cartwright, Lisa, 186, 231n65, 252n18, 254n26, 255n39, 255n45, 256n53

Chion, Michel, 189–90, 192–94, 240n11, 240n13, 240n18, 241n27, 246n18, 253nn23–24–25, 254n27, 254n34, 255nn37–38, 255n40, 255n42, 255n44, 256n55

chronophotography, 30

circus, 43

Clark, Alfred, 32

Clark, Arthur C. *See 2001: A Space Odyssey*

Clover, Carol, 204, 239n7, 256n60, 257n68

Coma, 212

Comolli, Jean-Louis, 195, 255nn46–47–48

contingency, 50–51

A Corner in Wheat, 70, 80, 94, 149

coroner, as term, 34

The Country Doctor, 24, 65, 66, 71, 81, 86–87, 90–91, 94–95, 99, 101–102, 149, 218, 220, 237n53, 238n64

Cranford, Ronald, 179, 184–85, 213, 252nn13–14

Cruzan, Nancy, 184, 212, 252n12, 257n67

Curtis, Scott, 170, 197–98, 212n10, 250nn63–64, 252n17, 255n49

Dead Man Walking, 59, 63, 240n54

death: and cinematic technology, 15–18, 70, 105–106, 144, 215–18; and life, 5, 23, 105; and "on/off" switch, 42, 50, 104, 113, 123, 154, 180; and technology, 6–10, 25, 99, 183–86; and repetition, 14, 17, 59, 92; as lack of synchronization, 135; as photographic stillness, 13–14, 76, 84; history of confirming, 6–10, 75, 82, 214; multiple moments of, 10, 12–13, 18–20, 57, 72, 74–75, 101, 117, 152–77, 215; natural, 22, 184; violent, 22, 26; virtual, 203. *See also* dying; posthumous motion; registration

death drive, 160–62

decapitation. *See* beheading

Deleuze, Gilles, 86, 92, 236n45

Demolition of a Wall, 58

The Departure of a Great Old Man, 83

Descartes, René, 6, 222n15

Detour, 156–57, 159, 166, 248n34

Detweiler, Robert, 144–45, 245n3

Dick, Kirby, 218

Dickinson, Emily, 145

Diderot, Denis, 8, 230n52

diegetic screen (monitor), 189–90, 195–96, 199, 206

digital media, 190, 197, 199, 207

Dircks, Henry, 34

disembodiment, 62, 65, 105–106, 113, 129, 131–35, 181, 192–94, 217

D.O.A. (1950), 143, 144, 152–53, 157–59, 162, 166, 171

Doane, Mary Ann, 36, 49–51, 54, 58–59, 103, 105, 113, 115, 117, 125, 227n19, 230n53, 230n59, 231n65, 231n71, 239n5, 240n19, 247n27

documentary, 20, 26, 169, 198, 209, 218–20

Donnie Darko, 24, 171, 175–76

Double Indemnity, 156, 165, 166, 247n28, 247n31

Dr. Jekyll and Mr. Hyde (1931), 126, 243n57

Dracula (1931), 127, 239n4

Dunne, Philip, 147

dying, 4, 22, 23, 26: and narrative editing, 69, 73; as cinematic form, 59, 84, 150; as flashback, 56, 159–63; as progression into silence, 133; body, 28, 187, 198–99, 207; process of, 39, 55–59, 66, 154, 177, 195, 209, 215; twice, 146, 165–77

Dying (Roemer), 169

Edison Company, the, 2, 23, 28, 30, 34–35, 45, 54, 57–58, 185, 251n9

Edison, Thomas, 7, 28, 34, 35, 40, 42–44, 46, 52, 59, 62, 64, 105, 159, 217, 222n15, 228n35

editing, 23, 37–38, 67: and Deleuze, 86, 92; and the curative cut, 66, 88; and the palliative cut, 66, 68–69, 100; as realization of death, 174–75; contrast, 68; narrative, 66, 72, 99, 101–102; parallel, 73, 75, 84–85, 88–110. *See also* substitution splice

Einthoven, William, 180

Eisenstein, Sergei, 29–30, 226n2, 236n40, 238n61

electric current, 44, 48, 50–52, 57

electrocardiograph (EKG), 10–12, 25, 96, 180–81, 186–88, 195–96, 209, 213, 218

Electrocuting an Elephant, 23, 48, 54, 56, 64, 236n47, 246n16

electrocution, 19–20, 23, 28, 42–62; and Edison, 43–44, 52

electroencephalograph (EEG), 24, 183, 185, 187–88, 196, 198, 213, 218

Elfelt, Peter, 40, 46, 228n30

The End (2004), 218

L'Eve Future, 7

execution: critique of, 62. *See also* beheading; electrocution; gas chamber; hanging; lethal injection

Execution by Hanging, An, 23, 35–36

Execution of Czolgosz with Panorama of Auburn Prison, 23, 46–48, 50, 52, 55, 73, 84, 91, 232n73, 236n47

The Execution of Mary, Queen of Scots, 2, 30–31, 34, 36, 137, 217

Expressionism, 164

Faces of Death, 47

The Faded Lilies, 81

Faulkner, William, 144

Fell, George, 43–44

Fiedler, Leslie, 25, 225n49

Fischer, Lucy, 120, 123, 126

flashback, 149, 152–73

flatline, 10–11, 96, 180–81, 183, 185–87, 189, 196–97, 199, 201–203, 207, 209, 212, 214, 217, 220

Flatliners, 214

Ford, John, 24, 94, 146–50, 246n15

Fothergill, John, 7

Foucault, Michel, 8, 61

Frankenstein: 1931 film, 135–36, 179, 185, 239n4, 250n63; Mary Shelley's

novel, 7, 8, 250n63. *See also The Bride of Frankenstein*

freeze-frame, 84

Freud, Sigmund, 104, 156, 160–61, 223n20, 239n2, 248n40, 249n43, 254n32

Fried, Michael, 49, 230n52

Frontline (television show), 184, 27n67

funerals: and cinema, 134; in films, 23, 25, 103; William McKinley, 40–42, 114

Galvani, Luigi, 8

gangster films, 136–38

gas chamber, 61–63

Gaudreault, André, 37–38, 227n23

Gerry, Elbridge, 43, 52

The Ghost!, 34

Gimme Shelter!, 93

Gish, Lillian, 2, 72, 81, 83, 97, 235n38

Godwin, William, 7

Goodwin, Sarah Webster, 20, 224n41, 226n9

Gorky, Maxim, 1, 2, 27, 221n1, 224n40

Griffith, D. W., 23, 65–73, 75, 77, 79–95, 99, 101, 110, 112, 149, 164, 216, 220, 239n8, 240n21, 241n38, 244n71, 245n1

guillotine, 28–29, 34, 39. *See also* beheading

Gunning, Tom, 38, 69–73, 91, 99–100, 222n16, 226n1, 227n25, 237n53, 238n59, 238n64, 239n8, 245n1, 253n21

Hale, Matthew, 43

Hallelujah!, 128, 130–31, 134, 141, 147

The Hamlet (Faulkner), 144

hanging: in film, 35–36

Hansen, Miriam, 35, 227n155

Harvey, William, 8

Hawks, Howard, 137–38

Hearts in Dixie, 129–30
Heise, William, 35, 44
Hemingway, Ernest, 144
Henderson, Brian, 149, 246n12
Henrettelsen, 40, 46
Hertz, Carl, 34
High Fidelity, 104, 118, 134
Hill, David Bennett, 43
histrionic acting. *See* acting
Hoffman, E. T. A., 7
horror film, 126–27, 135, 204
The House with Closed Shutters, 24, 72, 74
How Green Was My Valley, 24, 93, 94, 146–50, 174, 177
Howard, Jessica H., 129, 133, 243n61, 244n70

I Want to Live!, 61–62, 249n54
In Old Chicago, 60, 139
Inception, 201
instantaneity, 28, 36, 49, 53–54, 104

The Jacket, 171, 173
Jacob's Ladder, 171
Jacobs, Lea, 77–78, 234n26, 234n28, 235n30
James, Henry, 144–45, 177, 235n35, 241n39, 246n41
Janes, Regina, 33, 226n9
The Jazz Singer, 24, 106–107, 110–15, 117–19, 121–22, 128, 138, 140–41, 159, 173, 233n22, 239n8, 240n17, 241n38, 242n41, 243n60
JFK, 4
Joan of Arc (Edison), 35

Kakoudaki, Despina, 51, 230n56
Kemmler, William, 9, 52, 53, 57
Kennedy, John F., 4, 15, 19, 222n8
Kennelly, Arthur, 52
Kermode, Frank, 160, 248n41

Kill Bill 2, 2
The Killers (1946), 151–52
kinetoscope (Edison), 34–35, 198
Kingsley, Charles, 93, 238n558
The Kiss (Edison), 35, 227n12
Kleinman, Arthur, 210, 257n65
Knight, Arthur, 122, 131, 242n46, 244n66
Kol Nidre, 107, 109–111, 113, 115–17, 128, 141, 234n22. *See also* music
Kozloff, Sarah, 147, 149–50
Kracauer, Siegfried, 96, 238n63
Kübler-Ross, Elisabeth, 172, 209
Kubrick, Stanley, 181, 187–88, 190, 211, 256n55, 257n64
kymography, 186, 195

Lady in the Lake, 150
Laennec, René, 8
Laplanche, Jean, 71
Lastra, James, 139, 244n81
Lesser, Wendy, 64, 232n77
lethal injection, 63
Letter from an Unknown Woman, 157
Lewis, Joseph, 140
life-support technology, 59, 181–87, 189, 206, 208, 211
Lippit, Akira, 56, 231n67
Liquid Electricity; or, the Inventor's Fun with Galvanic Fluid, 48
Little Caesar, 136–37
The Love Parade, 138
Lowenstein, Adam, 20, 224n40, 226n1
Lubin, Sigmund, 35
Lubitsch, Ernst, 138, 242n46
Lumière Brothers, 1, 58

MacDonald, Carlos, 53, 57, 230n48, 231n63, 231n68
magic theater, 34–37
magnetic resonance imaging (MRI), 197
The Magnificent Ambersons, 93

Maltby, Richard, 138
Maltin, Leonard, 173, 250n66
mammy figure, 129, 131–34
Mamoulian, Rouben, 120, 122–23
Man with a Movie Camera, 92, 237n54
Manhattan Melodrama, 60
Marey, Jules-Etienne, 30, 186, 198, 252n18
Marin, Louis, 38–39, 228n27
The Matrix, 25, 202–203
Maurice, Alice, 130, 224n65
McKinley, William, 40, 41, 42, 46, 228n33
McKinley's Funeral Cortege at Washington, DC, 41
Meisel, Martin, 77
melodrama, 60, 71–72, 75, 85; and tears, 100–101; and "too late," 71–72, 74, 100, 110, 114, 115, 119–20, 141; "text of muteness," 81, 85, 120
Merleau-Ponty, Maurice, 95, 238n61
Metz, Christian, 118, 155, 241n33, 247n30
Micco, Guy, 10–11, 209, 211, 217, 223n25
Michelson, Annette, 7, 222n17, 237n55
Milestone, Lewis, 139
Million Dollar Baby, 208, 211, 257n63
mnemonic, 96–97
Mondo Cane, 47
Montgomery, Edward, 61
Moretti, Franco, 100, 238n66
The Mothering Heart, 81
Motion Picture Production Code of 1930, 60
mourning portrait, 89–90
Mulvey, Laura, 13, 22, 223nn28–29, 224n36
The Mummy (1932), 127
Münsterberg, Hugo, 70, 233n10
Murder, My Sweet, 151
Murnau, F. W., 97, 249n57

Murray, John, 11–12, 180, 210, 222n16, 223n26, 251n1
music: as registration, 104, 117; funerary, 109; non-diegetic, 135, 140; offscreen, 107–117
Musketeers of Pig Alley, 72, 79
Musser, Charles, 32, 36, 226nn6–7, 229n46, 230n37, 237n52

narrator system (Gunning), 69–70, 74
Neale, Steve, 100, 248n36
Near Death (Wiseman), 169, 198, 209, 212
Nesbet, Anne, 29, 226n2, 236n40
noir, 125, 150–73

offscreen music. *See* music: offscreen
organ transplantation, 182, 204–206
The Others, 173, 177
Oxenberg, Jan, 21, 218–19

The Painted Lady, 79–80, 235n34
painting, 38–39. *See also* mourning portrait
Pasolini, Pier Paolo, 14–20, 50, 66, 174, 224n31, 232n1, 247n23, 250n69
Pathé Company, 39
Pearl, Daniel, 64
Pearson, Roberta, 77–78, 234n25, 235n32
The Perils of Pauline, 75
Pernick, Martin, 8, 223n18, 223n21
persistent vegetative state, 183–84
physiology, 186, 190
polygraphic gaze, 212
Pontalis, J.-B., 71
Pope Pius XII, 182
Porter, Dennis, 171
posthumous motion, 19, 24, 76, 81, 87–96, 107, 126, 135–36, 139, 196, 201, 207; and the monitor, 186; and the pan, 89–92, 220; and voice-over,

144, 146, 164–67; postdiegetic,
149–50, 171–77, 205
posthumous shock, 51
posthumous voice. *See* voice-over
The Postman Always Rings Twice
(1946), 163
post-synchronization. *See* sound
The Power and the Glory, 146, 245n7
President's Bioethics Committee, 9, 186
Psycho, 2, 13, 42, 200–201, 249n58
Pudovkin, Vsevolod, 30, 238n61
Pynchon, Thomas, 103

Quinlan, Karen Ann, 183–85, 187

Reading the Death Sentence, 35
reenactment, 45–53
registration, 23–24, 33–34, 48–49, 51–52,
63–64, 66, 68–69, 72, 74–76, 158,
179–80, 193–94, 204, 208, 218, 220;
absence of, 55–57, 123, 125–26, 192,
200, and flashback structure, 172–77;
and music, 104; and sound, 24, 106,
117–42; and space, 133–35, 141; and
the camera, 26, 57, 122–23; and the
monitor, 185, 191, 199, 201–203, 208–
213, 217; and voice-over structure,
144, 152–71, 208–209; as crying,
132; as motivation for documentary,
218–20; in Griffith, 79–81 86, 91;
nonhuman, 24, 66, 75, 91, 96–97
Reprieve from the Scaffold, 35, 164
Rhetorica ad Herennium, 95
Robinson, Edward G., 2
Roemer, Michael, 169, 209
Rogin, Michael, 108, 115–16, 239n7,
239n10, 241n26
Romance of a Jewess, 74, 234n23
Ruby, Jay, 89, 236n46, 237nn50–51

San Francisco Examiner, 61
San Quentin, 61, 63

The Sands of Dee, 93–94
Saving Private Ryan, 2
Scarface (1932), 136–37, 244n77
The Scarlet Letter (1926), 97–98
Schiavo, Terri, 179, 184–85, 213, 252n13
science fiction film, 181–94, 196,
201–203, 213
The Sealed Room, 84–85, 92
Seltzer, Mark, 50
Shelley, Mary. *See Frankenstein*
Shooting Captured Insurgents, 44–45,
47–48, 55
silence, 128, 146, 179, 187. *See also*
stillness
Silverlake Life, 218–20, 224n43,
237n57
Silverman, Kaja, 13, 42, 157, 200–201,
224n30, 228n34, 242–43n51, 248n35,
256n54, 256n56, 256n58
The Sixth Sense, 24, 168, 171, 173, 175,
177, 250n59
Sjöström, Victor, 97–98
snuff, 3, 4, 47–48
Sobchack, Vivian, 4, 18, 20–22, 28, 85,
222n11, 227n21, 231n72, 236n44
sound (in cinema), 23, 105, 117–18; and
the continuous-level soundtrack,
139; as noise, 119; asynchronous,
119–23, 126–28, 135; post-
synchronization, 110, 129–34;
synchronized, 104–105, 110, 112,
114, 125, 128. *See also* music;
acousmatic sound
Southwick, Alfred, 43
Spadoni, Robert, 127, 135, 239n4,
243n58, 244n74
Spanish-American War, the, 44
The Stand-Up, 172
Steel Magnolias, 25, 206–208, 211,
257n62
Stevens, M. L. Tina, 182, 251n5, n7,
252nn15–16

Stewart, Garrett, 13, 16, 22, 170,
 223n27, 224n34, 234n24, 235n39,
 237–38n57, 246n20, 252n17
stillness: as perpetual death, 207–209;
 motion of, 84; slide to inertia, 48,
 54, 68, 76, 80, 83–86, 101, 104
Stowe, Harriet Beecher. See Uncle
 Tom's Cabin
Strange Days, 203–204
Sturges, Preston, 146–47
substitution splice, 32, 36–39, 54
superimposition, 117
Sunset Blvd., 151, 155, 158, 164–66,
 168–69

tableau, 70, 77–78, 84, 86, 88–90, 101,
 109–110, 114, 209; and editing, 77;
 of grief, 70, 76, 80, 131–32, 148
Tabu, 97
technology. See death: cinematic
 technology; life-support technology
television, 63–64
Telotte, J. P., 155, 159, 161, 170,
 246n17, 247n29, 247n31, 248n38,
 249n52, 250n62
Tenenti, Alberto, 162
Teresi, Dick, 5, 192, 222n13, 223n19,
 223n24, 251n4, 254n35
Thacker, Eugene, 198, 255n52
thanatosis, 56
Thank You and Goodnight, 21, 218
Thelma and Louise, 93, 238n57
Thomson, David, 2–3, 221n2, 221n5
Tolstoy, Leo, 83
Topsy: the elephant, 54–55, 57–59,
 84–85, 231n64, 236n47
Total Film Magazine, 2
Tudor, Mary, 33, 36
Turim, Maureen, 154–55, 247n26

Uncle Tom's Cabin (1903 film), 54, 77,
 117, 239n7

undead: as condition of medium,
 119–25, 127

Vaucanson, Jacques de, 6
verisimilar acting style. See acting:
 verisimilar style
Vertov, Dziga, 17, 92
Vidor, King, 81, 83, 128–29, 131–33,
 138, 243n64
voice-off, 125
voice-over, 23; of the dead (voice-after),
 164–71; of the dying, 152–64
Vovelle, Michel, 162

wax museum (Musée Grevin), 39
Way Down East, 73
Welch, Gillian, 215
Westinghouse, George, 9, 44, 228n35
Whissel, Kristen, 45, 228n31, 229n41,
 229n44, 230n50
White, James, 49
The Widow Jones, 35, 227n12
Wilde, Oscar, 1, 4
Williams, Linda, 71, 73, 100, 110–11,
 115–16, 231n70, 233n17, 233n22,
 238n69, 239n7, 239n9, 240n15,
 240n17, 240n20, 241n23, 241n37,
 246n19
Winslow, Jacque Bénigne, 7–8
Wiseman, Frederick, 169, 198, 209–210
The Wizard of Oz, 21, 109
Wood, Gaby, 6, 222n15
Wunderli, Richard, 162–63, 249n48,
 249n53

Yates, Frances, 95, 238n62

Zapruder, Abraham: film of Kennedy
 assassination, 4, 14, 15, 18, 19, 20,
 222n8
Zecca, Ferdinand, 39
Žižek, Slavoj, 166, 249n56

FILM AND CULTURE: A series of Columbia University Press **EDITED BY JOHN BELTON**

*What Made Pistachio Nuts? Early Sound
Comedy and the Vaudeville Aesthetic*
HENRY JENKINS

*Showstoppers: Busby Berkeley and the
Tradition of Spectacle*
MARTIN RUBIN

*Projections of War: Hollywood, American
Culture, and World War II*
THOMAS DOHERTY

*Laughing Screaming: Modern Hollywood
Horror and Comedy*
WILLIAM PAUL

*Laughing Hysterically: American Screen
Comedy of the 1950s*
ED SIKOV

*Primitive Passions: Visuality, Sexuality, Ethnog-
raphy, and Contemporary Chinese Cinema*
REY CHOW

*The Cinema of Max Ophuls: Magisterial
Vision and the Figure of Woman*
SUSAN M. WHITE

Black Women as Cultural Readers
JACQUELINE BOBO

*Picturing Japaneseness: Monumental Style,
National Identity, Japanese Film*
DARRELL WILLIAM DAVIS

*Attack of the Leading Ladies: Gender,
Sexuality, and Spectatorship in Classic
Horror Cinema*
RHONA J. BERENSTEIN

*This Mad Masquerade: Stardom and Masculin-
ity in the Jazz Age*
GAYLYN STUDLAR

*Sexual Politics and Narrative Film: Hollywood
and Beyond*
ROBIN WOOD

*The Sounds of Commerce: Marketing Popular
Film Music*
JEFF SMITH

*Orson Welles, Shakespeare,
and Popular Culture*
MICHAEL ANDEREGG

*Pre-Code Hollywood: Sex, Immorality, and
Insurrection in American Cinema, 1930–1934*
THOMAS DOHERTY

*Sound Technology and the American Cinema:
Perception, Representation, Modernity*
JAMES LASTRA

*Melodrama and Modernity: Early Sensational
Cinema and Its Contexts*
BEN SINGER

*Wondrous Difference: Cinema, Anthropology,
and Turn-of-the-Century Visual Culture*
ALISON GRIFFITHS

*Hearst Over Hollywood: Power, Passion,
and Propaganda in the Movies*
LOUIS PIZZITOLA

*Masculine Interests: Homoerotics in
Hollywood Film*
ROBERT LANG

Special Effects: Still in Search of Wonder
MICHELE PIERSON

*Designing Women: Cinema, Art Deco, and
the Female Form*
LUCY FISCHER

*Cold War, Cool Medium: Television,
McCarthyism, and American Culture*
THOMAS DOHERTY

Katharine Hepburn: Star as Feminist
ANDREW BRITTON

Silent Film Sound
RICK ALTMAN

*Home in Hollywood: The Imaginary
Geography of Hollywood*
ELISABETH BRONFEN

*Hollywood and the Culture Elite: How the
Movies Became American*
PETER DECHERNEY

Taiwan Film Directors: A Treasure Island
EMILIE YUEH-YU YEH AND DARRELL
WILLIAM DAVIS

*Shocking Representation: Historical Trauma,
National Cinema, and the Modern
Horror Film*
ADAM LOWENSTEIN

China on Screen: Cinema and Nation
CHRIS BERRY AND MARY FARQUHAR

*The New European Cinema:
Redrawing the Map*
ROSALIND GALT

George Gallup in Hollywood
SUSAN OHMER

Electric Sounds: Technological Change and the Rise of Corporate Mass Media
STEVE J. WURTZLER

The Impossible David Lynch
TODD MCGOWAN

Sentimental Fabulations, Contemporary Chinese Films: Attachment in the Age of Global Visibility
REY CHOW

Hitchcock's Romantic Irony
RICHARD ALLEN

Intelligence Work: The Politics of American Documentary
JONATHAN KAHANA

Eye of the Century: Film, Experience, Modernity
FRANCESCO CASETTI

Shivers Down Your Spine: Cinema, Museums, and the Immersive View
ALISON GRIFFITHS

Weimar Cinema: An Essential Guide to Classic Films of the Era
EDITED BY NOAH ISENBERG

African Film and Literature: Adapting Violence to the Screen
LINDIWE DOVEY

Film, A Sound Art
MICHEL CHION

Film Studies: An Introduction
ED SIKOV

Hollywood Lighting from the Silent Era to Film Noir
PATRICK KEATING

Levinas and the Cinema of Redemption: Time, Ethics, and the Feminine
SAM B. GIRGUS

Counter-Archive: Film, the Everyday, and Albert Kahn's Archives de la Planète
PAULA AMAD

Indie: An American Film Culture
MICHAEL Z. NEWMAN

Pretty: Film and the Decorative Image
ROSALIND GALT

Film and Stereotype: A Challenge for Cinema and Theory
JÖRG SCHWEINITZ

Chinese Women's Cinema: Transnational Contexts
EDITED BY LINGZHEN WANG

Hideous Progeny: Disability, Eugenics, and Classic Horror Cinema
ANGELA M. SMITH

Hollywood's Copyright Wars: From Edison to the Internet
PETER DECHERNEY

Electric Dreamland: Amusement Parks, Movies, and American Modernity
LAUREN RABINOVITZ

Where Film Meets Philosophy: Godard, Resnais, and Experiments in Cinematic Thinking
HUNTER VAUGHAN

The Utopia of Film: Cinema and Its Futures in Godard, Kluge, and Tahimik
CHRISTOPHER PAVSEK

Hollywood and Hitler, 1933–1939
THOMAS DOHERTY

Cinematic Appeals: The Experience of New Movie Technologies
ARIEL ROGERS

Continental Strangers: German Exile Cinema, 1933–1951
GERD GEMÜNDEN